Myth, Ethos, and Actuality

MYTH, ETHOS, AND ACTUALITY

Official Art in Fifth-Century B.C. Athens

David Castriota

The University of Wisconsin Press

The University of Wisconsin Press
114 North Murray Street
Madison, Wisconsin 53715

3 Henrietta Street
London WC2E 8LU, England

5 4 3 2 1

Printed in the United States of America

Library of Congress Cataloging-in-Publication Data
Castriota, David, 1950–
 Myth, ethos, and actuality: official art in fifth-century B.C. Athens
 / David Castriota.
 352 pp. cm.—(Wisconsin studies in classics)
 Includes bibliographical references and index.
 ISBN 0-299-13350-8 (cloth) ISBN 0-299-13354-0 (pbk.)
 1. Art, Greek. 2. Art patronage—Greece. 3. Art and state—
 Greece. I. Title.
 N5630.C38 1992
 709'.38'5—dc20 92-50247

For Rachel and Brian

Contents

Chapter 4: The Persian Wars and the Sculptures of the Parthenon / 134

Chapter 5: The Parthenon Frieze, Persia, and the Athenian Empire / 184

Illustrations

Figures

Maps

Acknowledgments

My interest in the art of fifth-century Athens began in 1985 at Columbia University, where, as visiting assistant professor, I taught an undergraduate seminar on the subject. I am first of all indebted to David Rosand, then chair of the department, for suggesting that I offer such a course. The opportunity to study the Athenian monuments closely with a small and gifted group of students first alerted me to the issues and complexities of mythic analogy. This interest was soon to become an abiding concern for me, and it intensified as I came to explore the broader use of myth in Greek art in the undergraduate courses that I developed subsequently at Duke University. The portions of this study dealing with Polygnotos and Pheidias were first presented at the College Art Association Meeting in 1987, in the session on Greek iconography chaired by Warren Moon. I am deeply grateful to Emily Vermule, the respondent at this session, for her useful comments and criticism at this early stage.

I would also like to thank the various other scholars whose feedback and advice contributed so substantially to this book as it began to take shape. Robert Wallace read a preliminary draft of the chapters on Polygnotos and Pheidias. Warren Moon and Barbara Fowler, the editors of the classical series at the University of Wisconsin Press, read the original draft of the book-length version. Jeffrey M. Hurwit and Jerome Pollitt generously consented to be outside readers, and I am deeply indebted for their detailed and expert response to my work. I feel that I owe a special debt to Jerome Pollitt, not only for his valuable criticism and encouragement of this project, but more generally for the inspiration that his work on Greek art and literature has provided, an inspiration that is evident in much of what follows. I wish to express my thanks to Barbara J. Hanrahan, senior editor at the University of Wisconsin Press, for her interest in my work and all her efforts throughout the publication process.

I am grateful to the American Philosophical Society, to the National Endowment for the Humanities, and to the University Research Council of Duke University for the funding to defray the cost of on-site study of the monuments. I also want to express my thanks to the staff at the Akropolis Museum in Athens for allowing me to study and photograph the Parthenon material, especially the unexhibited remains of the metopes. Mark Stansbury-O'Donnell has graciously consented to let me use his graphic reconstructions of the Polygnotan paintings in the Knidian Lesche; I deeply appreciate his commitment to the principle of scholarly interchange. Regarding matters bibliographic, I also owe a great deal to the diligence and skill of my

xi

research assistant, Heather Hornbuckle. And, as always, I am grateful to my wife, Jill Meredith, for her help and advice in editing this work at various stages, and for her unflagging support in all things.

The late Warren Moon, I feel, deserves the ultimate acknowledgment here. He was a scholar of enormous vitality who had a profound affect on all who were privileged to know him as a friend and colleague. It was he who first encouraged me to pursue my ideas about mythic transformations in the fifth-century monuments when he chose to include my paper in his College Art Association session, and he continued this encouragement every step of the way as the project evolved into a book and was accepted for publication. I do not exaggerate in the least in saying that without his help and support, this study would never have come to fruition. I hope that the result is in some measure worthy of his faith in me and my work.

Myth, Ethos, and Actuality

Introduction

The Mythic Analogue and the Celebration of the Persian Wars

It has become a commonplace among classicists that the experience of the Persian Wars profoundly altered the Greeks' attitudes toward themselves and their past. The mainland Greeks of the early fifth century B.C. were the first urban culture to check the expansion of the largest and most powerful empire that had yet emerged. They did so at considerable cost. As they stood amidst the devastated remains of their cities and shrines, they attempted to make sense of their triumph over Xerxes in something more than tactical or logistical terms. And so the Greek leadership at this time, especially in Athens, turned to the religious and moral paradigms of heroic myth, not only to celebrate their victory and newfound power in the Aegean, but to explain and justify it as well. Such stories were far more than fable; they were accepted as early history, and they had been created to serve as archetypal narratives that lent order and pattern to matters of fundamental importance.[1] Mythic traditions exemplified the causes of human excellence and achievement, as well as weakness and failure, for they addressed the issue of *ethos,* human character or behavior, and the consequences, good and bad, that human action would incur. Myth also provided a focus for the closely connected beliefs about divine intervention in the affairs of men and the role that human character and conduct could play in the fate or judgment allotted by the gods.

One might commemorate a contemporary achievement in direct terms, by dwelling at length upon the actual accomplishments of specific individuals. But among the Greeks it was less presumptuous and far more flattering to do this indirectly, through the guise or analogy of the epic heroes and their divine protectors. In the poetry of the first half of the fifth century,

3

the odes of Pindar and Bakchylides illustrate this technique. These victory songs consistently extol the virtues of aristocratic athletic champions by digressing upon the character and deeds of mythic predecessors, and the grace or favor of the gods essential to success. Pindar's Sixth Pythian Ode, for example, celebrates the young victor of a chariot race and the honor that he brought upon his father's house. But the poem accomplishes this largely by circumscribing the victor's achievements and qualities within the context of the more renowned mythic bravery, equestrian skill, and filial piety of old Nestor's son at Troy:

> The front shines in the clear air,
> Thrasyboulos, on your father announcing
> for you and yours the pride
> of a chariot victory in the folds of Krisa—
> a tale to run on the lips of men.
>
> *First of all gods, honor*
> *the deep-voiced lord of the lightning and thunderstroke,*
> *Zeus Kronides;*
> *next, through all their destiny never deprive*
> *your parents of such reverence even as this.*
>
> In the old days mighty Antilochos proved one
> who lived in that word.
> He died for his father, standing up
> to the murderous onset of the Aithiop champion,
> Memnon; for Nestor's horse, smitten by the shaft of Paris,
> had fouled the chariot, and Memnon attacked
> with his tremendous spear.
> And the old Messenian was shaken
> at heart and cried aloud on his son's name.
>
> And the word he flung faltered not to the ground; in that place
> standing, the young man
> in his splendor bought by his own death his father's rescue,
> And of those who lived long ago men judged him
> pre-eminent among the youth for devotion
> to those who begot them, for that terrible deed.
> All that is past.
> Of men living now, Thrasyboulos
> comes beyond others to the mark in his father's eyes. . . .
> .
> The blossom of youth he carries is nothing violent,
> but wise in the devious ways of the Muses.

To you, Poseidon, shaker of the earth, lord
of the mastering of horses, he comes, with mind to please you.[2]

For the Greeks the value of myth lay in its capacity to subsume and
rationalize the immediate circumstances of human experience, its ability to
express "the specific in the light of the generic," as Pollitt has so aptly put
it.[3] In a mythic guise, contemporary events could be made to appear as the
outcome of long-established patterns of human action and divine will, and
thus endowed with a deeper cultural and religious significance.

Recent studies have indicated that this mythic-analogic outlook had be-
gun to make an impact on the visual arts and public ceremonial of Athens as
early as the sixth century B.C., particularly under the tyrant Peisistratos.[4]
But Pindar's poetry alone demonstrates that mythic prefiguration must al-
ready have been an established honorific strategy among the Greeks by the
late Archaic period, and thus it soon emerged as an organizing principle for
celebrating the victorious confrontation with Persia in all media of expres-
sion.[5] Certain myths lent themselves readily to such comparison. The epic
of the Trojan War, depicting a rich and powerful Asiatic kingdom humbled
by a united Greek effort, provided an almost irresistible analogue for the
Persian Wars generally, and especially for the aggressive, punitive cam-
paigns of Kimon and the Delian League in Thrace, the Aegean Islands, and
Asia Minor during the 470s and 460s. The desire to find effective ancient
precedent for contemporary events also helps to account for the new form
and significance that various myths acquired at this time. The Asiatic Ama-
zons, previously a remote and exotic enemy, now became invaders of At-
tika, repulsed by the Athenians and their national hero Theseus, just as the
Athenians had beaten back Dareios and Xerxes at Marathon and Salamis.

There can, in fact, be no doubt that the Greeks saw their victory in such
terms. In Book I (3–5), Herodotos actually cites the Trojan War as the
source of the enmity between the Greeks and the Persians; and in his ac-
count of the preparations for the battle of Plataia (IX, 27), he portrays the
Athenians reciting the Trojan War amidst a litany of great mythic deeds as
they claim the honor of leading the left wing against the Persians. Had they
not displayed valor and dedication to the cause of justice in aiding the sup-
pliant Herakleidai and the defeated Argives after the disaster at Thebes?
Had they not driven the Amazons from Attika? And had they not done their
part in the struggle against Troy, not to mention their more recent triumph at
Marathon?

The thrust of the Athenian claim lay in the capacity of such mythic ex-
ploits to document an ancestral tradition of excellence and achievement,
especially against Asiatic enemies, with the great event of Marathon a gen-

eration earlier playing an intermediate role between the ancient deeds and the contemporary assertions of valor. As various scholars have suggested, this passage probably reflects a format that developed in Athenian public and funerary rhetoric in the period just after the Persian Wars. During the course of the fifth century and the one following, orators like Lysias, Isokrates, and Demosthenes would constantly reiterate these very events as a fixed catalogue of Athenian accomplishments.[6] Indeed, by the fourth century the Athenian victories against Dareios and Xerxes had become so thoroughly mythologized through such comparison that Demosthenes, in his *Funeral Oration* ([LX], 10–11), could comfort the relatives of the war dead with the suggestion that the fifth-century triumphs over Persia actually surpassed the mythic struggle of the united Greeks against Troy.

Immediately following this, Demosthenes expressly states the purpose of his eulogy and its mythic catalogue—to link the deeds of the worthy dead to the feats of their noble forefathers. Such a direct comparison of myth and actuality asserted an unbroken continuity of heroic virtue reaching back to the most remote times. In a very real sense, the catalogue of exploits had been created to provide a kind of cosmogony of Athenian excellence, a tradition of origins that could explain and verify all present claims. And so when the Athenians voted three herms near the Agora to commemorate Kimon's victory over the Persians and Thracians at Eion in 476/5 B.C., the statues were inscribed as follows:

> From this city (Athens) Menestheus once marched out with the Atridai,
> Leading his army to war on the divine plains of Troy.
> None knew better than he, of the bronze-armoured Greeks, Homer tells us,
> How to manoevre the line or draw up the battle array.
> So the proud title has clung ever since to the children of Athens,
> Masters of warlike arts and leaders of valiant men.
>
> They too were men of stout heart, who beside the swift current of Strymon
> Under Eion's walls fought with the sons of the Mede:
> Pitiless famine and fire they brought to beleaguer the city,
> Death-dealing Ares they followed, and harried their foes to despair,
>
> This shall stand as the tribute which Athens paid to her leaders,
> Homage to hard-fought victories, earned by their valiant deeds.
> Those who come after may read and from this memorial take courage,
> And in their country's cause march no less bravely to war.[7]

The strategy of comparison in these verses is essentially identical to that of Pindar's Sixth Pythian Ode. Here Kimon's victory against the Persians

was made to transcend immediate circumstances. It now assumed an epic dimension, tied to the greatness of the past, the fulfillment of the standards of achievement and divine approbation already established among the mythic Athenians in their struggles against Asia. And, in its turn, Eion now stood as an inspiration to subsequent generations.

Kimon and his aristocratic supporters were well attuned to the enormous political value of manipulating mythic analogues in this fashion, not only in rhetoric and the verses inscribed on official monuments, but through various forms of public and private activity. Modern scholarship has focused largely on Kimon's efforts to identify himself with the figure of Theseus.[8] By defeating the Dolopian pirates on the island of Skyros about 475 B.C., Kimon appeared to avenge Theseus' death there at the hands of Lykomedes. And after the campaign, when Kimon returned amidst great pomp with the newly discovered bones of Theseus, which he had transported on his own trireme, the Athenians received their leader as if Theseus himself had come home. The recovery and translation of the relics to a newly constructed shrine, or Theseion, near the Athenian Agora earned Kimon the permanent admiration of the city, associating him in the popular imagination with the new conception of Theseus as the national hero of Attika. The Fourth Dithyramb on Theseus, which Bakchylides composed for the Athenians at about this time, is studded with allusions to Kimon and his family, and it is possible that the contemporary Athenian historian Pherekydes even attempted to trace the leader's genealogy back to Theseus himself.[9] Kimon cultivated this link further through tendentious displays of altruism toward the poor, emulating qualities attributed to the ancient hero.[10]

Such actions, along with the physical presence of Theseus' shrine and relics, would keep Athenians mindful of recent exploits like Skyros. But the visual arts also played a key role in Kimon's propaganda, especially the large-scale paintings that decorated the Theseion and the other public monuments of the 470s and 460s or the early 450s: the Stoa Poikile in Athens, the Knidian Lesche at Delphi, and the Shrine of the Warlike Athena at Plataia. None of these paintings has survived; they are known only through literary descriptions, although certain Attic red figure vases of the mid-fifth century may to some extent reflect these lost monumental works (see figs. 1–7). As creations of the leading innovators of Early Classical painting, they have long been the subject of intensive study regarding their spatial pictorial properties and capacity for emotive or psychic expression.[11]

Yet there are also clear indications of the more specific symbolic or ideological purpose that these monuments and their paintings served. The first is the votive or commemorative nature of the buildings themselves in connection with distinct, actual events, as in the case of the Theseion. Along such

lines, Gauer's penetrating study of Persian war memorials has shown more generally how the use of campaign spoils to finance the production of artworks as thank-offerings provided an enduring link between such monuments and the events that brought them into being. By Pausanias' time the gilded statue of Athena atop a palm tree erected at Delphi, and the Promachos on the Athenian Akropolis, were still remembered as votives for Eurymedon and Marathon, paid for with Persian booty.[12] Evidence of conscious allegorical intent also emerges in the painted decorations of the Kimonian monuments, where various eponymic, toponymic, or biographical cues served to associate their primarily mythic subject matter and characters with contemporary events, places, and people. And finally there is the larger programmatic structure or context of the paintings as unified, extended ensembles of mythic analogy or comparison. The juxtaposition of different myths was itself a highly expressive artistic technique whose study can tell us much about the original sense or intent of these works.

Accordingly, a growing body of scholarship has come to view the monumental paintings made under Kimon and his circle as analogous to the Eion herms—a deliberate, officially sponsored celebration of recent military achievements in a mythic guise.[13] But, for the most part, this scholarship has approached the paintings and their relation to actuality only in the most immediate, circumstantial terms, as if simply noting the general cultural or geographic parallels between mythic deeds and those of the present could somehow explain the intent and function of these complex and important programs of imagery. It is, however, doubtful that the Athenians would have attempted to correlate even the most momentous events of recent history with the highly charged and privileged traditions of myth unless this process stemmed from a much more profoundly significant rationale or agenda, one that sought to exploit as fully as possible the fundamental didactic and dialectical capacities of myth itself.

Any truly effective commemoration of a victory involves a certain measure of causality; it must locate the event within a larger ideological construct in order to explain and justify such an achievement as the logical and just consequence of accepted pattern or law. In the poetic celebrations of this kind cited above, it is the personal quality of the victors that the verses laud as the true source and essence of their achievement, and not only their skill, but their valor, duty, and piety as traditional requisites of manly virtue or excellence, *arete*. It is this collective set of attributes—the character or *ethos* of the victor—that provides the real basis of comparison between the events at hand and the corresponding deeds of ancient heroes, in keeping with the more general, paradigmatic function of myth itself.

Within this decidedly ethical framework, Greek myth portrayed the out-

come of events as contingent upon the inner character and the conduct of protagonist and antagonist alike, and concomitantly upon the final judgment of the gods who watched over all human activity. If the mythic Greeks or Athenians had defeated enemies like the Trojans, the Amazons, or the Centaurs, there was a reason for it. In each instance the conflict and its outcome were meant to exemplify a deeper principle or lesson suggesting the triumph of one sort of human character or standard over another. Because of this, and because the Greeks of the Classical period generally tended to examine and explain phenomena in terms of binary oppositions or antitheses, it is well worth considering an aspect of the fifth-century monuments that remains largely unexamined: how the more fundamental, ethical significance ascribed to ancient or mythic conflicts was a primary factor in their ability to mirror and validate the contemporary struggles against Persia.

This objective is all the more pressing because scholars have long recognized the ethical qualities or concerns that were attributed generally to Polygnotos and other Greek painters of this period.[14] Indeed, the surviving testimonia regarding the new expressive capacities of painting beginning in the second quarter of the fifth century more or less oblige us to consider the ethical dimension of the murals that decorated the Kimonian monuments. Aristotle was convinced that painters could communicate the qualities of human character, much like poets, tragedians, or rhetoricians, and he praised the venerable works of the fifth century because of their concern with such qualities. He had an especially high regard for Polygnotos, who was an *agathos ethographos,* "a worthy painter of character."[15] In the *Politics* (1340a, 37–40), Aristotle documents the Greek belief that paintings of this kind could inspire or influence the spectator positively through the ethical lessons that they expressed; he advises that the young be encouraged to look at the works of Polygnotos and those of other painters and sculptors who were also *ethikos*—whose creations expressed human character.[16]

Such testimony is a strong incentive to recover more fully the substance and programmatic content of the mythic narratives utilized in the visual artistic celebration of the Persian Wars during the fifth century, even if the monuments themselves are no longer available for scrutiny. Although one is compelled to rely primarily on literary evidence for these lost works, the data are surprisingly informative, especially since our sources in the poetry, drama, rhetoric, and history of the fifth and fourth centuries also provide a rich documentation for the specific ethical content of the various mythic narratives under consideration. In such literary modes the thematic sense and implication of the subject emerge vividly, serving as a useful guide for the interpretation of the corresponding depictions in painting or sculpture of the same period, as the studies of Webster, Pollitt, and others have shown

repeatedly.[17] One may readily expect the ancient Greek spectator to have approached the subject of a visual work from a perspective acquired not only through other works of visual art, but also through various contemporary media or modes of expression, and it is plausible that painters or sculptors would consciously have anticipated such experience on the part of the audience to achieve a similar thematic effect in their own work.

Here again, the evidence virtually dictates such an approach, since Classical philosophers and rhetoricians constantly asserted the relation or equivalence between representations in the visual arts and what they perceived to be the closely allied arts of poetry and oratory. By Hellenistic and Roman times, it had become a standard practice to compare the quality of expression in painting and sculpture with that of rhetoric.[18] But Aristotle and his immediate predecessors were already convinced of the common basis of all forms of expression. Visual art, like poetry, engaged in *mimesis*, "representation"; the poet and the painter or sculptor were equally *eikonopoioi*, "makers of images." Aristotle could readily compare the narrative of a play to the formal structure of drawing or sketching in black and white, just as its dramatic character development might correspond to the use of color in painting. And Plato before him considered all the arts to be an exercise in *mimesis*, and based upon an analogous use of order, pattern, and repetition.[19]

Yet what seems especially to have unified the arts in this Greek view was their common ability to represent the ethical bases or motivations of human action, and their capacity to affect, instruct, or persuade the audience in relation to such issues by means of *mimesis*. In nearly every instance where Aristotle correlates the workings of poetry and painting or sculpture, his comparison pertains to the portrayal of *ethos*, human character, and ultimately his interest has to do with the influence that such ethical representations may exert upon the public. That is why he most esteems those painters and sculptors (and, in the context of his discussion, poets or dramatists as well) whose works address the issue of human character and its relation to human action. The activity of these artists is to be judged worthy and useful above all because exposure to their work is beneficial to the *polis*.[20] Accordingly, Aristotle also emphasizes the necessity for moral or ethical purpose in oratory. In the *Rhetoric*, the speaker is said to be able to persuade by virtue of the character that he can exude in his speech, since the good qualities that he is seen to possess lend added force to his argument.[21] Orators, therefore, like poets, painters, and sculptors, should also be concerned with human character and its effect upon men's actions.

Unfortunately, Aristotle says precious little about how paintings may have communicated these qualities. But in the *Politics* (1340a, 30–35), he

does at least remark that visual forms or *schemata* can operate in this way, since they are perceivable signs, *semeia,* "bearing the form and color of character." Earlier opinions attributed to Sokrates help to illuminate Aristotle's point. In a dialogue with the painter Parrhasios preserved in Xenophon's *Memorabilia* (III, 10, 4–5), Sokrates asserts that in pictorial representation the face, posture, and movement of a man may provide glimpses of his nobility, freedom, and self-control *(sophrosyne),* just as these features or physical attributes may communicate his baseness or his arrogant lack of restraint *(hybris).* Parrhasios then agrees that painting can indeed convey these qualities by such means. From these remarks, one gets some idea of the kind of signs that might convey "the form and color of character," as well as some indication of how Aristotle's opinions about "ethography" may have reflected a more widespread view, and one that already existed in the fifth century. The exchange between Sokrates and Parrhasios also provides a forceful illustration of a point that Pollitt has made more generally— that the ethographic preoccupation of Early Classical artists did not focus only on good or noble qualities, but also on human flaws or weakness.[22]

Since Aristotle repeatedly makes the analogy between visual art and poetry or tragedy, it is also possible to extrapolate something more of the Classical Greek view of the ethical capacity of painting from his detailed comments in the *Poetics* on the function and expression of character in drama. Within the dramatic narrative, *ethos,* like thought, is basic to all action. It determines the success or failure of all the participants. Character reveals the quality of those who perform the action through their moral purpose, indicated in turn by the things that they strive for or reject. And, conversely, their actions manifest their moral purpose or motivation, and ultimately their character.[23] In conjunction with the remarks of Sokrates, these observations suggest clearly enough how the outward action or expression of the figures in a work of visual art could readily communicate the inner character of protagonist and antagonist alike in order to explain and reinforce the significance of the subject or theme depicted.

Agonistic myth was by definition a clash of opposing characters, a mode that lent itself intrinsically to any medium equipped with the formulae to depict expressive contrasts of mood and motion, and consequently there is good reason to approach the Athenian monuments with this in mind. If fifth-century visual artists were preoccupied with the depiction of *ethos,* like contemporary poets, dramatists, and orators, then this general concern must have played a part in the way that they utilized mythic guises or analogues to express and celebrate the struggle of the Greeks against the Persians. The actions of the mythic Greeks and their opponents in these works of art must have constituted an ethical antithesis in which the participants'

moral qualities were denoted visually as the evident determinants of success and failure. In this sense such works operated as visual exempla whose usage was consciously meant to parallel the didactic and teleological strategies of contemporary poetry and rhetoric. To the extent that the use of these mythic themes in public monuments of the fifth century was truly intended to prefigure the triumphs over Dareios and Xerxes, then the force of such imagery, its very rationale, must have turned largely on the issue of human character as a determining factor in the struggles of the Greeks against their enemies in ancient and recent history. For the works of this period, *ethos* was the essential variable in the equation or analogy between myth and actuality.

This study traces the operation of the ethical variable as a fundamental strategy in the officially sponsored Athenian monuments of the second and third quarters of the fifth century B.C. The goal is to understand the monuments and their imagery as finely tuned vehicles of an official ideology, visual disseminators of a more widespread cultural dialectic based upon Athenian claims to moral excellence and achievement literally as a national tradition. In this regard the present study reapplies or extends to the history of Greek art the methods and insights of the historical, philological, and anthopological research that has so radically transformed our assessment of fifth-century Athenian culture in recent decades.

Using the available literary and material remains, this approach can disclose how the visual arts also shared in a process of conscious transformation or manipulation, even distortion, in which the choice, narrative presentation, and the very matter of mythic traditions were all carefully tailored or reworked in order to project a uniformly positive exposition of Athenian virtue in triumph over evil. When viewed from the perspective established by recent studies of Athenian mythmaking in poetry and rhetoric, the examination of official fifth-century visual art also brings us face to face with the sexism and xenophobia basic to Athenian culture, and with the process of leveling that inevitably attends the creation of a convincing public imagery in the service of the state. Complex realities and potential contradictions are reduced to a system of binary oppositions—to the victory of justice and law against aggressive violence and disorder, and to the putative superiority of the Hellenic *ethos* over that of foreigners, who are compared disparagingly to women and wild animals. The judgment or will of the gods, no longer a source of uncertainty and anxiety beyond human understanding or prediction, becomes a foregone conclusion: divine approbation for the Hellenic victor, whose ethical claim to such favor is never in doubt.

Here one especially senses the unity of intention and technique between the visual arts and rhetoric in Athens, and perhaps the factors that prompted

the rather negative attitudes of Plato and Sokrates toward both media. In the *Republic,* for example, Plato attacks the illusionism (*skiagraphia,* "shading") that had developed in late fifth-century painting, comparing it to sorcery and sleight-of-hand tricks; in the *Menexenos* he invokes the words of Sokrates to condemn orators as men who "bewitch our souls when they laud our city in every possible way."[24] What emerges from these objections is a profound disquiet in at least some quarters about the persuasive power of representations that purported to address and convince in rational, objective terms, while in reality they appealed on a sensory, emotive, and ideological level that a less critical audience might find irresistible.[25] Aristotle's positive emphasis on the didactic potential of rhetoric, drama, and visual art probably approximates the view of those members of the establishment who commissioned the speeches and monuments of the fifth century, for the very assumption that such expressions could edify and inspire the public was a crucial aspect of their rhetorical strategy. The less optimistic appraisal of these media by Sokrates and Plato may well be more realistic. The underlying attraction of rhetoric and monumental programs of painting and sculpture to those who instigated such public imagery resided in the affective power of these arts—in their capacity to promulgate a glorified view of official policy and action by equating it with traditional morality and law.

In the public sphere, the role of *eikonopoios* that artists like Polygnotos shared with contemporary poets and rhetoricians should be understood not so much as that of a "maker of images," but rather in the more modern sense as that of "image-maker." Plutarch (*Kimon,* VIII, 6) leaves no doubt as to the ideological effectiveness of the Theseion and its paintings when he tells us that the erection of the shrine did more to win its founder the respect of the Athenian people than any of his other accomplishments. Plutarch's rhapsodic excursus in *Perikles,* XIII, 1–3, on the timeless vigor and grandeur of the Akropolis project as a symbol of Athenian achievement testifies as well to the profound impression that such monuments could make, and not only for the generation that saw them rise to completion, but for all posterity. Already by the later fifth century, Thucydides' comments on public architectural works anticipate the concern of Plato or Sokrates about the deceptive potential of painting and rhetoric. In Book I, 10, 2, he speculates that in some future time the material remains of Sparta would hardly indicate the power and importance that she had once exercised, while the great buildings of Athens would make her appear to have been twice what she really was.

The following chapters examine how the visual artists of Kimon's time and the succeeding decades applied all their skill and ingenuity to advance the ideological agenda and requirements of official patrons, exploiting as

fully as possible the expressive and persuasive qualities of their media. Chapter 1 traces the origin of the ethical and cultural polarity that was believed to have been central to the Persian Wars and their outcome. This background is essential in understanding how such notions of moral and geographical otherness provided the guiding conceptual matrix for the particular use or transformation of *mythic* narratives as analogues for this struggle in the representations of poetry, rhetoric, and the visual arts. Chapters 2 through 4 focus on the programmatic paintings of the Kimonian period, the first artistic monuments to apply this strategy, and the subsequent use of such imagery in the Periklean period, and specifically the sculptural program of the Parthenon as the most ambitious monument to the victory over Persia. Here the objective is to place the Periklean development within a larger fifth-century setting by considering how the Parthenon's planners elaborated upon the existing tradition of mythic comparison in order to produce an even more complex and effective statement of Greek or Athenian ethical and cultural superiority.

The concluding chapter is devoted to the Parthenon frieze. While the frieze ostensibly depicts a contemporary religious ceremonial rather than a mythic subject, its form and meaning were predicated on the same ethical and heroic precepts and political ideologies central to the Parthenon metopes and their forerunners in the monumental painting of the preceding decades. The evidence suggests that the frieze too rationalized actuality in terms of myth, although in different terms, by infusing the image of the present with the qualities or values of the mythic past, essentially inverting the strategy of the metopes and earlier painting. In this sense, the frieze may also be understood as an expression of Greek victory over Persia under the leadership of Athens, and one that was based no less upon the unremitting Athenian claim to ethical superiority and excellence.

Much of what follows is speculative. It is presented in the belief that the goal of recovering the original sense and purpose of these monuments justifies recourse to the more uncertain avenues of interpretation, particularly since most of the works are imperfectly known or poorly preserved. This is not, however, the impediment that it seems. To a great extent the analysis here concentrates not on the works themselves but on the corresponding representations of contemporary literary texts, as indicated earlier. Yet this kind of hermeneutic surrogation provides far more than a methodological expedient or stopgap; nor is it justified primarily by the underlying relation that the Greeks themselves attributed to the visual and literary arts. The unifying network of attitudes, concepts, and opinions that informed all media of expression was part of the fabric of Athenian life and consciousness, and interplay among the various media was a vital factor in the making

and operation of all forms of public imagery. Such interplay itself should provide the real focus in any attempt to reconstitute the meaning and impact of the monuments, for, ultimately, what we are tracking here is not really the formal structure and content of programs of painting or sculpture, but something more dynamic and complex—a larger interpretative process or system in which the works themselves functioned as an interface between the thinking of the artists or planners and that of the viewing public.

Over the past few decades, critical theory has increasingly stressed the active role of the reader/interpreter in the perception or "making" of the work. Within such "reader-response theory," as it has come to be known, members of the audience operate as far more than passive recipients of the work and its content, however substantive and structured it may be. They emerge rather as participants responding to an author's invitation to produce or perform the work for themselves in the very act of interpreting it. This carries with it certain expectations regarding the interpretative competence of the audience if the author is to succeed in communicating effectively, and various literary theorists have grappled with the problem of what or who would constitute the "ideal reader" or "model addressee." But the collective notion of "interpretive communities" that Fish has developed more recently to characterize this process is especially relevant in the present context. Here an author may anticipate a larger audience that shares a similar set of "strategies"—conceptual, analytical modes that facilitate their ability to interpret what they perceive with relative uniformity, and hopefully in accord with the author's intentions. Fish also insists that the particular form or substance of the interpretation produced resides not in the work or text itself, but primarily in the "interpretive strategies" shared by author and audience.[26]

This methodological model is highly pertinent to the problems under consideration here, for it enables us to understand the Athenian monuments as mediating structures that constantly invited a viewing public to *rein*-terpret or *re*enact the central tenets of official Athenian ideology—tenets shared, assimilated, and reinforced from all quarters, from public rhetoric, poetry, and drama, as well as from the popular traditions of daily civic discourse. As such the visual arts remain a key element in the larger enterprise of official Athenian image making, but we may now appreciate how their effectuality could emerge only in an interpretive context established in turn by the whole array of values, beliefs, and prejudices identifiable with Athenian culture. Our imperfect knowledge of the form or structure of the monuments becomes less of an obstacle if we see them as integral with comparable expressions in other media that are better preserved and that provide an independent vantage for determining the sense of the imagery and its impact upon its intended audience.

Yet such models from critical theory are relevant even where the data on the monuments are not so deficient, especially if it is indeed the shared strategies of interpretation (rather than the work itself) that generate the work's meaning for the viewer. To be sure, the more one knows about the formal structure and content of an artwork, the better equipped one is to recover its meaning, but it is essential to recognize that students of ancient art are never really engaged in a direct reading of the visual properties of the work itself. We are at worst reading these properties through the filter of our own values and sensibilities; at best we are attempting to reconstitute through historical study how the original "interpretive community" might have understood the work. The result, if we are lucky, falls somewhere in between.

In the end, any interpretation is more or less involved in making or remaking a given work, and so—in principle, at least—those who attempt to interpret an ancient monument proceed much as spectators have done since the work was completed. From a historical perspective, what matters is how closely modern interpretations recapitulate the interpretive process of the ancient or original audience. In what follows, the issue is not whether the various interpretations of the imagery can be proven conclusively, for, given the evidence, there is little that one could say about the programmatic content of these monuments that would pass such a test. The issue is whether these interpretations approximate plausibly the operation of such imagery within the broader ideological discourse that can be documented among the patrons or planners and the audience that they addressed.

The paintings and sculptures of these fifth-century monuments were elaborate and costly products of the leading artists of their day, made under official patronage, and designed to give visible form and expression to the values, aspirations, and pretensions of the Athenians during this most vital and expansive period of their history. Consequently, it is essential to pursue their original import and nuance by every means possible. One must attempt to envision the problems that confronted the artists as they worked to develop a typology of representation that could suggest a seamless unity between the achievements of the past and those of the present. But what this entails is nothing less than attempting to reconstruct the interpretive strategies shared by the Athenian elite and the public whose confidence and consensus this elite sought to establish and manipulate.

1

Ethos and Antithesis in the
Greek View of the Persian Wars

Hybris **and** *Sophrosyne*

It is well known that the Greeks of the fifth century were inclined to see their struggle with Persia in grandiose, archetypal terms, as a moral and cultural victory in which the ethical predicates of Greek society had successfully withstood the arrogant and unrestrained aggression of Asiatic imperialism. This view of the triumph over Xerxes did not, however, originate so much from a realistic appraisal of the events themselves; it emerged much more immediately from the Greek attitudes concerning the role of character in the human social order, especially within their own urban culture or city-state, and from a tendency to apply internal Greek values as a universal standard of reference and judgment. A key facet of domestic political theory was the problem of *hybris* or immoderation. The religious connotation and dimension of *hybris,* particularly as it was depicted in Greek tragedy and epic, probably constitutes the most familiar usage of this theme. But the issue of *hybris* was hardly the special preserve of the poets; it was a human flaw whose effects translated readily into the fabric of daily life among the ancient Greeks. In its broadest sense, *hybris* connoted insolent and willful acts of outrage, a form of behavior arising from a lack of restraint or a lack of respect for lawful limits of various kinds. Such acts included far more than arrogance or impiety against the gods; they could be directed at one's superiors, at one's equals, and against inferiors as well. Men might commit *hybris* against acknowledged civic or religious authority, or toward one another. Aristotle, in the *Rhetoric* (1378b, 23–25), offers what appears to be a more limited and technical definition, but one that focuses on the inherent arrogance of the crime:

Hybris is doing and saying things at which the victim incurs dishonor, not in order to get for oneself anything which one did not get before, but so as to have pleasure. . . . It is a cause of pleasure to the *hybrizontes* that they think that by doing harm they themselves are more superior.[1]

Hybris was considered to be socially destructive, a moral and practical threat to the equilibrium of the *polis*, and Athenian law explicitly proscribed such behavior. Acts of *hybris*—physical violence and sexual or verbal abuse that dishonored other citizens, women, children, and even slaves—could be prosecuted under a severe indictment *(graphe)*. Demosthenes (XXI, 45–46) warns his countrymen that an act of *hybris* wrongs not only the victim, but the state as well: "Nothing, men of Athens, nothing is more intolerable than *hybris,* or more deserving of your anger." Isokrates (in *To Nikokles* [II], 16), advances a similar argument as a basic principle of statecraft: "You (Nikokles) will lead the people wisely if you allow the masses neither to commit nor to endure *hybris.*"[2]

Within the antithetical parameters of Greek discourse, however, the ill effects of such behavior could not be contained through punishment alone; they needed to be offset by the positive example of an opposing principle. Just as the *polis* officially condemned the crime of *hybris,* it extolled the benefits of *sophrosyne*—moderation or self-restraint. By the sixth and fifth centuries, *sophrosyne* was already an acknowledged civic virtue, closely tied to Greek notions of individual worthiness or good character, and even to the "good order" of the *polis* itself. North has drawn attention to a body of Classical funerary inscriptions and poetry that lauds the *sophrosyne* of the subjects or praises them as *agathos kai sophron,* "both worthy and moderate."[3] The pairing in these inscriptions of *sophrosyne* with such qualities as *arete* ("excellence of character") and *andreia* ("heroic courage or manliness") illustrates the level of esteem accorded to moderation and restraint as attributes of outstanding individuals. Pindar also stresses the collective benefit of this trait as a communal, political ideal. In his first Paian he exhorts Apollo, as god of self-restraint, to crown the children of Thebes with *sophron eunomia* ("moderate or wise Good Order") as if it were a wreath of blossoms.

In creating this ethical dialectic, this abstract opposition between the character of those who facilitated the social order and that of those who threatened it, the Greeks portrayed the achievement of Greek urban society literally as a triumph of moral excellence or restraint and respect for law. But such an internal dialectic—good versus bad individuals within the *polis*—could readily be adapted to subsume the external struggle of Greek society against a foreign people like the Persians, and it should therefore come as no

surprise that the Athenians and other Greeks of the second quarter of the fifth century eagerly pursued this option. Having achieved a victory of almost epic proportions, they were little inclined to assess the motivations and shortcomings of the invading Persians realistically in the context of international policy and military strategy. Instead they progressively elaborated a mythology of cultural antithesis and confrontation, a highly polarized view of the Hellenic character in opposition to that of the Persians or Asiatics in general, to provide a plausible explanation for the struggle with the barbarians and its outcome.

Heinimann has traced the intellectual underpinnings of this process to developments in early Greek ethnographic and medical inquiry during the fifth century, and to the general Hellenic tendency to analyze phenomena in terms of opposing principles. The Greek attitude toward the Persians was in fact very different from the pseudo-biological or genetic racist arguments for national superiority that have arisen in more recent times. Insofar as they believed the national character of peoples to be determined largely by culture, fifth-century Greeks saw the distinctions between themselves and other peoples as an ethical issue, as the result of differing custom, training, and political organization. Within such an outlook, the confrontation with Persia would have appeared to be enormously meaningful and all-encompassing. The victory was that of the Greek *ethos* itself, and of the religious and political principles of law and moderation that the Greeks believed to have conditioned their own national character.[4]

The Defeat of Persia in Drama and History: The Ethical Rationale

If the evidence of Aischylos and Herodotos is an accurate guide, the perceived cultural/ethical polarity between the Greeks and Persians revolved around the opposition of *hybris* and *sophrosyne*. Classical historians and philologists have repeatedly emphasized how adroitly the Greeks of this period resorted to the collective wisdom concerning *hybris* and its consequences as an explanation for the defeat of the barbarians at Salamis and Plataia.[5] Only seven years after Xerxes' invasion was repulsed, Aischylos produced the *Persians,* an elaborate condemnation of the Asiatic enemy on religious and ethical grounds. The cause of their defeat is anything but military, as is revealed when the messenger brings the disastrous news of Salamis to the Persian queen:

> Do we seem to you to have been lacking (in numbers) for this battle?
> No, it was some divine power *(daimon)* that destroyed the host,

> weighing down the scale with unequal fortune.
> Gods safeguard the city of the goddess Pallas.[6]

Nor is this judgment of the gods arbitrary. The play asserts a direct, causal relation between the actions of the Persians and their fate. Aischylos has Queen Atossa and her attendants conjure up the ghost of Dareios, and as the risen specter of the Great King surveys the factors that ruined Xerxes' enterprise, he is particularly horrified by the irreverent, impious acts committed under his son's authority. Xerxes had shackled like a slave the sacred waters of the Hellespont with a bridge of boats, thinking to control the gods, even Poseidon. In Greece itself he and his troops transgressed all lawful limits in waging their campaign, for which, Dareios warns, they had paid and would continue to pay dearly:

> The crown of wretched suffering awaits them there,
> Requital for their *hybris* and their godless thoughts.
> They went to the land of Greece and did not scruple to strip
> The images of the gods, set fire to their temples.
> For altars were destroyed, and shrines of the gods pried up
> From their foundations and strewn about in complete confusion.
> Therefore, since they acted evilly, they suffer
> No less evilly in turn, will suffer more. . . .
> .
> And heaps of corpses even generations hence
> Will signify in silence to the eyes of men
> That mortal man should not think more than mortal thoughts.
> For *hybris* blossomed forth and grew a crop of ruin,
> And from it gathered in a harvest full of tears.
> As you look upon these deeds and recompense for them,
> Remember Athens and Greece and let no man hereafter,
> Despising what he has from heaven, turn lustful eyes
> To others, and spill a store of great prosperity.
> For Zeus is standing by, the punisher of thoughts
> Too overboastful, a harsh and careful scrutineer.[7]

The *Persians* was in no sense a history. Instead it treated recent historical events within the thematic conventions and parameters of dramatic performance, as a shared communal experience intended to reaffirm the religious, moral, and political bonds that united the *polis*. Aischylos sought to reduce the complexities of imperialism and international conflict to the more fundamental issues of human choice and comportment, and to man's responsibility toward a higher law or authority. To judge by the evidence of poetry and philosophy in Archaic and Classical times, he essentially adapted the

existing beliefs about *hybris* and its consequences in order to produce an acceptable scenario of self-destruction centered on the youthful and impetuous Persian king. By the early sixth century B.C., Solon had already pointed out the relationship between excessive prosperity and a tendency to commit outrage.[8] In his definition of *hybris* in the *Rhetoric*, Aristotle particularly stresses its currency among the young and the wealthy, a point to which he returns later in that text and in the *Politics* as well. In the *Nikomachian Ethics* he also states that the inability to control good fortune and a superior position often makes men hybristic.[9] Accordingly, Aischylos has Atossa and the ghost of Dareios dwell upon the reckless immaturity of Xerxes and his unwillingness or incapacity to be satisfied with the immense prosperity and dominion that he had inherited (see esp. lines 753–786). By such means the dramatist recast the motivations and geo-political objectives behind the Persian invasion entirely within the moral and ethical constructs of his own culture.

Nevertheless, it would be a mistake to see the *Persians* simply as a warning against youthful arrogance or the pitfalls of wealth and power. The play presents such acts of *hybris* as a specific outgrowth of oriental social or state structure; the Persian outrages against man and god had occurred on a grand scale, involving the whole of Xerxes' army. The faults that Aischylos strives to portray are not only those of an individual, but those of an entire political system that existed to serve the unchecked obsessions of an absolute monarch—"the raging ruler of populous Asia, driving his incredible herd against the entire earth."[10] To the generation of Aischylos, Persian imperialism and the unlimited power of the Persian king were intrinsically hybristic, the epitome of excess in political as well as moral terms, a fundamental affront to the measured and orderly existence imposed on man by the gods. It was the very antithesis of the more limited, human scale of the Greek state, and of the rule of moderation or law central to the *polis,* whose citizens should, as Pindar advised, be guided by *sophron eunomia.*[11]

Bearing in mind, as Heinimann has argued, that fifth-century Greeks considered the character of nations or peoples to be determined not only by nature but by their social habits, custom or law, and political structure, it is clear that Aischylos was asserting the basic disparity between the *ethos* of the Persians and that of his countrymen along such lines. Early on in the play (lines 241–244) Atossa inquires about the organization of the Athenian state or military. Yet the very terms and vocabulary in which she frames her questions, along with the response of the Persian chorus, all aim at underscoring the importance of the respective cultural or political traditions in the outcome of the struggle.

A: But who herds the manflock? Who lords the army?
Ch: They're not anyone's slaves or subjects.
A: Then how can they resist invaders?
Ch: So well that they crushed Dareios' huge and shining army.[12]

Within this brief exchange Aischylos has alerted his audience to the real significance of the contrast that the Greeks or Athenians preferred to draw between their own society and the absolute monarchy of the Persians—the difference between a strong and forceful character bred on the preservation of liberty and autonomy, and a character accustomed to direction like sheep or cattle. In his account of Salamis, Aischylos brings this contrast into sharper focus, with particular emphasis on the piety and discipline of the Hellenic protagonists. The Persian messenger tells Atossa:

> The first thing was a sound, a shouting from the Greeks,
> A joyful song. . . .
>
> fear stood next to each one of our men,
> Tripped up in their hopes: for not as if in flight
> Were the Greeks raising then a solemn paean-strain,
> But rushing into battle with daring confidence . . .
> .
> At once, with measured stroke of surging sea-dipped oar,
> They struck the brine and made it roar from one command. . . ,
> .
> At first the streaming Persian force withstood the shocks;
> But when their crowd of ships was gathered in the straits,
> And no assistance could be given to one another,
> But they were all being struck by their own brazen rams,
> They kept on breaking all their equipage of oars,
> And the ships of the Greeks, with perfect plan and order, came
> Around them in a circle and struck. . . .
> .
> Now every ship that came with the Persian armament
> Was being rowed for quick escape, no order left.[13]

The Greeks join in battle with a hymn to their gods, their unity dependent not upon allegiance to a leader, but upon a common set of values and unswerving purpose. In contrast to this pious bravery and orderly resolve, the Persians have no courage, only numbers, and this soon turns into a liability as their massive naval force collapses in self-destructive disarray and aimless flight. The lesson that the dramatist offers is a plain one. The subservient agents of imperialism, no matter how numerous or violent, are useless in a

battle of the last resort; they are no match for the discipline and dedication of free and moderate men struggling to preserve their way of life. Athenian rhetoric clearly supports this reading of Aischylos. In his account of Salamis in the *Funeral Oration* ([II], 41), Lysias emphasizes that a few men are more apt to risk danger in the cause of freedom than a great multitude of subjects whose only purpose is their own enslavement. The more general remarks of Demosthenes in his *Funeral Oration* ([LX], 25–26) are also relevant. There the orator draws a similar distinction between those ruled by fear of absolute power and those reared on freedom and duty. The former lack shame, and therefore the resolve and commitment to fight bravely to the end, while the latter cannot abide the thought of doing less than is expected of them.[14]

In the end, this opposition between the *ethos* of Persians and the *ethos* of Greeks was none other than the opposition between *hybris* and *sophrosyne*. Aischylos' account of Salamis and the catalogue of crimes enumerated in Dareios' speech were hardly unrelated. The dramatist encouraged his audience to conclude that the excesses of the Persians had arisen from a perverse or inverted system of values; he portrayed them as a people who indulged in violence and outrage when and where their numbers made it easy, but who crumbled in the face of strength, a people who lived in awe of a monarch, while they insulted the authority and the shrines of divinities. Against this he contrasted the orderly determination of the Greeks to overcome this moral weakness and criminality. Aischylos never gives a name to the quality of the Greek resistance against Persian *hybris*. Perhaps it would not have been *sophron* to laud the *sophrosyne* of his countrymen, but even as he presented it, no one in the audience would have missed the point. Small wonder that the gods had accomplished the destruction of the Persians through the agency of the Greeks, in recognition of the superior opposing Hellenic character.[15]

And so by 472 B.C. the Athenian rationale for the victory over the barbarian had already begun to take shape. It would continue to develop, culminating in the more thorough and extensive survey of the conflict between Europe and Asia in Herodotos' *History*. Although he was active in the succeeding generation, Herodotos' work exhibits the traditional religious outlook of the lyric and elegaic poets of the late sixth and early fifth centuries, especially Pindar, Bakchylides, and Aischylos, as various scholars have observed.[16] He was certainly familiar with Aischylos and with Pindar, since he mentions them and even quotes Pindar's work (cf. Herodotos II, 156, and III, 38). Thus it is not surprising that his account of the war with Xerxes often echoes the specifically religious perspective articulated in the *Persians*.

In Book VIII (143), the Athenians rebuke the Macedonian advice to make terms with the Persians; they will trust instead in the aid or retribution of the gods and heroes whose shrines Xerxes had burned (cf. Themistokles' opinion concerning the outcome of Salamis in Book VIII, 109). Earlier, in Book VIII (37), Herodotos had actually reported the intervention of gods and heroes as the Persians prepared to plunder the sanctuary at Delphi. According to this account, thunderbolts fell from the sky, breaking off two pinnacles of Mount Parnassos, which crushed the attacking Persians, and Herodotos says that the great fallen rocks were still there for him to see. On the authority of the survivors, he also reports that the spirits of the local heroes Phylakos and Autonoös then rose up and harried the fleeing barbarians. And Herodotos himself expressly refuses to question the validity of the oracle that the Athenians received just before Salamis, foretelling the punitive intercession of the gods against the arrogant and unrestrained Persians:

> Then shall Justice (Dike) quench Excess (Koros),
> the son of Outrage (Hybris), who is terrible and furious
> and thinks to devour all things.
> Bronze shall meet with bronze, and with blood shall Ares
> turn the sea to Phoenician purple.
> Then shall far-seeing Zeus and Lady Victory (Nike)
> bring upon Greece the day of freedom.[17]

Herodotos' accounts of divine intervention and his emphasis on the Salamis oracle all disclose a broader concern that already permeated Aischylos' portrayal of the Persian Wars; here too the Greek claim to moral excellence, their commitment to law and moderation, was ultimately a claim to divine support or inspiration. In opposing the Persians, the Greeks acted as champions of Zeus, agents of his will and authority. The Greeks had to wage the war, but in the oracle Zeus and his helpers Ares and Nike appoint and confer the victory upon those who uphold their cause. Dike, the Justice of Zeus, is directly opposed to the voracious greed, excess, and *hybris* synonymous with Xerxes. The substitution of Dike for the *sophrosyne* equatable with the Greeks is significant. It points up rather clearly that the Greek quality of moderation was readily interchangeable with the principle of Justice in the context of such agonistic confrontation: in defending the principle of lawful limits, one undertook to uphold the ordinances of Zeus and the just punishment of those who violated his authority. For Herodotos as well as Aischylos, the Greeks became nothing less than mortal equivalents or surrogates of Zeus and his divine agent, the goddess Dike.

Apart from his reference to this oracle, however, Herodotos preferred not

to use the term *hybris* in describing the motives or events of the Persian invasion, although his portrayal of the Persian war council (VII, 10) is a transparent homily on the dangers of excessive pride in all its manifestations. There, in a manner strongly reminiscent of the ghost of Dareios in the *Persians,* whose superior wisdom and injunctions had also gone unheeded, prudent old Artabanos vainly attempts to dissuade his nephew Xerxes from the grandiose plan to subdue all Europe:

> You see how the god smites with lightning those creatures who rise too high; they are not to exalt themselves, while the small creatures do not vex him. And you see how he always hurls his bolts on the tallest buildings and trees. For the god loves to punish all who presume to rise too high. Thus a numerous host is destroyed by one small in number. . . . The god allows none but himself to aspire too greatly.[18]

In a subsequent and equally fruitless attempt (VII, 49), Artabanos warns Xerxes that the land itself is the ally of the Greeks, since it will eventually starve an army so large, also echoing the words attributed by Aischylos to Dareios' ghost in the *Persians* (790–794). As we shall see, the imagery of Artabanos' speech here actually comes rather close to a passage in the *Agamemnon.* But Herodotos' greatest debt to the kind of argument advanced by Aischylos in the *Persians* was the notion that the ethical disparity between the Greeks and Persians had been a major determinant of the war and its outcome. In his account of Xerxes' war council, the historian also tries to show that the numerical superiority of the Persians was deceptive. Numbers would ultimately prove useless, not only because the very excess of Xerxes' enterprise would invite divine anger, but because the Persians would be facing Greeks. For Artabanos had in fact prefaced his admonitions against excessive pride by warning also of the superior valor and resolve of the Hellenic opponent as a vital factor not to be overlooked:

> You, O King, are intending to campaign against men much more formidable than the Scythians, men who are said to be the best (warriors) on land or sea. . . . For these men are said to be stout of heart, as one may easily see since the Athenians alone utterly destroyed so great a host as that which went into Attika with Datis and Artaphernes.[19]

The reason for the Athenians' prowess in battle was by no means obscure, to Herodotos' way of thinking; it was a direct consequence of Athenian political and social institutions. Earlier, in Book V (78), the historian had observed how under despots the Athenians had remained spiritless, without appetite for achievement or distinction as fighters. But once they had attained

equality and freedom under democracy, they became the greatest of warriors, striving zealously on their own behalf.[20] Yet this explanation operated only as a subtext in the war council narrative. And in the discussion between Artabanos and Xerxes, Herodotos had articulated the larger opposition between the Greek and Persian character much as Aischylos had used Dareios' ghost, creating an internal or subordinate antithesis by pitting the intransigent *hybris* of Xerxes against the moderate advice of another Persian, who also discourses upon the ethical strengths of the Greeks. Herodotos would expand upon this strategy in Book VII, substituting the exiled Spartan king Demaratos, a Persian collaborator, in a narrative that directly addressed the underlying ethical opposition between Greek and oriental society.

In this episode, Xerxes has just crossed over into Thrace, and he summons his expatriate guest to inquire whether the Greeks would dare to resist a force so great. Once Demaratos has been assured that he can speak frankly, he answers by opposing Persian numerical superiority to Greek character and the factors that determine it:

> In Greece, poverty has forever existed as a natural occurrence, while excellence of character *(arete)* is a thing obtained, a thing earned by wisdom and the strength of law *(nomos)*. Through such constant usage, Greece has warded off both poverty and despotism.[21]

Xerxes, of course, summarily dismisses the argument that men with the ability to choose freely would willingly go up against hopeless odds. He cannot really accept or perceive that the institution of freedom and accepted custom or law could engender such strength of character, or that character alone could guarantee such dogged resistance. To the oriental monarch, only the awe or fear of a single absolute ruler could compel sacrifice of this sort. Using the specific example of his former Spartan compatriots, Demaratos tries once again to explain the Greek character in terms that the Persian king might understand:

> They are free, but not entirely free. There is a lord over them—Law *(nomos)*—whom they hold in awe much more greatly than your (subjects) do you. And whatever that one (Law) may command, they do. He always commands the same thing—not to turn in flight from battle, however numerous the opposition, but to maintain battle order, either to conquer or to perish.[22]

What appears here as a simple contrast of the rule of law with monarchy or despotism probably subsumed a good deal more. Hesiod already considered *nomos* a gift from Zeus to mankind, along with *dike* ("justice"). By the late sixth century, the philosopher Herakleitos could characterize human

laws as "nourished" by the one divine law, and in the earlier fifth century Bakchylides and Pindar still connected the principles of law and order closely with Zeus.[23] Thus, in the Greek view, the superior claim of law to human obedience rested on its origin in divine will as opposed to the will of some overblown mortal. Moreover, Herodotos may also have been playing on the multiple meanings of *nomos*—not only law or custom in an institutional sense, but also a sense of the boundaries or limitations, moral as well as geographic, that laws or customs establish. The distinction that Herodotos sought to draw in this episode was between the unrestrained and prideful expansionism pursued by Xerxes and the lawful adherence of the Greeks to the moral and political limitations established by the gods. In this context, the unremitting obedience to *nomos* and its limits ultimately exemplified the religious and political virtue, *sophrosyne* (cf. the *sophron eunomia* of Pindar's first Paian), which functions here as an implicit antithesis to the inherent weakness and *hybris* of untrammeled despotism and monarchic imperialism, both opposed in their very essence to the principle of *nomos*.[24]

As the war is about to begin, Herodotos neatly inserts this exchange between a Greek and a Persian to sum up the fundamental differences between both peoples, distinctions whose impact would emerge further as his narrative continued. However, the self-conscious intensity with which the historian draws this contrast as a sweeping generalization is striking. It may well reflect a heightened and more systematic conception of Persian or Asiatic otherness that had become current among the Greeks by the middle of the fifth century or in the succeeding two decades. A generation earlier in the *Persians,* Aischylos had preferred to articulate such distinctions or contrasts more implicitly, through particular examples, as in his depiction of the battle at Salamis. But the moral conclusion that he urged upon the spectator was ultimately the same as that stated in the conversation between Xerxes and Demaratos. Subservience to a royal master made the Persians weak in character, and thus ultimately unsuited to the challenge of battle. The Greek was free; he would triumph over the barbarian because he followed the moderate dictates and standards of excellence established by divine law instead of succumbing to the intimidation and excess of earthly power.

Thus, Herodotos' presentation of the conflict between Europe and Asia still largely exemplified the religious outlook and comparative cultural or ethical dialectic that had developed among the Greeks in the period just after the Persian invasion. It was not so much an analysis of fact as it was a mode of discourse that was willing to conceive of the Persian only as an antithesis: an other and an inferior, a foil designed to assert and validate the moral or cultural superiority of those who had defeated him.[25] Herodotos, like the

generation that preceded him, saw a fundamental relation between culture and *ethos* as the decisive issue of the Persian Wars. And so it is rather fitting that in Book III (38) he concludes an earlier discussion of the differences between the Greeks and other peoples by quoting a line from Pindar whose lesson Xerxes would soon learn: "In all things Law *(nomos)* is king."[26]

Ethos in the Marathon Painting

From the perspective of such historical and literary evidence, the question now arises as to how extensively or specifically this ethical/cultural rationale informed the visual artistic celebrations of the Persian Wars. Here the most immediately relevant monument is the famous painting of the battle at Marathon in the Stoa Poikile, completed a decade or so after the initial production of Aischylos' *Persians*. Like its counterpart in drama, this painting was exceptional in depicting relatively contemporary events in a medium normally reserved for mythic representations. One might therefore reasonably expect the Marathon painting to share something of the ideology and belief basic to the *Persians*, not only because they were approximately contemporary manifestations of Athenian culture, but because they served a similar and unusual purpose.

The labor of recovering the structure and contents of the Marathon painting from a substantial but disparate body of literary testimonia has occupied historians of Greek art since Robert's time, and it continues to provide a significant topic of research, as evidenced by the more recent work of Harrison and Hölscher and the collaborative efforts of Francis and Vickers.[27] One can in fact discern much about the ethical content of the painting from the most extensive single account of the work from antiquity, that of Pausanias (I, 15, 3). What he tells us tends to indicate that the main lines of the composition, the disposition and comportment of the participants, and the development of the action or narrative all worked to convey a visual contrast in human character along the lines that Sokrates had suggested to Parrhasios. The painting was a graphic statement of ethical antithesis, and the specific content or ideology of this antithesis was precisely the sort encountered in Aischylos, and at various points in Herodotos as well.

The painting begins with the Athenians and their Plataian allies first colliding with the Persians on more or less even terms. By the time one reaches the central portion of the composition, the battle has taken a decisive turn. The Persians are already fleeing in a disorderly rout, pushing one another into the nearby marshland. By the end of the painting, the Persians

are scrambling desperately toward their ships. Even from this limited description, one can sense how the pictorial conventions of sequential action in the painting deliberately emphasized an antithesis between the steadfastness of the Greeks and the changing response of the Persians—the collapse of Persian nerve before the relentless Greek advance. Scholars have repeatedly noted the close correspondence between what is known of the Marathon painting and Herodotos' version of the battle, and some have suggested that his account drew directly on the painting in the Stoa.[28] Yet the course of the battle in the painting also runs remarkably parallel to Herodotos' account of Salamis, and, for that matter, to the account of Salamis in Aischylos' *Persians*. Initially the barbarians withstand the Greek attack, but then their resistance degenerates into a panic-stricken, chaotic jumble, as they become bogged down and trapped by their own ranks and eventually run for their lives.

Perhaps the Persians really were incapable of utilizing the advantage of a large fighting force, allowing enemies to turn Persian numerical superiority into a liability. Perhaps they always lost their nerve when they encountered fierce and protracted opposition, and perhaps one is to conclude that they had never faced a worthy opponent before they fought the mainland Greeks. Or perhaps these accounts and the Marathon painting all present us with a set pattern, a formulaic image of barbarian inferiority—the fearful and directionless lackeys of the Great King—a character portrait deliberately concocted to pale by comparison with the selfless discipline and courageous unity of the Greeks.

In Herodotos' narrative Demaratos warned Xerxes that monarchic intimidation could never inspire anything approaching the level of courage and orderly battle prowess that Greeks could achieve in the service of law, even without a single leader. There is good reason to believe that the Marathon painting consciously exemplified this political-cultural contrast and its military consequences. Pausanias observes that not only the commander-in-chief, Kallimachos, but also the general Miltiades and the hero Echetlos, are conspicuous in the painting. The testimony of Pliny (*Natural History*, XXXV, 57) and Aelian (*On Animals*, VII, 38) indicates that the warriors Epizelos (Polyzelos) and Kynegeiros also figured prominently in the overall composition. From what is known of how these warriors acquitted themselves at Marathon, they seem especially to have exemplified the tenacity of the Greek resistance. Miltiades urged the Greeks on against the enemy, keeping them mindful of their responsibility. Kallimachos was supposed to have amazed and horrified the barbarians by fighting to the death although riddled with enemy spears or arrows. Epizelos lost his sight in the battle but continued to fight undaunted and unscathed. Echetlos inflicted heavy losses

on the Persians though armed only with a plough, a paradigm of the humble but dogged and effective resistance of the Greek people themselves. And at the end of the painting young Kynegeiros lost his hand (or hands) while grabbing hold of a beached Persian ship, stubbornly refusing to allow the fleeing barbarians even to escape.[29]

All this would naturally have divided the spectator's attention among a number of outstanding Athenian defenders, and it seems to have been a deliberate means of stressing the spontaneous, collective resolve that the Persians were supposed to have found invincible. In the fourth century, the orator Aischines (*Ktesiphon,* III, 186) was still impressed by the relative anonymity of the Marathon painting and the nearby Eion herms, which, in his opinion, celebrated victories as national accomplishments rather than as the achievement of any one man. Thus the Marathon painting elaborated visually upon the argument advanced in the *Persians* (241–244), where Atossa asks how the men of Athens could withstand enemy attacks without a master over them, and the chorus responds by citing the lesson of Marathon itself: "So well that they crushed Dareios' hugh and shining army."

The Marathon painting also included a suite of protecting gods and heroes; Pausanias mentions Athena, Herakles, Theseus, the eponymous Marathon, and Echetlos, and there may have been others as well.[30] Here again the passage from Aischylos' *Persians* (345–347), quoted above in this chapter, offers a striking parallel in asserting that

> some divine power . . . destroyed the host.
> .
> Gods safeguard the city of the goddess Pallas.

There is, moreover, an unmistakable analogy to Herodotos, especially to Book VIII (143), where, as indicated earlier, the Athenians avow their trust in the just retribution of the gods and heroes whose shrines the Persians had destroyed. Still, the literary sources never quite achieve the causal relation between the motif of divine or superhuman intervention and the theme of the triumphant Greek *ethos* that the visual juxtaposition of man and god in the Marathon painting must have impressed upon the viewer. In the most immediate terms, the gods and heroes in this work appeared as a powerful source of aid and inspiration, urging the Athenians to persevere in their battle. Yet the inclusion of these superhuman figures in the midst of the struggling Greeks implied a deeper connection. It reinforced the notion that the Hellenic law or custom that they upheld was divine in origin, and that in defending such law the Greeks had become agents of Zeus and his justice, partners or surrogates of Dike. In addition, there was a long-established Greek pictorial

tradition in which protector-gods were shown accompanying heroes like Herakles or Theseus during their exploits.[31] By adapting this convention to the depiction of a more contemporary event, the level of the struggle and the character of the protagonists were given a heroic or quasi-heroic dimension, rendering the victory at Marathon more plausible or acceptable as a pendant to the truly mythic and heroic themes depicted nearby.

Thus the Marathon painting is a work of fundamental importance for the study of the Kimonian monuments. It provides a vital and indisputable link between the monumental painting of this period and the moral or ethical and religious ideology surrounding the victory against the Persians in contemporary literary remains. But the Marathon painting also connected the realm of myth with that of actuality. Here the Athenians of the fifth century joined forces with the ancient heroes, especially Theseus, and with his divine protectress Athena. The painting plainly instructed the observer on the analogy and comparability of past and present, of recent achievements and those of remote times. One could ask for no better justification to explore the contemporary relevance of the mythic paintings produced under Kimon for the Stoa and the other buildings of this kind. Yet if the Marathon painting is truly a touchstone for the political intent and resonance of these monuments, then it becomes essential to expand the inquiry to include the issue of ethical content. If the mythic paintings were to operate as a profound and meaningful prefiguration of triumph against the Persians, then they too must have addressed the maintenance of law through the agency of a superior *ethos.*

With this in mind, it hardly seems accidental that by the second quarter of the fifth century, the myths depicted in the officially sponsored Athenian monumental paintings had also come to function as icons of the conflict between *hybris* and *sophrosyne.* In every case the myths too can be shown to have exemplified the opposition traced above, in which the moral weakness and uncontrolled greed, violence, and impiety of *anomoi*—those who had no regard for law—clashed with the strength and moderation of those dedicated to upholding it. Each of these mythic battles also asserted the inevitable judgment of divine justice, *dike,* against those who defied or ignored the ordinances of Zeus, just as they asserted divine favor for those who defended the Olympian law. Some of these mythic subjects were intrinsically suited to such an opposition; others were not. But all, as we shall see, were adjusted or transformed in various ways to facilitate and maximize this usage. In the chapters that follow, it will become clear that those who commissioned and executed these paintings carefully weighed the potential of each mythic paradigm to encompass the very same antithetical and ethical analysis that informed Aischylos' or Herodotos' portrayal of the Persian

Wars, and the Marathon painting as well. But in opting to extend the discourse to the realm of myth in this way, the creators of these monuments took the process a step further: they sought to expand and reinforce such analysis through the implicit claim that the victory over the Persians was only the most recent chapter in a timeless, heroic struggle to maintain the law and order established by the gods.

2

Ethos and Antithesis in the Kimonian Monuments

The Theseion

Among the monuments produced under Kimon, a deliberate commemorative function is clearest in the case of the Theseion or shrine of Theseus. The original location of this monument is still uncertain but probably lay to the southeast of the excavated portion of the Agora. In immediate, practical terms, it served to house the relics of Theseus recovered during Kimon's operations against the Dolopian pirates on the island of Skyros in 475 B.C., but it was effectively a votive as well, built to celebrate the victory and the consequent "return" of Theseus to Athens.[1] There is no hard evidence that the spoils of the campaign paid for the building, although this is certainly possible. In any case, its paintings must have directly reflected these events and the significance that they held for the Athenians.

The paintings commissioned to decorate this building all dealt with Theseus' mythic exploits, as was appropriate for his *heroön*. They showed the battle against the Centaurs at the wedding of Peirithoös, the Amazon invasion of Attika, and the story of Theseus' recovery of the ring of Minos during the trip to Crete (Pausanias, I, 17, 2–3). The last of these was the work of the well-known artist Mikon; the authorship of the others is uncertain.[2] Some scholars have also suggested that an apparent digression in Pausanias' description of the shrine—an allusion to Herakles' rescue of Theseus from the Underworld—could be a muddled reference to a fourth painting. This must remain conjectural, however, even though an Underworld rescue would have provided an effective mythic parallel for Kimon's recovery of Theseus' bones from Skyros.[3] Nevertheless, the choice of themes here was not simply a consequence of the new popularity of Theseus in Athens at this time; nor did it simply reflect Kimon's attempts to associate

33

himself with this mythic prototype. The program of imagery was carefully selected and adjusted to mirror the larger military agenda of Athens and her League against the Persians in the Aegean, and to validate that agenda in moral or ethical terms. Taken as a whole, these paintings formed a far more detailed and coherent system of analogy or comparison than scholars have generally recognized.

The Centauromachy

Among the myths depicted on the Theseion, and more generally among the Kimonian monuments, the battle between the Greeks and Centaurs lent itself especially well to an overall strategy of thematic contrast or opposition. It had from the earliest times exemplified a range of distinctions: between the trained warrior and the raging brute, between human skill and animal violence, or between civilization and savagery.[4] Kirk has gone far in clarifying the underlying unity of all these contrasts; in a Levi-Straussian vein, he has extended Heinimann's analysis of the *nomos/physis* antithesis to interpret the battle against the Centaurs as a symbol of the even broader opposition between culture and nature. Within such a view the Centaurs appear intimately associated with the untamed forces of the natural environment.[5] Thus we may see them as a fitting antitype for armed opponents exemplifying the technology and discipline of civilized existence. Whether one turns to the sub-Hesiodic verses in the *Shield of Herakles* or to the François Vase, this basic opposition is foremost in Archaic representations of the battle; it is the contrast of armor and spear against tree limbs and boulders.[6]

In the earliest versions of the myth, the battle resulted from a feud. Under the influence of too much wine, the Centaur Eurytion had behaved grossly at the house of Peirithoös, and in return his hosts cut off his ears and snout and sent him on his way (*Odyssey*, XXI, 295). Only later did the Centaurs opt to continue the struggle with the Lapiths in a pitched battle out-of-doors. But from the evidence of vase painting, architectural sculpture, and much later literary sources, this conception had changed drastically by the period just after the Persian Wars. Now Peirithoös receives a number of Centaurs as his guests, and the occasion is clearly his wedding feast. All the Centaurs get drunk and succumb to the bestial element in their make up, as their behavior degenerates into unbridled lust and violence toward the Lapith women. A fierce struggle erupts amid the furniture and equipment of the celebrations (see figs. 1 and 2b). The extant remains of Archaic poetry are insufficient to determine whether the version of the Centauromachy at the wedding feast had already taken shape by the sixth century. The works of art

that depict the battle in this new form, however, are no earlier than the 470s, and the treatment of the myth along these lines in all media seems to be a development of the Early Classical period.[7]

These changes betray a still more basic transformation in the myth; they effectively made the Centauromachy over into a symbol of yet another opposition: that between moderation and outrageous excess. This contrast had to some extent been latent or implicit in the story from its inception. By the mid-sixth century, the poet Theognis stated that the Centaurs had been destroyed by their *hybris*. But the new fifth-century recension asserted this theme much more forcefully. The crimes of the Centaurs at the wedding of Peirithoös constituted a multi-faceted archetype of *hybris*, encompassing offenses against social custom and propriety as well as those against the gods. Initially it involved the abuse of wine. Already in the *Odyssey*, (I, 226–228) the suitors are characterized as *hybrizontes* for their excessive drinking and feasting; and among the Classical Greeks drunkenness continued to be associated with *hybris*. Toward the middle of the fifth century, the epic poet Panyassis (quoted in Athenaeus, *Deipnosophists*, 36D) characterized the abuse of wine as the first step in an inevitable pattern of *hybris* and *ate*, "ruin."[8]

But the Centaurs' *hybris* also manifested itself in sexual, societal, and religious terms. Drunken insolence fueled an uncontrollable lust that was an outrage against the modesty of the Lapith women, a willful affront to the honor of the Lapith men, and an insult to the lawful institution of marriage established by Zeus and, by extension, the larger social order that marriage supported. The Centaurs also dishonored Zeus in his capacity as "Xenios," protector of the sanctity of hospitality and guest-friendship, by defiling the wedding feast and the status of the Lapiths as hosts. The Centaurs' *hybris* therefore involved impiety as well as insolent brutality, drunkenness, and sexual immoderation. Thus, in the *Trachinian Women* (1095–1096), Sophokles describes these creatures expressly as "hybristic," and he underscores their criminal nature not only by stressing their overbearing force or violence, but also by branding them more generally as *anomos*, "lawless."[9]

The physical aspect of the Centaur lent itself to this new conception of the myth. By the Geometric and Orientalizing periods, the combination of human and equine forms was already an artistic convention for representing baleful, monstrous forces inimical to god and man.[10] DuBois has also stressed the violence and sexuality associated with the equine portion of the Centaurs.[11] However, the evidence of Xenophon best enables us to appreciate the Centaurs' capacity to epitomize *hybris* at the Lapith feast. In the *Kyropaideia* (VII, 5, 62), the horse is characterized as naturally hybristic, a flaw that can be remedied only by gelding. And in *Hieron* (X, 2), as the tyrant

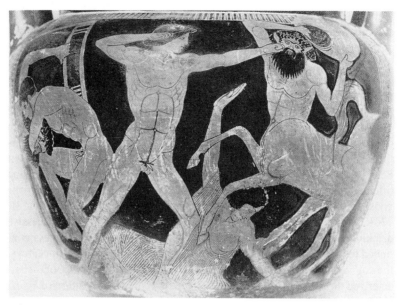

Figure 1. Attic red figure krater by the Florence Painter, Florence, Museo Archeologico, 3997 (from E. Pfuhl, *Malerei und Zeichnung der Griechen,* 3 vols., Munich, 1923, fig. 489).

explains his repressive doctrines of government to the poet Simonides, he notes that some people are like horses; the more they get, the more they want, and the more they are apt to become insolent or hybristic. It would seem that the Centaur's equine aspect included the violent, insatiable, or excessive propensities popularly attributed to the wild, untamed horse, and it was this inner character that their behavior and outward physical aspect exemplified so effectively at the wedding of Peirithoös.

In positive terms, the *ethos* of the Centaurs' adversaries here was no less significant. As repressors or punishers of the Centaurs, Theseus and his hosts exemplified *sophrosyne,* restraint or moderation; they upheld respect for the lawful limits imposed by the gods. The passage from the *Trachinian Women* branding the Centaurs as hybristic and lawless specifically addressed this opposition. There the Centaurs are enumerated among the various monstrous enemies of settled human existence that the great Herakles subdued in his struggles on behalf of mankind. Like Herakles, the Greeks at Peirithoös' wedding have now become agents of divine justice, *dike,* upholding the order and authority of Zeus. The new form of the Centauromachy illustrated the maintenance of those very principles of law and self-control that the Greeks considered basic to civilized life and commu-

nity, and it asserted the superiority of the Greeks over those who lacked these qualities.[12]

The Attic red figure krater by the Florence Painter, which probably follows the large-scale version of the Theseion, provides some idea of how effectively an early Classical muralist could convey this moral or ethical opposition in visual terms (fig. 1).[13] The female Lapith at the center of the scene underscores the mood of brutality and outrage. Her breast hangs out of her disheveled garment as she falls to the ground, raising her arm in supplication and turning her face downward in modesty and humiliation. The Centaur himself epitomizes savagery and irreverence, fighting wildly and using as a weapon one of the vessels from the feast, tangible evidence of the affront to Zeus' laws of hospitality, just as the Centaur to the left brandishes a piece of furniture. The contrast between the opponents is profoundly expressive. The male Greek or Lapith is in every sense the antithesis of the Centaur. He is taut, muscular, and alert; his actions are ordered and controlled as he defends the woman with a boxing technique redolent of training and discipline. His facial expression is cool and nobly determined. The Centaur rears awkwardly; the drunken and brutish confusion in his face turns to shock and anguish as he reacts to the well-placed blow delivered by the boxer, who might even be Theseus himself (see fig. 1).

The diminutive frieze on the neck of the krater from Numana by the Painter of the Woolly Satyrs is also likely to depend upon the original in the Theseion, although it does not for the most part capture the monumental expressiveness of the combatants in the Florence Painter's version. Yet the artist does communicate the impious outrage of the Centaurs through a more detailed rendering of the disrupted banqueting hall and its furnishings, which would also have been effective in the large-scale prototype (fig. 2a–b). And here too the self-assured pose and careful musculature of the central ax-wielding figure emerge as a paradigm of control and *arete,* completely opposed to the impulsive raging of the Centaurs (fig. 2b).[14]

All the details of these works converge to assert one overriding principle: the superior *ethos* of the Greeks as worthy defenders of moderation and law, pitted against an enemy of savage, sinful, and inferior character. The use of expression and gesture here vividly illustrates Sokrates' remarks to Parrhasios on the "ethographic" capacity of painting to express the qualities and extremes of human character (cf. figs. 1 and 2b, top right):

There pierces through the countenance of man, through the very posture of his body as he moves, a glimpse of nobility and freedom, or again of something in him low and grovelling—the calm of self-restraint [*sophronikon*] and wisdom, or the swagger of insolence [*hybristikon*] and vulgarity.[15]

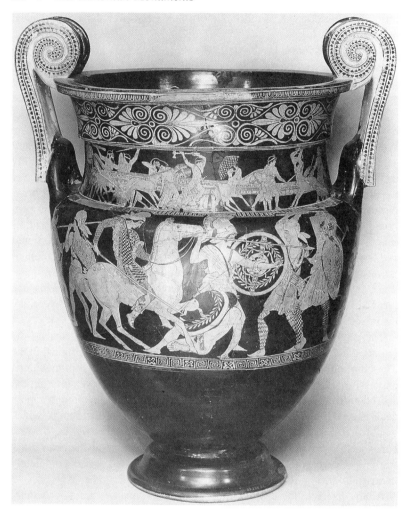

Figure 2a.
Figure 2a–d. Attic red figure volute-krater by the Painter of the Woolly Satyrs, from Numana, New York, Metropolitan Museum of Art, Rogers Fund, 1907, 07.286,84 (2a, 2c, 2d: photos MMA; 2b: A. Furtwängler and K. Reichhold, *Griechische Vasenmalerei,* Munich, 1924, pl. 12).

Woodford maintains that the new treatment of the Centauromachy imparted an ethical and moral dimension to the myth that is not discernible in earlier literary and artistic representations of the theme, but this view requires some qualification.[16] The Archaic opposition of the civilized skill and discipline of the Greek against the wild, untamed force and violence of

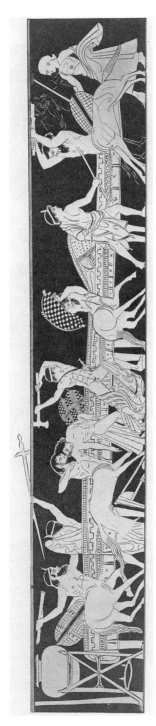

Figure 2b.

39

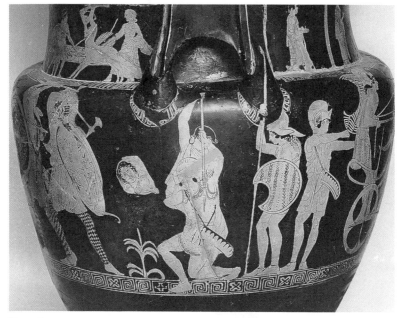

Figure 2c.

the Centaur already held within it the seeds of the contrast between moderate man and unrestrained beast that we see in the works of the Florence Painter and the Painter of the Woolly Satyrs. The differences are those of degree and causality. What the Archaic Centauromachy lacked was an internal cue or sign that could explicitly link the belligerent rage of the Centaurs in the woodland battle to the earlier offense of Eurytion at the house of Peirithoös. In transferring the battle to the wedding itself, the Greeks of the fifth century focused on the cause of the struggle: the *hybris* of the Centaurs. Indeed, they made it the focal issue of the entire narrative, for what appeared now was not only the immediate theme of a battle against ferocious monsters, but the struggle of the Lapiths to contain and punish evident affronts to modesty, marriage, or hospitality—a struggle to maintain what were held to be the lawful limits and foundations of society.

It is not so much that the fifth-century Greeks sought to impart a wholly new meaning to the Centauromachy, but rather that they emphasized and expanded upon its ethical implications. Although Woodford's assessment of these changes may be somewhat overstated, her explanation of the specific motivation behind them is well worth considering further. In her discussion of the monumental Centauromachy at the Theseion, she suggested briefly

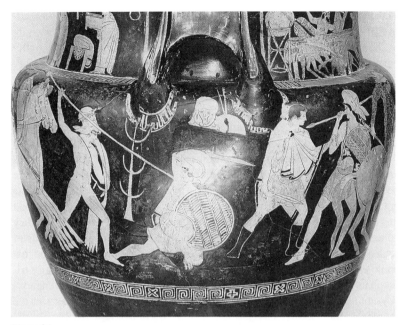

Figure 2d.

that the new conception of the battle was intended to mirror the rape and impiety of the Persians during their invasion of Greece. As evidence Woodford cited Herodotos' account of the Persian embassy to the Macedonian court at the time of Dareios' Scythian campaign (V, 18–20). After drinking to excess, the Persian guests began to fondle or demand the Macedonian womenfolk. Like the Centaurs, they died for this affront to the honor and hospitality of their hosts, for Herodotos tells us that the Macedonians then slaughtered the entire Persian embassy.[17] The analogy to the wedding of Peirithoös here is striking; it is difficult to decide whether the new conception of the Centauromachy was modeled after such events, or whether Herodotos has passed on an account of the Persians tailored to resemble stories about the Centaurs at the feast. Yet Herodotos also documents such behavior during Xerxes' campaign, and in rather less anecdotal terms. In Book VIII, (33), he reports that during the devastation of Phokis, the Persians raped one group of women so brutally and repeatedly that the victims died.

In the aftermath of the Persian Wars, the image of lawless violence that had become central to the depiction of the Centaurs could provide a particularly unattractive and useful mythic analogue for the barbarian invader.

The complexity of the Centaurs' *hybris,* involving lust and impiety in addition to wanton belligerence, comes rather close to Herodotos' overall account of the invasion in Phokis, where the rape episode appears amid a lengthy narrative that includes the pillaging of shrines or temples. Brutal impiety would therefore have been an extremely important facet of the parallel that the Centauromachy offered for the present; on the evidence of Aischylos as well as Herodotos, the Persians' disrespect toward Hellenic religious institutions loomed large in Greek minds in the decades following the war. And the Centaurs' greedy violence also provided a handy mythic prefiguration for the unlimited appetite for conquest and domination ascribed to Xerxes and his followers. Xenophon does, after all, emphasize the capacity of some people to indulge in the insatiable *hybris* of horses. Perhaps the artists entrusted with developing a program of mythic analogy in the Theseion took this popular wisdom rather literally. It may well be that the new fifth-century conception of the Centauromachy evolved specifically to meet the needs of such a program—that is, to provide a more appropriate mythic analogue that could evoke the many sides of Persian *hybris* and illustrate the eternally triumphant struggle of the Greek character against an ethically inferior enemy.

Another look at the Centauromachies by the Florence Painter and the Painter of the Woolly Satyrs (Figs. 1 and 2b) shows how effectively the lawless violation of the women or the irreverent disruption of the feast could express the opposition between Greek and Persian in a mythic guise. The sudden arrest or confusion of the Florence Painter's Centaurs offers a recognizable mythic analogue for the literary and artistic depictions of the Persians at Marathon and Salamis, whose aptitude for battle evaporates as they meet well-ordered and concerted resistance. For their part, the central figures of both versions embody the discipline and moderate resolve of the Greeks in such accounts, defending their homeland and ancestral laws, the epitome of *sophrosyne* and *arete,* a powerful precedent for Herodotos' Athenians in Book VIII (143) as they vow never to relent until they have avenged the desecration of Attika's religious sanctuaries (cf. figs. 1 and 2b). In this mythic form the Greek claims to divine aid and approbation in their struggle against Xerxes appeared more than justified. If these red figure versions do indeed derive from the Centauromachy in the Theseion in the late 470s or early 460s, then the lost monumental work should be seen as an artistic landmark, a major innovation in the movement to portray the events of the present as the fulfillment of an ancient Greek commitment to law and justice.

Surprisingly, no scholar except Woodford has so far attempted to examine how the technique of mythic prefiguration in the paintings of the Early Classical period might have involved a detailed condemnation of the Persian national character in contrast to that of the Greeks. Apart from the Cen-

tauromachy, the issue of ethical or moral antithesis in these monumental battle narratives remains largely unexplored. There is, however, considerable evidence to support such an interpretation for the remaining themes depicted on the Theseion, and in the paintings commissioned for other buildings during this period as well.

The Amazonomachy

As in the case of the Centauromachy, it is generally accepted that various Attic red figure depictions of the Amazonomachy by the Niobid Painter and his contemporaries (figs. 2–4 and 6) were adapted from the large-scale painted versions of these themes in the late 470s or 460s in Athens. The combination of the Amazonomachy and the Centauromachy at the wedding of Peirithoös on the krater from Numana by the Painter of the Woolly Satyrs

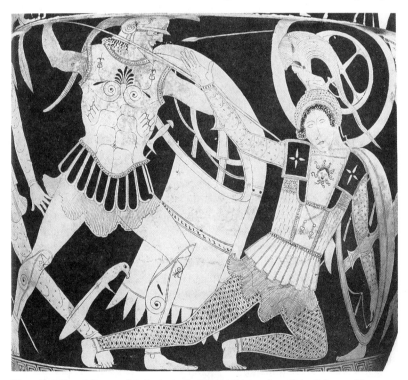

Figure 3. Attic red figure volute-krater by the Niobid Painter, from Gela, Palermo, Museo Nazionale, G 1283 (from P. E. Arias and M. Hirmer, *A History of 1000 Years of Greek Vase Painting*, New York, 1962, pl. 179).

(see fig. 2a) may indicate a direct dependence upon the Theseion paintings, where both themes were similarly juxtaposed, but this remains unproven.[18] There is nevertheless one clear indication that the Attic vase painters of this period were directly familiar with the large-scale Amazonomachy of the Theseion: they adapted the devices that the painting utilized to assert its thematic relevance to recent events. Among the Amazons depicted on an Attic red figure bell-krater from Spina, two are inscribed as "Dolope" and "Peisianassa," names nowhere attested in surviving versions of the myth. As various scholars have noted, these are eponyms or epithets referring to Kimon's defeat of the Dolopian pirates of Skyros, and to Peisianax, Kimon's brother-in-law, who may have taken part in the campaign. For the first of these inscriptions, the implication is clearly that the vase follows the version of the Theseion, where an Amazon labeled "Dolope" served to specify and reinforce the analogy of the painting to the campaign against Skyros.[19]

However, the true relevance and effectiveness of the equation between the Dolopes and the Amazons emerges only in the context of "Medism"—collaboration with the Persians, or Medes, as they were also known. Herodotos (VIII, 132 and 185) includes the Dolopes among the list of Greeks who sided with Xerxes in 480. There was, in addition, an Amazon of sorts who came from Asia Minor to aid the Persians against the Greeks, and she was a maritime Medizer as well. This was the famous Karian Artemisia, the queen of Halikarnassos, who fought in the naval battle at Salamis. As a native of the same city, Herodotos knew of her exploits and refers to them more than once (VIII, 87 and 93). From later sources, we also know that she went about dressed and armed like a man.[20] It is moreover apparent that fifth-century Athenians conceived of Artemisia as an Amazon, since Aristophanes juxtaposes her with the warrior women as equivalent symbols of female aggression in his comedy *Lysistrata* (674–678). Thus the imagery of victory over Dolope and her female comrades in the Theseion painting was designed to condemn the Skyrian Dolopes more specifically as faithless Persian sympathizers, and it thereby rationalized their destruction as part of the punitive actions waged by Kimon and the Delian League against Persian interests in the Aegean throughout the 470s and 460s.

The use of mythic analogues to illustrate the moral perfidy of Medism was, as we shall see, an important component in the public imagery of Kimon's time. All the same, the full import of the Amazonomachy depicted on the Theseion, and particularly the new form in which it appears, depended primarily upon the more general remodeling of the image of these warrior women as prefigurations of the Persians themselves. The story is an old one in Greek art, already attested on a work of the very late Geometric period.[21] Some have speculated that the Amazonomachy was based historically

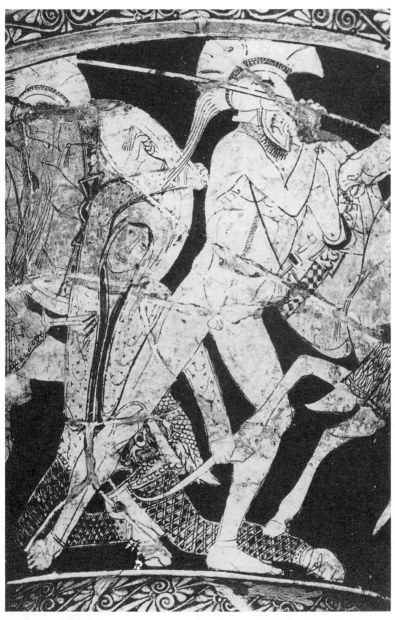

Figure 4a.
Figure 4a–d. Attic red figure calyx krater from Bologna, Bologna, Museo Civico, 289 (from
Corpus Vasorum Antiquorum, Italia, fasc. XXVII, pl. 73, 4 and 6, and E. Pfuhl, *Malerei und
Zeichnung der Griechen*, 3 vols., Munich, 1923, fig. 504).

45

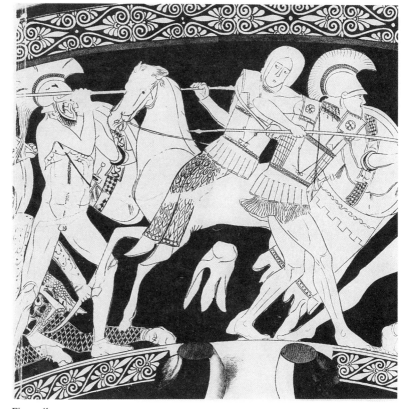

Figure 4b.

on some early confrontation between the patriarchal Greeks and matriarchal societies that they encountered, although this view is now largely discredited. From its inception the Amazon myth probably functioned as a nightmare image of women beyond control, an image designed to justify male supremacy.[22] At this early stage, however, the struggle with the warrior women was conceived as an offensive operation. Initially the myth centered on Herakles and his campaigns against the Amazons in their Asiatic stronghold at Themiskyra. Eventually, in the Attic art of the late sixth and early fifth centuries, Theseus accompanies Herakles or leads his own expedition against the warrior women, carrying off the Amazon Antiope.[23]

Yet this was not the story that the large-scale painted Amazonomachies of the fifth century depicted. In his description of the paintings on the Athenian monuments, Pausanias (XV, 2, and XVII, 2) says that they showed

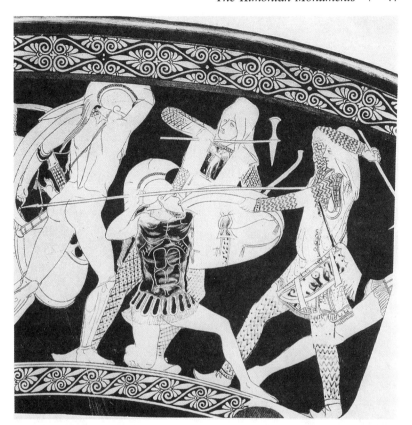

Figure 4c.

Theseus and the men of Athens fighting the Amazons. In remarking on the version also displayed in the Stoa Poikile, he refers specifically to the Amazon invasion of Attika; in the case of the Theseion, he tells us that the subject was the same as that on the shield of the Athena Parthenos, which unquestionably depicted the Amazons attacking Athens.[24] By the early 450s, Aischylos' *Eumenides* (685–689), refers to this version of the myth, and it recurs in the speech of the Athenians before the battle of Plataia in Herodotos (IX, 27). But the story cannot be attested any earlier, in literary or visual artistic remains, and there is a good case for seeing it as an entirely new recension of the Amazon myth designed to parallel the recent Persian invasion of Attika.[25]

The Attic Amazonomachy was an important component in the *epitaphios logos*—the annual, official, mass eulogy for all those who had died in defense of Athens during the year, a custom that originated sometime after the

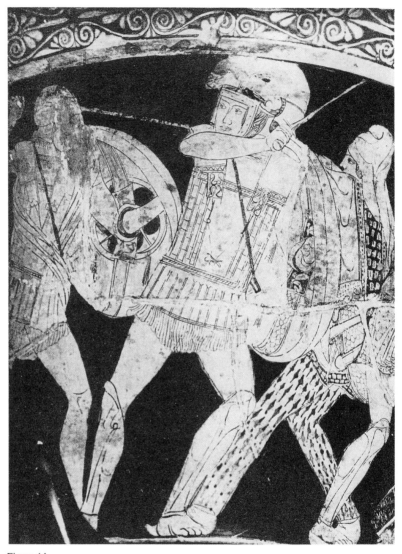

Figure 4d.

48

Persian Wars. These speeches consisted primarily of reciting a fixed catalogue of Athenian exploits that connected mythic deeds with the recent triumphs over Dareios and Xerxes. Kierdorf is probably correct in arguing that the use of this catalogue was originally a more widespread rhetorical *topos* that developed in various forms of public or official oratory in Athens at this time. No actual speeches of this kind from the Kimonian period have come down to us. However, the elements of the abbreviated speech that Herodotos attributes to the Athenians at Plataia in Book IX, (27) recur in an expanded and richly detailed form in sections 4 to 26 of the early fourth-century *Funeral Oration* by Lysias. There can be little doubt that here Lysias preserves the same rhetorical tradition that influenced Herodotos.[26]

Speeches of this kind are perhaps the best evidence we have of how aggressively the Athenian state manipulated mythic traditions in order to rationalize its struggles against others, even if it meant adjusting or transforming the basic setting and import of the myths employed.[27] One cannot be sure whether the Attic Amazonomachy was specifically a creation of such rhetoric. But it is very likely that these public speeches gave the Amazon invasion of Attika its definitive form and overtly ethical emphasis. Consequently, they are indispensable in understanding the use of this myth in the officially sponsored monumental paintings as yet another object lesson of crime and punishment, like the Centauromachy, a moralizing tale that could contribute to the Athenian program of invective against the Persians through the calculated analogy with the past.

Overall, Lysias (II, 4–26) uses the catalogue of exploits to demonstrate the courage and nobility of the Athenians and their vigorous dedication to the defense of Greek moral and religious law. The Athenians are literally the children of the soil of Attika, untainted by primeval aggression against earlier indigenous inhabitants; thus they are naturally disposed toward defending the common good and freedom of Greece in the cause of justice, especially against invaders.[28] To Lysias, the victory over the Amazons was above all a triumph of this sort, and consequently it won for the Athenians "an immortal memory of *arete*" (excellence of character). The Amazons represented, of course, the complete antithesis of these moderate and noble values. As opposed to the Athenian commitment to freedom and justice, the warrior women from the East stood for barbarian enslavement *(douleia)* and an implacable desire to dominate others. Lysias recounts how the Amazons had already achieved an Asiatic empire of great size by conquering the nations around them. But they could not be content with this; they could not resist the lure of conquering a country so renowned as Athens, and so they mustered those that they had already subjugated into a huge barbarian horde and attacked—to their utter ruin. "Having lusted unjustly after the country of others, these women justly lost their own."[29]

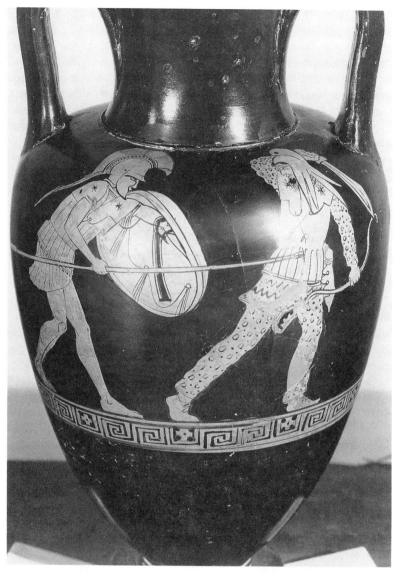

Figure 5. Attic, Nolan red figure neck amphora, New York, Metropolitan Museum of Art, Rogers Fund, 1906, 06.1021.117 (photo MMA).

50

In Aischylos' *Eumenides* (685–690), the invading Amazons are said to have established their base of operations on the Areopagos while laying siege to the Akropolis, clearly an intentional parallel to Xerxes' attack in 480 as documented by Herodotos (VIII, 52–53).[30] Thus it is hardly surprising to see the more extended and moralized account of Lysias as a close and deliberate recapitulation of the events of the Persian Wars, and the Greek view of these events; nor can one ignore how closely the rationale for the Amazons' invasion and destruction follows the kind of analysis that Aischylos and Herodotos applied to Xerxes' campaign. The Amazons are motivated by the same presumptuous expectations of limitless expansion and victory, marshaling their numberless subjects to extinguish the freedom that lay as yet beyond their control. They exhibit the same incapacity to rest content with the power that they already hold. The dominion of Asia will not suffice; they must have Athens and Greece as well.

The Amazon myth in this form was designed, or perhaps redsigned, literally to provide a mythic analogue that could extend the moral flaws ascribed to contemporary Asiatics back into the remote past, just as it presented the opposing virtues of the Athenians as qualities of long standing. In *Archidamos* ([VI], 42) and in the *Panathenaikos* ([XII], 196), Isokrates expressly refers to the Amazons and other mythic invaders of Attika as perpetrators of *hybris*. Lysias neglects to give the crimes of the Amazons this label, but he did not need to; his audience knew it well. It was the lawless insatiability that Aischylos condemned in the *Persians,* the outrage stemming from an inability to control prosperity, wealth, and power, a weakness that Greek poets and philosophers from Solon to Aristotle had repeatedly warned against.

Yet another side of Amazonian *hybris* lurked just below the surface of the rhetorical tradition that Lysias followed, an aspect believed to reside in the very gender of these female enemies of Greece. To the male-dominated society of fifth-century Greeks, aggressiveness or assertiveness of any kind on the part of women was intrinsically hybristic. Demokritos states plainly that "it was the utmost outrage *(hybris)* for a man to be ruled by a woman."[31] However, Aristophanes' comedy *Lysistrata* provides the most extensive and telling evidence of this view. The potential female threat to the established patriarchal order was a subject that Athenians ultimately did not find amusing, and Aristophanes' humorous treatment of this theme reveals a good deal of the stress of gender politics in Classical Athens.

On three occasions the male characters refer to the rising of the women specifically as *hybris* (399–401, 425, and 658–659), and it is only a matter of time until the agitated chorus of old men raises the specter of the female aggressor in myth and recent history to illustrate the gravity of the present threat:

Is the *hybris* of these deeds not enormous?

. .

If anyone should give them (the women) just a little hold over us,
they will not be lacking in persistent skills.
They will build ships to sail against us
and wage naval battles, just like Artemisia.
And if they turn to horsy matters,
write off the (Athenian) cavalry.
For a woman is a most horsy thing, with a good seat
that will not slip in the gallop.
Just look at the Amazons that Mikon painted, fighting men from horseback.
No, rather we should grab them all by the neck
and harness them into collars of wood.[32]

Here the issue of female *hybris* is instantly made to recall the memory of the Amazons and the related events of the Persian Wars. To the Athenians, it was nothing less than outrage that Artemisia, the "Amazonian" queen of Halikarnassos, should fight for Xerxes at Salamis. As Herodotos tells us (VIII, 93), the Athenians offered a bounty of 10,000 drachmas to anyone who could take her alive, so horrified were they that a woman should make war against them. In the Athenian view, the Amazons were women of a similar disposition; they had the temerity to jump on horses and to fight with men, and thus they were equally hybristic, as Mikon's painting demonstrated.

Aristophanes, however, is rather specific about the real nature of the *hybris* attributed to the Amazons and others of their gender. The overall theme of the passage is insatiability; it relies upon the assumption that women are fundamentally unable to be content with what they have, and the concomitant need to keep them in check so as to preserve the social and moral order. Athenian men must control women in order to restrain the inherent female propensity for domination and excess, an opinion that Aristotle would later repeat. The chorus leader's railing is perhaps the best example of the sexist rationale for male supremacy that Tyrrell and Just have traced more broadly in their studies of gender relations in fifth-century Athens.[33] In this portion of the *Lysistrata*, Aristophanes addresses what is implicit in Lysias: the Athenian view that the obsessive aggression or imperialism of the Amazons was gender-related. Here one finally begins to appreciate the factors that prompted Athenian myth-makers to recast the Amazons in the image of the greedy Xerxes and his invading Persians. This convergence between ethnicity and gender was designed to assert and denigrate the incontinent character of an external Asiatic "other" through comparison to the more familiar internal female antitype to the moderate, disciplined Greek or Athenian male and his social order. The new external threat

to the good order of the *polis* was thereby equated with the longstanding internal threat that Hellenic men had always fought to contain.[34]

There is even more in this richly nuanced passage that can help to explain the choice of a female analogue for the Persian enemy, particularly in connection with analogues of a more immediately bestial nature. After the reference to Artemisia, the chorus leader's invective becomes bawdier as he focuses on the equine (as opposed to equestrian) quality of the Amazons and women in general; "a woman," the old man says, "is a most horsy thing." The word that he uses, *hippikotatos,* may be taken simply to mean "most skilled in riding," especially if one follows his argument that a woman's rump clings well to a horse's back. But the specifically equestrian sense of this word operated only on a superficial level. The more general or primary connotation of *hippikos*—"horsy," that is, "of or pertaining to horses"—should alert us to another widely held Greek or Athenian notion that Aristophanes is getting at: the ethical compatibility between horse and woman.

This supposed equation or affinity is, in fact, deeply embedded in the very terminology that the Greeks applied to young women and marriage, as Gould has shown. In fifth-century drama unwed girls were generally referred to by the noun *polos,* "young mare" or "filly." This was no mere figure of speech. The adjectives also commonly applied to maidens, *admes,* literally "untamed" or "unbroken," and *adzux* and *adzugos,* "unharnessed," were terms properly applied to horses and other animals that require a man's training to bring them under control. This vocabulary demonstrates well enough that the Greeks, or Athenians at least, considered women to be instrinsically wild or unrestrained in a bestial sense, probably in connection with the larger *nomos/physis* antithesis in which the female was identified with the natural environment, outside or peripheral to the civilized order attributed to the male. Only when married and under the proper care and handling of a man was a woman thought to be "broken in" and "yoked."[35] Here again, it is instructive to recall the assertion of Xenophon's *Hieron* (X, 2) that some people are like horses; the more they get, the more they want, and the more they are apt to be hybristic. Some people, indeed—women, and especially Amazons. Small wonder that Mikon showed them waging their insatiable aggression against Athens on horseback, and that the chorus leader in the *Lysistrata* closes his harangue with the admonition to get the horsy females back in harness where they belong.[36]

One cannot miss the analogy between the equine *hybris* attributed to women or Amazons and that of the Centaurs discussed earlier. Each in their own way graphically articulated the unrestrained and bestial *ethos* that repeatedly challenged the Greeks. The Centaurs' equine immoderation appears

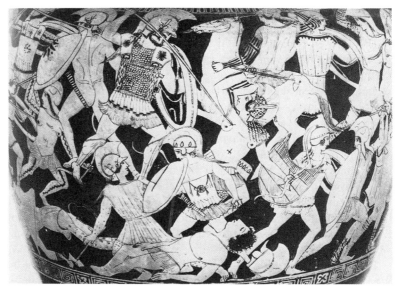

Figure 6a.

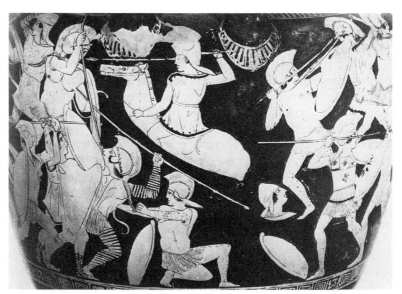

Figure 6b.
Figure 6a–d. Attic red figure volute-krater by the Painter of Bologna 279, Basel, Antiken-
sammlung and Sammlung Ludwig BS 4860 (from "Amazones," *LIMC*, I, 2, Munich, 1981,
no. 302, ills. a–d).

54

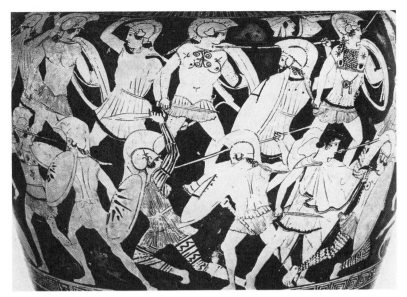

Figure 6c.

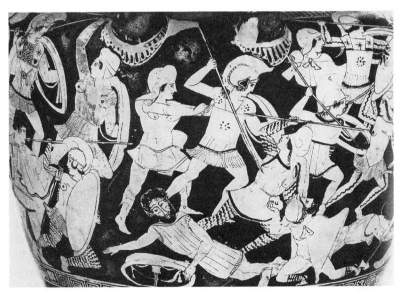

Figure 6d.

55

as immediately physical, a visual constituent of the enemy manifested in their very form, and thus it gives rise to an especially violent and physical kind of excess (cf. figs. 1 and 2b). The Amazons only *ride* horses, so that the horsy element is to some extent disengaged or separate, but it is internal as well; in place of the brutal savagery of composite monsters, the Amazons' more subtle equine affinities emerge in the unrestrained appetite of an enemy invader who lusts after military domination rather than immediate physical or sexual control (fig. 2a). Yet this insatiable propensity for military and political aggression too was ultimately an animal quality in the Greek view, as Lysias indicates at the end of the catalogue of his country's achievements (II, 19). There he observes that the Athenians considered it the action of wild beasts to rule over others by force. Thus the lust for power that Lysias and the characters of Aristophanes ascribe to Amazons or women was in its way as bestial as the sexual appetite and brutality of the Centaurs. The only difference lay in the particular crimes that such insatiability engendered.

So far as one can judge from reflections in Attic red figure, the paintings of the Theseion attempted to convey the ethical parallel between Centaurs and Amazons in graphic terms, through the equine qualities or predilections of these mythic antagonists; the Amazons are frequently shown on horseback (see figs. 2, 4, and 6), echoing the format of Mikon's large-scale version as attested by the old chorus leader in *Lysistrata*. And here the nomenclature of the Amazons may have played a role in articulating their horsy *ethos*. In the literary sources and red figure vases, the names given to the Amazons are often compounds of the word for horse, and many specifically suggest their hybristic equine aspect: Hippolyta means "of the stampeding horse"; Hippothoe, "impetuous mare"; Melanippe, "dark mare"; and Alkippe, "powerful mare." On the bell-krater from Spina, in addition to the Amazon inscribed as Dolope, another mounted woman is identified as Hippomache, "battle of horses."[37] It is possible that all these red figure versions follow the large-scale original of the Theseion, where the names of the Amazons helped to underscore the character or nature of the opponent, and the full import of their defeat.

Yet the Theseion paintings also strove to compare the ultimate weakness and inferiority of both Amazons and Centaurs in contrast to the valor of the Greeks. In the central duel of the Amazonomachy on the Niobid Painter's krater from Gela, a Greek and an Amazon appear locked in mortal combat (fig. 3).[38] The Greek is magnificently equipped in full armor, striding forward with a pose and gesture that express heroic discipline as well as strength and valor. As he skillfully delivers a mortal wound to his female opponent, she falls to her knees unnerved, with a visible expression of shock and pain

in her face, and raising her arm in a plea for mercy. This entire formula is immediately reminiscent of the clash between the Greek and the Centaur on the Florence Painter's krater (fig. 1), where the violent and arrogant onslaught of the enemy suddenly collapses in anguish and confusion, in vivid contrast to unfaltering Hellenic control. The krater from Numana by the Painter of the Woolly Satyrs also portrays some of the Amazons with this expression of anguish and dismay in the scenes beneath the handles; it is evident in the damaged face of one who is speared by a Greek, and another nearby who lies wounded behind a hillock (fig. 2c).

One may of course dismiss these similarities as the result of the common pictorial devices or conventions of Archaic and Early Classical battle scenes of this sort. But if these paintings do reflect the qualities of the lost monumental forerunners of the Theseion, as scholars generally maintain, the analogy of gesture and expression in the Amazonomachy and Centauromachy paintings would have effectively communicated the myths' underlying similarity. The lawless and bestial aggression of the savage or alien enemies could never prevail against the superior *ethos,* moderation, and control of the Greek defender; whenever the two came face to face, the shocking reality of Greek superiority would emerge.

The words of the sixth-century philosopher Thales shed some light on how this underlying connection between Amazons and Centaurs ultimately helped to refine and strengthen the analogy of both to the Persians. According to Diogenes Laertius (I, 33), Thales is supposed to have thanked the gods that he was born a human rather than an animal, a man rather than a woman, and a Greek rather than a barbarian. DuBois, assuming that this statement reflects a more widespread view, has argued that a Greek male of the fifth century would probably have understood the experience of the Persian Wars in terms of an antithesis between his own male-centered culture and a compound animal/female/barbarian enemy. The use of the Centauromachy and the Amazonomachy in the decoration of the Theseion would then appear to be a natural and appropriate consequence of such an outlook, as DuBois also suggests. But, like Tyrrell, she tends to focus her analysis on specific societal or cultural manifestations of otherness, in which Amazons and Centaurs function analogously as enemies of the principles of marriage and exchange that applied to women in the Greek world. In this view, both appear as liminal creatures existing at the periphery of a society dominated by male humans, and it is in these terms that they seem to correspond to the Persians, who also exist beyond Greek culture, outsiders who operate beyond the limit of Greek geography and norms until their very otherness brings them into conflict with Hellenic society.[39]

Nevertheless, the extreme polarity that the Greeks saw between them-

selves and their enemies, historical as well as mythic, was predicated on the deeper ethical issues that encompassed all such oppositions. Fundamentally, the Centauromachy and Amazonomachy were indeed mythic justifications for the societal restrictions that the Greeks imposed on women, as various scholars have argued. But there was much more at stake here. These "restrictions" were cloaked in the mantle of a male rational order or civilization originating in divine law; accordingly, the use of mythic opponents to this order as analogues for the Persians aimed more broadly at transposing the underlying ethical perfidy and inferiority attributed to women and monsters so as to create a new image of lawless otherness appropriate to the barbarian. In time there would be ample room to refine this process; at the point when the program of the Theseion was conceived, however, this ideology of antitheses was still in the making, and so the paintings focused on the overriding trait uniting all those who threatened civilized law and order—incontinence.

The comparison to the warrior female was meant to condemn Persian imperial policy as the result of a national *ethos* fatally flawed by an uncontrollable lust for power that was believed to be typical of women and animals rather than men. Functionally, the analogy of the Amazon was essentially the same as likening the Persians to composite, animal enemies, for both approaches ascribed to the barbarian an inhuman and unmanly intemperance that made him aggressive or violent, but ultimately no match for the moderate and disciplined Greek male. It was the bestial appetite and immoderation shared by untamed woman and untamed monster that lay at the heart of the conscious and highly charged system of contrasts in these paintings at the Theseion. The Centaurs provided a powerful image of the animal savagery and impious excesses attributed to Xerxes and his Persians during the campaign, while the Amazons on horse and foot evoked the inhuman (i.e., unmale) excess and insatiability of Persian imperialism itself.

Theseus and the Ring of Minos

In the Theseion, it is clear that the altered conception of the battles against the Centaurs and Amazons provided a new ethical vantage for the celebration of the victory over the Persians. The opposition between the righteous, heroic Greek *ethos* and the inferior character of a criminal enemy began to emerge as a source of unity and logic for the extended display of myth on such monuments. In this regard, the scene at the Theseion depicting Theseus' encounter with Minos offered a particularly instructive pendant to the battle against the Centaurs. Once again the work focused on the lawful defense of Greek womanhood, as Theseus checked Minos' unrestrained advances toward one of the girls in the party of young Athenian hostages

during the voyage to Crete. We are fortunate in having an extended poetic account of this myth roughly contemporary with the Theseion—Bakchylides' Third Dithyramb (Ode XVII):

> And Theseus, bronze at the chest
> Spun dark looks from his brows,
> And words scored his mind:
> "Son of strictest Zeus [Minos],
> You no longer steer
> Your reckless force
> in the lanes of Law.
> Let the last seasorrow come—
> But decreed by the gods
> And the dipping scales of Right [*dike*]—
> No tacking when it comes.
> For now, hold your headlong ways.
> .
> So, commander of Crete,
> Rein back your pride [*hybris*]
> That runs us into straits!
> I'd hate to look
> At the lovely light
> Of immortal Morning,
> Once you forced a struggling girl.
> Long before, we'll come to grips—
> And god will guide our course.

The young hero then humiliates the boastful Cretan tyrant by retrieving the ring that Minos had cast into the sea as a test of Theseus' descent from Poseidon:

> Theseus flashed up
> The scooping stern,
> And yes, what thoughts
> Of the Cretan lord he dashed,
> Leaping dry from the spray . . .
>
> And Nereids throned in light
> Sang shrill from hearts
> Reborn in joy, and the ocean
> Rang in her billows, and round him
> The young ones hurled sweet voices
> High in hymns. Delian Apollo,
> Delight in the choral dances of Ceos,
> Grant us godspeed, work our seachange.[40]

Bakchylides' poem demonstrates that by the second quarter of the fifth century, the myth of Theseus' victory over Minos had also become a parable of the retribution meted out by the gods and their heroic champions against arrogant opponents who abuse their strength or power. Theseus is not victorious solely because of his divine parentage, for Minos could make a similar claim. The Athenian prince triumphs because of his moderate and restrained nature and his commitment to law and justice *(dike)*. His struggle against the forces of *hybris* therefore has the blessing of the gods. Bakchylides asserted this image of the young hero even more explicitly in the succeeding Fourth Dithyramb on Theseus (Ode XVIII), which recounted his destruction of the antisocial brigands who threatened the route from Troizen to Athens:

> In truth, god urges him on in his resolve
> to visit justice *(dike)* upon the unjust.
> For it is no light matter that those
> who do evil should not always meet with evil.
> All comes to an end in the long course of time.[41]

Bakchylides' Fourth Dithyramb celebrated Theseus expressly for an Athenian audience and probably, as Barron has argued, to further the identification between the ancient hero and Kimon.[42] The Third Dithyramb, however, was written by this Kean poet for a chorus of his own people, who like many other Islanders, held themselves to be descendants of Minos. Thus it is likely that Bakchylides' negative depiction of the Cretan king ultimately reflected an Athenian agenda, a reworking of the Theseus myth that now assumed a wider currency in the Aegean as part of Athens' hegemony of the Delian League.[43] Like the Centaurs and Amazons, Minos too had become a foil for asserting moral rectitude and opposition to arrogance as an ancient Athenian tradition.

Nothing is known of the details or formal structure of Mikon's large-scale version of this story in the Theseion. Instead of describing the picture, Pausanias (I, 17, 3), relates the myth itself, apparently because "Mikon did not show the entire story." But what aspects *did* the painter include? Did he, as is often assumed, focus on the undersea journey, following the tradition current in Late Archaic and Classical Attic red figure? We shall probably never know for certain, but the "large-scale" spatial quality of the version on the late fifth-century krater in Bologna by the Kadmos Painter is hardly in itself a decisive argument for connecting it with the painting in the Theseion, as some would suggest.[44]

Rather, Mikon may well have focused on Theseus and Minos, as Bakchylides had done, and not on the trip to the sea floor preferred by Attic vase painters. Brommer has already suggested that Mikon might have left Poseidon out of the sea-floor scene, in contrast to ceramic versions.[45] But per-

haps the muralist took the even more unprecedented step of depicting the dramatic clash between the main antagonists aboard the ship, or even the grand finale in which Theseus emerged triumphantly from the sea. This would readily explain Pausanias' remark that the subject of the painting was not immediately intelligible. The undersea visit to Amphitrite or Poseidon would not have been that difficult to recognize, especially on the basis of earlier Athenian artistic traditions, whereas visual representations of the other portions of the narrative as recounted by Bakchylides may have been a good deal less familiar.

If Mikon's work did in fact address the conflict or opposition between Theseus and the ruler of Crete in direct terms, then it very likely shared the ethical emphasis of the contemporary poetic account, serving as an exemplum of Athenian excellence and commitment to law. Amid the other murals of the Theseion, however, the painting should have directed its moral lesson specifically toward the Persian Wars or their aftermath, and in this regard too Bakchylides' account of the story supports such a reading. In lines 31–32 and again in 53–54, the poem stresses Minos' descent from Europa, yet, significantly, she is never referred to by name, but only in terms of her oriental background: the "daughter of Phoinix" (i.e., "the Phoenician"), and the "white-armed Phoenician maiden."[46] The decided and unusual emphasis here on Minos' Levantine or Asiatic origins can have been intended only to reinforce his function as an analogue for Athens' contemporary enemies, as Barron has indicated, especially since the Persian fleet was for the most part Phoenician.[47] In fact the comparison here was more focused than this. As a specifically "oriental" monarch or thalassocrat, Minos could effectively prefigure Xerxes himself, precisely as Aischylos portrayed him in the *Persians* at just about the same time—a reckless and hybristic tyrant of land and sea alike, unbound by any strictures of law or moderation.

Mikon's rendering of the story must also have served to bring out the parallel between these ancient and modern enemies. Yet the work's symbolic rebuke of Minos and his sea power probably alluded most immediately to Kimon's suppression of Xerxes' maritime agents, the Dolopians.[48] On an ethical level, the painting also condemned the lawless arrogance of these Medizing pirates who had outraged the peaceful and civilized commerce of Athens and her allies in the Delian League, just as Minos had lorded it over Aigeus and his people, to the point of attempting to outrage the young Athenians taken in tribute. The precedent of this myth therefore made Kimon's expedition to Skyros appear as an appropriate and dutiful response to the Asiatic *hybris* that had once more come to infect the Aegean; by ridding the seas of such tyranny, Kimon was emulating his illustrious forerunner and counterpart Theseus.

The latter part of Bakchylides' Third Dithyramb further illustrates the particular ethical resonance of this story as a mythic guise for Athenian thalassocracy and its claims to safeguard the seas from the Persians and their predatory lackeys. The closing exhortation alludes, of course, to the celebration dance that Theseus and his companions performed after sacrificing to Apollo at Delos, on the way back to Athens (Plutarch, *Theseus,* XXI). Yet Apollo was also the Greek deity most closely associated with *sophrosyne* and the punishment of *hybris,* and patron of the Delian League as well.[49] Students of this poem have suggested that it was commissioned to be sung on Delos as part of an Athenian-sponsored festival emphasizing Theseus and his cult as a pan-Aegean, Ionian hero.[50] But the poem's reference to Apollo, especially in connection with the pious celebration of Theseus and the other young Athenians, shows how effectively such a highly moralized recension of this myth could prefigure and glorify Athenian naval power in the Aegean as a divinely sanctioned rule of law, the embodiment of *dike,* committed to the just punishment and repression of criminal excess. This was ultimately the point of the painted version of this story in the Theseion as well.

As such, the work was a highly appropriate companion piece to the other subjects depicted in Theseus' shrine, which similarly exemplified the opposition of Greek society to lawless outrage. Here too one wonders whether Theseus' voyage to Crete had always been conceived in such terms, or whether the strong moral overtones, and perhaps even the clash between Theseus and Minos, were a new interpolation. Artistic representations of Theseus' visit to Amphitrite or Poseidon first appear in the late sixth and early fifth centuries, during the period when the mythic cycle of Theseus was undergoing a process of expansion and codification in Athens.[51] But at this time the underwater journey may have served primarily to demonstrate the alternative tradition that traced the young hero's descent from Poseidon rather than Aigeus, in connection with the maritime aspirations of Athens, and there is nothing in these vase paintings to indicate that the undersea visit was originally conceived as part of Theseus' voyage to Crete. Neither the shipboard clash between Theseus and Minos, nor the pointedly ethical treatment of this episode, nor even its narrative function as the circumstance that prompted Theseus' undersea visit, can be documented before Bakchylides.[52]

It is quite possible, therefore, that during the second quarter of the fifth century, exponents of the visual and literary arts in Athens and its political dependencies transformed or reemphasized Theseus' Cretan expedition as they had the Centauromachy and the Amazonomachy—specifically to provide a more thoroughgoing and relevant analogy to the ethical/cultural rationale for victory against the barbarians and those who aided them. The tale of Minos' ring was also related to the fundamental theme of bestial

immoderation that informed the imagery of the accompanying paintings of the Theseion. Functionally, the Minos episode must have operated somewhere between the extremes of untamed monster and untamed woman. The Cretan king was neither animal nor female, but he exhibited the physical lust and appetite for domination of the Centaurs and Amazons alike, providing an effective link or transition between the other two works. And as the ruler of an island and tyrant of the Aegean, Minos also operated as a counterpart to the nearby image of the Amazon Dolope, likewise serving to extend the mythic condemnations of unlawful violence and aggression beyond the Persians to their surrogates, the Dolopian pirates of Skyros, whose defeat the shrine of Theseus most immediately commemorated. Together, the various paintings presented a highly unified and unflattering analogy for the character of the Persians, their king, and their Greek collaborators, a suitable and many-sided antithesis for the *arete* and *sophrosyne* of Kimon and his Athenians, and their great mythic forebear.

The Shrine of the Warlike Athena at Plataia

As the earliest of the Kimonian monuments, it is significant that the Theseion and its decorations already included the issue of Medism as a facet of the ideological campaign against the Persians. Another monument, however, condemned the ethical flaws of the Greek collaborators far more extensively and exclusively, and it should also be recognized as a key constituent in the official Athenian program of large-scale painting commissioned during this period. This was the sanctuary of Athena Areia, the "Warlike Athena," located near Plataia. Plutarch (*Aristeides,* XX, 1–3) records that the shrine was built after the decisive battle there against Mardonios and his forces in 479. To settle the ensuing dispute between the Athenians and Spartans over who deserved the first prize for valor, the Corinthians proposed that it be given to a third party, the local inhabitants of Plataia. The Athenians and Spartans then gave the Plataians eighty talents of the spoils from the battle to build the sanctuary and decorate it with paintings. Pausanias (IX, 4, 1–2) is more specific about the decorations: Polygnotos contributed a painting of Odysseus having just slain the suitors, while Onasias painted the Argive expedition under Adrastos against Thebes. Both were placed on the walls of the pronaos. Pheidias constructed the cult image, a colossal statue of Athena made of gilded wood with a marble face, hands, and feet.[53]

Pausanias' account of the shrine's funding and commemorative function,

however, is at variance with that of Plutarch. Instead, Pausanias tells us that the project was paid for with booty from Marathon that the Athenians gave to their Plataian allies. Some have rejected this testimony on the assumption that the connection with Marathon implies a date for the shrine before Xerxes' invasion, in which case it would have been destroyed during Mardonios' campaign in Boiotia. Since the victors at Plataia swore not to restore the shrines desecrated by the Persians, the sanctuary of Athena Areia must, in this view, have been an entirely new foundation.[54]

The context of Plutarch's remarks does in fact seem to indicate that the shrine was made in the period immediately following the battle, when Aristeides was the Athenian commander against the Persians, with Kimon as co-general (cf. Plutarch, *Aristeides,* XXIII, 1). Robert even suggested that the painting by Polygnotos might be one of his earliest works, datable to the mid-470s, but if all the decorations were part of a single campaign, including the cult image by Pheidias, who was apparently younger than Polygnotos, then they must have postdated the original foundation of the shrine sometime after 479—and probably by a considerable amount of time. A date in the late 460s or the succeeding decade is more likely.[55]

All the same, Pausanias may not be entirely wrong about the connection with Marathon. He and Plutarch may each have transmitted only a part of the tradition accurately, and thus their testimony may really be complementary rather than contradictory. The shrine itself would have been erected as a monument to the triumph at Plataia, immediately following the battle, and from the spoils supplied by the Athenians and Spartans, as Plutarch states. The cult statue and the paintings, however, may have been added later, to commemorate not only Plataia but Marathon as well, since the Plataians had done distinguished service in both battles. Here it is useful to remember that Pausanias (IX, 4, 2) mentions another painting in the shrine, located at the base of Pheidias' statue of Athena—a portrait of Arimnestos, who commanded the Plataians both at Marathon and in the subsequent battle on their own home ground against Mardonios. It is entirely possible that the Athenians provided the Plataians with additional funds from the spoils of Marathon, perhaps during the 460s or 450s, to pay for these new decorations. The paintings and statue may well have originated as part of a larger program of dedications made at this later time from Marathon booty, including Pheidias' other works, the Athena Promachos on the Akropolis and the statue group at Delphi. Consequently, Pausanias may have erred only in his apparent assumption that the entire monument was from the very outset a Marathonian votive.[56]

Pausanias' remarks are in any case important as evidence for direct Athenian involvement in the project. In his opinion it was the Athenians who had

paid for the work. The background of the artists that he mentions also suggests that the impetus for the building decorations came ultimately from Athens. Apart from Pausanias' references to this monument, we know nothing of Onasias, but Pheidias' origins hardly require comment.[57] And although Polygnotos was Thasian by birth, Kebric has recently demonstrated the painter's intimate connections with Athens and Kimon's family as part of the evidence for Athenian involvement in the erection of the Lesche of the Knidians at Delphi and its painted decorations.[58] It is also likely that the choice of divine patron for the shrine at Plataia was due to Athenian influence or involvement, since, as Gauer has pointed out, Athena was not among the divinities whose aid was invoked by the Greeks before the battle.[59] The impact of Athenian cult at Plataia would make sense in view of the close political and religious ties that had existed between these cities since the late sixth century (cf. Herodotos, VI, 107–108). During the Great Panathenaic festival, the Athenians even offered a prayer linking themselves with the name of the Plataians in memory of the aid that they alone had given Athens at Marathon.[60]

Collectively, the evidence suggests that the Plataians were only the ostensible patrons and that the Athenians were silent partners in the erection of a monument outside their borders. One might expect, therefore, that the shrine of Athena Areia and its decorations served ultimately to glorify the Athenian role in the struggle against the Persians. Examination of the subjects depicted in the paintings bears this out.

The Seven Against Thebes

As early as 1836, Welcker proposed that the epic scenes in the shrine of Athena Areia commemorated the victory at Plataia in a mythic guise. He saw Onasias' painting showing the defeat of Adrastos and the other attackers of Thebes as a direct prefiguration of Masistios' and Mardonios' ill-fated invasion of Boiotia.[61] Nevertheless, in the epic of the Seven it cannot have been the Thebans themselves who provided a mythic analogy for the victory of united Hellas. They and most other Boiotians at Plataia were Medizers, fighting alongside the Persians against their fellow Greeks (cf. Herodotos, IX, 67, and Plutarch, *Aristeides,* IX, 2). In the context of a monument to Plataia, one is more inclined to see the assault of Adrastos and the other heroes against Eteokles and his Theban supporters as a mythic guise for the united struggle of the Greeks against the Persians and their Medizing Theban cohorts.[62]

Yet even along these lines, this myth did not provide the best of analogies to Plataia, since the initial Argive attack on Thebes ended in disaster.

Thomas, however, has begun to unravel these difficulties by suggesting that the depiction of the Seven against Thebes in Onasias' painting might have been intended to evoke a closely related theme: the subsequent intervention by Theseus and the Athenians to retrieve the bodies of Adrastos' comrades for proper burial at Eleusis. In support of this interpretation, he has emphasized the importance that fifth- and fourth-century Athenian orators placed upon their ancestors' intervention in the mythic Theban campaign.[63] Like the Attic Amazonomachy, it was a major component in the catalogue of exploits developed for the *epitaphios logos*. In his *Funeral Oration* ([II], 7–10), Lysias recounts the Theban affair in detail, with particular stress on the religious and moral issues that were at stake. Whatever the Seven Argives had done, they had paid with their lives, and the Athenians reckoned that it was wrong to deny them burial. It was the lawful right of the dead to be interred, and to deny this generally accepted law, this *nomos hellenikos*, was nothing less than *hybris* against the gods. After failing to persuade the Thebans with words, the Athenians felt duty-bound to intervene militarily; and having justice as their ally, they triumphed, thereby displaying their *arete*, excellence of character, in contrast to the impiety of their enemy.[64]

The story was also current in fifth-century Attic tragedy, where it was treated with a similar moral emphasis. It figured in Aischylos' *Eleusinians*, although in a somewhat different form. This work is unfortunately lost, but Plutarch (*Theseus*, XXIX) tells us that Aischylos had the Athenians recover the bodies by imposing a truce on the Thebans. Euripides, however, in his *Suppliants* (650–744), adhered to the more bellicose version of the *epitaphios logos*. There, Theseus and his army stand before the walls of Thebes while the Athenian heralds make their purpose known to Kreon. They have come for the corpses, in defense of the law incumbent on all Greeks, the *nomos panhellenikos*, that guarantees burial to those fallen in battle. Kreon ignores the Athenian plea and sends forth his troops, ultimately to be defeated. As Adrastos later observes when he hears of the outcome, "the deluded people of Kadmos committed *hybris* upon *hybris*, and perished in turn."[65]

It comes as no surprise, then, that the Athenians were said to have invoked not only their mythic achievements in the Trojan War, the Amazonomachy, and the victory at Marathon, but also this exploit against Thebes, in the debate for command of the left wing before the battle at Plataia (Herodotos, IX, 27). The rather pointed nature of this mythic analogue in the specific context of Plataia is clear from the details of the battle itself, since there the Athenians were occupied mostly with the repulse of the Medizers, and above all the Thebans, whose troops they slaughtered in great number (Herodotos, IX, 67). In fact the myth of Athenian intervention

at Thebes offers a particularly striking similarity to the central episode from the battle as Plutarch records it in *Aristeides* (XVIII, 4–6, and XIX, 2).

In this account the Thebans and the other Medizers obstruct the Athenians as they attempt to aid the Spartans against the Persians. The Athenian commander Aristeides first implores them in the name of the gods not to hinder the defense of the Greek homeland. The Thebans, like their mythic forebear Kreon, callously ignore the just and rational Athenian plea to do what is proper, forcing Aristeides and his men to join battle and to decimate the finest of the Theban troops. Only after they had eliminated this threat could the Athenians come to the aid of the Spartans and finish off the retreating Persian troops (Herodotos, IX, 70; Plutarch, *Aristeides*, XIX, 3–4). When one bears in mind that the cause of defeating and punishing the Persians was touted as a sacred obligation, essential to maintaining the Greek law and custom that the Persians opposed or ignored (cf. Herodotos, VIII, 143–144), then it becomes clear that Theban Medism was, in the eyes of the Athenians and their allies, a transgression against such law, an outrage against the values and standards common to the Greek people. And thus we sense the deeper ethical implications of the analogy between Plataia and the mythic struggles of the Athenians against Thebes.

The story of Theseus' support for Adrastos and his fallen comrades clearly fitted the circumstances of Plataia far more closely than any other aspect of the epic of the Seven. Thus it is quite possible that the painting in the shrine of Athena Areia provided more than an oblique or indirect reference to the associated theme of the Athenian intervention as Thomas has suggested. What Onasias depicted may not have been the Seven against Thebes itself, but a more extended work that also included some aspect of the Athenian response to this event.

The evidence of somewhat later Attic vase painting supports this idea. Since its discovery at Spina in 1928, the scene of the Seven against Thebes on a krater by the Painter of Bologna 279 (a less talented follower of the Niobid Painter) has been assumed to depend upon a monumental prototype (fig. 7a). The treatment of space is fairly elaborate, with the action spreading out across two zones or levels. The rendering of the chariot of Amphiaraos with the horses shown frontally and sinking into the ground also smacks of the pictorial advances attributed to large-scale painting of the second quarter of the fifth century. In the opinion of many scholars, this vase painting was based upon Onasias' work at Plataia.[66] Still, it is likely that the vase followed the more elaborate prototype loosely, focusing on the major combat scenes. There is no trace of Euryganeia, the mother of Eteokles and Polyneikes, despairing over the battle between her sons, as Pausanias describes her in a later reference to the Plataian painting.[67]

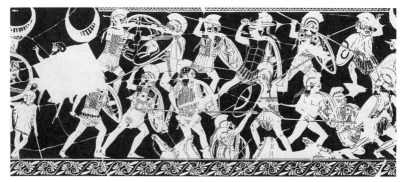

Figure 7a.
Figure 7a–b. Attic red figure volute-krater by the Painter of Bologna 279, from Spina (Valle Trebba), Ferrara, Museo Nazionale di Spina, T 579 (from *Acta Jutlandica,* 40, 3, Copenhagen, 1968, fig. 22a–b).

The subject on the reverse of this krater is less easily identified, but Simon has convincingly interpreted the scene as Adrastos and his countrymen appealing to Theseus for aid in recovering the unburied bodies of the Argive dead from Thebes (fig. 7b). The lower zone depicts the young Epigonoi, children of the fallen heroes, holding branches as symbols of their suppliant status. At the extreme right, Theseus stands battle-ready, carrying a shield decorated with images of his victory over the Amazons, as Adrastos leans upon a staff before him, making his appeal. The spirits of the dead warriors all stand behind Adrastos, larger in scale than their children below to suggest their elder and heroic status. They are grouped in threes about the central seated figure of Athena, who also holds or contemplates the branch of the suppliant dead, as they implore her directly to obtain their burial.[68]

Jeppesen does not accept Simon's reading of this scene, and he rather summarily rejects the suggestion that the portrayal of the Seven against Thebes on the opposite side of the krater in any way reflects Onasias' work at Plataia.[69] He argues instead that Onasias' painting showed an assembly of Polyneikes and the Argive heroes refusing the terms of settlement proposed by Eteokles before the battle (cf. Euripides, *Suppliants,* 739–741). And this, he suggests, was the subject depicted by the Niobid Painter on the Orvieto krater, following the large-scale original at Plataia. Here Jeppesen interprets the presence of Herakles, a Theban, and Athena, protectress of Tydeus, as intercessors on behalf of the unsuccessful peace initiative. Jeppesen also proposes that Onasias included an additional, adjacent scene— the duel between Eteokles and Polyneikes—and perhaps other significant combats of the battle before Thebes.[70]

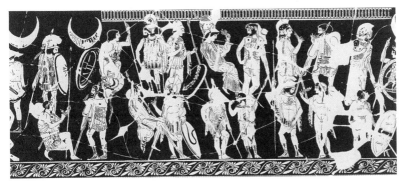

Figure 7b.

Despite Jeppesen's detailed and ingenious argument, there is little in the enigmatic name-vase by the Niobid Painter that appears to illustrate the matter of the Theban epic. This is especially true in the case of the pit with the seated and recumbent warriors, who are more readily intelligible as Theseus and Peirithoös in Hades, with the rescuer Herakles standing above them alongside their divine protectress Athena, as various other scholars have maintained.[71] Since the scanty documentation on Onasias' painting specifies only the Argive assault on Thebes and the duel of the brothers, any attempts to infer something more about its contents from vase painting should rely upon works whose relation to the Theban myth is less tenuous.

In this respect the krater by the Painter of Bologna 279 must take pride of place. Here we have a work based on monumental painting that unquestionably depicts the battle of the Seven. There is every reason to believe that the scene includes Eteokles and Polyneikes; perhaps they are the uppermost pair at the center, one of whom is distinguished from all the other combatants by his dark and muscular cuirass (fig. 7a). The inclusion of this theme on the vase, added to the fact that it merges continuously into the suppliant scene on the other side, lends considerable support to Simon's interpretation of these figures with their branches as none other than Adrastos and the spirits of his comrades, along with their children, begging Theseus to intercede on their behalf. Jeppesen is probably correct in his assertion that the painting at Plataia contained more than the battle of the Seven against Thebes—that is, that the battle itself was part of a larger composition. But the Bologna krater suggests rather strongly that Onasias juxtaposed the battle at Thebes not with some earlier attempt to make peace, but with the subsequent appeal for Athenian aid.

It is therefore surprising that Simon herself does not connect this suppliant scene with Onasias' original. Although she follows Rumpf in identifying the battle at Thebes on the other side of the vase as a reflection of the monumental version at Plataia, Simon still prefers to trace the scene with the appeal to Theseus to a hypothetical large-scale prototype that she believes to have once decorated the shrine of Poseidon Hippios at Kolonos.[72] Nevertheless, it seems far more likely that the decoration of the vase derives entirely from a single source that included both phases of the story. In addition to the thematic connection, the scenes on either side are very similar in compositional terms. Both utilize the same distinctive two-zone spatial organization, suggesting a modicum of depth by disposing the action along two parallel, superimposed planes or levels. Such formal congruence is not particularly effective or intelligible on a vase, where the viewer can only take in one side at a time. It would, however, have made a striking impression of visual and thematic harmony in a monumental setting where both scenes would have appeared side by side as complementary tableaux. If one can accept the obverse of the krater with Amphiaraos and his companions as a reflection of Onasias' painting, then why not see the pendant scene of Adrastos' appeal on the reverse as part of a larger, unified original at Plataia? In this case it is possible to imagine some sort of two-part composition or diptych encompassing the overall narrative (fig. 7a–b).

On the Bologna krater the concept of juxtaposing both stories as a single thematic and visual unity betrays far more than the predilections or concerns of this vase painter. One should sooner ascribe these aspects of his work to the prototype that inspired him, especially in view of his otherwise mediocre abilities. On the evidence of literary sources, the only apparent candidate for such a prototype is the shrine at Plataia, and thus one finds a plausible basis for inferring that Onasias' painting included more than the testimonia tell us. The fact that Pausanias mentions only the initial phase of the campaign is hardly fatal to this interpretation. It is clear that he has not attempted to give any detailed account of the work, and within the often summary parameters of his narrative, he may well have deemed the more general reference to the Seven against Thebes a sufficient rubric for a work whose thematic content was actually far more complex.[73]

If the Plataia painting did indeed also depict the theme of Theseus' support for the Argives against Thebes, then we must see it essentially as a monument to the Athenians, in keeping with Pausanias' evidence about the funding and background of the artists involved. The myth of Theseus' attack on Thebes cannot be attested before the Persian Wars; the tradition preserved by Homer and Pindar has the Argive dead buried at Thebes.[74] The version that evolved in Attic rhetoric and drama was undoubtedly new

and home-grown. The preceding discussion has emphasized the close thematic or narrative parallel of this myth to the battle of Plataia itself; and in the speech that Herodotos ascribes to the Athenians at Plataia in Book IX (27), it is their claim to have intervened at Thebes that most underscores the thematic relevance of the catalogue of mythic exploits as a whole to the circumstances of the impending historical battle. This cannot be fortuitous.

Using the later evidence of Lysias and Isokrates, Walters has made a strong case that Athenian orators deliberately interpolated the theme of Theseus' solidarity with Adrastos into the epic of the Seven as mythic justification for the anti-Theban initiatives of Athens in Boiotia during the period of the alliance with the Argives in the early 450s.[75] However, Athenian animosity against Thebes did not begin with these events, or even those of 480/479. During the late sixth century, Athens had already clashed with the Thebans when she pried the Plataians loose from the confederation of Boiotian states through armed intervention (Herodotos, VI, 107–108). In the long view, the issue of Athenian support against Thebes pertained more immediately to the Plataians than to the Argives; and it is possible that the recasting of the myth of the Seven in Attic funerary rhetoric began somewhat earlier than Walters has suggested, primarily as a response to the great victory over Mardonios and his Medizers.[76]

Yet even if the myth of Theseus' intervention on Adrastos' behalf existed by the 470s or 460s, it may well have been the Athenian offensive against the Boiotians in the early 450s that finally supplied the immediate pretext for outfitting the shrine of Athena Areia with the paintings and cult statue. At this time the bitter memory of Theban Medism, reawakened amidst new hostilities, would then have prompted Athens to give their Plataian allies a new share of the booty left over from Marathon to finance the work of Onasias, Polygnotos, and Pheidias. Thus the monument would have addressed a complex range of actualities. It was meant to fix the experience of the victory over the Persians and their collaborators within the larger framework of the ancient antagonism between Athens and Thebes while asserting as well faithful solidarity and alliance as the basis for the victory against this enemy.[77]

For the Plataians, the theme of alliance would automatically have subsumed the longstanding tradition of mutual support and fidelity between themselves and Athens, in which the battles of Marathon and Plataia were the high points. Here the lesson of Marathon was in fact an indispensable subtext, an implicit reminder of the Hellenic values that had been subverted and yet victoriously reaffirmed in the battle at Plataia. The use of the actual spoils from Marathon for the shrine of Athena Areia would have greatly underscored the ideological claims of this program of decoration, and this

alone should encourage us to accept Pausanias' statement to this effect, even though the monument was initially and primarily erected as a votive for Plataia.

One can easily see why Onasias or those who helped him plan the decorations of the shrine would readily have turned to the new, extended Athenian recension of the Seven against Thebes to celebrate the great triumph of Plataia. Like the Amazonomachy of the Theseion, Onasias' painting was intended as a visual artistic expression of the tendentious ethical lessons central to contemporary Athenian rhetoric. Consequently, the ancient spectator who was familiar with the details of Plataia and this newly coined sequel to the myth of the Seven would have responded predictably to Onasias' work in the particular context of the shrine of Athena. The painting(s) directly condemned the character of the Thebans as hybristic, lawless, willful, and intransigent; they had resisted the Athenians' rational and rightful appeal and therefore invited their own destruction. In the final battle against Mardonios, the Athenians had come to the aid of the Plataians and the other Greek states in their hour of need, just as Theseus had committed himself and his troops to assisting Adrastos and the Argives in the cause of justice. In this mythic guise, the events of 479 were made to conform to the most ancient precedents, once again glorifying the character and achievement of the Athenians while vilifying those who had opposed them.

What can be deduced about the programmatic function of the decorations for the shrine also helps us to appreciate the composite nature of Onasias' treatment of the Theban epic and his particular choice of narrative detail. The initial assault of the Seven and the clash between Eteokles and Polyneikes were necessary ingredients despite the failure of the venture. By including them, Onasias wisely anchored his work within the established and recognizable parameters of the myth, a tactic that lent plausibility to the new Athenian interpolation that he inserted alongside it: the earlier scene documented the circumstances that had required and justified Athenian intervention.

At the same time Onasias apparently decided against juxtaposing the battle of the Seven with the ensuing attack of Theseus. Instead he depicted the magnanimity and justice of Athens and her king toward the helpless Argives. Perhaps he also did this because even Athenian opinion was uncertain whether Theseus had recovered the bodies through an actual battle or simply by a show of strength at Thebes. In any case the suppliant scene provided a more effective image of Athenian alliance and solidarity against Thebes than the armed intervention that would follow, an intervention that was, moreover, implicit in the decision of Theseus, shown armed and ready, to receive and support the Argives (fig. 7b, far right). Thus Onasias' painting strove to extol not so much the Athenian resistance to Theban perfidy

but rather the political principle and resolve that had motivated the initiative, precisely as contemporary Athenian funerary orations utilized this myth. As such the work celebrated the central claim of Athens as faithful ally and just protector of the Greek cause, at Plataia, at Marathon, and whenever or wherever the need would arise.

The Slaying of the Suitors

The precise symbolic function of the Theban epic in Onasias' painting is crucial for an understanding of the accompanying scene that Polygnotos produced for the shrine: Odysseus having just slain the suitors in the hall of his palace. In this case too, Welcker long ago interpreted the subject as a mythic guise for the defense of the Greek homeland against the Persian intruder, a view still largely accepted by scholars.[78] But here again, context is everything. Onasias' painting focused mainly on the Thebans as Medizers, and this must inform our reading of the accompanying work by Polygnotos. Fundamentally, Welcker was correct; Antinoös, Eurymachos, and the rest were intruders or robbers who aspired unlawfully to the wife and estate of Odysseus, just as the Persian interlopers could be seen as pretenders to the sovereignty of Greece. But the real crime of the suitors was betrayal. Motivated by ruthless self-interest, they had abrogated all social responsibility to the house and line of the rightful lord. Even a cursory glance at Book XVIII of the *Odyssey* shows that Antinoös and his supporters were lawless conspirators; they plotted the murder of Telemachos and the usurpation of the kingdom (cf. *Odyssey,* XXII, 45–53).

The suitors in Polygnotos' painting were not intended specifically as mythic prototypes for the Persians; it is far more likely that they prefigured the Thebans and the other Medizers of Boiotia, Thessaly, Lokris, and Macedonia. We may conceive of the suitors as outsiders, violating a house that was not their own. But the royal house of Odysseus really represented Ithaka as a whole; in a very real sense the suitors were insiders, consisting largely of fellow Ithakans who were therefore violating a societal and political trust. To the Greeks of the 460s or early 450s, the suitors would not have recalled the invading Persians so much as the Thebans and their fellow Medizers, who betrayed their obligations to the common Hellenic defense in favor of their own perceived self-interest. The fight depicted in Book XXII of the *Odyssey* is a civil struggle as Odysseus, his son, and the only loyal Ithakans, the two herdsmen, oppose the combined strength of the suitors. Polygnotos' painting reapplied this story as a highly dramatic mythic analogue for the struggle of the Athenians and the only loyal Boiotians, the Plataians, against the Thebans and the other Medizers.

Here as well the subject of the painting had strong moral or religious overtones, for in selecting the struggle between Odysseus and the suitors, Polygnotos turned to another major icon of the punishment incurred by *hybris*. The *Odyssey* refers constantly to the *hybris* and violence of the suitors, often with a formulaic epithet.[79] In Book XX (370), the seer Theoklymenos calls the suitors *hybrizontes* to their faces as he prophesies their well-deserved destruction. Like the Centaurs at the wedding feast, they had outraged the household of their host and the laws of Zeus that protected the institution of hospitality. In Book XXII (34–40), as Odysseus prepares to destroy the suitors, he berates them for their impiety as well as their insolence:

> You dogs, you never thought that I would any more come back
> from the land of Troy, and because of that you despoiled my household,
> and forcibly took my servant women to sleep beside you,
> and sought to win my wife while I was still alive, fearing
> neither the immortal gods who hold the wide heaven,
> nor any resentment sprung from men to be yours in the future.[80]

After he has slain them all, Odysseus weighs the outcome in the same terms (XXII, 413–416):

> These were destroyed by the doom of the gods and their own hard actions . . .
> So by their own recklessness they have found a shameful death.[81]

The ethical opposition of the character of Odysseus and his defenders to that of his enemies could not be more extreme. Odysseus was the archetype of righteous vengeance, pitted courageously and nobly against strong odds, and thus he could count on the protective intercession of Athena to tip the scales of justice in his favor (cf. *Odyssey,* XXII, 205–206, 236–238, and 272–273).[82]

Unfortunately, the precise contents and structure of this Polygnotan painting are lost to us. Nor can we hope to find reflections of the work among later red figure vase paintings or reliefs depicting the murder of the suitors. These all show the violence itself, and this contradicts what is known of the version at Plataia. Pausanias' reference to the painting is fleeting, but he expressly states that it represented the moment just after the suitors were slain. It showed the aftermath rather than the event, in the true Polygnotan manner.[83] In such a setting it is likely that Odysseus appeared pondering the carnage and the battle against the angered kinsmen of the suitors that he knew would follow. Here Polygnotos may well have intended a more specific mythic parallel to the aftermath of Plataia: the siege of Thebes and the surrender of the leading Medizers that finally resolved the grievances of the

Greek victors against those of their countrymen who had supported Xerxes (Herodotos, IX, 86–88).

Despite the paucity of material evidence for the painting, one can rely on Polygnotos' reputation for focusing on the character of his subject, and also on the strong moral emphasis of the Homeric text. From this perspective, there is every reason to assume that Polygnotos strove to convey the superior *ethos* of Odysseus and his helpers as they surveyed the outcome of their struggle, standing in the great hall above the corpses of the treacherous suitors. The Ithakan king and his supporters had earned their victory by virtue of their nobility of character and their adherence to the principles of law and order, just as surely as Antinoös and his followers had incurred their own destruction through their irreverent betrayal of these principles. It was this contrast or opposition and its immediate consequences, in the momentary and dramatic calm just after the fight, that Polygnotos' painting unfolded before the viewer. If Polygnotos followed the *Odyssey*'s account at all closely, he may well have included Athena herself, since she had inspired and protected Odysseus and his comrades in their just struggle, and the painting was in the end located in a shrine dedicated to her. In this case, Athena's presence would have greatly reinforced the religious implications of the story.

It is not difficult to imagine the impact of such an image in the setting of a monument designed to celebrate the victory over the Persians and their Greek collaborators. In the nearby painting by Onasias, Theseus promised to punish the mythic Thebans for their *hybris* toward the Argives and the *nomos panhellenikos,* but the Homeric analogue portrayed such outrage against acknowledged political and moral principles expressly as an act of betrayal. In this Homeric guise, the failure of fifth-century Thebans to fulfill their sacred obligation to uphold Greek law and sovereignty against the Persians became not only an outrage to both god and man, but the outrage of traitors. Here it is worth remembering how at Plataia Aristeides had vainly implored the Thebans in the name of the gods not to hinder the defense of Greece. Thus the Thebans, like the suitors, were portrayed as causing their own destruction. The annihilation of the Theban aristocracy during and after Plataia became divine justice or retribution; the Athenians became the agents of this punishment with the blessing of the gods, following the paradigm established by Odysseus and his helpers. Here again, the ethical oppositions of the mythic past provided more than a flattering analogy to the events of the present; they justified contemporary actualities in moral and religious terms. Despite the uncertainties about their actual appearance and details, one can still sense how effectively the works of Onasias and Polygnotos in this monument would have functioned together, each

contributing a different but related mythic perspective that could rationalize the events of Plataia.

The Stoa Poikile: Persians, Amazons, and Trojans

The Stoa Poikile was located across the Agora from the Theseion, on the northern flank just beyond the Panathenaic Way. Thanks to the recent excavations of the American School at Athens, its precise location and date (toward 460 B.C. or shortly thereafter) have now been established (Map 1). In contrast to the Theseion and the shrine of the Warlike Athena, the Stoa was a civic building rather than a *temenos* dedicated to a hero or a divinity. Yet the available evidence indicates that the circumstances and motives behind its erection were generally similar to those of the monuments discussed so far. The Stoa was originally named "Peisianaktios" after Kimon's brother-in-law Peisianax, who apparently instigated its construction, and possibly while Kimon was temporarily in exile.[84] Here, too, the project may have been officially financed by spoils from Kimon's campaigns against the Persians, and thus the Stoa and its paintings would also have been tied ideologically to these contemporary events. The Stoa certainly functioned as a hall of victories in the later fifth century, when, according to Pausanias, (I, 15, 4), the building was hung with a dedication of bronze shields taken from the Skionians, and from the Spartans at Sphakteria.[85]

The paintings in the Stoa included two mythic subjects: the battle of Theseus and the Athenians against the Amazons by Mikon, and a scene of the aftermath of Troy's capture by Polygnotos.[86] The latter painting was clearly related in content and purpose to another that Polygnotos produced for the Knidian Lesche at Delphi, although, as we shall see, the extent of this connection remains uncertain. In the Stoa, too, the painters used deliberate visual cues or devices as a means of alerting the viewer to the relation between the mythic past and the present. An Amazon inscribed as Dolope on the Attic red figure bell-krater from Spina was, as indicated earlier, clearly a reference to the inhabitants of Skyros, and she probably derives from the Amazonomachy in the Theseion, which celebrated the Skyrian campaign in a mythic guise. However, another Amazon on this vase, inscribed as Peisianassa, can only allude to Kimon's brother-in-law Peisianax, so that it is tempting to see her as an excerpt of the Amazonomachy painted in the Stoa Poikile, which Peisianax founded.[87] This is especially likely since the adjacent painting of captured Troy in the Stoa also stressed the connection between myth and actuality, although in visual rather than

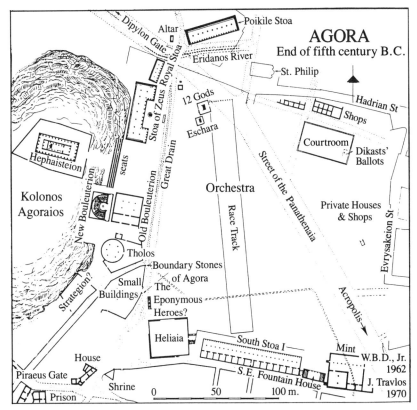

Map 1. Plan of the Athenian Agora in the late fifth century (after *Hesperia*, 53, 2, 1984, p. 4, fig. 3).

onomastic or eponymic terms. There, as Plutarch tells us in *Kimon* (IV, 5), Polygnotos depicted Priam's captive daughter Laodike with the features of Elpinike, who was the painter's mistress and the sister of Kimon.[88]

In contrast to the monuments discussed so far, the Stoa's paintings included a historical subject, the battle of Marathon. Consequently, scholars have never hesitated to interpret the associated mythic narratives as deliberate analogues for the recent struggle against the Persians. Here, the scenes of the Amazon invasion and Marathon documented Athens' defensive struggles against the Asiatic barbarian throughout history, while the image of the Fall of Troy demonstrated the united Hellenic offensive against these enemies outside Greece.[89] In the latter case, the analogy to the great victory of the combined forces of the Delian League under Kimon at the Eurymedon in Asia Minor comes most immediately to mind, but the Troy painting

would also have provided an excellent prefiguration of Kimon's victories in the Thracian Chersonese not far from Troy itself.[90] And there was, as we have seen, a striking and deliberate correspondence between the historical invasion of the Persians and the newly coined Amazon invasion of Attika.

In his description of these paintings, however, Pausanias (I, 15, 2–3) begins with a reference to still another scene that seems largely unrelated to the others: a battle of Oinoe in the Argolid, with the Athenians and the Spartans about to engage in combat. This battle is unknown in our historical sources apart from Pausanias, and despite numerous attempts, it remains a sore point for Greek historians and students of the Stoa Poikile alike—so much so that the Oinoe painting has often been explained away as a later addition to the original program of decoration.[91] But Francis and Vickers have proposed a more ingenious solution to this problem. They argue that the painting actually depicted the Attic village of Oinoe near Marathon, where the Athenians presumably joined up with their Plataian allies before engaging the Persians. In their view, Pausanias mistook this scene of armed unification for a depiction of imminent battle, just as he confused the Attic site of Oinoe with another town of the same name in the Argolid. According to their reconstruction, all four paintings were on the long rear wall of the Stoa, and the mythic scenes of the Amazonomachy and Troy would both have been framed by this larger Marathonian narrative of the battle itself and events leading up to it.[92]

Pausanias, it is true, seems secure in his belief that the Oinoe painting depicted Athenians and Spartans about to begin battle, and one hesitates to conclude that he and/or his Athenian informants would have misapprehended the content of the paintings in so famous and cherished a monument as the Stoa Poikile. Scholars have at times rejected the authority of Pausanias too readily, and the preceding discussion has attempted to uphold the accuracy of his account of the funding of the paintings at Plataia. But Francis and Vickers do cite a parallel in Book V (18, 6–7), where Pausanias is admittedly unable to determine whether two forces depicted on the Chest of Kypselos at Olympia are about to attack or greet one another. And even a native Athenian like Demosthenes could, as we shall see, entirely misrepresent the circumstances behind the rebuilding of the Akropolis less than a century after the project had been completed.[93] Thus Francis and Vickers' argument should stand or fall on its own merits, and not on the reliability of ancient witnesses whose accuracy was in any case not absolute.

Their proposed solution has various advantages. It convincingly sidesteps the historical and thematic difficulties posed by the Battle of Oinoe generally; and given Kimon's strongly pro-Spartan leanings, it especially avoids the unlikely scenario that he or his supporters would have opted to

include a depiction of a battle against the Spartans on a monument that they commissioned.[94] The interpretation of the Stoa's program as a larger Marathonian narrative surrounding the most relevant mythic analogues actually reaffirms Pausanias' value as a primary source here, since it renders more intelligible the unity of intent and structure that emerges so clearly in his description of these paintings. Throughout, Pausanias refers to the paintings collectively in the singular, as an uninterrupted sequence, suggesting very much that they functioned as a highly coherent ensemble or system. Thus the new reading of the Oinoe painting confirms a significant aspect of Pausanias' testimony despite pointing up his error in identifying some of the details.

But perhaps the greatest value of Francis and Vickers' interpretation is that it provides an opportunity to gauge the true extent to which the overall program of the Stoa concentrated on the perceived role of Athens as a leader in the united Greek struggle against foreign outrage and oppression. Unlike the paintings of the shrine of Athena Areia, those of the Stoa Poikile did not address the issue of Medism, but they were nevertheless designed to promulgate the more general ideology of Athenian dedication and service to the common Greek cause that was basic to the Plataian monument. The Marathon painting would actually have set the tone for this theme in the Stoa, and this function would have been greatly reinforced by the corresponding episode at Attic Oinoe as Francis and Vickers have now clarified it. Together both works would have epitomized the notion of Athens' alliance and solidarity with others through their depiction of united action with the Plataians.

To be sure, the Marathon theme primarily extolled the Athenians; it was intended mostly as a symbol of the salvation that *Athens* had achieved for all the Greeks by taking the lead in the struggle against the Asiatic menace, but the added emphasis on cooperation with the Plataians greatly underscored the implication that the Persian invasion at Marathon threatened more than Attika, and that in taking the initiative against the barbarians, the Athenians were not merely acting on their own behalf. One may counter that Athenian rhetoric of this period repeatedly claims the victory at Marathon as something that Athens had achieved alone and against impossible odds. Yet the involvement of the Plataians was a well-known fact; it was even celebrated by a special prayer offered during the Great Panathenaic Festival (Herodotos, VI, 111). This phraseology of solitude is perhaps no more than rhetorical exaggeration intended to stress a primary rather than exclusive role for Athens in the battle. In the end, whenever the great event at Marathon was cited in such rhetoric, it was always to furnish proof of Athens' hegemonic position in the forefront of the battle on behalf of the common laws and freedom of the Greek states.[95]

The scholarship on the Stoa Poikile has repeatedly stressed how closely the choice of subjects in its paintings paralleled the catalogue of mythic and recent achievements touted in Athenian rhetoric. As the decoration of a public, official building, the ensemble of paintings in the Stoa Poikile gave a lasting, monumental expression to the formulaic association of these events in such speeches and in the popular opinion that the rhetoric was designed to influence. In this connection one can imagine how effectively the Stoa's paintings served as a focus and stimulus for popular discourse or reflection in a readily accessible and much-used public space.[96] But if the underlying strategy of this imagery was to promulgate through varied media the notion of a disciplined, selfless dedication to freedom as a hallmark of the Athenian character, then it is still necessary to explore the role of that issue in the remaining mythic narratives displayed in this monument, especially in the larger context of pan-Greek freedom.

Not surprisingly, the Amazonomachy of the Stoa seems to have been intended largely as a mythic guise or transposition for the theme of Athenian service in the common defense of Greece, explaining the more recent self-sacrifice of the Athenians at Marathon as the fulfillment of ancient precedent and tradition. Isokrates' *Panegyric* ([IV], 68) informs us that the Amazons ultimately desired the enslavement of all Greece, but that they concentrated their assault on Athens, thinking that an initial victory here would bring about the capitulation of the remaining states. This is precisely the strategy that Lysias' *Funeral Oration* ([II], 21) attributes to Dareios in the Marathon campaign, and the parallel between both battles in the Attic rhetorical tradition cannot be accidental, for both underscored the role of Athens as a magnet for foreign imperialist aggression and the first line of defense for the Greeks as a whole. In much the same way, the painting of Theseus and his men pitted against the Amazons would have exemplified the very origin of the dedicated and selfless character displayed in the nearby image of Miltiades, Kallimachos, and their comrades, as they too checked the Asiatic incursion that ultimately threatened the freedom of all Hellas.

While this ethical analogy between ancient and more contemporary Athenians operated mainly on a collective level, it is still tempting to speculate on how it emerged more specifically in the comparison between the leading Athenian figures of both paintings. The preceding discussion has already noted how the relatively anonymous and collective aspect of the heroic Greek resistance in the Marathon painting impressed ancient spectators like Aischines (see *Ktesiphon*, III, 186). But in her discussion of the textual sources for the painting, Harrison has also drawn attention to the special treatment nevertheless accorded to Miltiades as a driving force or inspiration behind the battle.[97] He was depicted with his hand stretched out, urging

the Greeks on against the Persians, a pose or action that was probably meant to recall his leading role in persuading the Greek forces to engage the Persians swiftly and decisively (cf. Herodotos, VI, 109, 1). Harrison has argued further that this image of Miltiades later served as the model for the similar treatment of Theseus in the Attic Amazonomachy on the shield of the Athena Parthenos.[98] But this borrowing may not have been direct; perhaps the figure of Theseus in the nearby Amazonomachy of the Stoa already appeared in this pose as well, in order to press the analogy between the unflinching resolve of the contemporary Athenians and their leaders, and those of the past.

One may readily conclude that the depiction of Miltiades in the Marathon painting was intended to reflect directly upon the aims and accomplishments of his son, Kimon.[99] But here the key issue appears to have been more specifically the quality of character that Kimon displayed in firing and sustaining the resolve of Athens and its allies in the League to take the initiative against the Persians throughout the 470s and 460s. If the mythic leader of the Athenians in the Stoa Amazonomachy did in fact parallel the pose and outward character of Miltiades nearby, then perhaps the resemblance functioned at one generation's remove as a handy genealogical pointer to the parallel that Kimon constantly strove to establish between his own leadership and that of Theseus.

There is an excellent parallel for this in the Marathon monument at Delphi, which Pheidias produced from the Persian spoils (Pausanias, X, 10, 1–2). Unlike the Stoa painting, the Marathon monument focused exclusively upon Miltiades as the victor of this famous battle; and in this case it invoked a larger mythic setting by placing his statue among those of the ancient Attic kings Erechtheus, Kodros, Theseus, and Theseus' son, Akamas. The group may also have included Philaios, son of Telamonian Aias, from whom Kimon and his family, the Philaids, claimed descent.[100] Gauer and others have interpreted the Marathon dedication at Delphi as a monument of filial or family piety on Kimon's part, and in this sense it has good parallels in Athenian funerary practices of Archaic and Classical times.[101] But the Delphic statue group related most directly to the program of paintings in the Stoa, where the Marathonian exploits of Miltiades and his fellow Athenians were similarly juxtaposed with those of Theseus, and possibly even with those of Theseus' sons in the adjacent Troy painting.[102]

In both these monuments Kimon was an unseen presence, the final link in a chain uniting the remote and recent past with contemporary events. In the Stoa, the paintings collectively asserted that the legacy of the ancient Attic heroes and their progeny had been reborn in Miltiades and *his* son. Here we have the visual artistic equivalent of the sort of direct comparison between

myth and actuality encountered in the epigrams of the Herms commemorating Eion, which stood just west of the Stoa (see Map 1).[103] But this analogy operated in more profound terms than scholars have thus far indicated. For, no less than the epigrams, the paintings too asserted a continuity of the Athenian *ethos,* an unbroken tradition of excellence and leadership in the larger Greek cause, which would unfold as the achievement of each generation inspired and renewed itself in the successes of those who followed.

In the Stoa Poikile, then, the theme of insatiable barbarian aggression took a somewhat different turn from what one would have encountered at the Theseion. In place of the contrast between civilized and lawful moderation and the "inhumanity" of limitless violence and domination achieved by the juxtaposition of Amazon and Centaur, one senses a more pointed emphasis on the Athenian as a just and selfless defender of his fellow Greeks against a foreign menace. The change is due primarily to the pairing of the Amazonomachy with Marathon. The precise significance of the Amazon myth could be made to change in context, and this is why it was utilized once again in the Stoa only a decade or so after it had appeared in the Theseion. Scholars have attempted to distinguish between the two versions in terms of the formal pictorial structure and specific narrative content.[104] But perhaps the differences were largely thematic, depending upon the associations of the imagery in the paintings that accompanied the Amazonomachy in either case.

Within this play of opposites, the juxtaposition with the Marathon painting may have imparted still other overtones to the Amazonomachy in the Stoa that were not stressed in the Theseion, especially in regard to the *ethos* of the Amazons themselves. The discussion in Chapter 1 argued that the composition or narrative structure of the Marathon scene deliberately evoked the Persian lack of resolve or tenacity in the face of disciplined and unremitting Greek resistance. The development of the initial encounter into disorganized flight strove to illustrate graphically that those who had known only slavery and domination could not hold their own against free men fighting in defense of laws or principles that both cultivated and demanded strength and courage. In this regard it seems that the character of the Persians was made to conform to traits popularly associated with women.

Athenian literary sources repeatedly ascribed to women not only incontinent greed, but also a fundamental incapacity for bravery and fortitude, a tendency to panic, in deliberate contrast to an ideal of disciplined, tenacious courage *(andreia)* that was in its very terminology male. The related ideals of freedom and autonomy were similarly seen as male, in contrast to the natural propensity of women toward slavery.[105] Thus it comes as no surprise that here too the Amazons serve as an analogue to unify the traits

attributed more generally to women and barbarians. In Lysias' account (II, 4–6), the Amazons start out haughty or high-spirited, bent on enslaving Greece and adding it to their empire. But in meeting the Athenians, the warrior women finally come to grips with truly worthy men, finding that their spirit was commensurate only with their female nature.[106] The imperialist ravages of the Amazons had previously gone unchecked because of their technological superiority and the inexperience of earlier opponents. But against the Athenians, they crumbled.

The Amazonomachy of the Theseion may already have indulged in the kind of analysis preserved by Lysias; perhaps one can detect something of this view in the vase paintings where the Amazons, like the Centaurs, go down in confusion and anguish against the disciplined resistance of the Greeks (cf. figs. 1 and 3). Yet at the shrine of Theseus, the imagery seems to have centered on the womanish and bestial incontinence that could be attributed to Xerxes and his followers. Emphasizing the Amazons' gutlessness would have been a far more effective strategy in the Stoa version, where it could prefigure or mirror the mass panic and rout of the Persians at Marathon, sinking into the marshes and scrambling madly for the ships. Recent studies have noted the function of the Amazon invaders as a mythic indictment of the effeminate, slavish Asiatic barbarian.[107] Yet the "female" lack of fortitude would have constituted one of the more salient aspects of this condemnation. Thus it is worth considering whether the Stoa Amazonomachy showed the women gradually turning to flight like the nearby army of Dareios.

Unfortunately, the related vase paintings provide only glimpses of how the Amazons' defeat may have come across in the Stoa version. Amid the series of duels on Bologna 289, a Greek kills an Amazon with a sword thrust in a composition much like that on the Niobid Painter's krater from Gela (figs. 3 and 4a).[108] But in place of the shocked and anguished (or confused) facial expression of the Niobid Painter's Amazon, the expression of the dying Amazon on Bologna 289 looks weak, and she hardly seems a serious adversary for her Greek opponent. A mounted Amazon beyond her is unhorsed by a fatal spear thrust, as she timidly attempts to fend off the weapon with her hand, glancing sideways at her assailant as she averts her head in fear (fig. 4b). Two more Amazons on this vase (figs. 4c and d) seem almost to cringe, leaning away from their striding adversaries and clutching their weapons close to their necks instead of striking or parrying with strength and confidence. The difference in content between Bologna 289 and the krater from Gela may reflect a different model, arguably that of the Stoa Amazonomachy rather than the one in the Theseion. In any case, the Bologna krater communicates visually the transformation that Lysias (II, 5) empha-

sizes in his account of the Amazons: their arrogant and high-handed aggressiveness evaporated when they finally faced a worthy opponent like the Athenians.

There is no indication of a rout as a major compositional format in any of the vase paintings that reflect the monumental Athenian Amazonomachies, but individual duels on these works support this idea. On the krater by the Painter of the Woolly Satyrs, a Greek grabs an Amazon who glances back at him as she is running; on the opposite side of the vase, another Amazon turns to escape into a speeding chariot driven by her companion (fig. 2c, right, and 2d, right). Similar scenes appear in the Amazonomachy on a second krater from Numana by the Painter of the Berlin Hydria, and on a dinos by the Group of Polygnotos.[109] Amazons who are slain as they fall also appear to have been running from their attackers (fig. 2c).[110] It is, of course, uncertain how much the generic scenes of Greeks fighting Persians also current in Attic red figure toward the middle of the fifth century may reflect the Marathon painting; yet it is significant that even these more limited depictions often center on the destruction of an enemy who suddenly turns or looks back in the act of flight (see fig. 5).[111] The Persian on this example is almost identical in pose and armament to a fleeing Amazon on a neck amphora by Polygnotos.[112]

Most of these ceramic Amazonomachies are probably no more than pastiches, comprising vignettes excerpted and reassembled from the original large-scale works. On a krater by the Painter of Bologna 279, however, the panic of the Amazons is more extensive; there, virtually all the Amazons are slain as they attempt to escape their attackers in various directions (fig. 6a–d).[113] Like the version of the Seven against Thebes by the same vase painter, the multi-level composition here is especially suggestive of a monumental prototype, and possibly the later version of this theme in the Stoa (cf. figs. 6 and 7). Perhaps this example affords the best opportunity to gauge how the overall composition of the Stoa Amazonomachy may have paralleled the clash/panic/rout formula of the adjacent Marathon painting to communicate the common lesson that Asiatic aggression had always collapsed in fear when confronted by Athenians who were committed to the defense of their homeland and all of Greece as well.

Like the battle against the Amazons in the shrine of Theseus, the version in the Stoa projected a highly gendered conception of the barbarian—the view that the Persians were motivated by the same uncontrollable appetite for power and domination that Athenians attributed to women. But the Amazonomachy in the Stoa focused much more directly on the corollary of this view—that the Asiatic barbarian lacked the manly fortitude to realize such objectives. They were no match for "real men" bred on the discipline essen-

tial to freedom and autonomy. The Theseion castigated the inhuman (i.e., un-male) immoderation of Persian imperialism through the reciprocal guises of Amazon and Centaur. Yet in the Stoa, along with the Marathon painting, the Amazonomachy achieved a more refined level of invective that could assert the inherent paradox and hypocrisy of imperial lust for power as the perverse outgrowth of an unmanly character ultimately lacking in real strength. In both versions the underlying polarity between Amazon and Greek was generally similar. Nevertheless, one senses the considerable variation and nuance that the subject could achieve from monument to monument.

The Amazonomachy in the Stoa may also have struck a new and distinctive note by focusing on yet another facet of the female *ethos*—intransigent recklessness, or *ate*. Here one can base the interpretation directly on the remarks that Pausanias inserts as he describes the painting (I, 15, 2). He tells us that "only in the case of the women did defeat fail to eliminate the reckless disregard of danger."[114] The campaign of Herakles against them did not warn them away from the invasion of Attika, just as they would return yet again to fight the Athenians and the other Greeks at Troy. Lysias (II, 5-6) had also commented upon the Amazon's stubborn, female recklessness: "On account of the risks that they incurred rather than by virtue of their bodies, they were deemed to be women. It was a quality innate to them alone, not to have learned from their mistakes."[115] It is therefore likely that here Pausanias was passing on a moralizing interpretation of the Attic Amazonomachy that had attached itself to the myth in verbal and visual form from its very inception.

Yet the preoccupation of the orators and the muralists of the Stoa with the persistent female appetite for self-destruction becomes clear only when one recalls that the new version of the Amazonomachy had been deliberately reworked to parallel the actions and putative motivations of the Persian invaders. This aspect of the Amazons too was a transparent guise for the fatal intransigence that the literature of the period ascribes so forcefully to Xerxes and his supporters. In the *Persians,* the messenger instructs Atossa in the lessons of Marathon; later, the ghost of Dareios bewails the fact Xerxes ignored both the earlier setback and his father's injunction to leave European Greece alone. And all through his account of the events leading up to the war, Herodotos too highlights Xerxes' repeated unwillingness to heed the warnings of Artabanos or Demaratos regarding the formidable Greek courage and skill that the Persians had already encountered to their detriment at Marathon.

Like voracious *hybris* and lack of fortitude, *ate* is not treated specifically as a female trait in the portrayal of the Persians by Aischylos or Herodotos, although Herodotos (III, 134) does attribute the instigation of the ill-fated

Marathon expedition to Dareios' wife, Atossa. Since there appears little or no historical basis for this account, Herodotos may have included the episode primarily to emphasize the feminine aspect of the folly that made the Persian monarchs attack Greece again and again.[116] Still, the gendered condemnation of the barbarian emerges effectively only in the comparison to the Amazons, and if Pausanias and Lysias are any indication, the guise of the warrior women made the obstinate Persian refusal to profit by past experience yet another manifestation of the unmanly immoderation and arrogance attributed to Asiatics. In the Stoa the direct comparison to the Marathon scene would have reinforced this interpretation. Under Dareios the Persians had already shown their inferior character when they clashed with the Athenians, but Xerxes would try again at Salamis, at Plataia, and at Mykale. Together, both paintings attacked the manhood of the Persians not only in terms of a power-lust and gutlessness branded as female, but in terms of a womanish appetite for trouble and self-destruction as well.

Pausanias' narrative elides rather neatly from his observations on the Amazon character to his brief description of the adjacent scene by Polygnotos showing Troy's defeat. When viewed in the context of the Stoa and against the larger backdrop of official Athenian imagery or propaganda, there can be little doubt that this mythic depiction of a united Greek offensive against an Asiatic kingdom also operated as a guise for the campaigns of Kimon and the Delian League in Thrace and Asia Minor, as scholars have often noted. It is true that traditionally Athens had not loomed large in the Trojan epic, but this will have mattered little to those who manipulated mythic precedent in the arts of rhetoric and painting to advance Athenian claims to excellence during this period. In Book II of the *Iliad* (552–556), Homer himself asserts the exceptional battle-prowess of the Athenian king Menestheus among the Greeks at Troy, as the verses on the herms commemorating Eion did not fail to point out. In the speech before Plataia recounted by Herodotos (IX, 27), the Athenians take special pains to emphasize that they were in no way inferior to any of their Greek compatriots in the Trojan War. Admittedly, the Trojan theme did not remain a staple of the mythic catalogue of exploits in the surviving *epitaphioi logoi* of the fourth century, but the evidence of the herms and Herodotos indicates that this classic mythic paradigm of panhellenic triumph against the power and arrogance of Asia was irresistible to Athenian image-makers in the period following the Persian Wars.[117]

Yet the Trojan theme provided the Stoa with more than a convenient geographic and political analogy for Greek military solidarity against an eastern power. The smooth transition from Pausanias' comments on the self-destructive recklessness of the Amazons to the Fall of Troy may have

been an almost intuitive response to the common theme that the sequence of paintings originally impressed upon the spectator: all Asiatics, past and present, had repeatedly incurred destruction at the hands of the Greeks because of their inability to learn from the experience of earlier confrontations. Even in the generation before Priam, Troy had already been sacked by Herakles in requital for the arrogance and faithlessness of its king, Laomedon. But still the Trojans preferred to take on the united Greeks rather than surrender Helen. Moreover, by the second quarter of the fifth century B.C., the expedition against Troy was seen as a righteous struggle, a war of retribution. Much like the Centaurs, Paris had accepted and then abused the institution of hospitality through the rape or theft of his host's wife. Here, too, Paris' *hybris* was not only an outrage against the honor and prestige of Menelaos, but an act of impiety toward the societal norms ordained by Zeus Xenios. The offense was compounded and broadened when Paris and his countrymen arrogantly refused to surrender Helen even at the price of their nation's peace and well-being.[118]

Bakchylides devoted an entire poem to this issue, his First Dithyramb (Ode XV) entitled "The Sons of Antenor—The Demand for the Return of Helen" (see the Appendix for a complete translation). It depicted the embassy of Menelaos and Odysseus, which attempted to avoid the war through diplomatic means. The opening portion is badly mutilated, but at the climax of the poem, Menelaos publicly addresses the Trojan people, reminding them of the judgment of all-seeing Zeus and the obligation of a just society to maintain the principles associated with the supreme Olympian: Dike (Justice), Eunomia (Good Order), and Themis (Right). As he closes his plea to desist from the lawless and impious abduction of Helen, Menelaos warns of the danger and deceptiveness of the outrage that impells such action. "Irreverent Hybris" has given the Trojans what rightfully belongs to another, but inevitably "she" (i.e., the criminal action that *hybris* inspires) will lead them to ruin.[119] In another poem, his Eleventh Epinician Ode, Bakchylides closes in praise of the Greeks at Troy after they had finally made good this admonition:

> When, in time
> by the will of the blessed gods
> they sacked Priam's well-built citadel
> along with the bronze-chested sons of Atreus.
> Whoever keeps justice in his breast
> will in all due time achieve
> measureless feats of Achaian strength.[120]

In the approximately contemporary *Agamemnon*, Aischylos too dwells upon Paris' outrage against Zeus' laws of hospitality. He characterizes Paris

and the Trojans as "impious" or "irreverent," and as "men who spurn into obscurity the great altar of Dike."[121] Agamemnon and Menelaos do not simply act on their own behalf; it is Zeus Xenios who sent them to punish the Trojan crimes (cf. lines 60–62 and 524–537). In lines 355–402, Zeus, as god of guest-friendship, actively wills and participates in Troy's punishment, casting a net of doom over the sleeping city while the Greeks prepare for the final attack. The fate of the Trojans is the "lightning stroke of Zeus," a "destruction paid in full to men wicked beyond endurance, who presume beyond just measure."[122] Here, as in Bakchylides, the Greeks attack Troy with a sacred mission; they are instruments of Justice or Right, who administer a fitting punishment ordained by Zeus himself.

In the Stoa Poikile, the Trojan theme would have assumed the kind of role that the Centauromachy had played in the Theseion: the people of Troy would have stood as transgressors against the social and moral order established by Zeus, epitomized by the laws governing hospitality and the exchange or control of women among civilized men. But this substitution involved a significant change. Instead of comparing the insatiability of the Amazons to the more spontaneous, overtly bestial, and violent abuse of marriage and *xenia* by the Centaurs, the juxtaposition with the Troy painting in the Stoa sought to focus on a more insidious, premeditated manifestation of greed and arrogant lust, which could also effectively mirror the portrayal of the Amazons in the rhetorical tradition of this period preserved by Lysias (II, 4–6). Like the covetous Paris and his people who are admonished in Bakchylides' First Dithyramb, the warrior women had cast envious eyes on others, in this case the Athenians because of their achievements and standing among the Greek states. The terms in which Lysias frames this indictment, however, are especially significant: "having *lusted* unjustly after the country of others, these women justly lost their own." Here even the goal of military domination is subsumed more generally within the unrestrained appetite ascribed to women, and in the specifically sexual terms that figure so prominently in the catalogue of excesses generally attributed to women by Athenian men.[123]

The correspondence between the lusty appetites of Amazons and Trojans was particularly effective as a mythic precedent for the greedy incontinence and sensuality attributed to contemporary Asiatics.[124] In the oracle on the Battle of Salamis preserved by Herodotos (VIII, 77), as we have seen, Xerxes is the incarnation of "*koros* (excess), the son of *hybris*, who is terrible and furious and seeks to devour all things." In Aischylos' *Persians* (821–828), the wailings of Dareios' ghost over the crimes of his rash young son and his followers come remarkably close to Menelaos' warning to the Trojans in Bakchylides' Dithyramb, particularly the imagery of blossoming

hybris and uncontrolled desire for the possessions and prestige of others, and the divine justice or retribution that this will inevitably incur (cf. the Appendix, lines 50ff.).

The graphic pictorial versions of these subjects in the program of the Stoa Poikile must have operated in similar terms. There too the mutual analogies between the mythic themes would have amplified their relevance and immediacy as paradigms for recent history. By juxtaposing and comparing the analogous ethical flaws and punishment of the Asiatic Trojans and Amazons, the mythic paintings of the Stoa provided a collective ancient precedent for the actions and fate of the Persians depicted nearby, who had similarly attempted to take and dominate what did not belong to them, in reckless disregard for law and moderation, and once again to their utter ruination. Thus the Stoa's paintings aimed at condemning the Persians on various levels. In panel after panel they emerged as enemies of freedom and autonomy, motivated by implacable avarice and jealousy for the attainments of others, yet lacking the manly fortitude and resolve to carry their lawless designs through to completion, or even the sense to abandon them before the cost became immeasurable. There was much to ponder here for spectators familiar with the rhetoric of antithesis that pervaded the public oratory, drama, and poetry of this period, especially when they reflected on a *topos* central to these media of expression—the leading role of Athens in the defense and salvation of the values that the barbarian had dared to transgress.

The Knidian Lesche at Delphi

There is in fact a good deal more to consider about how Polygnotos utilized the Troy theme within the larger program of the Stoa Poikile, and particularly with regard to the issue of the united struggle to uphold Greek law and custom. But it is first necessary to extend the discussion to the other major monument in which Polygnotos utilized the Trojan myth to explore these issues and concerns—the Lesche (or Clubhouse) of the Knidians at Delphi. Of all the projects commissioned for the display of large-scale paintings during the second quarter of the fifth century, the Lesche has left the most extensive remains in the archaeological and historical record. The foundations of the building itself are still to be seen at the summit of Apollo's sanctuary.[125] Polygnotos' paintings, elaborate panoramas of captured Troy and the Nekyia (or Underworld visit) of Odysseus, are of course no longer preserved; nor have they left any surviving trace in the vase painting of this period. But Pausanias' description (X, 25, 2 to X, 31, 12) of these famous

and highly esteemed works is unusually informative; indeed, it constitutes the most substantive and detailed literary account that we have for any monumental painting at this time.[126]

As its name indicates, the Lesche was apparently produced under the patronage of the people of Knidos. No hard evidence links this building or its decorations with Kimon and Athens, and research in the past has argued that the paintings were decidedly anti-Athenian or pro-Dorian in content.[127] However, Kebric's study of the Lesche and its paintings, and of the historical circumstances behind the monument, has called such opinion into serious doubt. Kebric makes a strong case that the whole project was in effect a thank-offering for the great victory over the Persians at the River Eurymedon in Asia Minor at about 469/8, and was financed by the rich booty taken in this campaign.[128] The shrine of Apollo at Delphi was especially appropriate for such a votive, since he was the patron deity of the Delian League. As was argued above in the case of the shrine at Plataia, the Athenians here were probably silent partners in the creation of a monument outside their borders. In Kebric's view, the Knidians, whose city had served as a base of operations during the campaign, were only the ostensible patrons: Kimon and his circle instigated the erection of the monument, which ultimately glorified Athenian hegemony within the League in the highly visible setting of a pan-Greek sanctuary.

This argument rests upon a range of historical considerations, including the close personal ties between Polygnotos and Kimon or his family.[129] But the details and content of the paintings provide the clearest indication of the underlying "Atticism" of the Lesche. Scholars have long noted the inclusion of Theseus' mother Aithra and Theseus' and Peirithoös' sons in the Troy scene, and the emphasis on characters from the mythic cycle of Theseus in the adjacent Nekyia painting, figures whose depiction in the fifth century occurs otherwise only in Attic vase painting or in Attic sculpture like the Marathon monument at Delphi (cf. the presence of Theseus' sons Akamas and Demophon with Aithra in the Iliupersis by the Kleophrades Painter, fig. 9b, right).[130]

The Troy painting itself alluded directly to the military initiatives of Athens and the League under Kimon's leadership. Pausanias (X, 27, 1) mentions a dead Trojan inscribed with the name Eioneus in the Lesche painting. Although he says that this character figured in Lesches' *Little Iliad*, a Trojan named Eioneus nowhere occurs in surviving accounts of the Trojan War. The Eioneus of myth was a Thracian, whose son Rhesos fought as an ally of the Trojans.[131] This inclusion of a Trojan inscribed as Eioneus is most immediately intelligible as a counterpart to the Amazon Dolope in the monumental Amazonomachy of the Theseion. Since Robert's time, scholars have

tended to agree that here too the artist was utilizing his characters as eponyms. In this case the reference is to Eion on the Strymon in Thrace, emphasizing the painting's function as a mythic guise for Kimon's recent sack of that Persian stronghold.[132] Another figure in the painting, a captive Trojan woman inscribed as Metioche, may correspond to the Amazon Peisianassa as a reference to a member of Kimon's family. Also unparalleled in the literary tradition of the sack (cf. Pausanias, X, 26, 2), Metioche probably alludes to Kimon's elder half-brother Metiochos. He had been captured by the Phoenician fleet when their father Miltiades abandoned Thrace, and he subsequently took a Persian wife and raised his children as Persians.[133] Notwithstanding the strong historical reasons for connecting the Lesche and its decoration most immediately with the Eurymedon campaign, these characters show that the Troy painting of the Lesche referred more generally to Kimon and his victories in the later 470s and 460s.

If the scene of Troy's fall at Delphi was intended to parallel contemporary events, like the version in the Stoa Poikile, then it is equally important to determine how it functioned alongside the accompanying Nekyia painting within a larger programmatic context, especially in expressing the notion of Athens as a leader in the common defense of Greece. On the most superficial level, the Underworld visit of Odysseus (*Odyssey,* XI, 30–640) was an integral part of the Trojan cycle, and an episode bearing upon the *Nostoi* ("homeward journeys") of the Greek heroes was certainly a logical pendant to the final scene of Troy's capture and destruction. But this alone does not account for the specific choice of the Nekyia as a mirror for contemporary actualities, and, indeed, the painting includes many characters who did not appear in the Underworld visit recounted in the Odyssey, and who had no readily apparent connection with the Trojan War.

Robert was inclined to explain the interpolation of the non-Homeric figures in the Nekyia painting as the result of the diverse poetic sources that Polygnotos had at his disposal.[134] Yet here again Kebric's political interpretation appears to come closer to the circumstances that informed the painting's content and structure, especially in the case of Theseus and Peirithoös. In the Homeric account, Odysseus expressly regrets that he was unable to see these two illustrious characters (*Odyssey,* XI, 630–631); yet they were shown enthroned below Odysseus in the painting (Pausanias, X, 29, 9). The *Odyssey* reference is itself an interpolation ascribed by Plutarch (*Theseus,* XX, 2) to the sixth-century Athenian tyrant Peisistratos, and Polygnotos seems to have taken this process a step further by actually placing Theseus and his comrade among those visited by Odysseus in his Nekyia. Thus the inclusion of these two heroes is indeed strong evidence of the Athenian background or bias of the painting, especially in connection with

the presence of their sons Akamas, Demophon, and Polypoïtes in the near-by scene of Troy's capture.[135] Kebric also stresses the genealogical implications of the Nekyia, since Kimon was known to have traced his ancestry via Philaios back to the Telamonian Aias, and to Aias' cousin Achilleus and their uncle Phokos, all of whom appeared in the painting (Pausanias, X, 10, 3–4, and X, 31, 1).[136]

The interplay of genealogical, dynastic, and political elements in the Nekyia was, however, considerably more elaborate and extensive than Kebric has indicated, and it was directly relevant to the ideology of League unity that the Lesche celebrated generally. Various characters in the Nekyia painting belonged to the family of Neleus, the father of Nestor. These include Neleus' mother, Tyro; Pelias, his brother; Neleus' wife, Chloris; his daughter, Pero; and his grandson, Antilochos, who died at Troy (Pausanias, X, 29, 5 and 7; X, 30, 3 and 8; X, 31, 10). Neleus' descendants also included Kodros, king of Athens, and Kodros' son Neleus/Neileus, the mythic founder of Miletos. Apart from Antilochos, no male Neleids appeared in the Nekyia painting, as far as the evidence of Pausanias indicates. Yet their presence was strongly implied, especially since the *Odyssey* account of the Underworld visit already stresses the importance of Tyro, Chloris, and Pero, in genealogical terms, as Neleus' mother, wife, and daughter. Here it is significant that the family who ruled Miletos in the earlier fifth century traced their lineage back to Neleus/Neileus and his ancestors. Barron has shown that the names of certain of these Milesian Neleids of the fifth century were Messenian in origin, in keeping with the homeland of Neleus and Nestor at Pylos.[137]

Other personages in the Nekyia painting can also be associated with the colonization myths of the East Greek cities, and especially the home of the apparent patrons of the Lesche. As Robert long ago pointed out, there was Iaseus/Iasos, grandfather of Neleus' wife Chloris as well as the eponymous founder of Iasos in Ionia and the son of Triopas, who founded Knidos or Rhodes. Klytie and Kameiro, the daughters of the Milesian Pandareos (Pausanias, X, 30, 2 and 4), were respectively the tribal mother of the inhabitants of Kos and the eponym of Kameiros on Rhodes.[138] Since none of these figures appears in the Homeric account of the Nekyia, their insertion in the painting is likely to have some ulterior motive. Pausanias himself emphasizes their importance in East Greek colonization lore and lineage, and here again he may well be recounting a tradition that had been central to the painting from its very inception. Two other figures in the Nekyia, Iphimedeia and Klymene, had a similar background. The former was the daughter of Triopas and the sister of Iasos; she was venerated by the Mylasians of Karia (Pausanias, X, 28, 8). Klymene was the daughter of Minyas and the wife of

Iasos (X, 29, 6–7). The painting also referred to the origins of the more northerly East Greek cities by including Auge (mother of Telephos, who colonized Pergamon or Mysia) and Tellis of Thasos, the home of Polygnotos himself (X, 28, 3 and 8).[139]

In part, the roster of figures in the Nekyia scene reflects the Homeric account, and perhaps other literary sources known to Polygnotos. Yet it is hardly fortuitous that he outfitted the painting so liberally with members of the mythic families who were believed to have established not only Knidos, but various other Ionian and Island Greek *poleis* making up the Delian League. Nor is it coincidence that such personages should be distributed around the greatest Athenian hero, Theseus, or other mythic figures with whom Kimon claimed kinship, especially those who had fought at Troy. Collectively, these mythic characters provided a genealogical prefiguration of the League and the social or cultural bonds that held it together. The emphasis on the house of Neleus, which sired the Attic king Kodros and through him the founders of the Ionian cities like Miletos, is certainly intelligible as a mythic foreshadowing of Aegean political connections during the second quarter of the fifth century.

This message is particularly apparent in the portion of the painting that depicted Kimon's mythic relative Phokos exchanging gift-tokens of friendship with Iaseus (Pausanias, X, 30, 4). Iaseus is probably identifiable with Iasos, the mythic colonizer of the Karian coast, and since neither Iaseus nor Phokos was among those seen by Odysseus in the Homeric account of the Nekyia, it would appear that they too were included in the painting especially to reinforce the putative genealogical underpinnings of the contemporary political situation.[140] Pheidias made essentially the same claims in the statue group of the Marathon monument at Delphi when he depicted Kimon's ancestor Philaios in the company of Neleus, Kodros, Theseus, and the other Attic kings of myth.[141] As a literary parallel, one may also cite the *Ionika*, an epic poem composed by Panyassis of Halikarnassos during the early years of the League. Although only fragments are preserved, we know that it too celebrated the Ionian foundation myths centered on Kodros and Neleus.[142]

The theme of the Nekyia provided the perfect framework for this kind of imagery. Its timeless Underworld setting allowed Polygnotos to juxtapose plausibly a cast of characters that was rather disparate in chronological and thematic terms, including figures that did not really belong to the Trojan cycle. In this way the painter was able to develop a single mythic format that could combine Theseus and Peirithoös with Odysseus, Agamemnon, or Achilleus, while also presenting an image of solidarity and common dynastic or family traditions uniting Athens and her allies across the Aegean in a long-established pattern. There could hardly have been a better way to as-

sert the supposed political and cultural basis for the military achievements of Athens and the Delian League against the Persians, above all on a monument located in the main sanctuary of the League's patron deity and guardian.

It is easier to appreciate the impact or effectiveness of this programmatic celebration of Aegean unity with the help of Stansbury-O'Donnell's graphic reconstruction of the Nekyia painting (see fig. 11). The placement of Iaseus and Phokos in the upper register at about the middle of the entire composition would have emphasized the centrality of the age-old friendship that Kimon and his East Greek allies had inherited from their mythic forebears (fig. 11b, top center). A corresponding paradigm of illustrious friendship prominent in Athenian tradition, Theseus and Peirithoös, appeared at a point roughly equidistant between the Iaseus/Phokos group and the right extreme of the painting (fig. 11c, left).

Most of the remaining characters who prefigured the mythic origins or basis of the League were disposed around and between the pivotal groups of Iaseus/Phokos and Theseus/Peirithoös. Among the women to the right of Theseus were Tyro, Chloris, Klymene, Iphimedeia, and Auge, with Kleoboia and Tellis just beyond them in the boat (fig. 11c). Among them were also Phaidra and Ariadne on a swing, clearly pendants to the nearby figure of Theseus, and a further allusion to his exploits on Crete, which prefigured contemporary Athenian hegemony in the Aegean. To the left of Peirithoös, on the adjacent central panel, Klytie and Kameiro were playing knucklebones (fig. 11b, right, and 11c, left). In the remainder of the space between them and Iaseus and Phokos were the great Greek heroes of the Trojan campaign, including Achilleus, Patroklos, Agamemnon, and Antilochos (fig. 11b). By nesting the Trojan War heroes between two groups of figures relating to the foundation of the East Greek colonies and Athens' role in the ancient Aegean, Polygnotos emphasized the relation between the two themes. Here the painter achieved a particularly neat transition by placing Klytie, the tribal mother of Kos, immediately adjacent to the Neleid, Antilochos, whose family would play so great a role in colonizing the Ionian coast (fig. 11b, right).

The Nekyia's mythic-genealogical precedent for pan-Aegean Greek identity and solidarity must have supplied a profound ideological reinforcement for the more extended prefiguration of united Greek victory over the kingdom of Asia celebrated in the adjacent painting of defeated Troy. Like the Minos episode in the Theseion, or the paintings in the Stoa Poikile and the shrine of the Warlike Athena at Plataia, the program of the Lesche too was designed to articulate the ancient mythic origins of Athenian commitment and initiative within the larger, collective struggle of the Greeks to defend their ancestral traditions and standards. Indeed, Troy's fall would appear to

have been a linchpin of the collective mythological construct employed by official Athenian literary and visual arts of Kimonian times, to judge by the Stoa or the verses of the Eion herms alone. The Lesche paintings, devoted entirely to the Fall of Troy and its aftermath, had the scope to explore in detail the moral implications of the united Greek offensive against the Trojans, as a key theme in their celebration of contemporary events. Fortunately, the literary sources for Polygnotos' scenes of Troy's fall offer the richest and most extensive description of any large-scale painting of this period. And unlike the other subjects depicted in the Kimonian monuments, the Iliupersis already enjoyed a long and rich history in art and literature. It is therefore possible—and essential—to examine the sense and import of the Fall of Troy as it had been applied more generally among the Greeks of Archaic and early Classical times, since existing tradition must clearly have affected the way in which Polygnotos approached this subject and adapted it to the larger programs or objectives of the Lesche and the Stoa.

3

Polygnotos and the Transformation of the Trojan Theme in the Knidian Lesche and the Stoa Poikile

The Greek *Ethos* and the Iliupersis

In comparison with the transformations imposed on the other myths in the catalogue of deeds current among the orators and the monumental painters of this period, the new emphasis on the Greeks as vindicators of Trojan perfidy at first appears a relatively minor change. The Centauromachy had been made to erupt en masse at the wedding itself; a wholly new invasion of Greece had been manufactured for the Amazons; while the epic of the Seven acquired a sequel in which the Athenians now took center stage. Polygnotos' Nekyia scene also included a host of characters that had no place in the Homeric account, and he may well have been the first Greek artist to depict the theme of Odysseus' visit to the Underworld.[1] The innovative quality of Bakchylides' treatment of the encounter between Theseus and Minos is less certain, since it is our earliest surviving source for the story in any extended form. But if Mikon's painting in the Theseion did indeed focus on the shipboard clash between the young hero and the Cretan king, as suggested above, then it was without precedent in the iconographic tradition of Attic or Greek art.

In all these cases it would appear that the monumental painters, orators, and poets of Kimonian times did not scruple to alter and invent in order to make mythic themes more relevant as moral analogues asserting the superior character and motivation of Greeks or Athenians throughout the centuries. But in virtually every instance these transformations or interpolations were built upon the presumption of unquestioned excellence and heroism on the part of the Greek or Athenian protagonists, and especially Theseus. The Fall of Troy, however, did not conform to this pattern, and to apply it as a

paradigm of Greek excellence actually involved a more fundamental and sweeping transformation than any of the other themes discussed so far. There was certainly a solid basis for representing Paris and his people as perpetrators of outrage against Greek laws and values, as indicated earlier. Like Amazons and Centaurs, the Trojans could function thematically as polar opposites of the Greek *ethos*. Bakchylides and Aischylos leave no doubt that the united Greek offensive against them was righteous *in principle*. And had the Greeks actually conducted themselves with moderation during the taking of Troy, this theme would easily have provided an ideal mythic and heroic paradigm for the vindication of divine law against the sinful and arrogant power of Asia. But virtually every literary and artistic testimony that we have for the Iliupersis shows that the behavior of the Greeks in the sack of Priam's city was anything but exemplary.

Already in Homer, Odysseus privately recalls the shame and horror of Troy's fall as he listens at the Phaiakian court to Demodokos singing of the wooden horse:

> So the famous singer sang his tale but Odysseus
> melted, and from under his eyes the tears ran down, drenching
> his cheeks. As a woman weeps, lying over the body
> of her dear husband, who fell fighting for her city and people
> as he tried to beat off the pitiless day from city and children;
> she sees him dying and gasping for breath, and winding her body
> about him she cries high and shrill, while the men behind her,
> hitting her with their spear butts on the back and the shoulders,
> force her up and lead her away into slavery, to have
> hard work and sorrow, and her cheeks are wracked with pitiful weeping.[2]

From the Orientalizing period onward, Greek art also depicted the Iliupersis as it is known from the surviving literary sources—an ignominious and savage event ending in the slaughter of old men and children, and in the violation of women and temples.[3] Early examples like the well-known relief amphora of the seventh century B.C. from Mykonos already emphasize the excessive brutality of the sack. Beneath the scene of the wooden horse on the amphora's neck, the murder of Astyanax and the other Trojan children unfolds with gruesome repetition along the belly of the vessel as the Greeks snatch them from the arms of their hysterical mothers.[4] Attic vase painters were also particularly inclined to stress the savagery of the Greeks. On the mid-sixth-century Attic black figure amphora by Lydos, Neoptolemos has killed Priam's son Polites, who lies dead at his feet, and he dangles the little body of Astyanax before the aged king and the horrified Trojan women (fig. 8).[5] The violence and emotion of the scene is heightened by the

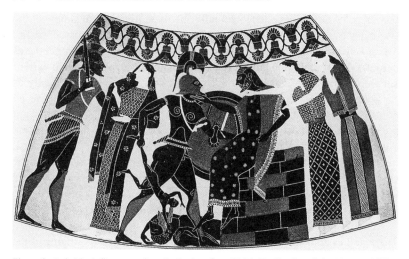

Figure 8. Attic black figure amphora by Lydos, from Vulci, Berlin, Staatliche Museen 1685 (from E. Pfuhl, *Malerei und Zeichnung der Griechen*, 3 vols., Munich, 1923, fig. 241).

impending slaughter of Priam, while the setting of the carnage at the altar of Zeus Herkeios conveys Neoptolemos' hybristic impiety. Only Menelaos at the far right pauses in his rage at the sight of Helen, who raises her veil in fear and supplication, or in what may be a bridal gesture, in keeping with the convention already established on the Mykonos amphora.[6]

The structure and content of this Iliupersis imagery were elaborated further in Attic red figure painting of the late Archaic period. On the fragmentary version from a kylix attributed to Onesimos, the inscription *dios hieron,* "Sanctuary of Zeus," on the altar beneath the doomed Trojan king specifies and underscores the impiety of Neoptolemos' actions.[7] But perhaps the most arresting version of the Fall of Troy appears on the red figure hydria from Nola by the Kleophrades Painter.[8] Again Polites lies dead at Priam's feet, but here the king of Troy collapses in grief upon the altar of Zeus with the lifeless, bleeding corpse of his grandson on his lap, as Neoptolemos delivers the final blow to the helpless, wounded old man (see fig. 9a–b). To the left another sacrilege unfolds as Aias Oileus attempts to rape Kassandra in violation of the sanctuary of Athena, at whose statue the princess has taken refuge in her nakedness and desperation (fig. 9a). To the right of Neoptolemos a Trojan woman heroically defends herself with a pestle against an armored Greek (fig. 9b).

Only the Athenian contingent turns its attention to more positive ends. Beyond the woman with the pestle, Theseus' sons Akamas and Demophon

rescue their aged grandmother Aithra (fig. 9b). After much fighting, the Trojan Aineias manages to save himself and his family on the opposite extreme of the composition (fig. 9a). The excess and brutality of these depictions call to mind not only the surviving literary versions of the sack, but also the warriors of Hesiod's third generation in *Works and Days* (145–146):

> A generation born from ash trees, violent and terrible.
> Their minds were set on the woeful deeds of Ares
> and acts of *hybris*. [9]

In its standard form the Iliupersis was hardly a paradigm of Greek *arete* or excellence in any sense. It was a shameful memory rather than a deed in which a Greek would naturally take pride, and there is little beyond the geographic context of Troy's fall that provides a flattering analogy for the Greek defeat of Persia. The Kleophrades Painter's moving depiction of the Iliupersis may indeed reflect the painful experience of Greek and Persian conflict. Perhaps it alludes to the brutal reprisal inflicted by the Persians against Miletos for its part in the Ionian revolt of 499, as Pollitt has indicated; or, if the vase dates to the very early 470s, it could have been intended as an analogue for the Persian sack of Athens, as Boardman maintains. [10] But in either case the Kleophrades Painter and his Athenian audience would have been identifying and empathizing with the Trojans and their sufferings rather than with their own mythic forebears. In the traditional form of this myth, it is the Greeks who remind us of Aischylos' Persians—impious desecrators of temples, unrestrained and exceeding all established bounds in the conduct of war. Thus, in the *Agamemnon* (338–342), Aischylos, also condemns the Greeks at Troy's fall, as Klytaimnestra speculates on whether they, like the Trojans, may too succumb to irreverence and impiety:

> And if they reverence the gods who hold the city
> and all the holy temples of the captured land,
> they "the despoilers" might not be despoiled in turn.
> Let not their passion overwhelm them; let no lust
> seize upon these men to violate what they must not. [11]

Aischylos might easily have portrayed Atossa or Dareios speaking these words of warning to Xerxes in the *Persians*. In fact, a bit later, when the chorus also considers the unbridled carnage and destruction that Agamemnon had unleashed, it closes with the very same admonition against arrogance that Artabanos would later offer to Xerxes in Herodotos' portrayal of the Persian war council:

The gods are not unaware of those who kill to excess.
In time, the dark avenging spirits
throw into obscurity him who prospered without justice,
by reversing his fortune and rubbing out his life. . . .
. .
To attain reputation beyond proper limit
is indeed of grievous consequence.
The great mountain peak is struck by the will of Zeus.[12]

The Trojans' insolence toward the god of guests had been intolerable, but in the Iliupersis the Greeks themselves epitomized the quality of *hybris,* calling down their own destruction by the gods. Few returned to their homes alive. According to tradition, Zeus, Poseidon, and Athena wrecked the returning Greek fleet with storms in retribution for their crimes in the taking of Troy.[13] And those who did get back, like Agamemnon and Odysseus, met a brutal and evil homecoming or years of tribulation on the return voyage.

The Iliupersis ranks among the most powerful and evocative of Greek myths, a lurid reflection of human weakness and excess in which none of the antagonists manages to avoid the transgressions that incur divine wrath. Perhaps we see this best in the *Agamemnon.* The sons of Atreus had come to avenge the affront to Zeus Xenios, but in the course of uprooting Trojan crime, they uproot the altars and shrines of the gods (cf. lines 525–527). It is no accident that the chorus's lengthy condemnation of Trojan presumption and impiety (lines 355–402) comes upon the heels of Klytaimnestra's prophetic admonition to the Greeks.[14] And perhaps the chorus directed the ensuing condemnation of arrogance and the murderous excess of the war not only at Agamemnon, but at Paris and the Trojan leadership as well, who were similarly responsible. Yet while this pessimism was well suited to the nature and function of Attic tragedy, it is difficult to see how such imagery could have operated within the programmatic structure of the paintings in the Kimonian monuments as described above. How and why would the planners of these works have utilized what had always been a canonic image of Greek atrocity and failed character as the centerpiece of a larger program designed to praise the Athenians and their allies as punishers of *hybris,* rather than perpetrators of it?

If the body of scholarship and the arguments presented here concerning the symbolic purpose of the paintings of the Lesche and the Stoa Poikile are at all correct, then the Iliupersis must somehow have functioned in these monuments as the accompanying themes did—in positive, heroic terms. On the evidence of the Eion herms, or Herodotos, the Trojan War was a signifi-

cant component in the catalogue of exploits documenting Athenian courage and virtue during this period, and it is only reasonable to expect that contemporary painting in official monuments would have treated this theme in the same way. Indeed, it is probably such epinician poetry and rhetoric rather than tragedy that best parallels the intent of the paintings. Even the sack of Troy is portrayed unambiguously as a just, heroic victory in the Eleventh Epinician Ode of Bakchylides cited just above in Chapter 2.

Leahy has in fact contrasted what he feels must have been the glorified treatment of Troy's capture in the "official" Kimonian version at the Stoa with the more traditional, antiheroic treatment of this theme in the *Agamemnon*.[15] In the Lesche, too, one is hard pressed to see the Fall of Troy, with its eponymous reference to the Persian defeat at Eion, as anything but a counterpart to the verses on the herms commemorating this victory, a moralizing allegory that depended heavily on the assertion of Greek rectitude and valor. Yet neither Leahy nor any other scholar has addressed the crux of this problem. In opting to exploit the anti-Asiatic potential of the myth by applying it as a heroic pendant to Marathon and the Amazonomachy, or to the celebration of League solidarity articulated in the Nekyia, Polygnotos was obliged to break decisively with the traditional meaning and associations of the story. He essentially had to redirect the sense and import of the Iliupersis as it had existed up to this point.[16]

Nevertheless, Polygnotos had an audience to convince, and one should not underestimate the care and discernment of the ancient spectator or those who may have consulted with the painters in planning the programs of these monuments. The versions of the Centauromachy and Amazonomachy featuring Theseus may not have enjoyed as much distinction or currency in Archaic times, and so the new recensions created in the fifth century had less of a tradition to compete with. The Athenian intervention in the Theban affair disputed the earlier version in which the Argive dead were buried where they fell, but in the main it was more an interpolation or addition to the epic of the Seven than a transformation, and so it would sink or swim on its own merits. Nor should one underestimate the use of these stories in the heroic catalogue of official rhetoric as a strong incentive for public acceptance, at least among Athenians.[17] In contrast, the Fall of Troy had been sung by Arktinos of Miletos, Stesichoros, and Lesches, and it had been a favored theme of Attic vase painters from the second quarter of the sixth century onward. Such a well-established and popular myth was not to be tampered with lightly. It could not have been easy for Polygnotos to render the Iliupersis acceptable to his contemporaries as a noble prefiguration of recent events, and it remains to be seen just how he managed to do so.

The Image of the Trojans

In approaching the theme of the capture of Troy or its aftermath, Polygnotos' basic objective would have been to emphasize the ethical antithesis between Greeks and Trojans. At one end of the spectrum, he needed to mollify or offset in some manner the unflattering image of the Greeks, but he would also have concentrated on any factors that could point up the ethical shortcomings of the Trojans. In the latter case the arrogance and impiety toward the laws of Zeus Xenios attributed by the Greeks of this period to Paris and the Trojan leaders who had supported him would have provided a convenient point of departure. But it is only to be expected that geographic or cultural considerations would merge with moral issues in this process—that the Greeks would seize upon the Trojans' Asiatic background to reinforce their function or relevance as mythic analogues for the Persians.

Considerable evidence in fact shows that the Trojans had come to be seen as mythic equivalents of the Persians in the second quarter of the fifth century. Some has already been touched upon in the Introduction, but there is a good deal more, and it is crucial in appreciating the extent to which the Trojans, like the Amazons and Centaurs, could exemplify an opposition to Greek law and custom. Herodotos (I, 4), tracing the enmity between Europe and Asia to the Trojan War, focuses on the disparity between the Greek attitude toward the theft of Helen as opposed to the opinion of the Persians or Asiatics regarding the deed. To the latter, the rape was improper, but hardly a justification for a war. Herodotos may have been suggesting that law or custom was not worth fighting for in the Persian view, but it is far more likely that he intended to show only that the Persians had no regard for Greek law and the code of behavior that it demanded. And he may have been implying that the Asiatic forerunners of the Persians at Troy also made light of Greek moral and religious values.

Attic drama, as we shall see, also portrays Hekabe, Kassandra, and Paris as barbarians, and it is readily apparent why the Trojans were generally recast in these terms after the Persian Wars. As outsiders, their irreverence and arrogance toward Greek norms and laws appeared more intelligible. This outlook made it plausible for Bakchylides to have Menelaos lecture the Trojan people on the precepts of justice and restraint essential to an orderly, civilized existence, and the destruction that would befall their city if they continued to ignore these issues. In this way the Trojans became a useful counterpart to the defeat of the Amazons, an equally forceful icon of perennial Asiatic immoderation and greed that could also help rationalize the struggle against Persia as a moral or ethical triumph grounded in a long-standing cultural polarity. This must have constituted a major feature of the

lesson offered by the scene of Troy's capture in the Stoa Poikile and the Knidian Lesche. Thus it is worth examining how the Asiatic aspect of the Trojans may have factored into Polygnotos' attempts to make them over into an unequivocal image or prefiguration of "the enemy."

Amid the testimonia that document the equation of Trojans and Persians by fifth-century Greeks, two are particularly relevant here. Herodotos (IX, 116) relates a story about the *heroön* at Elaios in the Chersonese in honor of Protesilaos, the first Greek to disembark and fall in battle in the Trojan War. The local Persian governor, Artayaktes, requested that Xerxes give him the shrine and votive treasures of Protesilaos, "this man who had made war upon your land and died in just consequence," to serve as an enduring lesson to the Greeks. In Book VII (43), Herodotos also tells us that on the march toward Europe, Xerxes stopped at Troy to hear the local lore about the citadel and to sacrifice to the Trojan Athena, while his Magi offered libations to the heroes, presumably those of Troy. If we can accept these accounts, they suggest that, like the Greeks, the Persians rationalized the war in terms of mythic precedent, as a vindication of the age-old animosities between Asia and Europe that Herodotos outlined at the beginning of his work (I, 3–5). But even if these stories are apocryphal, they show that fifth-century Greeks readily ascribed to the Persians a conscious affinity and sympathy with the mythic Trojans as political and cultural forebears.

Classical Greeks, and especially the Athenians, certainly sensed such an affinity between the Persians and the Amazons. We have seen how the details of the Amazon attack preserved in Lysias and Aischylos were consciously modeled on the events of Xerxes' invasion of Attica. The visual arts contributed to this process. By the later sixth century B.C., when the new empire of Kyros and Dareios had already imposed itself upon the Greek consciousness, Attic vase painters began to show these female warriors in the hooded cap or basklyk, tunic, and trousers common to Iranian peoples like the Persians and their nomadic relatives the Scythians.[18] Conversely, it is generally agreed that the image of the Persian enemy current in Attic vase painting from 490 to 450 was concocted not only from immediate experience but also from depictions of Amazons and Scythians already in use in Late Archaic vase painting (see fig. 5).[19] Pausanias (X, 31, 8) tells us that the Amazon Penthesileia in the Nekyia painting was holding a bow of Scythian type and that she wore an animal skin, suggesting a barbaric appearance. Mikon's Amazons must also have looked like this. Virtually all the vase paintings assumed to reflect his work show the Amazons dressed and armed in the oriental or Iranian manner (see figs. 2–4, and 6).[20]

It is easy to imagine how the uniformity of costume between the Amazons and the Persians in the Marathon painting of the Stoa amplified the meaning

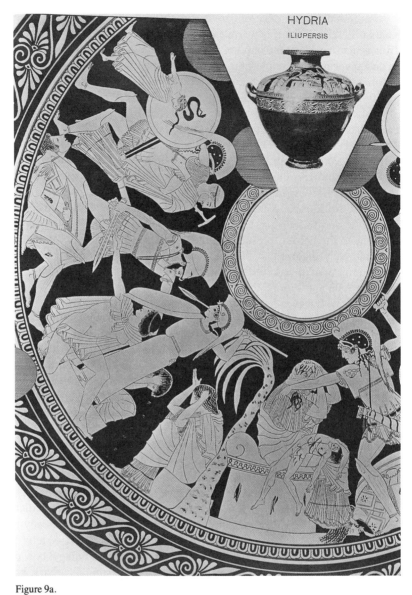

HYDRIA
ILIUPERSIS

Figure 9a.

Figure 9a–b. Attic red figure hydria from Nola, by the Kleophrades Painter, Naples, Museo Nazionale 2422 (from A. Furtwängler and K. Reichhold, *Griechische Vasenmalerei*, Munich, 1924, pl. 34).

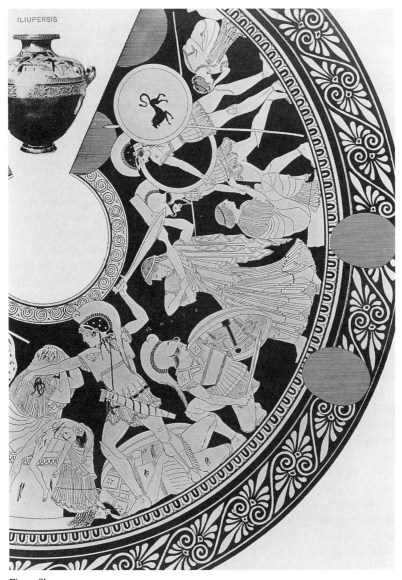

Figure 9b.

of the entire program. Unfortunately Pausanias neglected to describe the costume of the Trojans in the paintings of the Stoa and the Lesche. He does, however, say that in the Nekyia painting, Priam's nephew Memnon was accompanied by an Ethiopian boy to indicate that he was king of that nation, and he then digresses upon Memnon's role as the ruler of the Asiatic regions beyond Troy, stretching into the Persian realm (X, 31, 7–8). Thus it may well be that, like Penthesileia, this Trojan ally appeared as an oriental or barbarian. It is therefore important to consider other external evidence to see whether Polygnotos' paintings may generally have emphasized the Trojan-Persian affinity by such means.

Here the analogies of contemporary vase painting are not helpful. Attic black and red figure painters of the sixth and most of the fifth century persisted in depicting the Trojans in Hellenic dress indistinguishable from that of the Greeks (figs. 8–9).[21] Paris furnishes some of the rare exceptions in the later sixth century by sometimes appearing in the costume of the "Scythian archers" so prevalent in Attic vase painting of this period. However, the costume was probably intended to stress his prowess with the bow rather than his oriental extraction.[22] In keeping with the main trend of earlier fifth-century Attic art, Robert therefore reconstructed the Trojans of the Lesche painting as Hellenic in appearance, and he ruled out any possibility of oriental dress because Pausanias (X, 27, 1) refers to dead Trojans in cuirasses or breastplates.[23]

Nevertheless, Robert's specific objection is not cogent. Greek artistic representations of Persians, Amazons, and Scythians wearing the tunic, trousers, and bashlyk often include a cuirass of Greek type as well (figs. 3, 4b–d, 5, and 6b).[24] Robert's predecessors were in fact inclined to reconstruct the Trojans of the Lesche painting with oriental costume, following the analogy of later Classical works.[25] For by the end of the fifth and fourth centuries B.C., the depiction of the Trojans in Greek art had changed drastically; by then, they had assimilated the dress of Amazons or Persians.[26] During this period Paris appears in vase painting almost exclusively as an oriental prince.[27] In the Iliupersis scene on the late fifth-century Attic red figure krater from Valle Pega, Priam already wears the patterned trousers, tunic, and bashlyk, much as he would appear again in fourth-century Italiote Greek vase painting (fig. 20).[28]

If one looks beyond the visual arts, however, it is clear that the orientalized treatment of the Trojans began earlier. Attic drama of the second and third quarters of the fifth century had already explored the analogy of the Trojans and other mythic Asiatics with those of recent history. Here too Aischylos' *Persians* furnishes invaluable evidence for assessing this phenomenon. Although its depiction of the Persians is hardly objective, Bacon

has shown that the play's extensive use of Persian vocabulary and references to details of Persian dress, custom, and belief display the dramatist's deep and well-informed fascination with the trappings of oriental culture.[29] Aischylos applied this approach to the Trojans as well. Bacon points out the emphasis that Klytaimnestra places on the foreignness or "barbaric" quality of Kassandra and her native speech in the *Agamemnon* (1050–1060).[30] When at one point the wife of Agamemnon tells the captive princess to make signs with her "barbarian hand" in lieu of speech (i.e., Greek), the adjective that she uses (*karbanos* rather than *barbaros*) is actually an oriental loan word. It is unfortunate that Aischylos' *Phrygians* has not survived: here too his portrayal of the Trojans may have reflected these orientalizing devices.

In any case, such evidence is not lacking for the other dramatists. Bacon's careful analysis of the fragments of Sophokles has revealed a highly orientalized image of the Trojans. They share the same exotic vocabulary as Aischylos' Xerxes or Atossa; they make reference to Persian objects and observe Persian customs.[31] In Euripides' *Trojan Women* (1277–1278), Hekabe bewails her ruined Troy expressly as a once-proud *barbarian* city; while in Euripides' *Hekabe* (481–482), the queen laments Troy's capture more generally as the triumph of Europe over Asia. Bacon's examination of Euripides' plays indicates that Priam's people were shown in oriental costume as well. In the *Cyclops* (182–184), possibly produced before 438, Paris first dazzles Helen at Sparta with his many-colored or patterned trousers and the gold torc or collar around his neck.[32] These are precisely the attributes of dress that distinguish Persian nobles as described by Xenophon in the *Anabasis* (I, 5, 8).

The connection between this trend in drama and the depiction of Priam on the Valle Pega krater (fig. 20) is clear. Alföldi has stressed the impact of earlier theatrical innovations on the portrayal of the oriental king or despot in late fifth-century Attic vase painting as a tragic exemplum of *hybris,* and Schauenburg has indicated the relevance of Alföldi's work here more specifically to the representation of Trojan themes.[33] But Attic vase painters of the late fifth century may not have been the first to adapt the orientalized conception of the Trojans to the realm of the visual arts. As we shall see later, the orientalized Iliupersis scenes of late Attic and Italiote vase painting also display marked similarities to what is known of the more unorthodox and distinctive aspects of Polygnotos' versions of this theme. Consequently, their use of oriental costume for the Trojans could depend upon the paintings of the Stoa or the Lesche rather than contemporary theatrical productions. Scholars generally agree, and with good cause, that Polygnotos' handling of Troy's fall has little in common with the Late Archaic and Early Classical tradition of the Iliupersis in Attic vase painting. The hellenized

depiction of the Trojans may be yet another traditional iconographic formula that Polygnotos abandoned, especially since doing so would have furthered the overall objective of his work.

In the 460s this sort of exotic, pseudo-ethnographic detail would undoubtedly have helped to create an unsympathetic image of the Trojans as an opulent, barbaric, or Asiatic enemy—and above all in the Stoa, alongside the trousered and hooded Amazons and Persians of the adjacent paintings. This approach may even have extended to inscriptions accompanying the paintings. Francis and Vickers have revived and elaborated the theory that an epigram preserved in Lykourgos' *Leokrates* (109) was originally composed for the paintings of the Stoa:

> Defending the Greeks, the Athenians at Marathon
> laid low the power of the gold-clad Medes.[34]

The epigram was presumably inscribed below the various scenes, and the eight-word structure of the Greek verse would have allowed two words per painting. According to the sequence proposed by Francis and Vickers, the Amazonomachy was second from the left, with the phrase "Athenians at Marathon" beneath it, while the following scene of Troy's fall would have unfolded above the words "gold-clad Medes." Thus the individual portions of the epigram may have been designed to double as a kind of caption for the paintings above them, stressing the analogy between the historical and the mythic events. If this theory is correct, then it is especially tempting to envision Polygnotos' defeated Trojans in oriental costume above an inscription that would effectively have identified them with the Persians.

Yet if Polygnotos did indeed utilize the trappings of dress and culture in this way, it can only have been one aspect of his attempt to represent the Fall of Troy in more positive, heroic terms. A change of costume could help to assert the foreign, ethical inferiority of the Trojans, but this alone would not have been sufficient to offset or mitigate the behavior of the Greeks. It would take more than Trojans in trousers and bashlyks to render this subject an appropriate counterpart to the parables of the Amazonomachy and Marathon in glorifying the achievements and *ethos* of the contemporary Greeks.

For the crimes of Troy's sackers were not primarily the atrocities that they had committed, but acts of impiety, the very sin that they had come to punish. Priam and Polites were slaughtered at the altar of Zeus Herkeios; Kassandra was dragged from Athena's temple; the shrines and altars were burned and uprooted. It was the sacrilege of the Greek victors toward the Trojan gods, and the destruction that they would surely suffer in consequence, that Klytaimnestra addressed in her ominous speech to the chorus in

the *Agamemnon*. These offenses could not be brushed aside simply because they had been perpetrated against barbarians—not if the excellence and superiority of the Greeks was a crucial element in the parallel that these paintings strove to establish between the present and the mythic past.

For Polygnotos, the solution to the problem would also have depended on avoiding or softening those aspects of the Iliupersis that reflected poorly on the Greeks. He could not actually alter the events of such a popular and familiar tale; so drastic a measure would probably have found little acceptance among his viewers. But a painter of his skill and imagination could have accomplished this more subtly, through the careful selection and emphasis of particular characters and narrative details, as well as through the ethical qualities that the Greeks could be made to exhibit through such manipulation. And a closer look at what is known of the Troy paintings in the Lesche and the Stoa Poikile indicates that this is precisely what he did.

The Image of the Greeks

In the case of the Troy painting of the Knidian Lesche, we are extremely fortunate to have the lengthy and detailed description by Pausanias (X, 25, 2–27, 4). But although his account supplies considerable information about the content and structure of the painting, its composition is by no means clear, as the varied attempts at reconstruction over the last two centuries indicate. More recent scholarship on the painting has shied away from graphic reconstructions of any sort, preferring instead to discuss the work in purely verbal terms consistent with the nature and limitations of the surviving evidence.[35] Such an approach enables us to form a very general impression of the painting's layout or composition, and of the relative sequence and distribution of its *dramatis personae,* as Robertson's careful studies demonstrate.[36] But in attempting to envision the Polygnotan scheme of figures distributed horizontally and vertically across the linear indications of a rocky hillside, we come to depend inevitably upon the works of the Niobid painter and his circle, whose depictions with spatial landscape derive from roughly contemporary monumental painting.[37] And once we do this, it is only a short jump to a fully graphic reconstruction.

Among these, Stansbury-O'Donnell's attempts at reconstituting Polygnotos' paintings in the Lesche (figs. 10–11) appear far superior to those of Robert and his predecessors, based as they are upon a fresh and more critical assessment of the syntax and usage of Pausanias' account, as well as consideration of the dimensions and proportions of the building itself.[38]

Figure 10a. Left

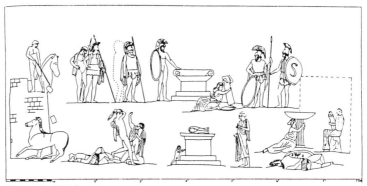

Figure 10b. Middle

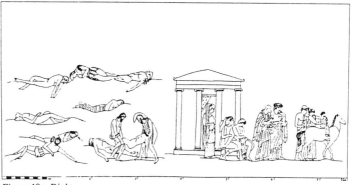

Figure 10c. Right

Figure 10a–c. Reconstruction by M. Stansbury-O'Donnell of Polygnotos' "Troy Taken" in the Knidian Lesche at Delphi (from *AJA*, 93, 1989, 203–204, figs. 3–5).

110

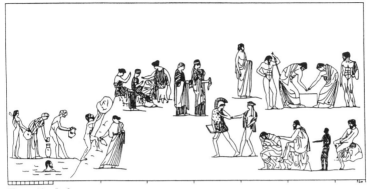

Figure 11a. Left

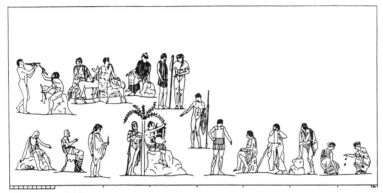

Figure 11b. Middle

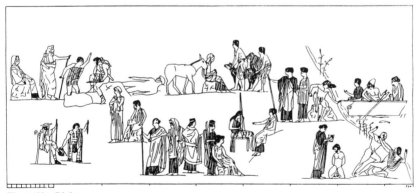

Figure 11c. Right

Figure 11a–c. Reconstruction by M. Stansbury-O'Donnell of Polygnotos' "Nekyia" in the Knidian Lesche at Delphi (from *AJA*, 94, 1990, 220–221, figs. 3–5).

111

Like Robert, Stansbury-O'Donnell has followed the form and conventions of mid-fifth-century Attic vase painting to restore many of the individual figures or groups in something approaching an Early Classical style. Yet, on the whole, the specific placement and overall spacing of the figures correspond more faithfully to Pausanias' description than Robert's crowded reconstruction does. Stansbury-O'Donnell's looser division of each painting into three sections or panels corresponding to walls on either half of the building seems consonant with the actual remains of the Lesche, and he has also substantiated and elaborated on Robertson's cogent argument regarding the direction of Pausanias' description.[39] Consequently, Stansbury-O'Donnell's reconstruction offers a reliable outline of the participants of these paintings, their relative disposition, and perhaps even the level of action and emotive content. There is no harm in using it as such so long as one does not accord to it the authority of an actual work of ancient art, and so long as one does not allow it to fix our conception of monumental painting in early Classical times.

Even on the most basic level, Polygnotos' version of the Fall of Troy differed drastically from earlier known depictions of this subject, as various scholars have stated.[40] Properly speaking, it is not an Iliupersis; it is "Troy taken" or "Troy captured," as Pausanias notes (X, 25, 2). The painting shows "the morning after" rather than the sack itself (fig. 10). The battle is essentially over. The right section depicts the corpses of Priam and his countrymen, but the king's body is nowhere near the altar of Zeus Herkeios (Pausanias, X, 27, 2; fig. 10c), and Pausanias (X, 26, 4) expressly states that only Neoptolemos is still killing Trojans. He appears in the central section in the lower register, in total contrast to the nonviolent events surrounding him (fig. 10b). Most of the painting is given over to the living, to survivors. At the far right the Greeks spare the Trojans Antenor, Theano, and their children. Though grief-stricken, they are allowed to depart with their possessions (Pausanias, X, 27 4; fig. 10c, right). On the opposite or left half of the painting, the captive Trojan women are distributed in two superimposed groups, probably across a rocky incline or landscape (fig. 10a, upper right). Just to their left are male survivors: several Trojan warriors, wounded and bandaged, who have escaped with their lives, and Helenos, the son of Priam (Pausanias, X, 25, 4–5; fig. 10a, right). In place of the violence of the sack, the painting relied primarily on the tragic, anguished faces and attitude of the Trojan survivors (explicitly noted by Pausanias) to illustrate the outcome of the war.

Below the other captive women is Andromache with little Astyanax tugging at her breast (Pausanias, X, 25, 9–X, 26, 1). He too has survived the sack instead of dying at the hands of Neoptolemos (fig. 10a, lower right; cf.

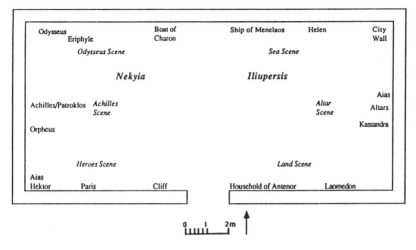

Figure 11d. Plan of the paintings in the Knidian Lesche by M. Stansbury-O'Donnell (from *AJA*, 94, 1990, 214, fig. 2).

figs. 8–9). Polyxena simply stands near them (Pausanias X, 25, 10), instead of being led away to be sacrificed over the grave of Achilleus. To the left of Andromache and beneath the captive warriors is Helen. She no longer confronts the rage of Menelaos as she did in earlier vase painting (fig. 10a, center; cf. fig. 8). She sits enthroned as a queen, while Agamemnon's herald requests that she release old Aithra to her grandson Demophon (Pausanias, X, 25, 7–8). Beyond Helen at the end of the painting are preparations for the naval departure (fig. 10a, left).

Perhaps the most unusual component in this elaborate series of tableaux is the central scene, which Stansbury-O'Donnell would place along the short righthand wall of the Lesche, beyond the wall of Troy and the wooden horse, and adjacent to the captive Trojan men and women (figs. 10b and 11d).[41] Here in the upper register were the Greek kings Agamemnon, Menelaos, and Odysseus, and well as Akamas and Polypoïtes, the sons of Theseus and Peirithoös respectively (Pausanias, X, 26, 2–3). They have assembled to administer an oath to Aias Oileus concerning his outrage against Kassandra, a story that is otherwise unattested in our literary sources.[42] Aias stands at the altar, and Kassandra sits nearby, still clutching the statue of Athena that she evidently dragged along as Aias tore her from the sanctuary. But we do not see any rape or violence (fig. 10b).

It is difficult to be certain of the precise meaning of this scene. According to Pausanias (X, 31, 2), Odysseus had urged that Aias be stoned for his crime against Kassandra. Some scholars maintain that here Aias was ac-

knowledging under oath the violation of the sanctuary, but denying any rape; Pollitt argues that he was contemplating the degree of his guilt before the gods.[43] Robertson, however, expanding upon Robert's earlier opinion, advances a somewhat different interpretation. It was a sin far worse than rape to uproot the goddess's image and to drag a suppliant from the protection of her sanctuary, facts that the painting made no effort to conceal and that the "oath" cannot have applied to. Robertson and Robert interpret the scene instead as a ritual atonement for these crimes.[44]

Still, it is uncertain that the scene was primarily intended to rehabilitate Aias' reputation simply through an act of penitence or ritual purification. In the nearby Nekyia painting, as we shall see, he appeared in the company of others who committed *hybris* and who therefore remained uninitiated and wretched in death, and there he plainly displayed the briny traces of his eventual punishment by drowning. It is more likely that the scene in the Troy painting focused rather on the assembled kings who *imposed* this ritual upon the transgressor. More than anything the scene attests to their prudent concern over Aias' impiety, and implicitly over any other such sins that may have occurred during the taking of Troy. Whether they are actually purifying Aias or holding him to account before the altar, they do so to cleanse themselves and the Greek host from any *miasma* stemming from the events of the night before (fig. 10b).

The scene clearly examines the flawed *ethos* and fate of Aias, as Pollitt maintains. But this part of the Troy painting seems primarily to have been asserting the pious concerns and good character of the other Greek kings at Troy, whose circumstances in the corresponding Nekyia painting, as we shall also see, were noticeably better than those of Aias Oileus or any of the Trojans.[45] Here, Polygnotos created an internal antithesis between the good Greek kings and a renegade among them, an opposition that ultimately reinforced the larger ethical polarity between the moderate and righteous Greek avengers and the hybristic Trojans. By making Aias an exception, the painter rationalized the outrage committed during the sack by containing it—by suggesting that the great majority had *not* indulged in such excesses, and that they deplored them in the strongest terms. The location that Polygnotos allotted to this scene—the central panel in the very middle of the entire composition—indicates the corresponding centrality of the theme of Greek rectitude within the painting as a whole (fig. 11d).

As part of this strategy, Polygnotos also placed Neoptolemos directly below the atonement scene. He too is exceptional, "the only one of the Greeks still killing Trojans" (fig. 10b). Nearby is an altar with a small child clinging to it, very possibly a legacy of the traditional iconography of Neoptolemos' rage (cf. figs. 8–9). But the altar near Neoptolemos in the Lesche

painting also relates to the one just above, in the scene of Aias' atonement, clearly an emphatic duplication, and one likely intended to help equate the isolated excess of both these Greeks (fig. 10b). Herodotos would later utilize a similar narrative convention when he depicted Artabanos as the only prudent and moderate Persian, struggling to dissuade Xerxes and the other Persian nobles from a disastrous course of action. In ethical terms, he was the positive exception that proved the rule about the Persian character. In the Lesche painting, Aias and Neoptolemos served as negative foils to illustrate the overwhelming excellence of the Greeks.

The flanking scene of Antenor and his family had a similar intent (fig. 10c). Later sources sometimes appear to portray Antenor as a traitor, a Greek sympathizer who aided in the strategy to take the city.[46] But these same sources, and Homer as well, also disclose a more favorable view of Antenor and his motives. In the *Iliad* (VII, 347–353), Dares the Phrygian (37), and Dictys Cretensis (IV, 22, and V, 1–3), he appears as a peacemaker, a voice of moderation who attempts repeatedly to persuade Priam to return Helen. He would rather make terms and end the threat to Troy's security. The First Dithyramb of Bakchylides, "The Sons of Antenor—The Demand for the Return of Helen" (see Appendix), extols his piety and good intentions, and shows just how highly mid-fifth-century Greeks regarded this Trojan. In this poem his wife, Theano, apparently welcomes and entertains the envoys Menelaos and Odysseus while her husband, "the godlike hero . . . wise in counsel," goes to intercede on their behalf with Priam in the hope of averting war.[47]

Here, Antenor clearly shares the ethical concerns of Menelaos, who then warns the assembled Trojan people of the dangers of *hybris* and the need to observe the laws of Zeus and Themis (Right). From this we see that Antenor and his family escaped destruction not simply as a reward for collaboration, but because they alone among the Trojans had respected the law of Zeus Xenios, whose breach effectively caused Troy's fall. Only he and his family offered hospitality to the Greek envoys and supported their efforts to set right Paris' crime against the guest-friendship of Menelaos. Quintus of Smyrna's account offers final proof:

> In other homes, other men lost their lives.
> From these arose then a lamentable cry.
> But not in the megaron of Antenor, for now
> the Argives remembered his welcome hospitality,
> how in time past he had hosted and sheltered
> both godlike Menelaos and Odysseus
> when they came to his city.

> And so bearing him (Antenor) kindness, the most
> excellent sons of the Achaians left him his life
> and allowed him his possessions, in proper awe of
> all-seeing Themis and a dear man.[48]

It was this spirit of Greek piety, duty, and magnanimity that Polygnotos' depiction of Antenor with his wife and children stressed so forcefully. In the internal ethical antithesis between Antenor and the rest of the Trojans, we have yet another exception that proves the rule. Just as they rebuked the outrage of Aias, the Greeks spared the pious Antenor, thereby displaying their own obedience to and reverence for the laws of Zeus as moderate and discriminating avengers of his justice. The composition of the painting itself perhaps drove this point home; the entire righthand section or panel was devoted to the salvation of Antenor and his family, played off against the nearby hillside strewn with the corpses of Priam and other Trojans who had paid for their persistent crimes (fig. 10c). Here the strong visual contrast effectively paralleled the contrast in character and fate, serving to condemn the great majority of Antenor's people, precisely as the exceptional flaws of Aias and Neoptolemos, depicted in the adjacent central panel, ultimately served to praise the character of the Greeks (cf. figs. 10c and 10b).

Yet Polygnotos did not stop here. One other Trojan in the painting was also an exception among her people, Priam's daughter, Laodike, who stood to the right of the lower altar in the central section (fig. 10b). According to several sources, Theseus' son Akamas had participated in the embassy of Menelaos and Odysseus. While Akamas was in Troy, he and Laodike fell in love and conceived the child Mounitos or Mounichos, who was raised by his captive grandmother, Aithra.[49] Laodike later married Helikaon, the son of Antenor. Polygnotos, however, seems to be alone in having her survive the Fall of Troy, presumably to be reunited with Akamas, who appeared just above in the atonement scene (fig. 10b, upper left).[50] Reinforcing the contrast offered by Antenor's family to the right, she too exemplified the few good Trojans who offered hospitality to the Greeks during their embassy, and so were spared from death or captivity. Her proximity to a dead Trojan emphasizes the punishment for the criminal arrogance in which the rest of her people had acquiesced (fig. 10b, lower right). Most significantly, Laodike's placement in the painting also provided an element of closure for the larger system of ethical contrasts, bringing the strategy of internal antithesis full circle. In visual terms she corresponded most immediately to Neoptolemos on the other side of the altar—one of the few good Trojans opposed to one of the few bad Greeks (fig. 10b).

Polygnotos often receives credit for revolutionizing the expressive capac-

ity and spatial composition of Greek painting in the generation following the Persian Wars, but his iconography was no less revolutionary. Nothing could have been more boldly innovative than a depiction of the Fall of Troy that eliminated virtually all the violence by shifting the time-frame to the morning after the sack, a depiction that replaced the singular visual horror of Priam's slaying with the more neutral statement of a supine corpse among other corpses, a depiction in which the murder of children or the rape and battering of women no longer had any place. As Robertson and Pollitt have emphasized, the innovations of Polygnotos' work reflect a new interest in the static, psychic, and contemplative potential of painting, which now focused on the consequence of men's actions, rather than on the depiction of action and violence that had so preoccupied Archaic Greek artists.[51] But there is no doubt that the moral image of the Greeks in the painting improved substantially as a result of this transformation. Neoptolemos now kills soldiers rather than old men and children; even so, he is conspicuously unique in the overall work. Instead we see the defeat of a prideful Asiatic enemy in an elaborate composition that tendentiously documents Greek forbearance and piety in the figures of those who have generously been allowed to live, and in the image of the assembled kings demanding the purification of Aias.

It may seem remarkable that Polygnotos could recast the Iliupersis in this manner, but what should surprise us more is that he managed to do so without really altering the matter of the story, in contrast to the radical transformations and interpolations imposed upon the myths examined earlier. Polygnotos did not directly dispute the original narrative of the Iliupersis, even if the changes in the overall impression that he created were at least as drastic. The painting does not deny Priam's death; instead, it adroitly bypasses the savagery, and perhaps the impiety, of his killing, since Pausanias (X, 27, 2) seems to indicate that Polygnotos followed Lesches in depicting Priam's corpse near the city gate rather than at the altar of Zeus Herkeios. For those astute enough to remember, the judicial murders of Astyanax and Polyxena were still to come.[52] Yet no indication of imminent death distinguishes the two from the other Trojan survivors.

In the account Pausanias wrote some six hundred years after the painting was completed, we can still sense the tension between Polygnotos' presentation of this theme and the expectations of an informed spectator. Pausanias strives constantly to establish points of contact with the literary parallels of Stesichoros and Lesches, and he digresses specifically on the deaths of Astyanax and Polyxena (X, 25, 9–10), adding, so to speak, what he feels to be missing. He identifies certain elements or characters as inventions of the painter.[53] In fact much of the painting can have been intelligible to Pausa-

nias only because of the use of identifying legends or inscriptions (X, 25, 3 and 5), a necessary expedient in so novel an approach to the Iliupersis. But at no time does he question the painting as an acceptable or plausible depiction of this myth. Fifth-century viewers may well have been more impressed by what they saw than by what was missing. And what they saw was a version of the Fall of Troy that zealously eschewed Greek impiety, excess, and brutality, a version that drew instead upon every useful element of the established myth to assert the responsibility of a foreign enemy for their own tragic fate at the hands of a noble, restrained, and just conqueror.

Ethos and Antithesis in the Nekyia

Polygnotos explored this ethical opposition between the Greeks and Trojans further in the accompanying Nekyia. The preceeding discussion considered the genealogy of characters depicted in this Underworld scene as a component of a larger mythic analogy for the solidarity between Athens and its League allies. Other figures served a different purpose. Here the new reconstruction by Stansbury-O'Donnell is once again enormously helpful in forming an impression of the content and structure of the painting, as well as the thematic and narrative interactions of its characters (fig. 11a–c). Like his reconstruction of the Troy painting in the Lesche, he sees the Nekyia as a tripartite composition. It begins in the middle of the long north wall opposite the entrance to the building, but continues to the left along the west and south walls (fig. 11d).

Both extremes of the painting were filled with the punishment of evildoers. At the end of the right panel were nameless sinners: a father throttles the son who had dishonored him in life, and a desecrator of temples or shrines is made to drink poison for his impiety (Pausanias, X, 28, 4–5; fig. 11c, bottom right). At the opposite end of the lefthand panel were the greatest transgressors of myth: Sisyphos with his boulder and Tantalos in his pool (X, 31, 11–12; fig. 11a, lower left).

In addition to these scenes of graphic punishment, there were various other figures who had specifically offended Apollo or his sister, Artemis, and whose presence in the Underworld alluded more subtly to the punishment of *hybris* by the deity of purity, rectitude, and moderation. On the right extreme, these included only the mutilated remains of Tityos, who had outraged Apollo's mother, Leto (X, 29, 3; fig. 11c, top left).[54] Most of Apollo's "opponents" were dispersed across the left half of the painting. Marsyas and Thamyris had foolishly challenged the artistic supremacy of

Apollo and his acolytes (X, 30, 8–9; fig. 11b, left). Meleager (X, 31, 3–4) too had clashed with Apollo and died as a consequence (fig. 11a, top, right of center). Aktaion (X, 30, 5) had offended Apollo's sister by peeking at her during her bath, and so Artemis had the young hunter torn to pieces by his own dogs. He sits adjacent to Marsyas, accompanied by his mother, Autonoe, and also by a deer and one of his dogs, references to Artemis and the manner of his death (fig. 11b, top left). Closely related was the figure of Kallisto, a follower of the virgin Artemis whom the goddess turned into a bear and hunted to death for abandoning her chastity. She sat upon a telltale bearskin near the end of the painting above Sisyphos (fig. 11a, top left). Right next to Aktaion was Maira, another of Artemis' followers who lost her virginity to Zeus and similarly paid with her life.[55]

Other figures in the painting, including some named in the genealogies of the founding families of East Greece, were relatives of those who had incurred the anger of Apollo, Artemis, or Zeus. Neleus' wife, Chloris, was the only child of Niobe to survive the mortal punishment imposed by Artemis and Apollo in return for her mother's irreverent pride. Triopas' daughter Iphimedeia was also mother to the giants Oltos and Ephialtes, who attempted to attack Olympos and outrage Hera and Artemis, and who were destroyed in turn by Apollo.[56] They both appeared among the women in the righthand panel (fig. 11c). Kameiro and Klytie (fig. 11b, bottom right) were the children of Pandareos, who, like Tantalos, had invited the anger of the gods (*Odyssey*, XX, 66; cf. Pausanias, X, 30, 2–3). Maira, to the right of Aktaion (fig. 11b, upper left), was also the granddaughter of Sisyphos (Pausanias, X, 30, 5). About half of these figures were already present in Homer's version of the Nekyia, and their connection to those who had offended Apollo may be of secondary importance at most. However, Klytie, Kameiro, Marsyas, Thamyris, Meleager, Aktaion, and Autonoe did not appear in the Homeric account. The first two were related to the genealogical theme, like Chloris and Iphimedeia, but the others, particularly those in the left half of the painting, seem to have been added by Polygnotos primarily to amplify the theme of sin and retribution.

In thematic and compositional terms, Marsyas and Thamyris were the most significant of these sinners. Marsyas was shown playing the flute that had inspired his presumptuous challenge to Apollo's supremacy as a musician, and beneath him sat Thamyris, blinded and dazed, with his instrument shattered, in punishment for his insolence toward Apollo's Muses (fig. 11b, far left). Robert carefully observed that Marsyas and Thamyris corresponded to the figure of Orpheus, who sat a short distance away, probably with his back to them (cf. Pausanias, X, 30, 6–9; fig. 11b, bottom center).[57] More recently, Simon and Robertson have suggested that the three musi-

cians represented an opposition of sorts; Orpheus was the faithful priest and devotee of Apollo, providing a sharp contrast to the prideful and immoderate Marsyas and Thamyris.[58] Thus the three epitomized *sophrosyne* versus *hybris*.

Like Marsyas and Thamyris, Orpheus did not appear in the *Odyssey* account of the Underworld visit. One might, of course, explain the addition of all these figures simply as a tribute to Apollo and Delphi. But by the Classical period, Orpheus would have seemed an especially suitable interpolation for any Nekyia, for he had become a major focus of Greek eschatology. In the Underworld imagery conjured up by Plato at the end of the *Apology* (41A–C) and in the closing part of the *Republic* (619B–620C), Orpheus figures prominently along with others depicted in Polygnotos' Nekyia: Thamyris, Agamemnon, Telamonian Aias, Palamedes, Thersites, Sisyphos, and Odysseus. In addition, Underworld scenes on fourth-century Apulian red figure kraters often include Orpheus as a requisite inhabitant among the dwellers of Hades.[59] In view of the mystic Orphic theology pertaining to immortality, purification, and retribution beyond the grave,[60] his opposition to the sinful musicians to the left seems all the more significant, especially since this was only the nucleus of a larger antithesis.

In the painting Orpheus played toward the Greek heroes of the Trojan War: Achilleus, Patroklos, Protesilaos, Agamemnon, and Antilochos (fig. 11b, right). And although Orpheus was a Thracian like Thamyris, Pausanias (X, 30, 6) expressly states that his costume was entirely Greek. Nor does Pausanias indicate that Orpheus' listeners were shown as unhappy or ill-disposed (cf. X, 30, 3). Marsyas was accompanied by his musical apprentice Olympos, who stood on his left, to judge by the sequence of Pausanias' description, and so it would seem that Marsyas played in that direction. His audience would therefore have consisted of the Trojans who were assembled further down in the adjacent panel (fig. 11b, top left, and 11a, lower right). Also unparalleled in the Homeric Nekyia, these figures included Hektor, seated with his Asiatic allies Memnon and Sarpedon, and the Amazon ally Penthesileia, standing just above and beyond them with Paris (fig. 11a, lower right). Pausanias (X, 31, 8) observes that Paris was shown clapping like a boorish rustic, attempting to get the Amazon's attention, but that Penthesileia turned her head from him in disgust, while Hektor, Memnon, and Sarpedon, in abject misery, comforted one another (X, 31, 5–6).

Here Polygnotos has interpolated the enemies of Greece in the context of the well-known Apolline themes of self-knowledge and moderation.[61] Paris, in his overweening greed, lust and irreverence to Zeus Xenios, had behaved more like the uncouth young herdsman on Mount Ida than a prince of Troy, and the greatest of the warriors who died on his behalf have finally come to

appreciate the true extent of their folly in defending his crimes. They had spurned the repeated opportunities to return Helen, preferring war until the conflict cost them their lives and the security of their city and people. Like the wretched Thamyris who sat just beside them in the adjacent central section (cf. fig. 11a, right, and 11b, left), they were now disconsolate in the knowledge of their error, made all the more evident by Penthesileia's disgusted response to the foolish and annoying behavior of Paris himself (fig. 11a, right of center).

At this point it is tempting to reconsider Schweitzer's contention that Paris was actually doing an oriental dance to the music of the Phrygian Marsyas. Within the gloomy setting of the Underworld, such demented frivolity would have provided a highly effective foil for the tragic realization of his nearby countrymen, and the ethnic overtones would certainly accord with the arguments already made above regarding the orientalized appearance of Memnon, Penthesileia, and perhaps the other Trojans as well, helping to impart a specifically barbaric quality to the rashness and arrogance that had led to Troy's destruction.[62] Still, it is difficult to believe that Pausanias would have failed to recognize the formal conventions of ancient dance, however exotic they may have been. In any case, the effect would have been essentially the same; by portraying the Trojans alongside the foolishly prideful musicians, Polygnotos established a strong contrast or polarity against the figures of Orpheus and the Greeks.

To be sure, the viewer could not ignore the positive, heroic virtues of the now wretched Trojan warriors, Hektor, Memnon, and Sarpedon. Yet this only made the lesson of their error and its consequences all the more poignant. And as in the adjacent scene of Troy's defeat, Polygnotos once again largely bypassed the ethical shortcomings that had brought Greeks like Agamemnon or Achilleus to an untimely end. In the company of Protesilaos, the first Greek of the expedition to set foot on Trojan soil, or that of the stainless Antilochos (cf. Pindar's Sixth Pythian Ode, quoted in the Introduction), the painting celebrated Achilleus' positive aspect as the greatest of the Achaian warriors, just as Agamemnon with his staff was *anax andron,* lord of the Greek host who had come to punish the insolence of Paris. Collectively they served as a positive antithesis to the despair and remorse of the Trojans.[63] Nor would anyone have been expected to quibble over the Homeric tradition in which Apollo favored the Trojan cause.

In much the same way, one may discern a glorified role for Theseus, who sat with his comrade Peirithoös in the righthand panel beyond the Greek heroes of the Trojan War (cf. fig. 11b, lower right, and 11c, lower left). Some have emphasized the impudence of their attempt to win Persephone as a bride for Peirithoös, and the punitive implications of their resulting en-

trapment by Hades in the Underworld.[64] Yet according to the sources, Theseus and Peirithoös came not simply to carry Persephone off, but to sue for her hand with the advice and sanction of Zeus' own oracle, and even then Theseus did so hesitantly and only out of loyalty to his friend.[65] Nor, as Simon has shown, is it clear that Polygnotos depicted Theseus as still trapped. Unlike Peirithoös, he had been freed by Herakles to reenter the Underworld properly after his death on Skyros, and since the Homeric account has Odysseus hoping to find Theseus there, the Athenian hero must already have returned as a shade.[66] All this would explain Pausanias' comment (X, 29, 9) that Theseus was shown holding two swords, his own and that of his comrade, while Peirithoös looked on with angry futility. Here Polygnotos sought to distinguish Theseus' active capacity from his comrade's passive entrapment.[67]

The other details of Pausanias' narrative (X, 29, 9–10) also suggest that Theseus' and Peirithoös' depiction in the painting was laudatory. He says that they appear beneath Odysseus himself and that they were shown on thrones, taking the trouble to contrast this to literary accounts where they sit bound by their flesh to rock. Pausanias then goes on to cite passages from the *Odyssey* and the *Iliad* in which Odysseus and Nestor praise the divine lineage and "godlike" character of both heroes. Here again it seems that his commentary is a response to the impressive nature of the imagery before him, or perhaps also to the traditional interpretation of the painting that had been passed on to him.[68]

A glance at the overall structure of the painting demonstrates how emphatically Polygnotos worked to establish this ethical division or polarity between both parts of the composition. Orpheus appeared just about in the center; allowing for a certain measure of error in the reconstruction, he may actually have appeared at the exact center, directly below the pivotal figures of Iaseus and Phokos (fig. 11b, center). Most of the painting beyond the Greek heroes of the Trojan War was taken up by Theseus and Peirithoös and the figures of the illustrious Greek women, including those connected with the colonization of East Greece (fig. 11b, right, and 11c, lower left and center). Nor can it be an accident that this is also the part of the painting where Odysseus and his men sacrificed the rams to establish contact with the spirits of the Underworld (fig. 11c, top left and center).

For the most part, the content of the right half offered a marked contrast to what appeared on the left, and not only with regard to Marsyas, Thamyris, and the Trojans. There were various Greeks in the lefthand portions as well, but unlike those on the opposite side, they were mostly offenders of some sort who also appeared in a less favorable or negative light. In addition to Aktaion, there was Meleager, who died at the hands of Apollo himself (X,

31, 3–4; fig. 11a, top center). Between him and Apollo's other opponent, Marsyas, there was even a contingent of Greeks who had fought at Troy— Thersites and Palamedes playing dice, while the two Aiases looked on (fig. 11a, top right, and 11b, top left). Pausanias (X, 31, 2) comments that Polygnotos had singled all these figures out as enemies of Odysseus, and, significantly, the whole group appeared directly above the common enemy of the Greeks, Hektor and the Trojan allies (fig. 11a, right).

Thersites was renowned in the *Iliad* (II, 211–221) for his lack of propriety and restraint in strategic assemblies, and especially for his abuse of Achilleus and Odysseus. According to Arktinos' *Aithiopis,* preserved in Proklos' *Chrestomathy* (ii), Achilleus eventually slew Thersites when the latter transgressed all limits by insulting the hero's love for the dead Penthesileia (who appeared just below in the painting). Odysseus then helped to purify Achilleus for the killing. Odysseus' animosity toward Aias Oileus climaxed in his attempt to have Aias stoned for crimes against Kassandra (Pausanias, X, 31, 2) that threatened to bring down divine wrath on all the Greeks, as the central panel of the Troy painting on the opposite end of the Lesche emphasized (fig. 10b). The violation of Kassandra, a prophetess, was also an affront to Apollo, but it was Athena and Poseidon who had Aias drowned for violating Kassandra and the sanctity of Athena's temple during the sack of Troy. And so in the Nekyia Polygnotos showed him as a drowned sailor covered with the telltale brine of his watery punishment (X, 31, 2–3), a counterpart to the nameless desecrator of shrines at the other extreme of the composition.[69]

Telamonian Aias also fitted this pattern. Despite his earlier distinction as a warrior, he behaved disgracefully when Odysseus surpassed him in the competition for the armor of his dead kinsman, Achilleus. Subsequently, after Aias' rash and vindictive attempt to attack the Greek army had failed through Athena's intervention, he committed suicide, and Agamemnon denied his body cremation. Even in the *Odyssey* narrative of the Nekyia, Telamonian Aias remains bitter and recalcitrant, unwilling to confront Odysseus and the circumstances that had destroyed him.[70] Since Aias was the father of Philaios, the eponymous progenitor of Kimon's clan, his negative portrayal here might appear incompatible with the contemporary political and genealogical motives behind the painting. But it is worth noting that Kimon's family took its name not from Aias but from his son, and any negative association would effectively have been offset or mitigated by the other illustrious mythic relatives of Kimon on the right half of the painting, Achilleus and Phokos. Moreover, Phokos had been unjustly murdered by his brothers: Aias' father, Telamon, and Achilleus' father, Peleus (Apollodoros, *Library,* II, 12, 6), while Achilleus' son Neoptolemos was also

singled out as an exception to Greek moderation and piety in the center of the Troy scene just opposite. Since a larger contrast between the good and bad deeds of this family was implicit or explicit elsewhere in the paintings, the portrayal of Aias himself in an unheroic light would not have clashed with the overall program in the Lesche.

Only Palamedes appears somewhat out of place in this part of the painting, at least according to the most familiar myths concerning him. Odysseus' animosity toward this character began early on when Palamedes exposed the ruse of feigned madness that the Ithakan king had concocted to avoid joining the Trojan War. The sources disagree as to how Odysseus finally exacted his revenge, but the most elaborate version is the one in which Odysseus contrived with the help of Diomedes and possibly Agamemnon to plant evidence falsely implicating Palamedes as a traitor in league with the Trojans; despite his denials at the trial, he was judged guilty and then stoned by the assembled Greeks.[71] All the same, the accounts of Palamedes' death vary considerably. Pausanias (X, 31, 2) cites a version in which he drowned. Euripides (*Orestes,* 432–444) briefly attributes Palamedes' destruction to Agamemnon; in Dares the Phrygian (28), he is even killed in battle by Paris.[72] Accounts of the false plot are uniformly late; nowhere are they attested by Homer or the poets of the fifth century. Xenophon's *Memorabilia* (IV, 2, 33) is the earliest extant source connecting Odysseus with Palamedes' destruction, but even here the fleeting reference makes no mention of a plot. On the whole, the traditions of Palamedes' death appear to have been quite fluid.[73]

Consequently, it is uncertain that Polygnotos intended to portray Palamedes as the innocent victim of Odysseus' treachery. Had he done so, Palamedes would hardly have conformed to the character of those around him in the painting, who had all invited their own ruin, even the nearby figure of Meleager. So far as one may judge from Pausanias' description of the painting itself, Palamedes was paired directly with his gaming partner; nothing sets him apart as different in character from Thersites or the two Aiases who look on (fig. 11a, top right). Thus Polygnotos seems to have depicted Palamedes as one who belonged in such company, suggesting perhaps that he was indeed guilty of collusion with the Trojans, in keeping with some variant of this changeable myth that has not come down to us in the literary tradition. The larger context of the painting also lends itself to this interpretation. Odysseus appeared directly across the room at the corresponding point on the left end of the section on the north wall (cf. fig. 11a, top right; 11c, top left; and 11d). Here the placement of the leading character, especially above the glorious Theseus, seems intended as a contrast to the tragic flaws that made his Greek opponents a liability or threat to the

expedition against Troy. As such, they appear above the Trojans themselves, and adjacent to Marsyas and Thamyris, instead of standing with the other Greek heroes beyond Orpheus (cf. fig. 11a, right, and 11b, right).[74]

Apart from the archetypal sinners who occupied the shorelines at either side of the Underworld, the overwhelming majority of the figures in the painting would appear, with few exceptions, to fit the polarized division proposed here. Neleus' daughter Pero sat on the far left, above Sisyphos' boulder (fig. 11a, left). She would certainly make more sense on the right, next to her grandmother Tyro, in place of Amphiaros' faithless wife, Eriphyle, who would be more at home on the lefthand side. The reason for this transposition remains elusive. But Neleus' brother Pelias, who sat beside Thamyris (fig. 11b, lower left), had died an ignominious death through the connivance of Medea, an end that he had brought upon himself for his cruel and unjust behavior toward his half-brother Aison and his family, and for failing to make good his promise to return Jason's kingdom if the latter brought back the Golden Fleece. As the betrayer of an oath, he called to mind the similar offenses against Poseidon, Apollo, and Herakles committed by the Trojan king Laomedon, whose exhumed corpse appeared across the room in the scene of Troy's fall (fig. 10c, center, and fig. 11d).[75] The placement of Schedios in the area between Pelias and Orpheus (fig. 11b, bottom left) could appear problematic if we took him to be the character by this name who led the Phokaian contingent in the Trojan War (*Iliad*, I, 517). However, Quintus of Smyrna in *Posthomerica* (X, 87) mentions a Trojan named Schedios among the warriors slain by Neoptolemos. Since Schedios too is a Polygnotan addition undocumented in the Homeric Nekyia, perhaps he is simply another Trojan slightly displaced from his compatriots just beyond Thamyris.

One last element underscored the overriding structural and thematic dichotomy between both halves of the Nekyia painting: the theme of religious initiation. At the beginning of the right side of the painting, the painter inserted the figure of his ancient Thasian predecessor Tellis accompanying Kleoboia, who, according to Pausanias (X, 28, 3), introduced the mysteries of Demeter to Thasos. Kleoboia was actually shown holding a chest of the type offered to Demeter (fig. 11c, far right). The pivotal figure of Orpheus too was intimately connected with the mysteries. According to Pausanias (IX, 30, 4), Orpheus was supposed to have discovered *telete,* mystic initiation, as well as purification from sin and the means of averting divine wrath. Thus he faced toward Kleoboia, with both figures effectively enclosing the whole right half of the painting (fig. 11b–c).[76] But between the torments of Sisyphos and Tantalos and the two-tiered grouping of Trojans and Odysseus' Greek enemies, Polygnotos inserted something wholly antithetical—fig-

ures carrying broken water jars, some of whom he inscribed specifically as "uninitiated." Other water carriers at the end near Sisyphos and Tantalos are identified by Pausanias (X, 31, 9 and 11) as people who also scorned the Eleusinian mysteries (fig. 11a, center and far left).[77]

Oknos, or "Procrastination," who sat with his donkey, is somehow related to the water carriers. Both he and the figures with pitchers appear together in the Underworld scene on a slightly earlier Attic black figure lekythos, and Diodorus Siculus (I, 97) documents Oknos' connection to water-carrying rituals in Egypt.[78] Like the women with broken pitchers, Oknos labored fruitlessly in the Lesche painting, braiding a cord while his donkey devoured the other end. Yet Polygnotos did not put Oknos at the left extreme beside the water carriers of the Nekyia; instead, he transposed Oknos and the donkey to the opposite end of the painting, not far from the riverbank with Charon's boat (fig. 11c, top center). Nor does this transposition seem arbitrary, since it parallels that of the demon Eurynomos, who also appears near the riverbank at the right (fig. 11c) instead of accompanying the suffering water carriers as he does in an Apulian red figure Underworld scene.[79]

Oknos' placement may simply have adhered to popular tradition, since Apuleius' Underworld narrative in the *Metamorphoses* (VI, 18) describes an analogous old man with a donkey not far from the shore of the ferryman. Nevertheless, Oknos' appearance on the right may indicate something more. Despite his identity as "Procrastination," Pausanias (X, 29, 1) states that according to the local lore Oknos was a good, industrious man, and in the painting he appears not far from the disseminator of the mysteries, Kleoboia. Consequently, he may well be antithetical in character and placement to the uninitiated water carriers at the corresponding extreme, although the precise sense of this opposition remains obscure (cf. fig. 11a and 11c).[80]

In any case there is a clear overall distinction between the figures of the uninitiated and those who had literally discovered and spread the practice of mystic initiation. And so it seems that the theme of the mysteries here was a significant feature within the play of opposites including Orpheus, Marsyas, Thamyris, and the various Greeks and Trojans. The practice of mystery initiation involved some notion of comfort or blessing that could be attained beyond the grave, in conjunction with the virtues of the deceased during their lifetime, just as avoidance of such practices invited punishment or retribution in the afterlife.[81] As discoverer of rites that could purge the *miasma* and divine displeasure incurred by sin, Orpheus was ideally suited to mark the divide between the alternatives of human character and religiosity that helped determine one's lot in the afterlife.

There can be no doubt about why Polygnotos used Orpheus in this way since the dichotomy that he created ran entirely parallel to the expectations

of peace or punishment so central to mystic eschatology. Placed within a framework established by figures synonymous with the origin and spread of mystic initiation, the illustrious Greeks of the Underworld appeared to partake in its blessings; in a profound sense they could be understood to have "heard" Orpheus' song. In contrast, Polygnotos placed the Trojans and various other *hybristes* outside this framework, and in proximity to those who had scorned the purity and bliss that such rites could secure beyond the grave. This arrangement was clearly meant to show that the underworld existence of the figures on the left side of the painting was qualitatively inferior to that of the righthand figures, not only in return for the errors that they had all committed in life, but in return for their failure to expiate their crimes through available ritual. Recourse to the option of mystic purification may even help to explain how ambiguous figures like Agamemnon or Achilleus could be placed on the side of rectitude and solace.

As indicated earlier, this polarity was not absolute; there were nameless sinners on the righthand shoreline, and there were Greeks who had fought at Troy on both sides of the painting, but the Greeks on the left functioned much as Aias Oileus and Neoptolemos did in the nearby painting of defeated Troy: they were exceptions to prove the rule, foils used to assert the *arete* of the Greek leaders who appeared beyond Orpheus in the Nekyia scene. Yet one did not have to compare the paintings to take in the meaning of this strategy; in the Nekyia itself the structured punctuation of the entire composition by antithetical figures suggestive of initiation to and exclusion from the mysteries brought home all the other oppositions through the contrasting assertions of blessing or retribution in the Underworld.

Greeks and Trojans in the Stoa Poikile

Since Polygnotos' work in the Lesche effectively reshaped the theme of Troy's destruction into an icon of Hellenic justice and retribution, it is necessary to consider how he pursued this objective in the Troy painting at the Stoa Poikile as well. Pausanias' description of the version in Athens is unfortunately much less detailed. He tells us only that the painting showed the assembly of the Greek kings to deal with the outrage of Aias, along with Aias himself and Kassandra, and the wives of the prisoners (I, 15, 2). From the testimony of Plutarch (*Kimon,* IV, 5), we also know that Laodike appeared among the Trojan women. Scholars have long observed the correspondence between these elements and portions of the scene of Troy's fall in the Knidian Lesche.[82] For the Stoa painting, however, Pausanias does not

specifically refer to an oath. Still, one should accept Robert's hypothesis that the painting focused on the central image of the Greek kings gathered around Aias, probably at an altar, as in the version at Delphi.[83] And because Pausanias describes the scene as a royal assembly, at least it is clear that here too the artist chose to depict not the moment when the angry Greeks first thought to stone Aias for his sacrilege, but a subsequent event in which the kings came together and deliberated over his crime.[84] The version in the Stoa also probably emphasized the Athenian contingent in this assembly—Akamas, Demophon, and Menestheus—as various scholars have suggested.[85]

One cannot, of course, be certain that the painting was limited solely to the elements that Pausanias mentions. Yet the extant evidence suggests that for the Stoa Polygnotos produced a more abbreviated composition, much like the upper register in the central section of the Troy painting in the Lesche (fig. 10b), but also incorporating some of the contents of the lateral panels. In the Stoa version the captive women of the left panel in the Lesche would have been disposed around or below the main group with Aias and the kings. Since there is no mention of the Palladion or statue of Athena, Kassandra may not have appeared clutching it as in the version at Delphi; she may only have sat or stood somewhere near Aias along with the other captive women. Nor does Pausanias mention male Trojans, alive or dead, in the Stoa painting. Yet he describes the women as the "wives of the captives," and is hard to understand why his brief synopsis would refer obliquely to captive husbands if none were present. Robert's suggestion that the corpses of the leading Trojans may have been scattered about is also plausible.[86]

Owing to the much more restricted evidence, no graphic reconstruction has ever been attempted for the Troy painting in Athens. Yet assuming a general similarity between the Stoa version and the corresponding portions of the better-attested example at Delphi, one can arrive at a very tentative idea of how the main or central area of the Stoa painting might have appeared. Figure 12 is a pastiche excerpted and reconstituted by the writer from Robert's reconstruction of the Troy painting in the Lesche. The Trojans' dress has been "orientalized" to illustrate the arguments made above. Since the literary testimonia are so limited, it is especially necessary in this case to emphasize that the details and the disposition of the contents are purely hypothetical, and intended only to suggest the painting's appearance in the most general terms.

Still, this reconstruction helps to evoke the kind of impact that the painting would have made upon the viewer. In what may well have been a less elaborate composition than the one in the Lesche, Polygnotos distanced the Greeks still further from any actual violence by eliminating it entirely, since the Stoa version probably did not include Neoptolemos. The painter depicted

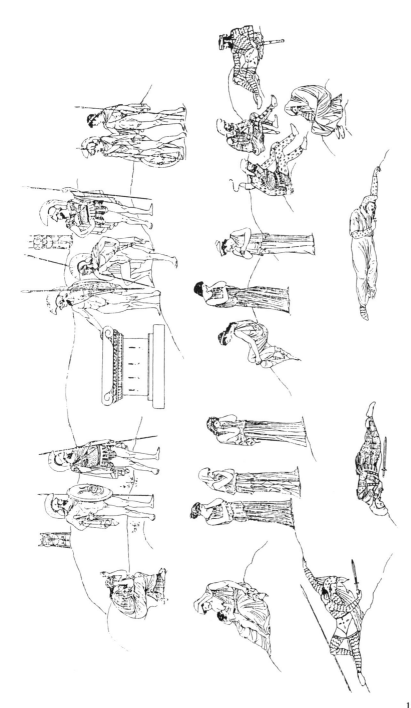

Figure 12. Suggested reconstruction by the author of Polygnotos' painting in the Stoa Poikile at Athens depicting the assembly over Aias' outrage (adapted from Robert's reconstruction of the "Troy Taken" at Delphi).

129

the humbling of once-proud Troy mainly through the figures of its defeated and enslaved survivors contemplating the ruinous consequences of their intransigence regarding Helen. In the Lesche, the oath imposed upon Aias had also been the central issue, occupying the whole of the upper middle section, with the other scenes grouped around it. But if the Troy painting in the Stoa did indeed focus primarily on the kings purifying or castigating Aias, then it would have asserted the issue of Greek rectitude and piety even more forcefully than the more extended version at Delphi. The internal antithesis between the virtuous Greek majority and the renegade Aias would have been more prominent and therefore more emphatic in the Stoa painting, and thus it would especially have underscored the ethical polarity between the righteous Greek victors and the arrogant Asiatics whom they had come to punish.

The use of internal antithesis on the Trojan side also seems to have been more restricted or concentrated in the Athenian painting. There is no evidence that the Troy scene in the Stoa included anything like the extended tableau of Antenor and his family in the Lesche; instead, the Stoa painting appears to have relied on the lone figure of Priam's daughter Laodike to exemplify the respect for *xenia* that most of her people had fatally disregarded. As we have seen, she gave hospitality and her bed to Theseus' son Akamas when he came to Troy as part of the delegation that sought the return of Helen without war. In view of the particularly Athenian resonance of this subplot, perhaps the less extended version of Troy's fall in the Stoa placed some emphasis on it. Akamas should also have figured prominently with Aias and the kings somewhere nearby. One can begin to appreciate the significance of Polygnotos' decision to portray Laodike with the features of his own lover, Kimon's sister Elpinike (Plutarch, *Kimon,* IV, 5), as an added means of heightening the painting's contemporary relevance.[87] Ultimately, however, Laodike's singular and vital function as a positive foil for Trojan perfidy seems to have been the primary factor in her inclusion; she balanced the central figure of Aias, the Greek exception whose isolated crime asserted the rectitude of most Greeks.

Ethos, Pathos, and Actuality

As far as one may judge, the depiction of Troy's capture in the Stoa Poikile reflects the same strategy of ethical opposition that Polygnotos applied in the Trojan or Homeric themes of the Lesche paintings, and all should be seen as part of a larger and well-coordinated program of public imagery

originating in Athens. This is not to deny or minimize the aims or preoccupations that have traditionally been ascribed to Polygnotos. In exploring the potential of the Iliupersis to subsume new historical circumstances and new moral implications, he drew fully upon the distinctive, ingenious, and innovative qualities for which his work has long been acclaimed. He focused his penchant for depicting human character and emotion upon the Trojans in their hour of defeat, thereby involving the audience and inducing them to ponder the whole range of actions and events that had brought the people of Troy to this end. He presented the spectator with a visceral illustration of the moral or religious concerns that emerge so forcefully in the contemporary poetic depictions of the Trojans by Aischylos or Bakchylides. In this regard the scenes of fallen Troy must have been among the more outstanding examples of Polygnotan *ethos* and *pathos*. [88]

But an overtly political agenda also informed this transformation in the Lesche and the Stoa. Polygnotos' sympathetic treatment of the Greeks at Troy's fall is unintelligible unless one sees it as a direct response to the requirements or intentions of the patrons who commissioned his paintings for these monuments, and it is here that one must also measure his success. No program that sought to display mythic precedents for the collective Hellenic triumph against Persia would have been complete without the Fall of Troy. In solving the problems posed by this theme through a studied and adroit suppression and reemphasis of the shameful acts committed by the Greeks, Polygnotos supplied a necessary ingredient for the paintings of the Kimonian monuments. He transformed the sackers of Troy into heroes at last, exemplars of *arete* and justice who could now appear plausibly as agents of divine retribution. By reworking the Iliupersis into a paradigm of Greek excellence and united resistance against barbarian perfidy, Polygnotos made the theme a fitting parallel for the moral invective of the Amazonomachy and Marathon paintings, or for the moral introspection of the Nekyia. And in doing so he furnished a parallel that could extend the system of mythic analogy beyond the defense of the Greek homeland in order to prefigure and justify the relentless punitive campaigns of Kimon and the Delian League against the Persians in the Aegean and Asia Minor. In this new form, Troy could now become Eion and Eurymedon.

In the Lesche, the positive image of the Greeks was crucial to the ultimate meaning of the larger program. Like the characters who prefigured the solidarity of the League in terms of ancient genealogy, the opposition between Greeks and Trojans in the Nekyia was also meant as an allusion to contemporary events. The pathetic Trojans in the Underworld closely paralleled the image of the Persian monarch presented by Aischylos. They too had been blinded by arrogance and self-importance as they rushed impet-

uously to their destruction, only to realize their mistake when it was too late. Paris and his supporters brought ruin to their nation like Aischylos' Xerxes and those who urged him on in his reckless endeavor. But the comparison to the Persians would hardly have been effective without the marked ethical antithesis that distinguished the Greeks from the Trojans in the Nekyia painting, and in the adjacent painting of Troy taken as well. This contrast, reinforced in the Nekyia by the themes of initiation and the justice meted out by Apollo, asserted the superior Hellenic commitment to commonly held religious precepts, suggesting ultimately that Kimon's military successes were something on the order of a crusade ordained by Zeus and his helper, the divine patron of the League.

In the Stoa paintings, which collectively asserted Athens' leadership in the just struggles against the envy and lawless greed of Asiatics throughout history, the new, improved image of the avenging Greeks at Troy was equally indispensable. In his contribution to the Stoa, Polygnotos disclosed the ethical disparity between Greeks and Trojans in more static and contemplative terms, in the aftermath of the war itself, but his distinctive approach neatly complemented the violent or dynamic character contrasts of the surrounding paintings, where the arrogant and unrestrained onslaught of Amazons and Persians collapsed before the moderate and disciplined Greek defense. Had the Greeks in Polygnotos' scene of punishment and vindication been any less moderate or disciplined than those in the defensive struggles depicted on either side, the program as a whole would never have achieved the unified moral emphasis so central to the official ideology that they were intended to serve.

As such these Polygnotan murals were major achievements in the sphere of political art, and they may well have been the most pertinent and effective of all the painted decorations that were commissioned to glorify the contemporary Athenian rise to power across the Aegean. They demonstrate, perhaps more clearly than any other of these works, that the use of mythic analogues was meant to evoke far more than superficial geographic or cultural similarities between recent victories and those of the heroic past. Such analogues were consciously manipulated to exploit all the most positive associations that the ethical conception of the hero could offer: a symbol of the best in character and deed to which one could aspire, a defender of the principles and limits established by the gods, and an enemy of those who violated such law. The orators never failed to remind us that this character had made the Athenians triumphant champions of virtue and justice in the remote past, and that by remaining faithful to such standards, they had again triumphed against Dareios, Xerxes, and Artaxerxes.

In the various mythic guises offered by these monumental paintings, as in

rhetoric and poetry, the military successes of Kimon and his men were to be understood as moral victories. Their martial prowess was to be seen as strength of character bred on the service of law and discipline, and thus their superiority in battle against the Persians and all enemies was meant to symbolize the superiority of their society or culture generally. Had it been otherwise, there would have been no cause to rework the original substance and intent of the various mythic traditions utilized in Athenian literary and visual arts; and had it been otherwise, there would certainly have been no need for Polygnotos to transform the Fall of Troy from a chaotic image of impiety and violent, unrestrained revenge into a quiet scene of moderate and just retribution.

4

The Persian Wars and the
Sculptures of the Parthenon

The Parthenon as a Victory Monument

The rise to power of Perikles and his supporters between the late 460s and
the early 440s resulted in a military and political climate very different from
that which had existed in Athens during the preceding decades. At home
this involved a shift from the oligarchic, aristocratic interests that Kimon
represented to a more radical form of democracy that increasingly appeared
to enfranchise the people at large. In foreign policy, tension and open hostil-
ity with Sparta began to divert attention and resources from the campaigns
against the Persians. The crusade against the Great King also lost momen-
tum in the wake of the failed attempt to conquer Egypt and Kimon's death
during the expedition against Cyprus; instead, Perikles now concluded a
formal peace with Artaxerxes in order to consolidate Athens' power through-
out the Aegean, even at the expense of the League allies.

These events accompanied considerable changes or reorientations in the
public building programs carried out in Athens under official patronage.
Instead of erecting completely new shrines and monuments of civic type
like the Stoa Poikile, Perikles and his architects concentrated primarily on
rebuilding the sanctuaries and temples that had been deliberately left as
"monuments to impiety" following the Persian sack of 480 B.C., and above
all those of the Akropolis. It is not unlikely that the treaty with the Persians
now seemed to justify a campaign of restoration that would have been im-
possible as long as the war of retribution against Xerxes and his successor
was still unconcluded and unresolved.[1] One cannot, moreover, attribute this
trend to Perikles alone. The destroyed temples at Sounion and Rhamnous
were rebuilt during the period of his leadership but probably at the instiga-
tion of the Ekklesia in Athens, as Boersma has indicated; no evidence sur-

vives to connect these monuments directly with Perikles himself. Their construction suggests a relatively broad-based official initiative for such restoration at this time.[2]

Yet despite these many changes, it is difficult to accept suggestions that the most outstanding of the Periklean restorations, the Parthenon, no longer addressed the triumph over Persia as the public buildings of Kimonian times had done.[3] The very idea of rebuilding the sanctuary of the Akropolis would have been inseparable from the circumstances of its destruction, just as the Theseion remained permanently linked to Kimon and his victory on Skyros. As replacements of uncompleted predecessors burned in Xerxes' sack, the new Parthenon and Propylaia were as much a thank-offering to Athena for the eventual victory over the Persians as they were monuments to the success and power of the Athenian state under Perikles' leadership.[4] They were in effect an architectural counterpart to the Persian war trophies that were kept on the Akropolis—the sumptuous armaments of Mardonios and Masistios taken at Plataia.[5]

A votive function of this kind, celebrating one or more military victories, is normally appropriate to monuments funded by a tithe of the booty. We know, of course, that the Periklean rebuilding of the Akropolis was not subsidized in this way; but by the fourth century, the commemorative function of the buildings may well have given rise to a tradition that directly associated them with the events and booty of 480. Demosthenes, in his speech against Androtion (XXII, 13), mistakenly identifies the victors of Salamis as "the men who from the spoils of the barbarians built the Parthenon and Propylaia, and decorated the other temples, things in which we all take a natural pride." Despite the error, the passage is extremely valuable historically; it demonstrates that the Parthenon was so closely associated with the victories of the Persian Wars that Athenians only a century later could lose sight of the actual circumstances behind its construction.[6]

The oft-cited passage in Plutarch's *Perikles* (XII, 1–4) representing the debate over the Akropolis project helps to clarify the nature of the connection between the Parthenon and the Persian Wars. Perikles was determined to defray the cost of the buildings with the accumulated contributions of the Delian League, which had been levied to wage the wars against the Persians and which had been recently transferred to Athens. His political opponents were against the project. They were uneasy about the increasingly autocratic nature of Athenian control over Asiatic Greece and the Islands, but they also feared the enormous political clout that Perikles and his supporters stood to gain as the official sponsors of a lavish and impressive building program commemorating Athenian standing and prestige.[7] Perikles' answer to his critics was simple enough: so long as the Athenians defended the

allies and kept the Persians at bay, they were meeting their obligations and should dispose of the surplus from the contributions as they saw fit, especially in view of the economic benefit that this would confer upon the city and its workforce. Thus the buildings may not have been financed by spoils, but they were closely identified with Athens' position as *hegemon* in the operations against Persia, and with the military and financial prerogatives appropriate to the supreme commander of the Delian League.

Some historians have doubted the historical value of this passage; they find it difficult to reconcile the martial characterization of the relations toward Persia with the existence of the Peace of Kallias, which, they assume, had been concluded by the time the debate took place.[8] It seems from the passage that some rebuilding was already underway, but it is not clear if this included the Akropolis project, begun in 447. Nor is it certain how soon Perikles' building program was initiated, although it has been dated as early as 450/49. The debate could conceivably have occurred before negotiations for the Peace were opened or formally concluded, in which case the passage would present no problems.[9] But even if the debate took place in 449 or the years immediately following, one ought not to assume that its language necessarily conflicts with the existence of the treaty. To do so would probably exaggerate the distinction between war and peace as it operated at the time.

Although the Athenians had ceased open hostilities with Persia, they could hardly have demobilized their navy after 449. The force of the treaty depended on the continued threat and maintenance of Athenian military power. Perikles himself would later acknowledge that the Persians yielded the seas to Athens only because of Athenian naval superiority, and still he had to contend with the possibility of Persian naval intervention in the Samian revolt of 440 (Thucydides, I, 116, 1–3, and II, 62, 2).[10] The objections of Perikles' opponents to the use of "funds collected for the war" could easily refer to revenues that had accumulated for some time before the Peace was negotiated. Perikles, moreover, speaks only of defensive operations in Plutarch's account.[11] In reality, the transition from actual engagement to this sort of "big stick" policy was more diplomatic than substantive in nature. Such policy still protected the allies from the Persians in the western Asiatic interior; it still cost money; and these were probably the arguments, among others, that the democratic leadership made to justify the collection of allied revenues after the Peace.[12]

The general authenticity of Perikles' response here has been corroborated by the so-called Reserve or Papyrus Decree, datable to 450/49 and preserved in the scholia on the passage in Demosthenes (XXII, 13) discussed above. Enough remains of the fragmentary text to see that it describes the transferal to the Akropolis of funds earmarked for the building project *and* for the maintenance of the fleet. Like the debate passage in Plutarch, this

suggests that building and defense were closely connected, and not only as a matter of fiscal management and expediency, but in ideological terms as well. To this one may add the evidence of the so-called Congress Decree preserved in *Perikles* (XVII) in which the Athenian leader called for a panhellenic conference to address the rebuilding of the shrines destroyed by the Persians and the protection of the sea lanes. It can hardly be accidental that these issues always appear related in the surviving historical sources. If they were indeed so closely intertwined, then there can be little doubt as to the significance of the Parthenon.[13]

Such evidence is crucial for establishing the historical and ideological context in which the Periklean building program took shape. The Peace of Kallias would not have altered substantially the prevailing sentiments of Athenians against the Persians, or the tendency of the Athenian leadership to exploit such sentiments in the public monuments glorifying the achievements of the state. The treaty may have put an end to the aggressive policy that Kimon had pursued against the Great King, but it will hardly have eradicated the bitter memories of Persian destruction or the desire to perpetuate the glories of Salamis, Plataia, and Eurymedon. The Peace was in effect a formal concession by Persia of the entire western Asiatic coastland, a tacit acknowledgment of the "liberation" of the Asiatic or Ionian Greek states whose subjugation under Kyros and Dareios had been a major cause of the conflict with Persia.

One can only imagine that Perikles and his supporters portrayed the Peace as the final achievement of thirty long years of war against the Persians.[14] In such an atmosphere the Parthenon would have appeared as the material expression of the Peace of Kallias, a crowning testament to the Athenian supremacy in the Aegean and much of western Asia that the Great King now accepted as fact. The financial backing of the Akropolis project only served to underscore this meaning. Athenian defense of the Aegean was made to justify the use of League funds in the restoration of the shrines and monuments destroyed by the Persians. Thus the Parthenon would have been understood as a symbol and reward for Athens' continued vigilance against the barbarian. Because of this, the various buildings and their decorations were linked to the struggles between Greece and Asia in the most profound terms.

But even when one recognizes that the Akropolis project was indeed a thank-offering of this kind, important questions remain. How did the imagery of the Periklean period relate to the official Athenian monuments of the preceding generation? There is of course a consensus that the Parthenon metopes too were intended as mythic analogues for the victory over Persia.[15] But to what extent did the artists who worked for Perikles and his supporters attempt to build deliberately upon thematic constructs already established in Kimon's day, and how did the ethical basis of the Kimonian

imagery inform the more extensive and systematic use of myth in the Parthenon program? In general terms, at least, the ethical implication of the Parthenon metopes as symbols of the conflict between Persian *hybris* and Greek *sophrosyne* has become a standard feature of Parthenon scholarship. But there is still much to consider in assessing how the program of the metopes articulated this opposition in point of detail. Did the program retain the kinds of transformation that the artists of the preceding decades had imposed on mythic analogues in order to bolster their relevance to actual events? And how might the planners of the metopes have attempted to expand upon the thematic content of the painted Kimonian imagery through the new possibilities inherent in the monumental scale and placement of Greek temple sculpture?

With these issues in mind, it is worthwhile reexamining the much-studied Parthenon sculptures as an expression of the Athenian *ethos*. Anyone who has experienced firsthand the Periklean buildings of the Akropolis or the remains of the Parthenon sculptures is well aware of their capacity to embody an ideal of cultural excellence. The buildings still overwhelm the spectator with an incomparable sense of grandeur and nobility; the outstanding quality and refinement of the architecture and its sculptural embellishment were meant to function as a material expression of achievement and greatness. Yet they were intended to reflect not only upon the goddess whom they honored, but also upon those who served her. The Parthenon and its sculptures celebrated the *arete* of the Athenian people as agents and protégés of the goddess most intimately associated with the order and authority of Zeus himself. If, by Kimonian times, the claim to moral or ethical superiority had already become a central issue in all official efforts to justify Athens' military and political status, then it is fundamentally important to consider more closely how such ideology culminated in the program of this greatest of fifth-century Athenian monuments.

The East Metopes: The Gigantomachy

The metopes of the Parthenon, produced under the supervision of Pheidias, depicted the Amazonomachy, the Centauromachy, the Iliupersis, and the Gigantomachy (see figs. 13–16).[16] The first three themes had already figured prominently in the monuments produced under Kimon and his supporters, so it is hardly surprising that they should reappear on the Parthenon. By the 440s the Athenian public was thoroughly familiar with the systematic display of Centaur, Amazon, and Trojan as a fixed set of mythic analogues for the Persian. It was an equation that Pheidias could scarcely have shaken even if he had wanted to do so, and in all probability the choice of subject

matter stemmed from a conscious desire to exploit the currency of these themes as fully as possible. The addition of the Gigantomachy to this mythic ensemble, however, was unparalleled in the earlier painted monuments.[17]

Pheidias had a number of reasons for including this theme, since it was already closely associated with Athena and the monuments of the Akropolis. The Gigantomachy was traditionally embroidered on the new *peplos* offered to the goddess in the Panathenaia, and it had been the subject of the late Archaic pediment of the Old Temple of Athena, the *Archaios Naos,* located on the north side of the Akropolis before the Persian sack.[18] But to a great extent Pheidias' choice seems to have centered on the myth's capacity to underscore the ethical or religious implications of the accompanying metopes. In his brief but insightful discussion of the Parthenon sculptures, Herington suggested that the Gigantomachy was included to symbolize the victory of the universal moral laws established by Zeus and his extension or surrogate Athena. This was the greatest of battles, the symbolic struggle between the cosmic order of the Olympians and the nether forces of chaos. Here was the ultimate mythic paradigm for the defense of law and *sophrosyne* and the punishment of *hybris,* in which the gods themselves suppressed the presumptuous and irreverent affront to their authority. As such it imposed a unifying ethical matrix upon the program of the metopes as a whole.[19]

The moralizing interpretation of the Gigantomachy among fifth-century Greeks and its use as a reinforcing paradigm or analogue for other mythic exploits can in fact be verified in the poetry of this period. In Bakchylides' First Dithyramb, as we have seen, Menelaos lectures the assembled people of Troy on the dangers of opposing the precepts of Zeus—the principles of justice, order, and rectitude fundamental to the good order of the *polis.* He concludes his sermon with the object lesson of the arrogant Giants, whose *hybris,* he emphasizes, had brought about their own destruction (see Appendix, lines 50–60). Here the myth not only symbolizes the supremacy of Olympian law, but provides a direct admonition and pattern for mortal action as well. Moreover, by Archaic times, the violence and disorder of the Giants and other monsters had already come to appear as the antithesis of the human values of moderation, virtue, and piety considered essential to civilized life—so much so that Xenophanes could question whether it was even appropriate to recount these myths at symposia, where sobriety and control were always at peril:

> It is not *hybris* to drink so much if one can
> reach home unattended, unless he is very old.
> Yet he among men is to be praised who,
> after drinking, brings forth noble thoughts,
> as memory serves, and he who speaks of excellence [*arete*],

Figure 13. Parthenon, east metopes (from J. Boardman, *The Parthenon and Its Sculptures*, Austin, Tex., 1985, ill. p. 235).

> recalling not the battles of Titans or Giants,
> nor of Centaurs, creations of the ancients,
> or furious civil discord. In these things
>> there is nothing good.
> But to be ever mindful of the gods,
>> that is worthy.[20]

The particular relation between Athena and Zeus, and the traditional connection of the Gigantomachy to Athena and her sacred site, also made the theme an apt component for the decoration of the Parthenon. Of all the Olympian deities, Athena was closest to Zeus. He had given birth to her from his own head, a fact explicitly recalled by the pedimental sculptures

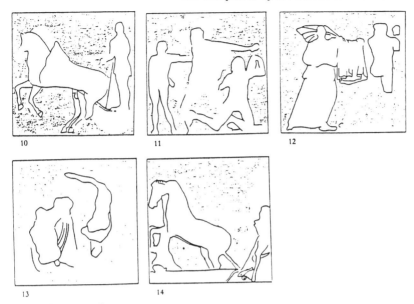

Figure 13. *(continued)*

directly above the Gigantomachy metopes (cf. figs. 13 and 18). On the Parthenon as nowhere else, Athena was his surrogate, the special champion of his law, as Herington has indicated. In connection with Zeus, the Gigantomachy was especially Athena's battle. If the reconstruction of the pediment on the Megarian Treasury at Olympia is correct, she and her father fought side by side in the battle against the Giants. In the Gigantomachy of the late Peisistratid marble pediments of the Old Athena Temple on the Akropolis, she occupied the central position, dominating the composition entirely.[21] And thus it comes as no surprise to find this theme embroidered on Athena's new *peplos* in the Great Panathenaia.

However, these associations ultimately disclose the enormous relevance of the Gigantomachy as a paradigm for the defeat of the Persians, especially in retribution for their sack of the Akropolis in 480. To the Athenians of the Archaic and Classical periods, the Akropolis had become a surrogate Olympos, paralleling the role of Athena as a surrogate or extension of Zeus.[22] In this context an affront to Athena was an affront to Zeus, just as an attack on her sacred mountain was directly comparable to the Giants' assault on Olympos. Xerxes' siege of the Akropolis would therefore have appeared analogous to the offensive of the Giants. Within the temple, the shield of the Parthenos made this equivalence almost explicit, since it juxtaposed the Gigantomachy directly with another indisputable mythic analogue for the Persian attack on the Acropolis, that of the Amazons (cf. Pliny, *Natural*

History, XXXV, 54, and XXXVI, 18; Pausanias, XVII, 2). In Aischylos' *Persians* (esp. 744–750), Xerxes, moreover is said specifically to envy and defy the limits and authority established by Zeus and his fellow deities. In his "gigantic" ambition to dominate all Asia and Europe, land and sea alike, the Persian monarch must have seemed to be another Alkyoneus or Porphyrion, a would-be usurper of the dominion and prerogatives that rightly belonged to the gods alone.[23]

As a direct although more elevated prefiguration of the struggle with Persia, the Gigantomachy was especially well suited to buttress and sharpen the ethical relevance of the accompanying metopes to contemporary actualities. Comparison to the exploits and objectives of the gods themselves served to establish the mythic Greeks or Athenians and their worthy descendants unambiguously as mortal surrogates for the gods in upholding Zeus' law; it made them appear to be in touch with divine purpose, just as their protectress, Athena herself, emerged as the direct extension or instrument of her father in the east pediment depicting her birth. When fifth-century spectators surveyed the Gigantomachy beneath the pediment demonstrating the unity of Zeus and Athena, they would have experienced the visual counterpart of the Persian messenger's statement to Atossa that "Gods safeguard the city of the goddess Pallas" (fig. 18).[24] The Gigantomachy, more than any other theme, could bring home the message that the Olympians had always supported and inspired the Athenians in their righteous struggles against arrogant lawlessness and disorder.

From this perspective, the Parthenon program may be seen in its very essence as a direct outgrowth of the ethical concern central to the literary and pictorial works of the Kimonian period: the view that the Greek or Athenian protagonists of myth and actuality were effectively agents of Dike, the Justice of Zeus. In Bakchylides' Dithyramb on Troy, it is "straightforward Dike" whom the lawless spurn—especially the Giants, whose primordial crimes are emphasized in the last two lines of the poem—and it is Dike's cause that the Greeks must uphold, following the paradigm of the gods themselves in their battle against the Giants. Similarly, it is Dike who will lead the Greeks to victory against Xerxes in the Salamis oracle recounted by Herodotos (VIII, 77).

In the mythic paintings of Kimon's time, however, this issue seems to have operated largely in implicit terms, against the background of common opinion or literary analogues like that of Bakchylides. So far as we can tell, the Marathon painting was the only Kimonian mural that definitely included divinities as an overt statement of support and inspiration, expressly stating the role of the Greeks as agents of Zeus' will and law. This sort of divine interaction within mythic narratives does, however, appear in somewhat earlier and contemporary architectural sculpture; in the west pediment of

the Temple of Zeus at Olympia, for example, Apollo similarly inspires or directs the destruction of the lawless Centaurs.[25] In the north metopes of the Parthenon too, a suite of divinities was added alongside the scenes of Troy's capture (fig. 16, nos. 29–32). But Pheidias' inclusion of the Gigantomachy metopes as a separate series, a collective image of the Olympians upholding Zeus' authority, was an elegant improvement on this strategy, a visual statement far more potent than the insertion of one or several divinities within another mythic subject. Here one begins to sense the process of thematic and compositional refinement that Pheidias consistently applied on this monument in order to move beyond the groundwork laid by his predecessors.

The West Metopes: The Amazonomachy

The west metopes of the Parthenon depicted a battle between Greeks and Amazons.[26] Despite their sadly mutilated state, scholars generally concur that they represented the Amazon invasion of Attika, for the corresponding Amazonomachy that Pheidias depicted on the shield of the Parthenos within the temple undoubtedly showed the Amazons attacking Athens.[27] The Amazons in the west metopes were also mounted, like those of the painted versions in the Stoa or the Theseion (cf. figs. 2, 4, 6, and 14). On this evidence, it appears that Pheidias adhered to the conception of the Amazonomachy that was already current in Kimon's day. Indeed, it seems natural that Pheidias should continue to develop the already elaborate image of perverted Asiatic womanhood that he had inherited from the painters and orators of the preceding generation as a guise for the Persians. Much of his audience would have come to the Parthenon with this tradition in mind, and by virtue of its locale, the Attic Amazonomachy on the Parthenon would have evoked the Persian siege of the Akropolis even more effectively than the versions on the Kimonian monuments. But our understanding of the precise import of the west metopes need not rely solely on such expectations. The larger array of sculptural themes on the west facade of the Parthenon suggests in and of itself that Pheidias continued to utilize the Amazonomachy as a rationale for the victory over Persia in connection with accepted male notions about female character, and that here he consciously strove to intensify this imagery through the thematic juxtapositions afforded by the adjacent pedimental sculptures.

To understand this, however, one must first consider the issue of Athenian or Attic autochthony. The notion that Athenian men were descended from the very land of Attika was a *topos* of the rhetorical tradition that had shaped the legend of the Amazon invasion, as various studies have shown.[28] But

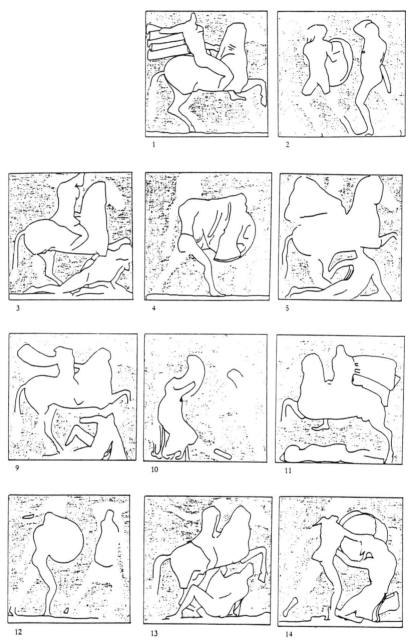

Figure 14. Parthenon, west metopes (from J. Boardman, *The Parthenon and Its Sculptures*, Austin, Tex., 1985, ill. p. 233).

144

such work has also demonstrated how this autochthonous origin was directly related to the self-proclaimed commitment of Athenians to the cause of justice and virtue. As men who claimed to have been born spontaneously from their land without having to conquer it, the Athenians asserted both their natural aversion to aggression and their instinctive tendency to defend the land to which they were so closely tied. And so in his *Funeral Oration* (LX, 4–8) Demosthenes channels his references to Athenian autochthony and justice directly into the catalogue of great exploits, with the defense of Attika against the Amazons at the head of the list. In Lysias' *Funeral Oration* (II, 16–22) the autochthony-justice *topos* ties the great mythic deeds to the defensive struggles of Athens against Dareios and Xerxes.[29]

The polarity between autochthony and aggression, then, was also a significant feature of the Attic Amazonomachy and the analogy that it provided for the events of the earlier fifth century. According to this view, the Athenian was the "natural" enemy or antithesis of the invading Asiatic. Thus it is likely that this issue figured somehow in the versions of the myth depicted in the Theseion and the Stoa Poikile, although it is no longer possible to evaluate how the paintings would have communicated such an idea. In the sculptural program of the Parthenon, however, there are indications. Harrison, following the earlier opinion of Stavropoullos, argued that the Amazonomachy depicted on the shield of the Athena Parthenos included the autochthonous heroes or kings, Kekrops, Erechtheus, and Pandion. Tyrrell has revived the idea, suggesting that these figures served as paradigms of autochthony, "avatars of the Athenian soil," emerging from the land itself to aid their descendant Theseus in repelling the foreign aggression of the Amazons.[30] Thus the inclusion of the ancient Attic kings would have helped to make the shield a visual illustration or counterpart of the autochthony-aggression polarity in contemporary Athenian rhetoric. But while these arguments are highly attractive, no literary testimonia or clear indications in the surviving replicas of the shield conclusively demonstrate the presence of such figures.

On the other hand, autochthony was certainly an important issue in the west pediment of the Parthenon.[31] There, it is the primordial or "original" inhabitants of Attika who witness the central contest between Athena and Poseidon for the divine patronage of Athens (fig. 19). On the left behind Athena is Kekrops, with a serpent between his legs to emphasize his earthborn nature. Beside him are his daughters and a young boy, possibly his son Erysichthon, or perhaps the child Erichthonios. Beyond him in the angle of the pediment is a figure identified either as an Athenian "hero" (i.e. a contemporary of Kekrops), or as a male river god personifying the Athenian locale itself. Another figure, presumably also a hero or ancient Athenian,

once occupied the space between him and Kekrops. On the right, behind Poseidon, we see the Athenian women with children of different ages (fig. 19).[32] Collectively they exemplify the continuous generations descended from the soil, a pristine manifestation of the autochthony extolled by the orators. We need only see these figures as part of a larger sculptural assemblage, with the battle against the Amazons directly below, to complete the analogy to the funerary speeches, or to parallel the conception of the Parthenos shield advanced by Harrison and Tyrrell.

In fact, the subject of the west pediment more or less obliges us to consider its thematic connection to the adjacent metopes, since it too presented a myth that ultimately exemplified the repression or containment of women by autochthonous males. One tends to focus on the immediate subject of the west pedimental sculptures—the victory of the female divinity Athena over Poseidon as patron of Attika—without considering the larger issues and consequences of the story or the varied forms in which this myth has survived. According to Varro (in Augustine, *City of God,* XVIII, 9), Kekrops himself supervised the vote among the Athenians to decide the contest. The men voted for Poseidon while the women supported Athena, and since they outnumbered the men by one, Athena was determined the victor. The enraged Poseidon flooded Attika, and to assuage his anger the men stripped the women of the right to vote, the right to pass their name on to children, and the right even to call themselves Athenians.[33] As Vidal-Naquet and Tyrrell have indicated, the latter two measures are closely related to another tradition in which Kekrops was said to have instituted marriage. Before this, women had mated promiscuously ("like beasts" in one account), so that no one knew his father. The establishment of monogamy by Kekrops was believed to have curbed the innate sexual excess of women while also ending the confusion about one's male ancestors.[34]

Because it too describes or rationalizes the institution of patriliny and male control of the social order, the tradition about Kekrops and marriage is clearly related to the version of the dispute between Athena and Poseidon preserved by Varro. These Kekropian "marital reforms" may readily be understood as part of the punishment imposed upon the women to placate Poseidon.[35] Varro's account and most of the sources on Kekrops and marriage postdate the Parthenon by at least four centuries, but the idea that the Athenians had collectively settled the divine contest is already attested by Xenophon's *Memorabilia* (III, 5, 9–10) of the earlier fourth century, where "Kekrops and his people" are said to have given judgment. And since Xenophon attributes this remark on the contest to Sokrates, the tradition would seem to have existed already in the fifth century.[36] The myth of Kekrops' laws ending female promiscuity and matriliny is also at least as old as the

fourth century, since Athenaeus quotes it from Kleanthos of Soloi, who was a pupil of Aristotle (*Deipnosophists,* 555c–d; cf. 235a).

Apollodoros (*Library,* III, 14, 1) acknowledges the tradition in which Kekrops and the other Athenians settled the dispute between Athena and Poseidon, but he rejects it in favor of the version where the twelve gods gave judgment (cf. Ovid, *Metamorphosis,* VI, 70–82). Hyginus (*Fabulae,* CLXIV) relates yet another variant in which Zeus alone acted as judge. In contrast to the tradition that made Kekrops and the Athenians arbiters of the dispute, neither of the versions with Olympian judges can be documented before the first century B.C. at the earliest, and they certainly do not accord with the sculptures of the west pediment, as Brommer and Simon have emphasized.[37] At the center of the composition, Athena and Poseidon appear in dynamic confrontation; originally they may have stood beside the olive tree and the salt spring, respective *martyria* or tokens bearing witness to their claim to the land of Attika (Herodotos, VIII, 55)—although the actual evidence for these elements in the pediment is weak (fig. 19).[38] The accompanying chariotry is suggestive of their arrival in Attika, with Nike as Athena's charioteer and Amphitrite tending the car of Poseidon. But neither Zeus nor the other Olympians appear as judges. The remaining figures to either side beyond the chariots are all mortal men, women, and children, with the possible exception of those to the extreme left and right, who may be personifications of local rivers or springs (fig. 19).

Yet there are considerable problems with Simon's attempt to explain the disparity between the pediment and Apollodoros or Hyginus by reinterpreting the subject as the later phase of the story, where the enraged Poseidon attacks Attika with floods.[39] The apparent clash between the divinities is hardly inconsistent with the initial dispute, since, according to Apollodoros, the strife *(eris)* of Athena and Poseidon was severe enough to warrant the intervention of Zeus. Nor does the juxtaposition of the main contenders on the pediment relate to any of the surviving accounts of Poseidon's violent response to the judgment. In Apollodoros he floods Attika with impunity. In Varro he desists only when assuaged by the disenfranchisement of the women. And in Hyginus, Zeus sends Hermes to restrain Poseidon from even attempting the flood. In no account does Athena herself confront or fend off the rage of Poseidon's waters, as the composition of the pediment would require us to assume.

In the end, such a reinterpretation of the narrative seems unnecessary. The precise moment depicted here is the version that Apollodoros rejects in his account of the myth, as Robertson has observed; the divine protagonists are challenging one another with their respective claims as Zeus parts the contenders and commands them to submit to the judgment of others.[40] Such

intervention is, at the very least, indicated by the arrival of Hermes and Iris behind the chariots of Athena and Poseidon respectively, since the former deities often function as the harbingers of Zeus' will. The supreme Olympian's command to end the dispute may have appeared even more emphatically if, as Simon argues, his thunderbolt originally occupied the apex of the pediment between the contestants.[41]

On the evidence of the pediment itself, the judgment to which Athena and Poseidon must submit is not that of the gods. Those who surround the central group of divinities are mortals, but they are not simply passive witnesses or spectators; their poses are varied and responsive to the contest at the center of the composition, suggesting direct concern if not participation (fig. 19). In the pediment it is Kekrops and the Athenians to either side who must choose their divine patron for themselves, as Xenophon and Varro relate it. Binder has emphasized the issue of priority (which god had reached the Akropolis first) as the basis for the respective claims of Athena and Poseidon, rather than the value of their tokens, the olive tree and salt spring.[42] But this does not really alter our understanding of how the dispute was finally settled. The *Memorabilia* (III, 5, 10) states clearly that there was a judgment *(krisis),* and that it was given by *hoi peri Kekropa,* literally "those around Kekrops" or, in the general sense of this construction, "Kekrops and his people"—that is, the ancient inhabitants of Athens.

Here the predominance of the women among the assembled Athenians is striking, especially in the light of Varro's account. Of the adult figures, seven and possibly eight are female. If we allow that figure *V* at the right is adult, only three or four figures at most could have been mature, male Athenian citizens. And if we follow the identification of figures *A* and *W* at either corner as river god and water nymph rather than mortals, this would make the ratio at least six women to two or three males.[43] Generally speaking, it is difficult to understand this emphasis on the Athenian women, above all as mothers attending to children. But it would make perfect sense as a means of stressing their majority support for Athena, as well as suggesting one of the punishments that they incurred to placate Poseidon—the loss of matrilinial succession with respect to the very offspring whom they hold (fig. 19).[44]

It is actually rather fitting that the paradigmatic figure of autochthony, the earth-born Kekrops, should preside over a vote or contest that ultimately deprived Athenian women of their sexual freedom, suffrage, and lineage rights, and particularly above the metopes showing the destruction of the Amazons. The principle of Athenian autochthony was not only the antithesis of aggression, as the orators stressed; in reality, it was also the antithesis of female power or autonomy. The concept of autochthony effectively trans-

posed the birth of Athenians from their mothers' wombs to a "fatherland" or *patris,* the soil of Attika (cf. Lysias, II, 17), to which they were connected through *patrilineal* descent.[45] In the sculptures of the west facade of the Parthenon, autochthony is opposed not only to the external aggression of the Amazons, but also to the internal, primordial threat of women within the *polis,* especially if the women's support for Athena was meant to suggest an abuse of suffrage in a bid for matriarchy, as Tyrrell and Brown have indicated. Thus the transition to monogamous marriage and patriliny that resulted from the contest was presented as the victory of male autochthony over the unbridled nature of the female, analogous to the Amazonomachy.

Moreover, the mythic Athenian women might just as well have saved themselves the trouble of seizing power by these means, for the victory of a goddess as such is illusory here. The Athena of the Parthenon was hardly a symbol or champion of feminine, maternal interests.[46] Rather, she was thoroughly integrated within the mythic traditions of autochthony and all that it implied for the female gender. According to the literary sources, Hephaistos pursued Athena, but the virgin goddess shunned motherhood and resisted his advances. When he ejaculated against her thigh, she cast the semen down onto the Akropolis, where the child Erichthonios was conceived and born from the soil itself. Athena had the child raised by the autochthonous Kekrops, and Erichthonios eventually succeeded him as king of Attika. In the west pediment, the child next to Kekrops' daughters (figure *E*) may be Erichthonios.[47]

Athena's aspect as the chaste and warlike Parthenos was thoroughly male-oriented, and it was also entirely in keeping with her origin as a surrogate and extension of Zeus, precisely as we see her in the east pediment of the Parthenon (fig. 18). There Zeus has arrogated to himself the female power of childbirth, much as Athenian autochthony disenfranchised the mother's womb. And within the larger setting of the myth, Zeus assimilated as well the female power of knowledge, having devoured Athena's pregnant mother, the Titaness Metis, female personification of "cunning intelligence." Athena's subsequent function as goddess of wisdom was thereby made to appear as a "patrimony" from the male deity who gave birth to her rather than an inheritance from her mother. Thus Athena's origin from Zeus negated maternal power and the autonomy of female divinity on various levels, just as she herself rejected motherhood within the antimaternal tradition of autochthony. And so it is consistent that her election as patron of Athens should ultimately negate the importance of the mother in succession and society at large. This is the commitment that Athena herself expresses in Aischylos' *Eumenides* as she casts her vote in favor of Orestes:

> There is no mother anywhere who gave me birth
> and, but for marriage, I am always for the male
> with all my heart, and strongly on my father's side.[48]

Logically then, it should have been the male Athenians who supported Athena, but in mythopoeic terms the women's support had distinct advantages. The women chose Athena, but for the wrong reason—to assert female power—and so their action documented once again the need to suppress the incontinent female character. Yet the support of the women enabled the Athenian men to have Athena as goddess without having to take the responsibility for passing over Poseidon, whom they placated by making scapegoats of the women. Only by recognizing the antifemale undercurrent in the myth of the contest depicted in the west pediment can one appreciate the extent of its relationship to the theme of Athena's birth over on the east facade of the temple.

Indeed, one can readily sense how both Parthenon pediments would have furthered a larger thematic construct intended to rationalize the containment of the female or of qualities deemed typical of women, in opposition to the interrelated male concepts of autochthony, justice, and ordered self-control. The primordial imposition of monogamous marriage as the appropriate role for women that resulted from Athena's victory on the West would certainly have related to the themes of the adjacent metopes on the South and East, which exemplified the punishment of the immoderate Centaurs and Trojans who later challenged civilized marital institutions. But the sexual constraints imposed upon the women in the aftermath of the vote would have pertained even more immediately to the theme of the Amazons, shown just below in the west metopes. The warrior women too were held to be lustful or licentious in the absence of male control; they were also bestial in their rejection of the chastity essential to paternal lineage.[49] Thus their defeat as an external female threat closely paralleled the internal suppression of female sexuality in the "civilizing" measures of Kekrops.

Still, these oppositions ultimately transcended the specific issue of marriage as a metaphor for the lawful order of Greek society. It was the broader theme of womanly incontinence that provided the force behind the collective imagery of the west facade, with its emphasis on the female "opponent." And once again the true dimension and purpose of this indictment emerges only in the light of the fundamental analogy between woman and barbarian, particularly within the strategy of mythic prefiguration that dominated the production of official rhetoric and artistic monuments in the

period leading up to the Parthenon. In Chapter 2 we saw that the negative image of the invading Amazon in Kimonian times had evolved from the more general conception of women as unrestrained by nature. The Amazons' unlimited and reckless appetite for domination, their imperialism, was branded as a female, even a bestial, trait; in utilizing the Amazons as mythic precursors for the imperialism of Dareios and Xerxes, the Greeks of this period ascribed to the Persians the insatiable character of women. Set amidst the west facade of the Parthenon, it is relatively certain that the Amazons in the metopes functioned this way as well. Many were mounted, displaying the equine *hybris* of their counterparts in earlier painting as they arrogantly attempted to trample underfoot the just defenders of democratic Athens (figs. 14 and 19).

Yet the direct juxtaposition of the pedimental sculptures on the west front greatly underscored this antithesis by unfolding an etiology of male political order from the inception of Athena's patronage, and by documenting the eternal opposition of this order to the female immoderation and injustice that threatened the *polis* from within as well as without (fig. 19). This interplay between internal and external threats was thoroughly at home within the larger *hybris/sophrosyne* antithesis that had been developed to condemn the Persians and their mythic predecessors, for as indicated in Chapter 1, this strategy too had originated in the traditional Greek aversion to immoderate behavior inside the *polis* itself. By helping to provide a more broad-based exposition of the insatiable, hybristic female appetite, the west pediment would have attuned the viewer to the underlying lesson exemplified in the struggles against the Amazons and their womanlike Asiatic successors, the Persians. It would have made the spectator especially mindful of a primary *topos* of fifth-century Athenian propaganda: the ceaseless efforts of the just, autochthonous men of Attika to suppress and punish lawlessness and excess.

Pheidias did not create this ideology; nor was he the first to apply it in the monumental arts. But on the Parthenon he exploited the highly suggestive qualities of scale and sculptural placement to produce a more complex and profound system of juxtapositions and qualifications than that of the Theseion or the Stoa Poikile. In doing so, he was able to augment the ideological claims of such mythic prefiguration while also managing to integrate these claims with the central myths explaining the structure of Athenian society and the origin and patron status of the city's goddess. The development of public programs of imagery in fifth-century Athens was not only a process of invention, but one of resynthesis and amplification as well.

The South Metopes: The Centauromachy

While the west facade of the Parthenon concentrated on the first component in the multiple antitheses of female, animal, and barbarian against the Greek, the sculptures of the south facade addressed the second, through the battle between Greeks and Centaurs (fig. 15). The juxtaposition of the Centauromachy with the Amazonomachy in the west metopes recalls the program of the Theseion, but here the extent of the continuity between monuments is not yet clear. Previous studies have not established how the Centauromachy of the south metopes functioned within the larger program of mythic analogues in celebration of the Persian Wars. Some scholars have even doubted that the Centaurs on the Parthenon were intended as a direct comparison to the Persians, seeing the battle instead as a generalized symbol of civilization versus savagery and immoderation, or of man's internal struggle to suppress his own bestial tendencies.[50] For some, the "internal" aspect of this struggle assumes a specific political dimension in which the purely Hellenic circumstances of the Centauromachy may be seen to prefigure the antagonisms between Athens and other Greek states.[51] As a result, the south metopes appear to constitute something of a sore point for the issue of programmatic or thematic unity in the Parthenon sculptures, and not only among the overall sequence of metopes, but internally as well. There is still major disagreement about the identification of the mysterious central metopes 13–20 on the south facade, preserved mostly in Carrey's drawings; nor is there any certainty about the nature of their connection, if any, to the remaining scenes of the Centauromachy.

The solution to all these problems must begin by identifying the version or setting of the Centauromachy depicted on the Parthenon. In his monograph on the metopes, Brommer emphasized the lack of details specifically denoting any of the heroic protagonists or the setting of the struggle. Because of this view, and because he was also inclined to interpret the central metopes as an Attic myth perhaps involving Erechtheus, he postulated that the south metopes depicted an Attic Centauromachy that has left no trace in the literary record.[52] But despite these objections, the south metopes are hardly devoid of details indicating the circumstances and locale of the battle. True enough, there are no couches to prove that this is the Centauromachy that erupted at the banquet. Yet five of the Centaurs are attacking women (cf. nos. 10, 12, 22, 25, and 29); and on a sixth, south 21, two women flee to the shelter of a cult image or shrine (fig. 15). Four of the women have disheveled garments and exposed breasts, suggesting rape, while on metopes 3, 7, and 8, the Centaurs are tangled in draperies that they have presumably torn from the terrified females.[53] On metopes 9 and 23, the battle

rages amidst overturned vessels; on metope 4 the Centaur uses a large cauldron or dinos as an improvised weapon (fig. 15).

The handling of the Centauromachy on the Parthenon leaves no doubt that the battle took place, at least in part, at a feast; there is no reason to suppose that this should be any other event than the one that we have already come to know in Attic art—the battle at the wedding of Peirithoös.[54] The individual duels at the two extremes of the series may suggest an outdoor battle. Simon argues that the holes in the hands of the Lapith and the Centaur of metope 1 once held a spear and a tree branch respectively. The Lapiths on south 4 and 11 have shields, and the one on metope 32 once had a helmet. Accordingly, Simon has suggested that the depiction of this theme on the Parthenon encompassed the larger narrative, not only at the wedding, but also in the pitched battle in the wild that occurred later.[55] However, Barron had already posited for the Theseion a two-part Centauromachy in which the fighting at the feast gradually spilled into the open areas beyond Peirithoös' palace, and the same may be true on the Parthenon.[56] It is also possible that the Lapiths were imagined to have grabbed spears and armor in the course of the struggle at the palace; the one with the shield on south metope 4 faces a Centaur armed with a large wine vessel, which indicates a setting at the wedding itself (fig. 15).

On the Parthenon, the emphasis on symposiastic equipment and the abuse of women shows that treatment of the Centauromachy also continued the transformations of Kimonian times; here too the theme was meant to embody the violation of *xenia* and all other societal order and custom. The protagonists of the south metopes were moderate defenders of the laws established by Zeus, pitted against irrational force, violence, and impiety. Among the extant Centauromachy metopes, south 31 probably communicates this opposition best in terms of expression (fig. 17). There the face of the Lapith exudes restraint and control as he delivers the blow to the Centaur's head. Like the majority of Centaurs in the south metopes whose faces survive, the one on south 31 is completely antithetical to his Lapith opponent; he displays a masklike visage of snarling bestiality. The visual conception of this polarity is fundamentally related to that on the Florence Painter's krater, which was probably based upon the version of the Theseion (cf. figs. 1 and 17). Like the master of the west pediment of the Temple of Zeus at Olympia, Pheidias adapted to temple sculpture the formal language or devices for depicting ethical oppositions that had been established by the great painters of the preceding decades. Since he himself was a painter as well as a sculptor, Pheidias' ability and inclination to make this transposition is hardly surprising.[57]

As in the case of the Amazonomachy, these formal and conceptual

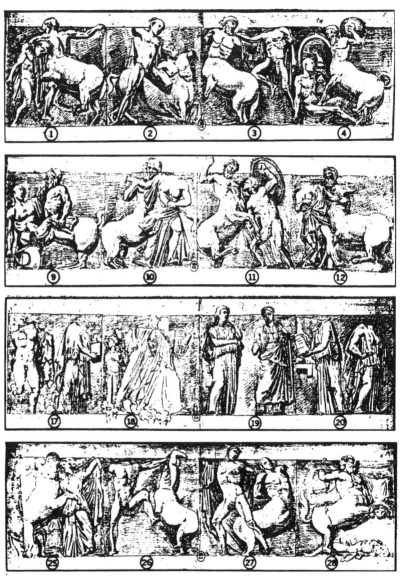

Figure 15. Parthenon, south metopes, as drawn by Carrey in 1674 (adapted from F. Brommer, *Die Metopen des Parthenon: Katalog und Untersuchung*, Mainz, 1967, pl. 149–152).

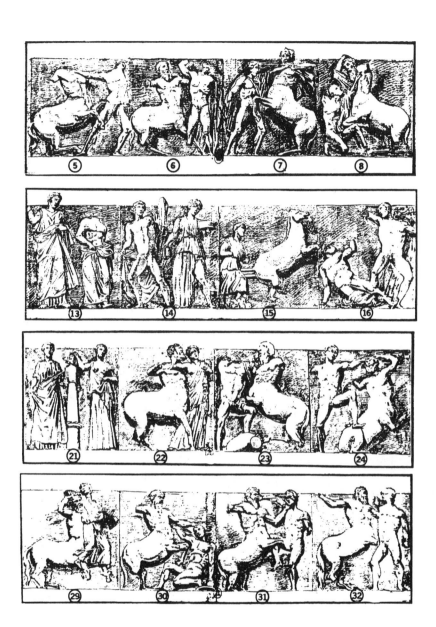

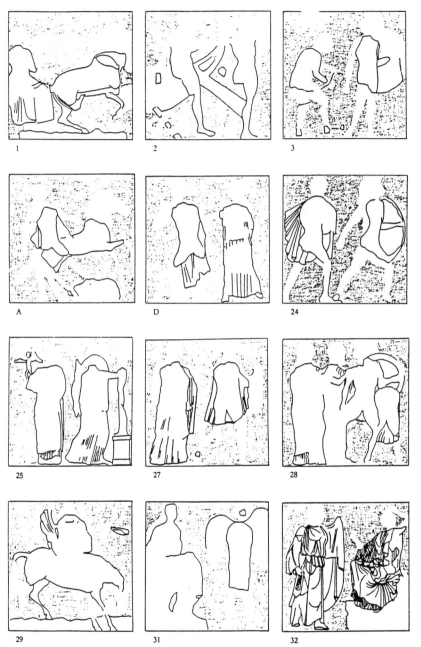

Figure 16. Parthenon, north metopes (from J. Boardman, *The Parthenon and Its Sculptures*, Austin, Tex., 1985, ill. p. 234).

156

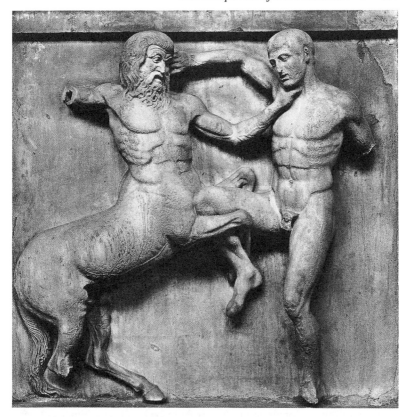

Figure 17. Parthenon, south metope 31, London, British Museum (from A. H. Smith, *The Sculptures of the Parthenon,* London, 1910, pl. 24, 1).

analogies to earlier monumental painting, and especially to the painted decorations of the Theseion, suggest that Pheidias was involved in an enterprise of much the same kind, although on a grander scale and level of complexity. For the Centauromachy as well, he could count upon an audience that had been exposed to the strategies of the Kimonian monuments, and his objective would have been to capitalize upon that familiarity. In the south metopes 13–20, as in the sculptures on the west facade, he also explored the possibilities of thematic elaboration or intensification to press the mythic comparisons of his predecessors more forcefully.

Most scholars consider these central metopes to be depictions of the more ancient Attic legends involving Erechtheus, Kekrops, or Erichthonios, although Robertson has looked to the myth of Daidalos as a possible identi-

fication in order to establish the link with Theseus more closely.[58] Yet none of these themes has any direct bearing on the Centauromachy. Some, like Langlotz and Corbett, abandoned the notion of a unified theme throughout the south metopes, but others have persisted almost intuitively in the belief that metopes 13–20 must illustrate some aspect of or adjunct to the battle between the Lapiths and the Centaurs.[59]

Among the latter, the studies by Harrison and Simon come closest to a viable solution. Harrison interprets metopes 17–20 as scenes of Peirithoös' wedding itself—preparations for the bridal chamber and the entertainers for the banquet—which gradually give way to the eruption of violence beyond the fleeing women of metope 21 (fig. 15).[60] For Simon, metopes 13–14 depict the ceremonial participants of the wedding, including Boutes, the father of the bride, on number 14. The rest Simon connects to an earlier narrative or subject, but one that is causally related to the Centauromachy: the story of Ixion, the father of Peirithoös. She identifies Ixion himself in metope 16, where he may be shown murdering Eioneus, his prospective father-in-law, just before his own wedding ceremony was about to begin. The surrounding metopes would then be the deities of justice and retribution reacting to the offense. Helios departs in his chariot on 15; on 17 Apollo with his cithara turns away from the deed and also from Hermes, who holds a blood-offering for purification; and on 18 Aidos and Nemesis depart for the heavens as well. After granting him purification, Zeus entertained Ixion in Olympos, where he even attempted the seduction of Hera. Simon identifies metopes 19 and 20 as scenes relating to this subsequent and greatest of Ixion's crimes.[61] Zeus eventually bound Ixion to a wheel of perpetual torture as punishment for his acts of *hybris,* but first he allowed him to consummate his deluded lust with Nephele, a cloud-phantom that Zeus fashioned in the form of Hera. The result of this unnatural union was the monster Kentauros, who then mated with the mares of Mount Pelion to produce the race of Centaurs (Pindar, Pythian Ode II, 20–49).

Like most other discussions of the central metopes, these interpretations are inconclusive and in some cases problematic.[62] But Simon's suggestion allows for a unified interpretation of the entire south series despite the evident shift in mood and content of metopes 13–20. Her identification of the specific subjects, however, may require some revision. Harrison accepts the attributions of Helios and Ixion on metopes 15 and 16, but she argues that the victim on 16 is too young to be the father-in-law. She sees him instead as a younger kinsman said to have been killed by Ixion in a variant tradition (fig. 15).[63] The fragments that have now been attributed to this metope do show this falling victim as beardless.[64] But one would sooner expect Pheidias to have depicted the better-known crime, especially since

the victim's falling posture would suit the manner of Eioneus' murder (he was cast headlong into a fiery pit). Nor is the lack of a beard necessarily indicative of youth, as the beardless gray-haired man in the Centauromachy by the Painter of the Woolly Satyrs shows (fig. 2b, far right). And perhaps the figures in metopes 13–14 are not participants at the wedding of Peirithoös, as Simon maintains, or Dionysos and the youthful exploits of Boutes, as suggested by Harrison. They seem to face or react to the violence on metope 16; they may also be the horrified guests at Ixion's own wedding (fig. 15).

The identification of the figure with the cithara on south 17 as Apollo is sound; he corresponds to Helios in the chariot on south 15, and together they serve as paradigms of purity and moderation who shun the outrage, as Simon suggests. But her identification of number 18 as Aidos and Nemesis is not compelling, especially in view of the carefully rendered cloudlike forms along the baseline of the metope. If the identification of the central metopes with the Ixion myth is at all correct, then the righthand figure on metope 18 must be Nephele or the "cloud-Hera." The identity of the figures to the left is unclear. The larger draped figure behind her might be Zeus himself fashioning the object of Ixion's deluded *hybris,* or perhaps Ixion in pursuit of the cloud-Hera. Praschniker long ago noted the archaism in pose and drapery of the righthand figure. By the mid-fifth century, this stylistic treatment had become a convention for depicting works of art, as well as a conscious reference to the past. In the case of Nephele, the archaic stylization would have served specifically to indicate fabrication or artifice, as a visual reminder that she was unreal or unnatural, while the old-fashioned detail could also have been meant to place this fabrication in an earlier, mythic period.[65] The "real" female figures in contemporary style on metopes 19 and 20 may be the actual Hera and her companion goddesses pondering the outrage of Ixion, and the couch in number 20 may be that of Hera and Zeus. Or one may follow Harrison's suggestion that these metopes take us back to the wedding of Peirithoös, amidst the bridal preparations, just before the battle breaks out (fig. 15).[66]

As Simon argues, the insertion of this myth in the south metopes would have performed an essentially etiological function; it explained both the origin of the Centaurs themselves and their hybristic impiety toward guest-friendship as an inherited propensity that originated in the very circumstances of their creation.[67] But this etiology subsumed much more than the outrage against *xenia.* The crimes of Ixion constituted an affront to the sacred institution of marriage and, by extension, to the entire social order that marriage regulated.[68] By killing Eioneus, Ixion sought to avoid paying the bride-price. The murder of his father-in-law was not only the slaying of a kinsman and a guest; it treated with contempt the laws of social exchange

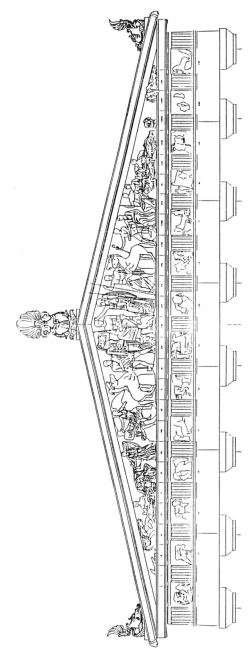

Figure 18. Parthenon, east pediment, reconstruction (from E. Berger, *Antike Kunst*, 20, 1977, Falttafel II).

160

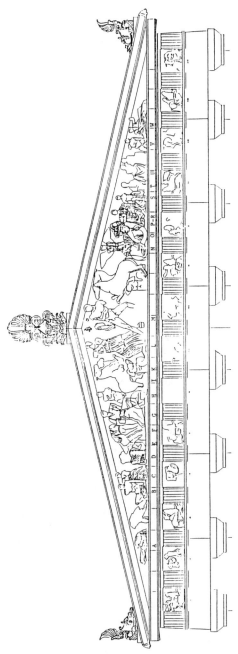

Figure 19. Parthenon, west pediment, reconstruction (from E. Berger, *Antike Kunst*, 20, 1977, Falttafel III).

161

that marriage facilitated. Yet even this was not enough. He committed this outrage once again and on an even grander scale by attempting to violate the archetypal marital union of Zeus and Hera. Ixion's *hybris* was not only an excess of presumption and impiety, but *ate,* an insatiable impulse for transgression that knew no limits or fear of reprisal, a willfulness immune to the lessions of experience.[69]

If this identification of the lost metopes is indeed correct, then it adds greatly to our understanding of the entire south series. To anyone familiar with the Lapith legend, the central metopes would have appeared as far more than a device to relieve the visual monotony of combat scenes between man and beast. As depictions of Ixion, they become the conceptual heart of the entire sequence, a paradigm within a paradigm, which helped to clarify the crimes of the Centaurs as an attack against the very basis of civilized life, provoked by an inborn and relentless hostility to divine authority. The sculptures on the south flank of the Parthenon addressed the crime of implacable desire as a major threat to social and moral order, and to that extent they served the same purpose as those of the west facade. Together they utilized the variable analogues of untamed animal and untamed female to articulate this theme, just as the paintings of the Theseion had done a generation earlier. But if Pheidias strove to intensify this theme on the West by juxtaposing the Amazonomachy with the contest of Athena and Poseidon in the pediment, he was no less zealous in his approach to the Centauromachy. On the South, however, where the tectonic possibilities allowed only for metope sculptures, he expanded upon the theme of insatiable outrage by nesting the Ixion myth in the very midst of the Centauromachy.[70]

All across the west facade, as we have seen, this strategy of analogic reinforcement tightened the ultimate parallel between Amazon and Persian by attuning the viewer to the womanish power-lust considered inherent to Asiatic imperialism. By extension, then, it seems plausible to interpret the attempts to amplify the lessons of the south metopes in much the same terms. Like the painted Centauromachy in the Theseion, the south metopes exemplified the antithesis of a character adrift in uncontrolled and violent desire, devoid of respect for god or man, and a character governed by discipline and moderation, whose primary commitment was the maintenance of law. Since this was the very polarity that Aischylos and Herodotos had utilized as their model for explaining the confrontation between Persia and Greece, the logic of the equation between Persian and Centaur would have been apparent to those who experienced the Parthenon, just as it had already impressed the spectators at the Theseion for more than twenty years.

Yet the addition of the Ixion myth, with its special emphasis on insatiable greed and impiety, would have greatly refined the analogy between Persian

and Centaur. Pindar's account in Pythian Ode II (25–29) stresses Ixion's inability to be content with his exceeding good fortune and great wealth. Moved by the "spirit of madness," Ixion craves the things that belong to his Olympian benefactor. The *hybris* that he manifests is the outrage of the rich and powerful who cannot control their superior position. We need little more than a change of costume and setting to make the transition from Ixion to the Amazons as Lysias describes them, or to the image of the Persian monarch familiar in Aischylos, Herodotos, or the orators: dissatisfied with all Asia, Xerxes and the Amazons must have Europe as well.[71] Like Ixion, Xerxes is not content even with earthly wealth or dominion: he must master the powers and prerogatives of the gods; he too is possessed by "some spirit of madness or distemper of the mind."[72] And like the Amazons, who could not learn from their mistakes, Ixion's persistent desire to defy the law and limit established by Zeus, even at Olympos, also prefigured the self-destructive intransigence or *ate* of Xerxes, who similarly failed to let the disasters of the preceding generation of Persians in Europe curb his irrational appetite for misfortune.[73] The Centaurs themselves could certainly evoke the savage and unrestrained violence of the Persian campaigns in Greece, as we saw earlier. But the inclusion of their progenitor Ixion infused the depiction of their crime even more specifically with an aura of reckless, hereditary insatiability, and a fundamental hostility to divine authority that could mirror and surpass the analogous qualities of the Amazons in prefiguring the Persians.

Considering this, it is surprising that some scholars, including Simon, are disinclined to see the south metopes as a mythic guise for the defeat of the Persians. In focusing upon the ancestry of the Centaurs as descendants of Ixion and relatives of the Hellenic Lapiths, they prefer to interpret the battle as a paradigm for internal Greek conflicts.[74] Here Simon indicates the struggles of Athens with Sparta, although the Thebans also come to mind. Thomas, in keeping with his suggestions concerning the Centauromachy on the Theseion, proposes a compromise of sorts in which the Centaurs of the south metopes could be seen to prefigure Greeks who had sided with the Persians.[75]

Nevertheless, such interpretations seem to misread or at least exaggerate the implications of the Centaurs' ancestry. The begetting of the Lapiths was natural and lawful, entirely within the prescribed bounds of social order and human sexuality. The creation of the Centaurs, in contrast, was fundamentally unnatural and criminal. It began with Ixion's impious lust for Hera; it was consummated through a bizarre union with the phantom Nephele, without the blessing of the Graces (cf. Pindar, Pythian Ode II, 42); and it was then extended by the monstrous Kentauros, who compounded his unnat-

ural, inhuman inheritance by mating with animals. The end result, the race of Centaurs, was hardly equivalent to the Lapith nation; the differences between them were ethical or cultural as well as physical.

Consequently, the Centaurs do not offer a valid analogy for the Spartans or even for the Athenians' Medizing enemies, who, despite the flaws ascribed to them, were at least Hellenic and wholly human. In the case of Medism especially, betrayal presumes equivalence. One can see the mythic Thebans or the suitors at Ithaka as analogues of treason primarily because they existed *within* the Greek society whose laws they had violated. As components in a system of mythic prefiguration, the Centaurs were fundamentally different. They were outsiders in every sense except the geographic, existing beyond nature, beyond law, and beyond the norms and conventions that defined Greek life, as duBois has shown. To Sophokles they were symbols of the monstrous and bestial, enemies of mankind and civilized life, directly comparable to the Hydra, Kerberos, the Nemean lion, and the Erymanthian boar (*Trachinian Women,* 1089–1100). As such the Centaurs were no more Hellenic than these other monsters and the Titans or Giants, with whom Xenophanes also compares them.[76] For this reason it would have been difficult to equate the Centaurs with Greek enemies of any kind.

Admittedly, a few of the Centaurs in the south metopes lack the grisly visage illustrated here in figure 17, but this is not necessarily symptomatic of a larger High Classical tendency to conceive of the enemy in more human and empathetic terms, as Rodenwaldt argued and as Schindler has more recently reiterated.[77] Considering the damaged state of the metopes today, the implication of these details is hard to determine. Of the twenty-three metopes that originally depicted the battle itself, only twenty survive in full or partial form, and nine no longer have the Centaur's head. Six (nos. 1, 2, 7, 26, 31, and 32) show the Centaur's face as bestial or masklike; number 29 is somewhat less animal, but still coarse, porcine, and lustful; only four (nos. 4, 5, 9, and 30) depict the Centaur with the more humanized, Pheidian facial type emphasized by Rodenwaldt and Schindler. Sadly, Carrey's drawings offer no reliable evidence here. Even though only one of the Centaurs' heads was missing at the time, his renderings of south 1, 2, 7, 26, 31, and 32 record none of the rage and bestiality still discernible in the Centaurs' faces today (cf. fig. 15, no. 31, and fig. 17). Thus it is impossible to ascertain how prominent a role this human aspect originally played in the overall series.

The inclusion of some Centaurs with a more manly facial aspect may have been intended to suggest internal conflict stemming from the creature's mixed nature or heritage. But in the context of the overt violence and impiety indicated by the drinking vessels overturned or brandished by the more

"humanized" Centaurs in numbers 4 and 9, this approach would seem only to have underscored the inability of the composite monster to overcome its *inhuman* proclivities. Even these less animal Centaurs exhibited a basic and characteristic aversion to Greek custom, and one that was as foreign in its way as the conception of the Asiatic Amazon. If the image of the Centaur did indeed function among the fifth-century Greeks as a guise for a contemporary enemy, then it can only have been the Persian, and thus one should understand the Centauromachy on the south metopes as entirely comparable to the themes depicted in the metopes on the east, west, and north facades.

The North Metopes: The Iliupersis

On the Parthenon, the goal of intensifying the existing tradition of mythic comparison was not limited to the addition of the Gigantomachy or even to thematic elaborations of the sculptures on the west and south facades. It is also evident in the choice and treatment of the Iliupersis as the fourth series of metopes on the north flank of the temple (fig. 16). The simultaneous juxtaposition of Amazons with Centaurs and Trojans that now unfolded around the Parthenon drew upon the analogical strategies of the Theseion and the Stoa Poikile respectively. In the Kimonian monuments, however, the effect had been more disparate. At the Theseion, the outrageous immoderation or insatiability attributed to women was made to parallel the similar propensities of untamed animals or monsters; in the Stoa paintings it had been compared to the unrestrained Asiatics of Troy. So it was on the Parthenon as well, but now these elements finally came together as a unified system, one complex polarity opposing the male Greek or Athenian *ethos* to the triple antitheses of female, animal, and barbarian.

It is perhaps surprising that the muralists of the preceding decades had not already attempted the simultaneous juxtaposition of all three themes, since the Trojan epic related so effectively to the others. The discussion of the earlier painted monuments has already stressed the strong analogies between the affronts to *xenia* and marriage committed by the Trojans and the Centaurs, but the inclusion of Ixion himself in the south metopes would certainly have heightened such parallels. His presence reminded the viewer that Paris and his supporters indulged in the *hybris* of the wealthy and powerful, whose exceeding good fortune had only made them more arrogant and desirous of the possessions of others, regardless of law or custom. The Ixion analogy also helped to emphasize that Paris' outrages against wedlock and guest-friendship were crimes against Zeus, and not only against

mortals. Here, such thematic connections would have gone hand in hand with the effects of tectonic placement. The Centauromachy and Iliupersis occupied the two long sides of the Parthenon, and in the language of architecture, tectonic equivalence could accentuate analogies in content. To the contemporary spectator, this calculated reinforcement of the ethical sense of the myths would have provided a doubly effective mythic guise for the lawlessness and arrogant greed of the Persian king.

The Iliupersis also ran directly into the Amazonomachy around the corner on the west facade, and, as in the Stoa, the Fall of Troy on the Parthenon complemented the Amazon invasion in causal terms. Since Perikles himself is known to have referred to Troy as a barbarian city in his speeches, the fundamental identity between these two mythic enemies of Greece would not have been lost on the Athenians of this period.[78] Here again Theseus' defense of Attika against the lawless aggression of Asia will have appeared to precede the offensive or punitive expedition against the Asiatic enemy in the succeeding generation, an effective parallel for the events of 490–479 and the subsequent campaigns that had made Athens supreme in the Aegean and the western Asiatic coast. The highly visible confluence of the metopes along the north and west facades of the Parthenon would have helped as well to underscore the deeper ethical analogy between Trojan and Amazon that was already a central issue in the Stoa: the reckless and insatiable appetite for dominion that repeatedly led the peoples of Asia to grief and destruction.

The subjects of the adjacent north and east metopes complemented one another equally well, since the downfall of the Trojans was also directly comparable to that of the Giants in the minds of fifth-century Greeks. When, in the closing lines of Bakchylides' First Dithyramb, Menelaos warns of the consequences of hybristic lust and irreverence toward the authority and precepts of Zeus, he leaves the Trojans to ponder the analogy of the arrogant Giants (see Appendix, lines 50–60).[79] Several decades later, in *Hekabe* (466–474), Euripides too connected these myths in his depiction of the captive Trojan queen. As she recalls the defeat of the Titans (that is, the Giants) that was embroidered on the *peplos* of Athena, Hekabe also considers her own country's destruction. Since she then describes Troy's ruin as a victory of Europe over Asia, it is clear how readily the paired analogy of Giants and Trojans could also allude to the defeat of Persia for the Greeks of this period. On the Parthenon, the direct juxtaposition of these mythic themes in the north and east metopes made the same comparison; like the works of contemporary poetry, the sculptures applied these myths as parallel analogues for the just punishment of those who transgressed the lawful order established by the gods.

What emerges most clearly from this continuous chain of relationships is

the pivotal and profoundly ethical role played by the Fall of Troy within the larger sculptural program that encircled the Parthenon. Here, as in the paintings of the Lesche and the Stoa, it appears that the Greek attackers must also have functioned in positive, heroic terms—vindicators of law and agents of divine justice. Another votive monument on the Akropolis recorded by Pausanias (I, 23, 9–10), further supports this view. Not long after the Parthenon was completed, Chairedemos, son of Euangelos, commissioned the sculptor Strongylion to construct a monumental bronze depicting Teukros, Menestheus, and the sons of Theseus looking or stepping out of the Trojan horse.[80] This work clearly aimed at glorifying or bolstering the Athenian role in the capture of Troy, and in terms that immediately recall the reference to Menestheus in the verses on the Eion herms, or the speech of the Athenians at Plataia in Herodotos (IX, 27).[81] Since the statue originally stood in or just outside the Brauronion, directly adjacent to the Parthenon, it is very likely that its heroic Athenians were meant to parallel the more extended depiction of Troy's capture in the nearby north metopes.

Yet if Pheidias and/or those who may have advised him put so much care and thought into the planning of the program, and if he was indeed so critically conscious of the strategies that he had inherited from the muralists of Kimon's day, then he must also have recognized the problems involved in applying the Fall of Troy as a mythic exemplum of noble, heroic action. Whatever the successes of Polygnotos, one cannot assume that the great painter had permanently dispelled the inherent contradictions between the earlier artistic and poetic tradition of the Iliupersis and the more recent inclination to utilize it as a prefiguration of the struggle with Persia; nor should one assume that the supervisor of the Parthenon sculptures could readily have transposed the novel aspects of Polygnotos' version of this theme to the format of metope reliefs. Pheidias too had to come to terms with those aspects of the myth that reflected poorly on the Greek character before he could make it function alongside the other themes of the metopes as a plausible and effective analogue for the victory of Hellenic *arete* against the barbarian. Here as well it remains to be seen how he dealt specifically with this problem.

In the case of the Parthenon, unlike the Troy paintings, we have the advantage of considering extant remains rather than the verbal descriptions of ancient witnesses. However, with the study of the north metopes, ravaged by time and war, we enter upon difficult terrain where the observations of Pausanias are sorely missed. Less than half of the series survives, and a number of metopes are too damaged to allow more than a general identification. Most scholars have agreed that metopes 24 and 25 represent Menelaos recovering Helen ever since Michaelis first pointed out their connection

with an Attic red figure oinochoe where the participants are identified by inscriptions (fig. 16).[82] Metope 28, showing a warrior, a boy, and two draped figures, can also be securely identified as Aineias escaping with Askanios and Anchises.[83] Consequently, there is no doubt that the north flank of the temple depicted the Iliupersis.

From this point our understanding of the metopes becomes increasingly vague. Metopes *D* (i.e., 23) and 27 show female figures led away by males, probably as refugees or captives (fig. 16). It is likely that one of these, or perhaps a similar scene among the lost metopes, depicted the rescue of old Aithra by her grandsons Akamas and Demophon.[84] Metope 2 shows a ship with male figures descending the gangplank. Adjacent metope 3 depicts an archer and a hoplite. The specific identity of the Greeks on metopes 2 and 3, and whether they are arriving or departing, is still contested.[85] Of metope *A,* with a standing male and a rearing horse, we know still less; even its precise location on the north side is undetermined.[86]

The study of the north metopes is fraught with controversy, as the surveys of scholarly opinion in the recent monographs of Brommer and Berger demonstrate too well. But certain facts do emerge. The Parthenon depicted the Iliupersis in the true sense; we see the nocturnal sack itself as the Greeks recover Helen and possibly Aithra, and Aineias and his family escape the death or captivity that befalls their fellow Trojans. This is not the morning after, and apart from the ship in metope 2, there is virtually no formal analogy with the Polygnotan conception of the Fall of Troy.[87] Nor is there any clear evidence that Pheidias attempted to equate the Trojans with the Persians by depicting them in oriental costume, as Polygnotos may have done. The only preserved figure of a Trojan warrior is the badly damaged Aineias on metope 28, who is naked and carries a circular hoplite shield, just like Menelaos on north 24. If Berger is correct in identifying north 27 and lost metope 26 as the departure of Antenor and Theano, it might provide some further similarity to the painting in the Lesche. However, this scene is also paralleled in Attic vase painting,[88] and it is the tradition of vase painting that provides the clearest analogies for the choice and typology of the Iliupersis scenes on north 23–28 (cf. fig. 16 with figs. 8–9).

Because of these connections with vase painting, scholars have repeatedly assumed that the missing north metopes must have included the other key elements of the Attic red figure cycle of the Iliupersis: the murders of Priam and Astyanax, the rape of Kassandra, and the Trojan woman fighting off the Greeks with a pestle.[89] Dörig's reconstruction of lost metopes 20–22 is based directly on the versions of the Kleophrades and Brygos Painters.[90] But these expectations may well be unfounded. One simply cannot disregard the fact that none of the extant north metopes depicts the excessively

base or violent scenes associated with the sack. There are scenes of rescue or captivity, escaping refugees, and the arrival or departure of the Greeks, and these are, as Ridgway has observed, remarkably toned down for an Iliupersis—so much so that one might for a moment doubt the identification of the theme here.[91] Nor is it possible to explain away the lack of impiety and savagery as the result of random destruction. The losses on the north facade are concentrated in the first two-thirds of the metopes, and it is there that one would have to place almost all such scenes. In that case it would be necessary to explain why Pheidias polarized the metopes thematically, clustering the episodes of slaughter and impiety and separating them from the scenes of survivors, instead of juxtaposing them directly as Lydos and the Kleophrades Painter had done (figs. 8–9).

The assumption that scenes of savage impiety once appeared in the north metopes also creates enormous thematic difficulties. By simply postulating that the series adapted the entire range of Iliupersis scenes established in contemporary vase painting, one is ultimately assuming that the north metopes also retained the original symbolic content and purpose of such ceramic prototypes. Traditionally, as we have seen, this myth served as a profound lesson or warning of the dangers of immoderation that threatened even the Greek heroes. Accordingly, the Greeks in the north metopes would themselves have exemplified *hybris,* in the original sense of the Iliupersis long established in literature and the visual arts. But on the Parthenon this meaning would hardly have made sense alongside the remaining metopes that displayed the struggle of the Greeks and their gods against the lawless forces of chaos and barbaric excess. If the Parthenon metopes were indeed a calculated exposition of Athenian *arete,* a strategy designed to exemplify or explain the deeper conflict between the national character of Greeks and that of barbarians, then nothing would have been more inappropriate than images of the heroic forebears at Troy committing acts of rape and sacrilege, slaughtering old men and children, and desecrating the shrines of Zeus Herkeios and Athena herself. Had Pheidias and his fellow sculptors portrayed these episodes, it would have subverted the underlying themes of moderation, piety, and excellence that had become basic to all official, public expressions of Athenian ideology, and that so effectively rationalized Athens' victory over the Persians.

From this point of view, the putative inclusion of the more violent, shameful scenes of the Iliupersis raises more problems than it would solve, in spite of the extensive gaps that remain unfilled along the west facade. The restoration of the missing north metopes solely on the analogy of vase painting ultimately calls into question the programmatic logic or harmony of the sculptures that decorated the Parthenon. Unless we are prepared to do so,

there is good reason to doubt that Pheidias would have included scenes of Greek excess and impiety. Therefore, it is probably not fortuitous that the surviving north metopes show no hint of this. Indeed, the impression is quite the opposite: *sophyrosyne* and rectitude rather than *hybris* on the part of the Greeks. In metopes 24 and 25, Menelaos desists from his rage in deference to the will of Aphrodite, who, through the visible aid of Eros, intercedes on behalf of the terrified Helen, just as Aineias must survive the catastrophic revenge of the Greeks under Aphrodite's protection on north 28 (fig. 16).[92] If the rescue of Aithra appeared here in north *D* (23) or 27, then the metopes would also have asserted familial piety as an Athenian trait.[93]

Reconstructions of the missing north metopes should depend primarily on the careful study of what remains, and on antiquarian drawings that may yet come to light. In the end, the allocation of three or four metopes to scenes of rape and sacrilege would barely fill the nineteen empty spaces on the north facade. The opinions of Picard and Studniczka that multiple scenes of massacre once occupied this void were purely conjectural.[94] Barring any new hard evidence to the contrary, it is probable that the north series presented a unified Trojan theme without the inclusion of additional legends, as some scholars have claimed.[95] But until the arguments concerning the narrative sequence of the metopes from left to right or vice versa are resolved, there can be no certainty or probability about the precise contents of north 4–22.[96] If one could determine that the ship in metope 2 was arriving, these metopes could have contained events leading up to the sack, or even scenes from the ten years' war, as Dörig and Jeppesen have proposed.[97] The fragments ascribed to the north metopes by Praschniker and Brommer would not conflict with this. In fact the fragments that Mantis has recently attributed to one of the north metopes show a struggle between two male figures, one with traces of a helmet crest.[98] Perhaps an extended series of combat scenes between Greeks and Trojans during the sack once filled the space, and/or more metopes of women led off as captives, a powerful symbol of conquest and punishment. The possibilities are many, but there is currently no proof that the north metopes ever included scenes of criminal excess on the part of the Greeks.

If, however, one takes the surviving data at face value, a very different picture of the Fall of Troy begins to emerge in these sculptures, and one that still reflects something of the innovations of Kimonian times. As indicated earlier, the iconography of the north metopes shows little analogy with what we know of the Troy paintings in the Knidian Lesche and the Stoa Poikile. Because of the substantial differences in time-frame and in the particular choice of episodes, it is highly unlikely that there was any direct and extensive formal or compositional similarity between the Parthenon and these

works, as Picard and others once maintained.[99] But if the arguments presented here are correct, Pheidias did assimilate the most important and distinctive aspect of the Polygnotan approach to this theme: the fundamental concept of selecting and recasting the narrative elements of the Iliupersis to render it a more effective comparison for the circumstances of the present. Pheidias utilized certain key scenes like the recovery of Helen or the escape of Aineias that could readily identify the subject matter. But he avoided the sacrilege of Priam's murder at the altar of Zeus and the rape of Kassandra in Athena's temple, so that the Greeks could appear to display moderation before the gods in punishing their Asiatic enemies as a suitable mythic analogy for their triumphs over the Persians.

Polygnotos' solution had been more radical: he chose to illustrate the aftermath of the sack in a relatively static setting. He focused pensively on the consequences of human action rather than the action itself to produce a pictorial imagery that was entirely novel and probably unfamiliar to his audience. In contrast, Pheidias appears to have taken a more traditional approach, but one that was arguably more effective for the sculptured metopes of a temple. By showing the sack itself, he was still able to rely on established iconographic formulae that could be recognized at a distance without the aid of accompanying inscriptions, while using only those scenes that reflected well upon the Greeks. In a sense his manipulation of the myth was intrinsically more subtle and acceptable than that of Polygnotos. Pheidias transformed the tone and content of the Iliupersis without apparently breaking away from the visual formulae that his audience had come to expect for this theme, a tactic far more suited to a public monument.

There can be little doubt as to Pheidias' reasons for adapting the Fall of Troy in this way. Like Polygnotos, he strove to make this theme workable alongside the others as a paradigm of divine justice administered through the agency of the Greeks, and here again he managed to reinforce such usage by interpolating additional elements within the larger sequence of the metopes, as he had for those on the south facade. The entire series of north metopes begins and ends with divinities. The goddess astride the horse on north 29 is Selene, as the remains of the lunar disk in the upper right indicate (fig. 16).[100] The astral divinity in the rising chariot of north 1 would seem to complement the descending Selene of 29, but its damaged state makes the gender and precise identity as Helios, Nyx (Night), or some other deity hard to determine.[101] The seated mature god facing a winged divinity on north 31 is generally accepted as Zeus with Iris.[102] The badly effaced standing gods of 30 and the seated and standing goddesses of 32 have not been identified conclusively, although north 30–32 seem to have formed an extended group with Zeus at their center.[103]

The inclusion of this suite of divinities essentially reversed the pattern of the south metopes: instead of inserting the gods into the middle of the series, Pheidias nested the entire Iliupersis within an enclosing framework of divine action or supervision, a strategy that would have been crucial to the highly rationalized and edited presentation of the Fall of Troy proposed here. While the identities of only Zeus, Iris, and Selene on metopes 31 and 29 are secure, they are sufficient to give some idea of the meaning of the ensemble as a whole and its relation to the adjacent scenes. Praschniker identified these metopes as *dios boule* (a divine assembly or council), which he saw as causally related to the scenes of the sack. He based his argument mainly on Tryphiodoros, *Taking of Ilion* (506–507), where Zeus weights the scales of judgment against Troy on the night of its fall.[104]

But there is more evidence of this kind. We have already seen how in the *Agamemnon* Aischylos repeatedly ascribes the Trojan War and the destruction of Troy to the will of Zeus Xenios as fitting punishment for supporting Paris' outrage against the hospitality of Menelaos. In lines 355–366 the chorus applauds Zeus Xenios as he and the goddess Nyx ordain the imminent destruction of Troy. On the Parthenon it is difficult not to see such a connection between Zeus on north 31 and the scenes to the left, especially since a nocturnal deity, in this case Selene rather than Nyx, also appears on north 29 (fig. 16). Her association with Nyx during Troy's destruction is, however, attested by a fragment of Lesches' *Little Iliad* relating the events leading up to the sack: "It was in the midst of Night (Nyx), while radiant Selene commanded."[105]

In Bakchylides' First Dithyramb on Troy, Zeus and his celestial acolytes play the same role. The fragmentary opening section even preserves a reference to "nocturnal" or "midnight doom," reminiscent of Lesches' or Aischylos' Nyx in this context. The latter part of the poem especially stresses the Trojans' responsibility toward Zeus and his helpmates Dike (Justice), Eunomia (Good Order,) and Themis (Right) and the inevitability of their destruction if they persist in their hybristic abduction of Helen (see Appendix). Here Bakchylides does not give Zeus the specific epithet of Xenios, but this aspect of the god is implicit both in the context of the poem and in Zeus' association with Themis, whom Pindar celebrates expressly as the *paredros* or coadjutor of Zeus Xenios in the roughly contemporary Eighth Olympian Ode (lines 21–22). Quintus of Smyrna recounts the fate of Troy in similar terms. During the sack, Menelaos has just killed Deiphobos, Helen's latest Trojan consort, and as he prepares to recover what is rightfully his, he exults above the corpse in the retribution that the gods have enabled him to exact:

It was not destined that my wife should bring you pleasure, since sinful men never escape pure Themis. For both night and day she watches them in every region, hovering on high above the tribes of men, punishing with Zeus those who indulge in evil deeds. [106]

Collectively, this literary evidence would seem to support Simon's argument that the divine assembly on the north metopes 29–32 depicted Selene with Zeus and Themis ordaining the Fall of Troy, much as they appear on a fourth-century Attic red figure pelike in Leningrad. [107] Simon's identification of the divine charioteer on metope 1 as Nyx, if correct, would also round out the ensemble of gods on the North as a visual pendant to the Selene, Zeus, and Nyx in the *Agamemnon* and Lesches. [108] But Simon's overall interpretation implies a substantial chronological discontinuity between the assembly of gods and the Iliupersis metopes proper, since the initial ordinance of Zeus and Themis had occurred much earlier, setting the whole matter of the Trojan epic in motion. [109]

Perhaps north metopes 30–32 portray a more contemporaneous divine assembly, like the episode preserved in Quintus' *Posthomerica* (XII, 185–218). There Zeus has just returned with Iris from the realm of Ocean, and with Themis' intercession he settles the hostilities that had erupted near Mount Ida between the pro-Greek and pro-Trojan factions of the gods over the imminent deployment of the wooden horse. The narrative accords well with the placement of Zeus and Iris in a rocky setting on north 31, and it would also suit north 32, even if the seated goddess there is not Themis, as Simon suggests, but Hera, as others maintain. [110] The figure on the left of metope 32 may be Themis. She stands upright and raises her garment in a gesture of appeal that could serve to indicate her righteous pleading with the other divinities to accept the will of Zeus (fig. 16). [111] Thus these metopes would depict the moment when the discord among the gods was terminated; the earlier ordinance of Zeus and Themis was thereby finalized, and the doom of Troy could begin. [112]

But whether this is correct, and whether or not Themis herself appears on the north metopes, the presence of Zeus here must to some extent involve his roles as Xenios and disseminator of justice—as punisher of the outrage that Paris and his countrymen committed against the religious obligations of hospitality and moral law. If Bakchylides and Aischylos are any guide to the significance attributed to this myth, then this aspect of Zeus and his righteous female acolytes was central to the theme of Troy's destruction in the minds of mid-fifth-century Greeks. On the Parthenon, Zeus and the other gods on the north facade must serve, at least in part,

to justify and explain the scenes of the Iliupersis preserved on metopes 23–28.[113]

In a sense, however, the inclusion of these deities constituted a form of overkill. The use of the Gigantomachy already asserted the issue of divine inspiration for all the accompanying metopes, as indicated earlier. Consequently, the added emphasis on the will of Zeus and his fellow deities in the north metopes betrays how earnestly and consciously Pheidias strove to improve and legitimize the actions of the Greeks at Troy's fall. In doing so he wanted them to appear as unquestionable executants of the divine retribution incurred by an insolent, Asiatic foe, just as Quintus describes the Greeks in the *Posthomerica* (XIII, 368–381). By avoiding the negative aspect of the Greeks' behavior and by interpolating the divine assembly in this way, Pheidias made certain that his Iliupersis would equal the moral or religious implications of the heroic themes on the South and West, to achieve a unified and consistent system of mythic analogy.

As a result of his efforts, the Parthenon constituted the most strident artistic expression of the Hellene/Barbarian antithesis yet attempted on a public Greek monument. In its sculptures Pheidias attained a new level in a generation-old campaign to vilify the Persians in the guise of mythic antagonists, and to rationalize the Hellenic victory over this enemy as the inevitable outcome of superior character and divine intervention. The program that he produced was the consummation of the Athenian public imagery created over the preceding two decades, a carefully planned network of comparison and resonance devoted primarily to advertising Athenian excellence in close connection with the superiority of their patron goddess. All across the sculptures of this temple whose very rebuilding perpetuated the memory of irreverent Persian aggression, Xerxes and his followers were caught in a web of analogies connecting the insatiable recklessness and impiety of Alkyoneus and Porphyrion with that of Ixion, Paris and Priam, and the female imperialists of Asia's past. In every case, these enemies had met their end according to the dictates of divine justice and law, either at the hands of the gods themselves or through the agency of the Greeks or Athenians who served the gods under Athena's watchful care. Within the temple, this message resounded across Pheidias' colossal statue of Athena as she extended Nike, "Victory," to the Athenians in her outstretched hand.[114] For those who had the Parthenon made, there could be no question about the help and inspiration that the gods had always given the Athenians in their struggles against the barbarian; nor was there any doubt about the quality of the Athenian character that had guaranteed such intercession.

Epilogue: The Iliupersis After Polygnotos and Pheidias

Today we might consider these efforts to neutralize or transform the original sense and impact of the Iliupersis as somewhat artificial and disingenuous, but in the decades following Plataia this project was clearly the order of the day. Kimon had transformed the Aegean into an Athenian lake, breaking for a time the power of the Persians throughout the coasts of western Asia Minor. As Perikles consolidated and expanded upon Kimon's initiatives, Athens entered her greatest period of military, political, and cultural prestige. In such a climate it is not surprising that Greek epic traditions would be made to conform to historical actualities in order to propagate the agenda of the developing Athenian Empire. Yet even though the highly specialized and idiosyncratic approaches of Polygnotos and Pheidias to the Iliupersis were very much a product of their times, it is still useful to assess the importance of these innovations by examining the impact that they exerted on the representation of Troy's fall in subsequent Greek art.

A brief look at drama provides some context for this later development. In the *Cyclops,* Euripides had given Paris the airs of a Persian noble. In *Hekabe,* produced in 425 B.C., and the *Trojan Women* a decade later, Troy is also a barbarian or Asiatic city, as we had seen. But in spite of this, these plays still presented the traditional view of the myth, in which the sympathy and empathy of the audience gravitated toward the tragic despair of the captives in opposition to the cruel excesses of the Greeks. In the opening portions of the *Trojan Women,* Athena exhorts Poseidon to destroy the homebound Greek fleet with the aid of Zeus in payment for their sacrilege (77–86). The sea god responds in agreement:

> Fool among mortals who in sacking towns
> lays waste the temples and tombs, and sanctuaries of the dead.
> Entering upon desolation, he himself is next destroyed.[115]

Once again it is the Greeks who most resemble Aischylos' portrayal of Xerxes, whose impiety and excess invite destruction. Later, as the Greeks tear Astyanax away from Andromache and prepare to murder him, she curses them with an epithet more suited to a Persian than to men of Hellas:

> O Greeks who have come to know the cruelties of barbarians,
> Why slay this blameless child? . . .

> O ruin upon the many barbarian Greeks.
> May you be destroyed.[116]

It is not surprising that a dramatist would cling to that aspect of the myth that best suited the nature and purpose of tragedy. Here, Euripides may actually have been using a mythic guise to condemn the recent atrocities inflicted on the people of Melos in reprisal for a revolt against Athenian authority in 415 B.C.[117] If this is true, then the barbarian cruelties that the Greeks have come to know are indeed ultimately those of the Persians, in a period when the Athenians now replaced them as ruthless masters of the Aegean and the coast of Asia Minor.

In Athenian visual arts, however, the gruesome Iliupersis of Archaic and Early Classical times did not weather the changes of the Kimonian and Periklean periods so well. Despite the prolonged and enormous popularity that it had enjoyed earlier, the frequency of this theme in Attic vase painting fell off sharply after the middle of the fifth century. The murders of Priam and Astyanax, the woman with the pestle, the rescue of Aithra, and Aineias' escape all disappeared as components of this theme; from this period there are only representations of Menelaos recovering Helen and one or two showing the rape of Kassandra.[118] The reasons for this are obscure; nor does it appear that the traditional form of the Iliupersis was supplanted by the new recension in the Lesche or the Stoa Poikile, for unlike the famous monumental Amazonomachies and Centauromachy, or the Marathon painting, Polygnotos' depictions of Troy have left no apparent reflections in Attic red figure of the second and third quarters of the fifth century. In Moret's opinion, Polygnotos had broken so decisively with the canonic representation of the Iliupersis in ceramic art that Attic vase painters were unable to assimilate his innovations.[119]

Elaborate depictions of the Iliupersis briefly reappeared in Attic red figure works at the end of the fifth century, like the krater from Valle Pega (fig. 20), and by this time they had changed substantially. Only the figure of Kassandra clinging to the Palladion adheres to the original conception. Priam, as we have seen, is now dressed like an oriental, if not a Persian. He still appears at the altar of Zeus Herkeios, but he no longer collapses helplessly or sits with his hands raised in panic as Lydos or the Kleophrades Painter had shown him. He resists physically, and he has just fallen back against the altar in his struggle with Neoptolemos (fig. 20). Nor does Neoptolemos dangle the corpse of Astyanax: the child has been transposed to the arms of his mother, who for some reason sits calmly at the side of the altar while her son reaches toward his grandfather. A standing, resistant Priam in a Phrygian cap or bashlyk also appears in the Iliupersis scenes of

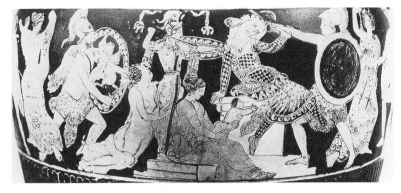

Figure 20. Attic red figure volute-krater from Valle Pega, Spina, Ferrara, Museo Nazionale di Spina, T 136 VP (from *Corpus Vasorum Antiquorum*, Italia, fasc. XXXVII, pl. 13, 4).

fourth-century Apulian vase painting, clearly derived from the new Attic version, although Astyanax has disappeared entirely from these later Italiote examples.[120] One other Apulian vase at Lecce shows Kassandra seated pensively near the Palladion while Aias stands relaxing to her left, both strangely juxtaposed with a running, frightened woman or priestess at the right (fig. 21).[121]

The sudden change in Priam's costume and attitude in late fifth-century Attic and fourth-century Italiote Greek vase painting is startling enough, but the calm and pensive figures of Andromache, Kassandra, and Aias in these works are blatantly at odds with the action and violence of the sack itself. In this context they are senseless, and they have all the earmarks of an interpolation from some other source. In his initial publication of the Valle Pega krater, Arias emphasized the extraordinary nature of the group of Andromache and her son, unparalleled in earlier vase painting, but recalling Pausanias' description of Astyanax and his mother, and of another child reaching toward an altar, in the Lesche painting (fig. 10a, right, and 10b). He suggested plausibly that the Attic vase painter had conflated two elements of the Polygnotan prototype and introduced them into an Iliupersis of more standard form.[122] Moret pointed to the same source, for the same reasons, to explain the peculiar calmness of Aias and Kassandra on the Lecce vase, which compares to Pausanias' description of the "oath scene" in the Lesche (cf. figs. 10b and 21).[123] Presumably the Lecce vase too derives from an Attic red figure forerunner contemporary with the Valle Pega krater.

The evidence indicates that Attic vase painters of the late fifth century produced a hybrid form of Iliupersis. This new conception seems to have used the Pheidian approach, depicting scenes from the actual sack in terms

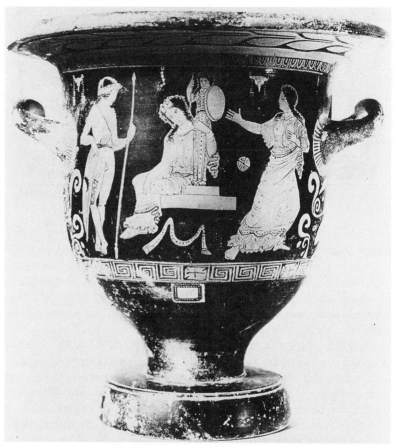

Figure 21. Apulian bell-krater, Lecce, Museo Provinciale Sigismondo Castromediano, 681 (from J. Moret, *L'Ilioupersis dans la céramique italiote; les mythes et leur expression figurée au IVe siècle*, Rome, 1975, pl. 1).

more flattering to the Greeks. But the vase painters combined this revised version of Troy's fall with the more static and pathetic Polygnotan treatment of Andromache and Kassandra, apparently at the expense of the internal logic of the composition. Moreover, the use of these distinctive Polygnotan features in the later Attic and Italiote red figure Iliupersis also tends to support the arguments advanced above that the oriental costume of Priam and the Trojans on these works could derive from the paintings of the Lesche or the Stoa. The more agonistic, struggling portrayal of the Trojan king may

be a wholly new development here. This, together with his new costume, effectively made Priam more an enemy than a victim, just as it transformed Neoptolemos from a butcher back into a warrior. Yet one wonders whether Pheidias may already have depicted a more equal and respectable struggle between the Greeks and Trojans, or even between Priam and Neoptolemos, in the lost north metopes of the Parthenon.

Why, after decades of resistance, did Attic vase painters finally assimilate the innovations of Polygnotos and Pheidias? It could have to do with the prestige that these artists' works may have enjoyed toward the end of the century. More probably, though, the answer is to be found in historical circumstances: a new wave of anti-Persian sentiment in Athens. The Spartans had become the major enemy, but throughout the later Peloponnesian Wars, intrigue and conspiracy with the western satrapies played a major part in the Spartan strategy to undermine the Peace of Kallias and Athenian power in the Islands and Asia Minor. Sparta's crushing defeat of Athens at Aigospotami in 405 B.C. had involved considerable Persian aid.[124] The sculptures of the Temple of Athena Nike on the Akropolis may already reflect this situation. The friezes of the temple itself, completed in the mid-420s, have always been identified as Greeks pitted against Greeks on the North and West, with Greeks fighting Persians on the South, while the somewhat later parapet surrounding the temple included Athena attended by Victories with Persian trophies. Hölscher interprets the north and west friezes as scenes from the Peloponnesian War, and the south frieze as a generalized or unspecified battle between Greeks and Persians. Collectively, they would seem to condemn the collusion between Sparta and Persia.[125]

More recently, however, Felten has challenged the traditional identification of the north and west friezes. He sees the chitons of the opponents here as semibarbaric dress deliberately intended as a contrast to the nakedness of the Greeks; he identifies these opponents as orientalized Trojans, with the duel between Achilleus and Memnon, their Ethiopian/Persian ally, featured in the north frieze. In Felten's view the parallel with the battle against the Persians themselves in the south frieze corresponded to the more general fifth-century tendency to analogize the Trojan and Persian Wars.[126] Indeed, if the south frieze is not simply a generic battle against the Persians, as Hölscher would have it, but the battle of Marathon itself, as Harrison maintained, the pairing of Trojan and Persian themes here would then specifically recall the paintings of the Stoa Poikile.

In any case, the Nike Temple reliefs demonstrate how, in a period when victory no longer came so easily, Athenians looked back fondly to their triumphs against Xerxes and his father. Francis has treated the similar preoccupations of the poetry of this time in his discussion of the *Persians,* a

lyric hymn to Apollo composed by Timotheos of Miletos for public performance in Athens in 410 B.C., which earned its author wide acclaim. Much of the work is lost, but the surviving portions recount the battle of Salamis, culminating in the thanksgiving to Zeus and Apollo for its outcome.[127] Yet if poetic and artistic expression in late fifth-century Athens was happy to bask in the glow of old victories over Persia, it is plausible that the mythic struggle against the Asiatic Trojans should also serve once more as a symbol of the triumph over the contemporary barbarian. All this, especially if Felten is correct in his interpretation of the north and west friezes of the Nike Temple, may help to explain why Attic vase painters of this period turned again to the Fall of Troy, and why they finally accommodated their treatment of the story to the works of art that had first transformed this theme into an effective symbol of Greek victory during the golden period of Athenian supremacy over Persia.[128]

Several decades later, the orator Isokrates still invoked the analogy of the Trojan expedition to incite Athens to war against the Great King, charging that the current humiliation of the Peace of Antalkidas far exceeded the insult of Helen's abduction, just as the conquest of all Asia would overshadow the fame of the Greek heroes at Troy.[129] The Spartan king Agesilaos had already shown how very seriously this ideology could be taken when in 396 B.C., as leader of a new "panhellenic" expedition against Persia, he attempted to sacrifice at Aulis in imitation of Agamemnon.[130] Plutarch's account (*Agesilaos*, VI, 4–6, *Pelopidas*, XXI, 3) lays particular stress on the perceived identity of the Persians with the Trojans as the motivation behind this act. Thomas has accordingly suggested that the monumental display of the Iliupersis on the east pediment of the Temple of Asklepios at Epidauros refers symbolically to this Spartan offensive.[131]

Agesilaos was recalled in 394, although hostilities continued down until 388.[132] Like the neighboring Akte or coastal states, the Epidaurians were allies of Sparta at the time and later in the 370s,[133] so they may have participated in the campaign. Homeric tradition also linked the patron deity of Epidauros with the theme: Podaleiros and Machaon, the sons of Asklepios, the god of healing, were the army surgeons of the Greeks at Troy. And like the Stoa Poikile and the Parthenon, the Temple of Asklepios paired the Fall of Troy with the Amazonomachy, in this case by including it on the opposite west pediment.[134] Moreover, Yalouris has shown that one of the akroteria on this temple represented a Nike, which could help to make the building intelligible as a victory monument.[135] The chronology, however, is problematic. Only Crome would date the building to the time of the actual campaign; Schlörb would put it in the 380s, the period of the negotiations for the Peace of Antalkidas or just after, while Roux, Burford, and Ridgway

would date it later still, to the 370s.[136] But the temple need not be contemporary with Agesilaos' initial expedition to have been intended as an allegorical expression of anti-Persian sentiment. Such feelings would have been equally at home in the two decades following the humiliating terms of the "King's Peace," as Isokrates' harangues demonstrate.

Despite its fragmentary condition,[137] the treatment of the Iliupersis in the Epidauros pediment itself provides the strongest indication that it served such a purpose. The central group showed Neoptolemos and a standing Priam in a Phrygian cap, not unlike the Valle Pega krater, only here Priam resists more vigorously, fighting back with both arms, and he is a nude warrior like his opponent (fig. 22). The scene is overtly agonistic; this is not the murder of a helpless old man, but a struggle to the death with an Asiatic enemy. The expression of pain on Priam's face conveys the anguish of defeat, but it is no more intended to elicit our sympathy than the faces of the Giants on the Altar of Zeus at Pergamon some two centures later.[138] Other warriors grapple to the far left, while Astyanax, still living, huddles against his mother's breast. Next to her another kneeling female grasps a Palladion or a statue of some other kind. She has been identified as Kassandra, perhaps too hastily, for in the fourth century she could easily be Helen about to be spared from Menelaos' rage through the intercession of Aphrodite or Eros.[139] On the other side of Priam, a woman holds a dying Trojan warrior, while a kneeling male protects another child (fig. 22).

The precise disposition of these sculptures is still subject to scholarly debate. The reconstruction illustrated in figure 22 is Beyer's modification of the original scheme proposed by Schlörb. Yet enough remains to see that the pediment reproduces the same sort of hybrid Iliupersis current in later Attic vase painting and related Italiote Greek examples. Here too Andromache holding Astyanax is reminscent of the painting in the Lesche, but again the scene has been interpolated into the sack itself, a sack in which the Greeks appear as warriors pitted against an oriental foe rather than the murderers of defenseless young and old. Nor is the relationship to the forerunners in somewhat earlier Attic vase painting purely visual or formal. It probably reflects the same kind of motivation: like Athenians of the late fifth century, the patrons at Epidauros in the 380s or 370s also sought to present the Iliupersis as a heroic mythic prefiguration of their animosity toward the Persian Empire or eastern culture generally. So long as such needs continued to exist, iconographic solutions of this kind would remain in use.

The Asiatic expedition of Alexander the Great represented the denouement of this process. The young king outdid Agesilaos. He sailed directly to the Troad, not only as a new Agamemnon commanding the united Greeks, but as a new Achilleus. He had in fact emulated Achilleus since childhood,

Figure 22. Restoration of the east pediment of the Temple of Asklepios at Epidauros (after B. Schlörb, *Timotheos*, Beilage, Berlin, 1965, modified by I. Beyer in J. Boardman, J. Dörig, W. Fuchs, and M. Hirmer, *Greek Art and Architecture*, New York, 1967, fig. 168).

and claimed descent from him. All during these campaigns he even slept with a copy of the *Iliad* under his pillow. Alexander would realize once and for all the hopes and expectations of men like Isokrates. At Troy he made offerings at the tomb of Achilleus, while his companion Hephaisteion honored that of Patroklos. But it is significant that this tendentious play on myth could not proceed until Alexander had also assuaged the spirit of Priam with a libation, right where he had died, at the altar of Zeus Herkeios. The new Achilleus did this consciously to rid himself of any lingering taint of the criminal excess of his "ancestor" Neoptolemos.[140]

Alexander's libation to Priam immediately calls to mind the scenes of Aias making amends for the outrage against Kassandra in the paintings of the Lesche and the Stoa Poikile.[141] In fact Alexander had personally consulted the oracle at Delphi just before the expedition to Asia and must have seen Polygnotos' splendid murals among the notable sites there; here it is also worth recalling how Alexander's teacher, Aristotle, recommended generally that the young be exposed to the positive ethical influence of Polygnotos' work.[142] Yet one need not posit the impact of these paintings to understand Alexander's actions at Troy. The parallel resulted just as much from a basic Greek tendency to adjust and harmonize the traditions of myth with the circumstances and ethical claims of the present, a tendency that had informed the goals and strategies of Kimon and Polygnotos, Perikles and Pheidias, as well as those of Agesilaos and Alexander. Such transformation and redirection was central to the monuments, poetry, and rhetoric examined throughout this study, and to the official ideology that these public modes of expression all served. Consequently, it cannot surprise us that once again, and now at Troy itself, the sins of the Greeks in the Iliupersis would be ritually cleansed and bypassed so that the fate of Priam and his people could be made to appear as an apt prefiguration of the justice in store for the Persian king.

5

The Parthenon Frieze,
Persia, and the Athenian Empire

The Frieze and the Ethics of Imperialism

As the most ambitious and elaborate of the fifth-century monuments created to idealize the Athenian state, the Parthenon was unprecedented in its lavish use of architectural decoration: ninety-two sculptured metopes around all four sides of the temple, in addition to the sculptured pediments of the east and west facades.[1] Pheidias and those who patronized his enterprise apparently spared no effort or expense in glorifying the divine protectress of Athens and the excellence of her people, and they explored every artistic and thematic alternative at their disposal to realize this goal. Even so, the full complement of sculptures appropriate for a Doric temple still seemed insufficient to the planners of the Parthenon; they determined that the building would have a continuous Ionic frieze as well, above a second, inner entablature on the short ends, and continuing around the top of the exterior cella walls. The addition of this second, Ionic frieze involved a difference in thematic content as well as formal structure. The pediments depicting Athena's birth and her accession as patron goddess of the city, and the metopes illustrating the victory of the Greeks and their gods over lawless barbarism, had fully exploited the potentials of mythic tradition and prefiguration. The frieze, in contrast, did not depict a specifically mythic theme, but one inspired by contemporary Athenian religious ceremonial.

Although the frieze of the Parthenon is much better preserved than the metopes or the pediments, it remains paradoxically the most enigmatic and elusive part of the sculptural program. If there is now a consensus that it somehow functioned as a generic representation of the *Panathenaia Megala*, the great Panathenaic festival held every four years, this interpretation is not beyond dispute, and many questions about the temporal sense or structure

184

of the depiction and the particular choice, arrangement, and identification of the participants and events, as well as their precise geographic setting, are still unanswered. Nor is it really clear just how the portrayal of this festival was intended to operate within the larger program of the Parthenon sculptures as a celebration of the Athenian state (fig. 23).[2]

The place of the frieze within the general development of Greek architectural sculpture is perhaps the most difficult issue of all. Scholars have often observed that the apparent depiction here of an actual, recurring, religious ceremony is unparalleled in the extant Greek architectural sculpture of Archaic and earlier Classical times, especially as the subject of a continuous Ionic frieze decorating all four sides of a temple. To some extent this seeming anomaly may be due to the many gaps in our knowledge of Archaic Greek architectural sculpture, and one may counter that earlier Greek analogies exist for various features of the Parthenon frieze. But generally it has come to stand as something unique, something of a foreign body within the evolution of Greek temple decoration. Accordingly, those dissatisfied with native Greek comparanda have looked for precedents in the ancient Near East, where there was a long tradition of official architectural sculpture and wall painting depicting contemporary ceremonial.

If a monument's meaning or iconographic function were entirely unrelated to the derivation of its artistic vocabulary, then the artistic sources of the Parthenon frieze would be an esoteric issue relevant primarily to specialists who trace the formal evolution of Greek architecture and its decoration; these sources would be of little concern to those who are interested more broadly in the complex visual discourse that the Parthenon's planners sought to impress upon their viewing public. However, students of the Parthenon frieze have long recognized the cultural and ideological implication of the parallels that appear to link it with the processional imagery of the ancient Orient, and especially that of Achaemenid Persia. Thus when Lawrence first suggested that the image of the Panathenaia in the Parthenon frieze was related to the ceremonial processions depicted on the facades of the palatial complex of the Persian monarchs at Persepolis, he had in mind far more than a formal borrowing of exotic compositional schemata. For him the general analogies of form and subject matter reflected the imperial aspirations of Periklean Athens, striving, as it were, to equal and surpass in political and artistic terms the corresponding achievements of the Persians.[3]

The most recent study along these lines by Root has elaborated upon this argument in considerable depth and detail. Focusing more specifically on the facade sculptures of the great Apadana or audience hall at Persepolis (fig. 26), she explained the ceremonial or processional imagery of the Persian reliefs as a carefully constructed visual statement meant to encompass

186

East

North

East

North

North

Figure 23. Parthenon, east and north friezes (adapted from J. Boardman, *The Parthenon and Its Sculptures*, Austin, Tex., 1985, 241–242, and F. Brommer, *Der Parthenonfries: Katalog und Untersuchung*, Mainz, 1977, fig. 5, 7, 8, and 14).

the harmonious order of the Achaemenid empire, a rich assemblage of pose and gesture expressing the complex hierarchy of relationships among the Persian king, his people, and his foreign subjects. As a direct response to this conception, the Parthenon frieze was an elaborate festival metaphor unfolding the ideal order and harmony of the Athenian empire and its subjects through the unifying image of public ritual.[4]

However, the earlier attempts at connecting these monuments, even Lawrence's, had posited in varying degree that the visual allusion to the Persepolis reliefs was an Athenian riposte or counterblast toward the Persians and their empire.[5] Accordingly, the general formal analogies between the sculptural decorations at both sites could be seen to function largely as a comparative device or framework for a dialectic of opposition. The differences in content between the monuments—autonomous citizens versus subject peoples, the Olympian gods versus the Great King, a subtle or minimal distinction between divinities and mortals versus the hieratic sanctity and remove of the Persian ruler—were conscious transformations asserting the superiority of Athenian or Greek culture to the imperial domination and theocratic monarchism of the Achaemenids.

Root's view was qualitatively different. Like Lawrence, she felt that the frieze's adaptation of Persian iconography was conditioned by the new and similar position of dominance that Athens had assumed in the Aegean and western Asia Minor by the middle of the fifth century B.C., but Root saw in this a certain measure of appreciation or sympathy for Persian imperial administrative and artistic conceptions. Thus the putative quotations from the Apadana were positively motivated and, in her view, far more specific and extensive than previously supposed. They were not merely cues for a visual indictment of the Persian system in opposition to that of Athens; they suggested instead an analogy of purpose, with the corollary that where the Persians had failed, Athens would succeed in her imperial aspirations.

The derivation of the Parthenon frieze from Persian sources has the advantage of explaining the unusual aspects of a major monument by positing the impact of another work of comparable significance and quality. It is of course tempting to see the most outstanding buildings of the Akropolis and Persepolis as a tangible expression of the competition between Athens and the Persians that set its stamp on much of the fifth century. But the "Persian thesis" as Root has advanced it also creates significant problems for students of the Parthenon. When viewed in this way, the Panathenaic frieze would emerge as a work whose thematic content and internal structure had evolved without any appreciable relation to the preceding development of Greek temple decoration, but rather as a self-conscious adaptation of Persian imperial imagery. Nor, in this view, does the frieze appear to express

Greek religious and political conceptions in any substantive way; it seems at best to be an accommodation of these conceptions to a foreign ideal of imperial authority.

The historical and archaeological evidence, however, does not justify such an interpretation. Most importantly, the visual analogies between the Parthenon and the Persepolis reliefs that have for so long fueled this discussion are far less substantial or convincing than one might suppose. There are undoubtedly compositional similarities—above all the manner in which both monuments treat the basic processional motif as corresponding, convergent files involving the presentation of gifts and animals to a central enthroned figure or figures (cf. figs. 23 and 26). But beyond this overall scheme there are surprisingly few real points of comparison. The architectonic context of the Persian reliefs is certainly very different from the single continuous band of the Parthenon frieze. Organized according to the venerable Near Eastern system of multiple superimposed registers, and decorating the foundation platforms and monumental staircases, these Persian reliefs function much more as orthostat sculptures than as the frieze of the building proper (fig. 26). Nor do the Apadana reliefs envelop the building structurally and compositionally as the Parthenon frieze does: rather, they decorate the north and east sides of the platform as two identical but discontinuous and independent systems, each limited to its own facade.

The internal structure of both works also differs considerably. The Apadana concentrates almost entirely on foot processions. On the Parthenon, the outer portions of the east frieze and eastern extremes of the north and south friezes display similar processions, but these account for less than a quarter of the entire frieze (figs. 23 and 25). Over two-thirds is devoted to processional and racing chariots and to galloping cavalry, with the cavalry alone occupying about half the length of the composition (fig. 25). As parallels here, each facade of the Apadana can offer only four chariots without riders, two without charioteers, and none of these is racing. Apart from the chariots, there are only nine horses on each facade, three among the Persians and six among the subject delegations, all led by grooms (fig. 26). Nowhere on the Apadana reliefs or those of the other buildings at Persepolis is there a single rider on horseback, the motif that so dominates the Parthenon frieze.

Conversely, the theme of the subject peoples or delegations who occupy half of each facade on the Apadana has no clearly discernible counterpart on the Parthenon. On the evidence of mid-fifth-century Athenian decrees, some of the figures leading the cows in the north and south friezes of the Parthenon could be assumed to depict the allied delegations making the required offering in the Great Panathenaia, but this is far from clear. And

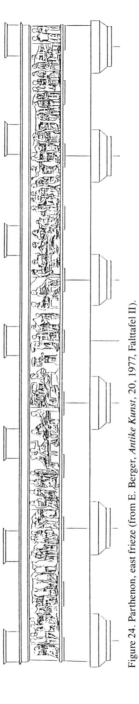

Figure 24. Parthenon, east frieze (from E. Berger, *Antike Kunst*, 20, 1977, Falttafel II).

189

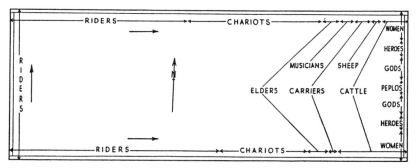

Figure 25. Plan of the Parthenon frieze (from J. Boardman, *The Parthenon and its Sculptures,* Austin, Tex., 1985, ill. p. 238).

even if there are allied delegates here, the frieze makes no apparent effort to distinguish them from the resident Athenians or their overseas colonists, who also made such offerings at this festival.[6] Still less do we see any attempt to contrast the Athenians with the foreign delegations as two opposing files in the manner of the Apadana reliefs (figs. 23 and 26). Thus the key feature of the Persian prototype and its imperial message—the explicit display of the subject peoples signaling their acceptance of a central authority—is nowhere in evidence on the Parthenon.

Such divergences should not be taken lightly, since even the fundamental compositional analogy of a bidirectional procession or file converging on enthroned figures is not unique to the applied decoration of these two monuments. In the Near East it already appears in the paintings of the Neo-Assyrian palace at Til Barsip.[7] The remains of at least seven continuous friezes of the Archaic period also display clear evidence of a bidirectional or convergent organization, and three of these include seated Olympian assemblies, while five display racing chariotry and cavalry, significant components of the Parthenon frieze that cannot be paralleled at Persepolis (see figs. 28, 31, 33, and 35).[8] The precise relation of these Archaic works to the Parthenon frieze will examined more fully below, but even initially it is evident that Archaic Greeks had already assimilated the Oriental concept of the processional frieze—its form and structure, and the manner of disposing the contents around a building—well before the sculptured facades at Persepolis had been erected or even conceived. And such Greek forerunners, as we shall later see, come far closer to the Parthenon frieze in their organization and specific content than the Apadana reliefs.

One aspect, however, has always appeared to provide a strong and undeniable link between the frieze and the Persepolis sculptures: the theme of an actual recurring festival, especially as the subject of the sculptural program on a building near where the ceremonial took place. In this regard the

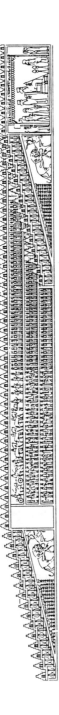
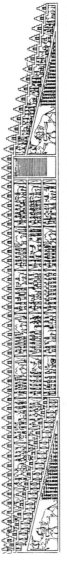

Figure 26. The Apadana, Persepolis, reconstruction of the north facade (adapted from M. Cool Root, *The King and Kingship in Achaemenid Art: Essays on the Creation of an Iconography of Empire*, Leiden, 1979, fig. 11).

191

Parthenon may have no local parallel, for although one can be relatively secure in identifying the subject of the frieze as the Panathenaic procession that perambulated the Agora and the Akropolis, there is no clear Greek precedent for portraying an actual religious event of this kind in temple sculpture. Here, then, the Apadana would indeed appear to furnish what cannot be found elsewhere in the sixth and fifth centuries as conclusive evidence of its impact upon the Parthenon. As a depiction of the *Nawruz,* the Persian New Year's celebration, the friezes of the Apadana would have functioned as self-referential decoration, preserving in permanent form the recurring ceremonial at Persepolis, just as the frieze of the Parthenon depicted the festive procession that culminated on the Akropolis.

Yet it turns out that this interpretation of the Apadana reliefs is largely hypothetical, based on assumptions about the apparent ritual character of Persepolis in general and a somewhat arbitrary reading of the reliefs themselves.[9] The assumed function of Persepolis as the architectural setting of a New Year ceremonial has come under increasing criticism. As Nylander and Calmeyer have shown, the *Nawruz* is poorly documented; it is known only from Islamic sources, and although these presumably reflect the ceremonial and practices of Sassanian times, there is as yet no ancient documentary evidence—Persian, Greek, or Roman—that a festival of this kind took place in the Achaemenid period, at Persepolis or anywhere else.[10] Nor do the earliest Islamic sources, which mention only Persian participants, provide any evidence for the widespread opinion that the *Nawruz* at Persepolis was a great imperial festival involving the gift-giving of all the subject peoples.[11] This view of the festival is largely an elaboration of modern scholarship. Once the gift processions of the Apadana reliefs were assumed to depict the *Nawruz,* the festival accordingly took on a pan-imperial aspect because of the emphatic sculptural display of the foreign nations or delegations.[12]

Although the Persepolis reliefs do indeed present the spectator with the image of a ceremonial procession, it is far from certain that they are a literal depiction of an actual, recurring event in which delegates traveled simultaneously to Persepolis from all over the empire. Using the surviving ancient literary testimonia for Persian royal ceremonial, Calmeyer has argued plausibly for a more abstract and synthetic interpretation of the Apadana reliefs. Greek sources mention gift-giving from subject peoples to the Great King, but as part of a series of ceremonies that took place during the ruler's travels through the provinces of the empire. At various locations he held court out of doors, enthroned under a canopy, and received the offerings and homage of his subjects. In Calmeyer's view the Apadana reliefs furnish an idealized amalgam of these outdoor ceremonies, replete with canopy and trees, in which all the nations come together symbolically and emblematically in one

great imaginary tableau conveying the extent and harmonious order of the empire around the unifying figure of the Persian monarch (fig. 26).[13]

It is possible, even likely, that individual gift-bearing delegations or embassies of this kind visited Persepolis, where they would have been confronted by this overwhelming visual imagery of unity, but it is unwarranted to assume that the reliefs depict one actual event, repeating or otherwise.[14] A real ceremonial of this magnitude and importance ought not to have entirely escaped the notice of Herodotos and his successors, even in the form of rumor. There is also no mention of such a festival among the inscriptions of Persepolis or the Apadana itself. The rich and accurate ethnographic detail of the Apadana reliefs, replicating the costume and equipment of real peoples, impresses the viewer with its immediacy, and it is therefore tempting to see the entire composition as equally real. Yet in the absence of such evidence, the Apadana reliefs should be understood as a grandiose ceremonial metaphor rather than a narrative or commemoration of actuality. They are a symbolic evocation of the Persian doctrines of kingship and empire rather than a literal record of an Achaemenid festival whose very existence remains undocumented.

Consequently, the procession of the Apadana reliefs appears fundamentally different in conception and function from the Parthenon frieze, whose relation to the actual cermonial of the Panathenaia, at least in generic terms, is beyond any reasonable doubt. The Apadana reliefs do not, as a result, constitute a clear or likely precedent for this aspect of the frieze. Once this becomes clear, the strongest link in the tenuous chain of connections between these monuments crumbles away.

On various levels, this notion of Persepolis as a model for the Parthenon frieze is something of a mirage, and one that has tended to obscure the real sources and motivations that informed the planners of the frieze. This is especially true when one considers the ideological function of the frieze, and indeed that of the building as a whole. Today it seems all too easy to accept the Parthenon as the embodiment of Athenian imperialism: paid for by the enforced tribute of subject peoples, it was in every way a material result of the military, economic, and political control that Athens came to exercise over the Greek cities of the Aegean Islands and western Asia Minor. From this perspective it might even appear natural for the Athenians to have embraced the ideology of divinely sanctioned domination utilized by their Persian predecessors. But to do so the Athenians would have to have rejected Greek political tradition and the official propaganda that they themselves had been promulgating for the last quarter-century.

How, one may well ask, could an imagery of imperial authority have functioned as part of the larger sculptural program on the Parthenon or any

other Greek monument of the period? This temple originated in an outlook that conceived of Persia primarily in terms of antithesis and opposition. Athens' standing among her allies had been predicated on the common goal of punishing the Great King, and from the late 470s onward Athenian public monuments had celebrated these victories specifically as a triumphant assertion of Hellenic law and moderation over the arrogance and impiety perceived as intrinsic to Persian monarchy and imperialism. This ideology had found its most ardent and lasting expression in the Parthenon metopes.[15] Ultimately, then, the Persian thesis obliges us to accept far more than the notion of the Parthenon frieze as a foreign body within Greek architectural sculpture. When interpreted in this way, the frieze becomes a foreign body on the Parthenon itself.[16]

It is one thing to have an empire, but it is quite another to advertise and justify imperial sovereignty as a principle of statecraft—especially in the media of monumental painting and sculpture, as the rulers of the ancient Near East had done. Despite the realities of Athenian power, neither the Parthenon nor the official ideology that it served could have openly attempted to legitimize a doctrine of empire in the 450s and 440s, and there is, in fact, considerable evidence that the image of authority that Perikles and his supporters sought to project in public rhetoric, ceremonial, and monumental arts deliberately obscured the true nature of the empire. But in order to appreciate this fully, particularly as it applies to an understanding of the Parthenon frieze, it is first necessary to consider the empire's origins against the background of Greek political theory.

By the mid-440s Athens had, in fact, achieved effective control of the Greek city-states throughout the Aegean Islands and the coast of Asia Minor, regions formerly under Persian domination. In practical terms it is hardly surprising that the Athenians adopted or continued certain administrative offices and practices initiated by their Persian predecessors—the system of tax or tribute assessment, or the use of *episkopoi,* roving commissars who facilitated local administration and reported any difficulties to the central authority.[17] But there was no context within the Greek world that would permit the assimilation of the larger Achaemenid or oriental ideology of imperial rule under a central monarchy appointed and supported by the gods.[18] The political structure of most Greek city-states at this time was still predominantly oligarchic and to a lesser extent democratic; the concept of divinely sanctioned absolute kingship was a vague memory preserved only in myth and the royal- sacerdotal functions of hereditary aristocratic priest-ships like the Archon Basileus in Athens.[19]

However, these obstacles are picayune compared with the difficulties that would have attended any Athenian declaration of imperialism as a legiti-

mate ideal of statecraft. The peoples of the ancient Near East had long since achieved a level of political organization whereby multiple cities and their territories could amalgamate into kingdoms, and kingdoms into empires, all under one unifying authority. But among the Greeks from late Geometric times onward, the *polis* or city-state had remained the essential unit of government and collective political identity.[20] Although a larger Hellenic or panhellenic consciousness is already discernible by the late eighth century, it served primarily to distinguish the Greeks as a whole from non-Greeks or barbarians in terms of language, social organization, and religion, and it therefore failed to produce any corresponding political structure or unity.[21] By Classical times the state was still conceived essentially in terms of the individual city and its hinterland; the *polis* served as the basis for civic administrative and military organization and the focus of patriotic duty. The independence or self-determination of the *polis*—its *autonomia*—was considered inviolable, the essential manifestation of *eleutheria,* "freedom." Infringement of this autonomy from outside the *polis* meant only one thing: *douleia,* "enslavement."[22]

This is critical in appreciating how the Athenians approached their *de facto* rule over other Greek states. Unlike the earlier imperial enterprises of the ancient Near East, the Athenian empire did not originate in an overtly aggressive policy of military subjugation and annexation. As is well known, Athenian rule of the *poleis* in the Aegean and Asia Minor evolved more slowly, through the gradual transformation or subversion of the Delian League. Although founded originally as a *symmachia,* an alliance of equals under Athenian hegmony, and dedicated to a war of retribution against Persia and to the liberation of the Asiatic Greek states, the League eventually became a tool of Athenian expansionism; the objectives of the *hegemon* shifted increasingly from war against the Great King to supremacy over the member states, who were step by step reduced from allies to the subject cities of an Athenian empire.[23]

The gradual and duplicitous nature of this process is crucial here. The empire took shape only as Athens came to assume more and more control over the operations and resources of the alliance, and ostensibly in accordance with the charter regulations of the League and its agreed objectives. Enforced oaths of loyalty to Athens supplanted the original charter oaths.[24] The Athenian demands for tribute began with the common allied contributions for the war effort, which Athens, as *hegemon,* could rightfully control.[25] Athenian involvement in the domestic judicial affairs in the member states may be traced to the more limited judicial prerogatives of League synods or councils regarding infractions committed by citizens of the member states against the larger organization. The increased influence of the

Athenian *Boule* in the internal affairs of the allied cities may similarly have evolved from whatever authority the Athenians had exercised as *hegemon* in the League Synod, especially after it moved to Athens, along with the League treasury, in 454.[26] The imposition of Athenian coinage on the allied cities in 448 followed League precedent as well: as early as the 470s various members had voluntarily given up minting their own coins when the Athenian coinage proved more stable and acceptable in their markets.[27] And when the Athenians replaced contentious oligarchies in the allied cities with democratic governments loyal or subservient to their own *polis,* they thereby extended their influence while appearing to foster freedom.[28]

Military coercion or repression certainly played a large role in this process, and there is the clear evidence of military colonies (cleruchies) and garrisons placed strategically in the allied territories.[29] But one can imagine the rather gray circumstances in which this force was used and justified. At no point did the Athenians place their foot symbolically upon the neck of a defeated subject state while invoking the will of the gods to sanction the deed. Instead they hid behind an ideology of alliance and parity as they progressively dismantled the autonomy of the very allies that they had pledged to lead in a war against Persian oppression. And they did so not only through naked force, but largely through the cumulative effects of judicial and economic measures that had the gloss of law and due process.[30] Thucydides' account of the Mytilenian grievances voiced against Athens at Olympia in 428 illustrates how well the allies eventually came to understand this Athenian duplicity:

> The allies were enslaved except for us and the Chians, while we, supposedly autonomous and having at least the name of freedom, campaigned alongside them. . . . And we were left "autonomous" only because it seemed to them that they could achieve their empire through words and policy which had the appearance of fairness rather than by forceful attack.[31]

The terminology of the Athenian imperial decrees from the 440s also discloses a strategy of denial. Only two such decrees from before 430 utilize a formal nomenclature of domination, and even these refer to "the cities that Athens rules," avoiding the more blunt and demeaning epithets *hypekooi* or *archomenoi* ("subjects") that occur commonly in Thucydides' account of the empire.[32] The Kleinias and Coinage Decrees refer, in even more neutral language, to "the cities."[33] But all other Athenian decrees before the Peloponnesian War (and many of those during and after it) persisted in using the term *symmachoi,* "allies" or, more literally, "fellow fighters," no matter how repressive the purpose of such legislation may really have been.[34] The

terms imposed upon Chalkis after their rebellion in 446 required the citizens of the defeated state to swear to be "loyal allies of the Athenian *demos*" in a document that looks rather like an agreement of popular solidarity, although it was in effect a treaty of submission.[35]

One might well expect the Athenians to pay lip service to the principle of symmachy or alliance during the earlier phases of the empire in the 440s as a practical strategy. Imperial domination was the interstate equivalent of tyranny within the *polis*. By Greek standards the doctrine of empire was fundamentally illegitimate, since it could not be reconciled with the autonomy considered essential to the city-state.[36] One last look at Aischylos' account of Xerxes' defeat demonstrates unambiguously the basic Greek aversion to the principles of vassalage and imperial dominion celebrated in the Apadana reliefs:

> And those throughout Asia's land are ruled
> No longer by Persia's laws.
> They carry their tribute no longer
> By a master's necessity fixed.
> Nor prostrate themselves to the ground
> And adore; for the royal
> strength is destroyed.
> The tongues of men are no longer kept
> in check; for the mass of men
> Went loose and free in their speech
> When the yoke of strength was loosened.[37]

The actual usurpation of allied autonomy was likely to require armed enforcement often enough; initially it was far wiser to attempt to soften, obscure, and rationalize this process by insisting, albeit falsely, that the original structure of the League was somehow intact, as the speech of the Mytilenians indicates. The highly flattering picture of the Athenian Empire served up by Lysias in his *Funeral Oration* must preserve something of the "alliance propaganda" that would have accompanied the imperial initiatives of the 450s and 440s:

For seventy years they ruled the sea and made their allies free from internal political discord. Nor did they deem it worthy for the few to enslave the many, but compelled all to be equal, not by making their allies weak, but by making them strong. And they displayed their own power to such an extent that the Great King no longer coveted the territory of others, but gave up his own, and feared for the remainder of it. In that time no trireme sailed from Asia, no tyrant ruled among the Hellenes, and no Greek city was reduced to slavery by

the barbarians. Such was the *sophrosyne* and awe that the *arete* of these (Athenians) inspired among all men. For this reason they alone became the foremost of the Greeks and *hegemones* of the cities.[38]

About a decade later, Isokrates, in his *Panegyric,* also recalled the days of the empire in such terms, and emphasizing even more strongly the positive ethical motivations of the Athenians:

> They behaved in the same way toward other (states), being of service to the Greeks but not indulging in acts of *hybris* toward them. Thinking to command them militarily but not to tyrannize them, they strove to be addressed as *hegemon* rather than despot, and to be regarded as saviors rather than destroyers, winning over the cities by doing good instead of subjecting them by force. . . . They were not concerned as greatly with powers as they were with striving to lead their lives in moderation *(sophronos).*[39]

The view of the empire in Lysias' eulogy and Isokrates' *Panegyric* reflects a rhetoric of moderate hegemony opposed to hybristic tyranny or despotism, an imagery of leadership dedicated to liberation and equality, that originally evolved in the period of the League.[40] Here the tendentious emphasis on the virtues of Athenian leadership went hand in hand with the praises of autochthony and the catalogue of mythic exploits that also figured in such speeches as symbols of Athenian virtue and opposition to imperialism.[41] But one need only recall the revolts and rapid suppressions of allies like Naxos or Thasos to see that this rationale for Athenian dominance was already a fiction in Kimon's day.[42] As Strasburger and Walters have indicated, such rhetoric had been deliberately created to smooth over or obscure the nagging discrepancy between Greek political principles and the aggressive imperialist reality of Athenian foreign policy.[43] There is no reason to think that the Athenians suddenly abandoned this strategy after the middle of the century as they accelerated their control over the allies. In his famous funeral oration, Perikles himself is portrayed indulging in the rhetoric of altruism (Thucydides, II, 40, 4–41, 1). There he extols the unique Athenian proclivity to be of service to others, holding up Athens as an exemplum of political and cultural excellence, the "school of Hellas."[44]

Still, this rhetoric of altruistic hegemony was only one component in the Athenian attempt to convince other Greek states that they were allies rather than subjects. In order to reinforce and legitimize its central role, Athens also began to exploit more fully the traditional Greek institution of amphictyony, a religious league involving various *poleis* who convened at a central site to fulfill the obligations of a common cult.[45] Here again the earlier structure of the Delian League provided the point of departure. The cult of

the League's patron deity, Apollo, on Delos, had served as a religious and geographic focus for the alliance and its Synod.[46] With the transfer of the League treasury in 454, Athens assumed these functions, and the way was clear for the substitution of Athena Parthenos as the patron goddess of a new amphictyonic symmachy.[47] This transformation was certainly complete by the early 440s, when, according to the Kleinias Decree, the allies were required to contribute a portion of the tribute revenues directly to the goddess Athena and to participate in the Great Panathenaia.[48]

This Athenian use of amphictyony had a decidedly cultural or geographic dimension and purpose. The amphictyonic aspect of the Delian League had followed the precedent of the Panionion during the sixth and earlier fifth centuries, a union organized around the central shrine of the Ionian Greek *poleis* at Mount Mykale.[49] The common purpose and unity of the League depended similarly on a larger pan-Ionian kinship or consciousness shared by the Greeks of the Islands and the western Asiatic coast, and by Athens as well. The role of Athens within this tradition was indeed pivotal. In the sixth century Solon stated that Athens had colonized the Greek cities throughout these regions; so did Herodotos. Thucydides also accepted the tradition that Athens had founded the lion's share of the member states in the Delian League.[50] From the outset, Athens' preeminence as League leader had been grounded in its claim to be mother-city of the East Greek *poleis,* and Athenian monuments like the Nekyia painting and the Marathon votive at Delphi had celebrated this colonial mythology as well.

Against this background the new amphictyonic emphasis of the League in the mid-fifth century and the shift of the cult to Athens appear as a strategic masterstroke. The *polis* of the *hegemon* and the worship of its chief deity now became the focus of an Attic-Ionian alliance that ostensibly reflected a much deeper pattern. Here, as was often the case among the Greeks, the functions of symmachy and amphictyony were commingled, but amphictyony could weather the transition from war to peace much more smoothly as a basis or justification for continued solidarity and the contribution of revenues once the Persian threat had diminished in the wake of the Peace of Kallias.[51] As a result, Perikles and his colleagues could also assert the common bonds of ethnic, cultural, and religious unity to help persuade the allies that their fiscal and military obligations to Athens were predicated on something more than fear and repression.[52]

To make certain of this, the theme of Athens as mother-city of the allied states became the ritual focus of their amphictyonic obligations. The Kleinias Decree of 448 stipulated not only that the allies were to bring a portion of their tribute as first-fruits to the goddess in the Great Panathenaia, but that they were to bring a cow and panoply of armor as well. From the evidence to

other decrees, it is clear that the cow and armor were the gifts required of recent Athenian colonists or cleruchs for this festival, and that the requirement imposed upon the allies followed the pattern established for colonists. The sense or purpose of this ritual can only have served to reinforce the popular traditions that portrayed Athens as the founder of the *poleis* throughout the Aegean.[53] In doing this Athens effectively claimed that the subjects of its empire were anything but *hypekooi* or *archomenoi*. Instead they would appear as *apoikoi,* ancient colonists, thus implying that they were after a fashion Athenians, sprung from a common source. In this sense the deference that they owed Athens and its goddess in matters of cult and military or political administration was to be seen as a token of piety and kinship rather than a mark of subjugation. This was of course a distortion, perhaps a grotesque distortion, of reality; but amidst the pomp and grandeur of the Great Panathenaia, the allies themselves might for a time have believed it all.

Here was the ideology of Athenian authority and leadership that the Parthenon and its frieze were intended to convey and glorify. There can be no doubt that the building included or referred in some way to the allies. It was the accumulated funds of the Delian League and the continuing tribute of the member states that paid for the construction of the temple, but the implications of this funding were anything but imperial. Instead the Parthenon symbolized everything that the League and the new amphictyonic alliance stood for in the official Athenian view: victory over Persia, the liberation of East Greece and the Islands, and a brotherhood of Attic-Ionian *poleis* throughout the Aegean united, under Athenian hegemony, by common origin, culture, religion, and military objectives. In this regard as well, the Parthenon built extensively on Kimonian precedent; its depiction of the Panathenaia as a pan-Aegean festival grew directly from the sort of colonial propaganda that the Nekyia painting and the Marathon monument had already applied to celebrate the united triumphs of Athens and its allies against the Great King.

But where, then, are the allies in the 160 meters of the Parthenon frieze? With the exception of the gods on the east side, almost all the participants are Athenians. On the evidence of ancient sources, the tray-bearers on the North and South can be identified as young resident aliens or *metoikoi* (fig. 23, second row from the bottom, left). If the hydria-bearers just behind them on the north were female, they too would correspond to what we know of the contingent of *metoikoi;* since they are male, however, their identification is uncertain.[54] The youths escorting the thirteen cattle or cows on the north and south friezes remain the only possible candidates (fig. 23, second row from the top). These could represent the allied delegations bringing

part of their required offering, but they could just as well be cleruchs, or even local Athenians, since the cow was a favorite offering to Athena.[55] In view of the large number of these animals, perhaps this part of the frieze was meant to depict all three groups of participants. Yet the young men leading the cows all look very much the same. Had the planners of the frieze wished to denote the cleruchs and the allies more specifically, they would have included the panoply of armor. It is significant that they did not. And even if they had, it would still not have distinguished between the real, contemporary colonists and the allies or "ancient colonists," and this may well have been the point.

The frieze does not always square with the surviving evidence about the festival, and one tends to ascribe such disparities to the inadequacies of our historical sources or to the generalized method of depiction applied by the designers of these reliefs.[56] But the composition is rich enough in the detail of ritual and offerings where the planners chose to supply it. The ambiguous treatment of the figures with the cows is therefore no accident. Athenian citizens, cleruchs, or allies could all have recognized themselves in this portion of the frieze. The detail is sufficient to allow this, but no more, for the planners sought to avoid or blur the actual distinctions between Athenian and colonist, and between colonist and ally or subject, just as the ritual requirements for the Panathenaia had been meant to obscure such distinctions. Like the ceremony that it depicted, the frieze strove for an imagery of pious unity between Mother Athens and her colonial offspring, old and new, in the act of worshiping the patron goddess of their symmachy. And so at this point it presented the viewer with a less specified or polyvalenced image that could operate as a visual counterpart to the propaganda of alliance and common origin promulgated by contemporary decrees and ceremonial involving the subject cities.[57]

Consequently, the Parthenon frieze did not emulate in any substantive way the Near Eastern ideology of empire that we see in the Apadana reliefs. In place of the open and explicit presentation of subject peoples paying homage to their earthly lord and his divinely appointed rule, the Panathenaic frieze disguised the empire behind the pious ceremonial of a mother *polis* and her daughter cities, so effectively concealing or minimizing the true subject status of those cities that we cannot be certain whether the allied delegates are there at all amidst the Athenians themselves. The image of benign leadership and common cause that Perikles and those around him sought to project to the allies had little to do with the imperial reality of Athenian rule in the Aegean; this image was the antithesis of oriental imperial ideology.

This is only to be expected. Effective public statements or glorifications

of the political order depend upon tradition or, more precisely, the manipulation of tradition. There was no Hellenic tradition for the celebration of empire. Thus the Parthenon frieze presented Athens and its "allies" in the only terms that would be familiar and acceptable politically, and that could confer some legitimacy upon Athenian power in the Aegean. It comes as no surprise, then, that the content and structure of the procession on the Parthenon frieze differ so extensively from the Apadana reliefs. Nor are these distinctions explicable as transformations imposed upon the Persian prototype or model, even in the sense of "counterblast." The differences are so profound that they betray the guiding impact of another, more local tradition of processional imagery that was far better suited to the depiction of the *Panathenaia Megala*. The capacity of the frieze to justify Athenian dominance in religious terms depended largely—as we shall see—on its use of such Greek precedent to convey the requisite impression of heroic leadership, excellence, and piety, a strategy entirely in keeping with the rest of the Parthenon's sculptures.

Archaic Greek Precedents for the Parthenon Frieze

Although the Parthenon frieze depicts the Great Panathenaia, scholars have emphasized that it is far from a literal account of the festival as it is known from written sources. The frieze was selective in its detail and highly purposeful in the way that it integrated the chosen elements in a continuous and richly varied, rhythmic whole that often ignored the precise order and locale of the various events and ceremonies making up the festival.[58] As such it is ultimately an abstraction, conditioned as much by earlier artistic usage or practice as it was by the experience of the Panathenaia itself. To a great extent the frieze's meaning and its potential impact depended upon how well its planners could adapt familiar pictorial formulae from earlier architectural sculpture to the depiction of the Panathenaic festival on a temple.

Two factors have so far impeded our understanding of this process. One is the rather limited and fragmentary preservation of earlier Greek buildings with continuous friezes.[59] Few works of this kind are known, and for the most part the precise architectural context or placement of the friezes is uncertain. Another difficulty is the mythic subject matter of much of the surviving material, since there is a tendency to see such works as irrelevant to the contemporary ceremonial content of the Parthenon frieze. Yet in view of the heroized aspect that recent studies have attributed to the frieze's Panathenaic celebrants, it is quite possible that the planners drew deliberately

Figure 27. Terracotta frieze from Thasos.

upon the iconography of earlier temple decoration depicting heroic myth. But before addressing these iconographic problems, it might be better to approach the issue of Greek precedent in formal or visual terms alone, in order to evaluate how closely the frieze followed inherited traditions of architectural decoration.

The procession on the Parthenon frieze consists of four basic components: cavalry, chariotry, processions with figures on foot, and the assembly of enthroned divinities. Individually, none of these components is particularly difficult to parallel in the extant continuous friezes of the Archaic period, as Brommer has already shown. Rampant horsemen appear on the terracotta friezes from the island of Thasos (fig. 27) and Düver in Asia Minor, while a slower cavalry procession occurs in the limestone temple frieze at Prinias on Crete.[60] Continuous friezes showing running chariotry are common in the Archaic period; there are marble ones from Kyzikos, Iasos, and Myous (fig. 28), and terracotta examples from Larisa, Phokaia, and Sardis, all on the western-Asiatic coast or the region immediately inland.[61] The fragments from Myous, Kyzikos, and Larisa provide no evidence of their original architectural context, but enough is left to show that these friezes were arranged as parallel, convergent, or divergent compositions somehow analogous to the Parthenon.[62] The temple depicted on an archaistic relief of the Augustan period indicates how these friezes might have looked within an architectural entablature. It shows a continuous band of racing chariots whose action runs in opposite directions from the corner of the building (fig. 29).[63]

Figure 28. Marble frieze from Myous (from J. Boardman, *Greek Sculpture: The Archaic Period,* New York and Toronto, 1978, fig. 222).

The terracotta frieze from Palaikastro on Crete depicted the well-known theme of the warrior stepping into a chariot, which, in keeping with Archaic conventions, is shown as already in motion, with galloping horses (fig. 30).[64] The remains of a late sixth-century marble architectural frieze from the Athenian Akropolis also shows a variation of this motif, with a draped figure rather than an armed warrior climbing into a chariot. Originally these reliefs may have decorated the *Archaios Naos* or Old Temple of Athena, and because additional fragments seem to depict seated figures, some have suggested that it could be part of an Archaic precursor for the Panathenaic frieze.[65] In any case, it is not difficult to see these and the preceding works as examples of the kind of Greek temple decoration that provided the formal basis for the chariotry and cavalry on the North and South of the Parthenon frieze, and even the portrayal of the *apobatai,* the contestants of the chariot-jumping event, as they exit and enter their moving vehicles (cf. figs. 30 and 23, bottom row, left).

Since its discovery, the frieze of the Treasury erected by the Siphnians at Delphi has provided the single most extensive Greek parallel for the Parthenon frieze.[66] It provides the only certain prototype for the tectonic placement of the frieze within the entablature and around the cella walls as a continuous composition enveloping the entire building.[67] And despite the enormous differences in thematic content, scholars have repeatedly emphasized the strong formal analogies that this monument offers in the use of cavalry and chariotry on the west and south friezes moving toward the image of the assembled, enthroned Olympians on the East.[68] The relation between the divine assemblies on the Treasury and the Parthenon is especially striking, since the gods are similarly arranged in two separate groups, with

Figure 29. Neo-Attic marble relief in the Villa Albani, inv. no. 1014 (from E. Simon, *Augustus: Kunst und Leben in Rom um Zeitenwende,* Munich, 1986, fig. 158).

Zeus occupying the same position in both friezes (see figs. 24 and 31). Vasic has argued for the direct impact of the Siphnian Treasury on the Panathenaic frieze, since Pheidias worked at Delphi shortly before he undertook the supervision of the Parthenon project.[69]

Nevertheless, it is possible that the Parthenon and the Treasury both reflect the more widespread currency of such themes and pictorial formulae in Ionian or East Greek architectural sculpture. It is therefore particularly unfortunate that the continuous parapet frieze of the Archaic Artemision at Ephesos is so poorly preserved.[70] The fragmentary remains of this work, made some thirty years before the Parthenon, provide only glimpses of draped female figures on foot, male figures leading horses and chariotry or entering chariots, and figures seated on thrones or stools who have been compared to the divine assembly on the Siphnian Treasury.[71] The identification of the subject matter is beyond recovery, but what survives appears to partake of the same formal repertory of processional, equestrian, and festive or Olympian imagery that we encounter in the other monuments of this region.

In addition to the Siphnian Treasury, the best evidence for the repertory and placement of temple friezes in the Archaic period is the so-called Kybele shrine.[72] This is a large stone temple model discovered under the synagogue at Sardis, and datable to the third quarter of the sixth century B.C. (fig. 32).

Figure 30. Terracotta frieze from Palaikastro, Crete (from Savignioni, *RM*, 21, 1906, 66, fig. 1).

At first glance the model seems to reproduce something that has no parallel in the archaeology of this period: a building with engaged or applied columns along the exterior cella walls, with tiers of superimposed panels of figural decoration in the areas between the columns. However, it is more probable that the engaged rendering of the columns was simply a technical expedient to make the model more compact and durable.[73] Ridgway has carefully observed that these columns appear to cover or interrupt portions of the figural decoration, and that we should therefore envision the sort of building that it replicates as having a freestanding colonnade enveloping the cella.[74] In this case, and considering the processional nature of the applied decoration, the "panels" are most readily intelligible as the visible portions of continuous friezes. The excavator, Hanfmann, would see the model as a reflection of the architecture of the reign of Kroisos. The use of multiple, superimposed registers or friezes appears more oriental than Greek, perhaps a local Anatolian or Lydian adaptation of the Hellenic styles favored by this ruler.[75]

The model is especially likely to replicate a temple with continuous sculptural decoration because nearly every motif or theme on it can be paralleled by the actual remains of continuous friezes found in western Asia Minor, the Aegean Islands, and Sardis itself.[76] The lateral decoration of the shrine is especially relevant to the Parthenon, as Hanfmann has indicated, for these portions show parallel or convergent files of solemn female figures in procession, similar to those of the east Parthenon frieze, although it is uncertain whether they are mortal priestesses or mythic processants like maenads,

West

South

East

South

Figure 31. East, west, and south friezes of the Siphnian Treasury at Delphi (from J. Boardman, *Greek Sculpture: The Archaic Period*, New York and Toronto, 1978; revised edition, London, 1991, fig. 212).

207

208

Right

Rear

Left

Figure 32. Temple model from Sardis (adapted from G. M. A. Hanfmann and N. H. Ramage, *Sculpture from Sardis: The Finds Through 1975*, Cambridge, Mass., and London, 1978, figs. 32, 38, and 44).

nymphs, or Charites (cf. figs. 32 and 23, second row from the top, left).[77] The lower registers of the lefthand side consist of reveling silenes or komasts. While these are different from the offering-bearers and the ministrants of the east and north portions of the Parthenon frieze, they nevertheless attest to the depiction of festive processions as a theme of temple decoration in this period. Even the motif of chariotry recurs on the shrine from Sardis, on the middle register of the back wall (fig. 32). But this little monument is particularly important since it demonstrates that these themes of festivity and procession were all part of an established repertory of decoration in the continuous friezes on Archaic temples.

Brommer also pointed to the analogies posed by the continuous architectural friezes in Archaic Etruria which depict chariotry and cavalry, although he did so only in the most summary or general terms.[78] Nevertheless, two Etruscan monuments are particularly relevant, in composition and content, to the Parthenon frieze. The first is the series of terracotta plaques that decorated a large colonnaded building at Murlo (Poggio Civitate).[79] The series included four repeating themes: banquet scenes, horse races, a procession on foot and cart with gifts or offerings, and a seated assembly of gods. Although nothing is certain about the order and architectural placement of these plaques, Gantz and Höckmann have both argued convincingly that the seated gods and the procession formed a unified composition; and it is clear that this existed within an overall ensemble that included galloping horsemen as well (fig. 33).[80] Here is an early Archaic monument that already displays key iconographic elements of the Parthenon frieze, with almost uncanny analogies in the seated goddess behind Zeus who raises her veil like Hera on the Parthenon, and the female figure at the end of the procession who carries a stool or *diphros* on her head like those at the center of the east frieze (figs. 33 and 23, top center). It is also clear that the overall ensemble at Murlo was bidirectional: the procession moves to the left, while the equestrians gallop to the right.

At Velletri in Latium another series of terracotta plaques was recovered in two campaigns near the site of an Archaic temple (fig. 35). The earliest of these constitute a stylistically and technically unified group produced in the same workshop for the same building, probably a temple. They included plaques showing a seated assembly of Olympians, and Demangel has stressed their similarity to those on the Siphnian Treasury and the Parthenon frieze.[81] But in addition to the Olympian assembly and banqueting scenes, the Velletri plaques also depicted galloping horsemen, racing chariots, and a slower chariot procession with participants on foot. Thus these terracottas disclose a range of iconographic components that corresponds almost entirely to the Parthenon frieze (cf. figs. 23 and 35). Here again there is no clear evidence

Figure 33. Terracotta frieze from Murlo, restoration (adapted from *Archaeology*, 21, 4, 1968, 252–261).

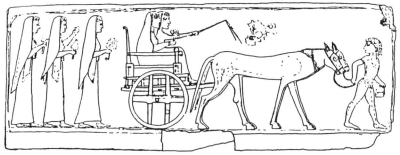

Figure 34. Terracotta frieze from Metapontum (from Fabbricotti, *Atti e memorie della Società Magna Grecia*, N.S., 18–20, 1977–1979, pl. LXI c).

for the placement of the friezes. One can deduce something about their arrangement by attempting to coordinate the varied profile and decoration of the borders on the plaques, but some of these borders were unfortunately cut down in antiquity. Still, the remains show that the slower procession ran in both directions while the racing chariots and the cavalry ran opposite to one another. And, as at Murlo, the slow procession in chariots and on foot moving to the right seems to form a larger unity with the assembly of gods (cf. figs. 33 and 35).[82]

Other Etruscan friezes display a less extensive array of analogies to the Parthenon, but they are no less striking. Examples from various sites combine cavalry with chariotry and processions on foot, including the motif of the departing warrior entering the chariot. The terracotta plaques from Acquarossa depicted a procession of revelers and musicians, including flutists and citharists like those on the north frieze (cf. fig. 36 and fig. 23, second row from bottom, center).[83]

One could hardly posit any direct connection between such Etruscan architectural terracottas and the Parthenon frieze. But it is equally improbable that these similarities are purely fortuitous, despite the enormous disparity in style and quality. At Murlo and Velletri the comparable use of equestrian and processional motifs in conjunction with the image of the assembled gods is far more pressing than any analogies offered by the Apadana, and no other single monument, not even the Siphnian Treasury, can provide the range of compositional and motival parallels to the Parthenon frieze that we encounter in the Velletri plaques.

However, the real significance of these similarities emerges only when the Etruscan works are seen in a larger context, as reflections or adaptations of Archaic architectural decoration produced in the Greek world, and especially in East Greece. Andrén and Akerström have emphasized the Asiatic Greek background of this whole class of Etruscan architectural

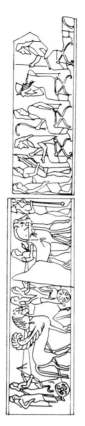

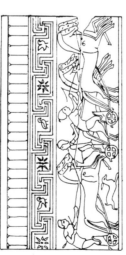

212

Figure 35. Terracotta frieze from Velletri.

decoration.[84] One can make the same argument for the thematic repertory of these continuous Etruscan friezes. Virtually every individual motif that they display can be paralleled in the continuous friezes of Ionia and the Aegean Islands, in stone or terracotta.[85] It is certainly true that the Etruscan examples sometimes add native Italic ethnographic details, along with other traits derived from the architectural decoration of mainland Greek centers or from Greek minor arts. But they are still intelligible largely as a response to or extension of the modes of temple decoration current in contemporary East Greece.[86] If the Murlo and Velletri friezes do indeed reflect such prototypes; then the analogies that they share with the Parthenon become readily intelligible and highly meaningful.

In general, the Etruscan material reinforces the conclusions that emerge from the surviving temple decoration of the Greek islands and western Asia Minor. Whatever specific themes or events they represented, there was a tradition of continuous friezes that laid strong emphasis on the visual, compositional principle of the moving procession, including or in association with equestrian participants in chariots and on horseback. Nor was it unusual for the gods to appear enthroned or seated together as part of this larger ensemble of themes (figs. 31, 33, and 35). Here was a mode of temple decoration that had long explored the possibilities of equestrian action, files of walking figures, and rows of enthroned divinities as an effective means of filling the longitudinal spatial requirements of the continuous frieze. It was this tradition that the Parthenon's planners adapted to create their image of the Great Panathenaia. Such East Greek precedent furnished almost readymade the basic format and many of the specific motifs needed to depict the festival and its events, as the designers of the frieze undoubtedly recognized. It remained only to supply the distinctive characters or ministrants, the requisite offerings and liturgical detail, along with the ebb and flow of energy and motion, that would make the depiction immediately intelligible to anyone familiar with the Panathenaia. The result was something essentially new, but it succeeded because it conveyed its message in the familiar vocabulary and syntax of existing Greek temple decoration.

Nevertheless, it would be a mistake to assume that the planning of the frieze was contingent purely on formal considerations of this kind. Spectators would not have forgotten the earlier iconographic sense or usage of the motifs that the Parthenon frieze drew upon, no matter how effectively these were now adapted to the portrayal of the Panathenaia. It is therefore important to consider how the earlier meaning or associations of these pictorial formulae were still latent in the Parthenon frieze, and the extent to which the planners intended to exploit such iconographic as well as formal potentials.

The issue of earlier iconographic usage can help especially to clarify the

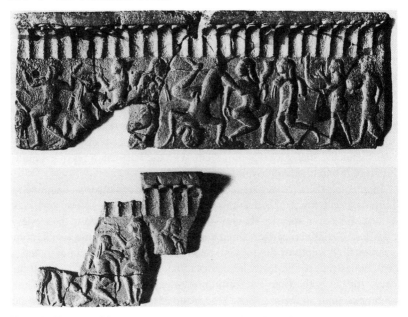

Figure 36. Terracotta frieze from Acquarossa (after M. Strandberg Olofsson, *Acquarossa,* vol. 5, *The Head Antefixes and Relief Plaques,* Acta Instituti Romani Regni Sueciae, Ser. 4, vol. 38, Stockholm, 1984, pl. IV, 1–2).

inclusion of the assembled gods on the east frieze, which has always appeared as somewhat problematic. Why depict the Olympians generally as the recipients or witnesses of a festival in honor of Athena? Various studies over the years have attempted to explain the presence of the other Olympians in relation to cult practices in Athens, Attica, and elsewhere in Greece and the Aegean. Most recently Mark has explored the possible impact of pre-Socratic philosophy or theology in the choice and arrangement of these divinities.[87] But the history or background of this Olympian iconography is also relevant. Typologically, such divine assemblies belong to a class of depiction known as *Daseinsbilder,* which has been studied extensively by Himmelmann-Wildschütz and Knell. While these are by definition images portrayed for their own purpose or value, as abstract manifestations of divine essence and power, Knell has shown that the theme of the assembled gods originated in representations of a mythic and narrative nature, especially those illustrating the welcome return of an Olympian after some absence, or the entrance and acceptance of a new member into the Olympian circle.[88]

The depictions of the assembled gods in the forerunners of the Parthenon

frieze all seem to have retained something of this original function and context. The subject of the Murlo frieze is far from certain, but a mythic theme is not unlikely. Since the shape of the cart is reminiscent of those used in nuptial processions, Höckmann has proposed a divine wedding, perhaps that of Peleus and Thetis, with the couple arriving at Olympos for the festivities.[89] Similar processions with carts of this kind in the terracotta reliefs of Magna Graecia have been interpreted as the mystic wedding or theogamy of Hades and Persephone (cf. figs. 33 and 34).[90] If the identification of the Italiote Greek works is correct, then they suggest that such processions had eschatological connotations, and this would tend to support the funerary interpretation proposed by Andrén for the Murlo plaques. Yet he sees the couple in the wagon at Murlo not as Hades and Persephone, but as the heroized dead who journey to a world beyond the tomb presided over by the gods in the adjoining plaque.[91] Thus the Murlo reliefs would depict a generic form of apotheosis. Gantz's interpretation of the scene as one of mortal worshipers bringing offerings to the divinities of a temple or shrine is less convincing.[92] Votive depictions of worship focus on individual divinities, or upon pairs and triads of gods united by cult practice.[93] In contrast, the extended enthroned assembly of the gods at Murlo immediately suggests Olympian order or Olympos specifically. Those who approach the welcoming Olympian throng are probably deities themselves, or those about to enter the domain of the gods, rather than mortal worshipers arriving at an earthly sanctuary.

These arguments apply to the Velletri plaques as well. Akerström had originally suggested that the figure with the bow and arrows welcomed by the Olympians might be Apollo returning after some absence or, more probably, Herakles being admitted to Olympos (fig. 35).[94] If we see the plaques with the winged chariot procession led by Hermes as part of this scene, it would seem to combine the versions of Herakles' entry to Olympos current on Attic black figure vases, where the hero is also accompanied by Hermes and other divinities alongside his chariot, or where Athena and Hermes present him to the enthroned Zeus.[95] More recently, Andrén has connected the imagery of the Velletri terracottas with that of the Murlo plaques. He interprets them also as a generic scene of the heroized dead—a man and wife—welcomed into the domain of the gods, but now with Hermes behind them in the role of *psychopompos*.[96] But even if Andrén is correct, it is still not improbable that the Murlo and Velletri friezes were adapted from Greek prototypes showing a specific, mythic entry to Olympos.[97]

In the domain of Archaic temple sculpture, the evidence suggests that the iconographic formulation of the assembled gods served to designate divine approbation, acceptance, or recognition, either toward fellow deities or to-

ward heroic and heroized mortals, especially those worthy of entering the Olympian company. On the Parthenon itself we have the analogy of the east pediment above the frieze, where the Olympians come together for no less a purpose than to witness the central event of Athena's birth, one of the themes in which the motif of the assembled gods may well have originated. The divinities on the east frieze of the Siphnian Treasury can be understood in related terms (fig. 31). There the assembled gods are not the recipients or goal of any procession. But as unseen heavenly witnesses of the heroic self-sacrifice of Antilochos at Troy, depicted to the right, their attention and animated discussion still focus on the achievement and the fate of the heroes in the earthly sphere. Here the divine assembly was included to convey the Olympians' direct concern and sympathy for illustrious and deserving mortals.[98] The east frieze of the Hephaisteion, approximately contemporary with that of the Parthenon, provides additional confirmation. There again the Olympians are inserted as an invisible presence, supporting and witnessing the heroic victory around them.[99]

If the highly charged image of enthroned, divine assemblies in Greek temple sculpture was normally reserved for scenes that celebrated festive concord among the gods, and/or the gods' recognition of heroic attainment and mortal excellence, then the inclusion of the enthroned Olympians in the Parthenon frieze would have sent an unmistakable signal to fifth-century spectators concerning the nature and status of the members of the procession that approached these deities on the North and South. Here the Panathenaia was depicted through the established sculptural conventions designating harmonious Olympian favor toward mortals, or even heroic apotheosis. Nothing could have glorified the festival and its participants more effectively.[100]

In this regard as well, Root argued for the impact of the Apadana reliefs, which she interpreted as an elaboration of iconographic formulae of apotheosis inherited from earlier Neo-Sumerian art, where the king or worshiper is led into the presence of an enthroned divinity, or where officials approach the enthroned king.[101] Yet it is unlikely that such Sumerian presentation scenes were meant to suggest the progression of a lesser being to a higher plane of existence. They and the related imagery of the Apadana reliefs expressed instead the veneration and obeisance owed to a superior being by those subject to him.[102] It was Archaic Greek art that first adapted the ancient Near Eastern presentation formula to the depiction of heroic apotheosis, especially involving numerous enthroned divinities, and it was this Greek tradition that the planners of the Parthenon frieze sought to capitalize upon.

Moreover, this sort of imagery was particularly at home in Athens. The

entry of Herakles to Olympos was well established in Attic black figure painting; it also decorated the pediment of one of the Archaic shrines on the Akropolis, and remained current in vase painting down to the end of the fifth century.[103] Boardman has argued that this theme probably became popular in Athens under the rule of Peisistratos as part of the tyrant's attempt to affiliate himself with Herakles and the protection of Athena. In Boardman's view, depictions of Herakles' entry into Olympos were intended to parallel Peisistratos' occupation of the Akropolis as his private residence, so as to demonstrate his proximity or relation to divine power and favor.[104] It may well be, as Boardman has also suggested, that during the sixth century the Akropolis had come to appear as a surrogate Olympos to Athenians; in the course of time, then, the Panathenaic procession of heroic Athenians that ascended to its heights might reasonably be construed and represented as a journey to the domain of the gods. Consequently, it becomes clear why the planners of the frieze did not make Athena the sole recipient or focus of the procession, in the manner of earlier votive reliefs, and why instead they opted to surround her with other divinities, using a format more immediately suggestive of passage to the Olympian realm.

Yet while apotheosis is strongly suggested in the overall structure of the procession toward the gods, one need not assume, as Boardman has also argued, that the Panathenaic celebrants are literally the heroized dead of Marathon in order to understand how such iconography could be made acceptable in this context by fifth-century standards.[105] The overt quality of apotheosis that Boardman's interpretation would attribute to the composition seems at odds with the detail of the frieze itself, since the two files of Athenians do not really come face to face with the gods as do the figures in the processions on the Murlo and Velletri friezes (cf. figs. 24, 33, and 35). In the context of the Panathenaia, such a direct approach to the Olympians might perhaps have appeared excessive or presumptuous, even for the victors of Marathon. The goal of those who designed the frieze was to create an atmosphere that could evoke the notion of apotheosis without asserting it so openly or specifically. In purely visual terms, the two groups of enthroned gods direct their attention primarily toward the processions that converge from either side, rather than upon the central *peplos* ritual, and Aphrodite on the right side even gestures toward the arriving celebrants (fig. 24, right). But the various figures at the head of the procession converse among themselves as if they do not notice the seated Olympians; only one, possibly a marshal, points in the direction of the center of the frieze, and this is ostensibly toward the *peplos* ritual or toward the procession at the opposite end, not at the deities, who apparently remain unseen (fig. 24, right).

While most scholars see the figures immediately adjacent to the gods as

the Eponymous Heroes of ancient Attika, some have expressed reservations about this identification, arguing that they cannot really be distinguished from the participants in the procession.[106] If these figures are indeed mortal Athenians, officials of some kind rather than the long-departed Attic heroes, it would explain their apparent indifference toward (i.e., unawareness of) the nearby gods (fig. 24, left and right). At any rate, this insentience toward divinity is a crucial feature, for it links the Parthenon frieze to such forerunners as the east frieze of the Siphnian Treasury and the roughly contemporary Hephaisteion frieze, where the approving gods similarly watch over earthly heroes as an invisible presence beyond mortal experience or perception (figs. 24 and 31). Here the planners of the Parthenon frieze found an effective compromise; the overall procession culminated in the Olympian realm in the manner of earlier apotheosis depictions, but only in larger compositional terms. The frieze preserved or respected the requisite distance between god and man, but conveying it more subtly, through the nuance of poses and gestures that reminded the attentive spectator of the gap between the actions of the earthly sphere, however excellent or heroic, and the omniscient divinities who supervised all such action.

If the inclusion of the enthroned Olympians can be explained in part as the result of a conscious attempt to maintain and exploit the formal and iconographic traditions of continuous frieze decoration in earlier Greek religious architecture, above all as a means of heroizing the theme of the Panathenaia, then the pronounced emphasis on equestrian imagery in the Parthenon frieze may have had a similar intent. In arguing for the possible impact of the Siphnian Treasury on the Parthenon, Vasic pointed to the analogous preoccupation with equestrian detail in the portions of the Delphic monument depicting the Judgment of Paris on the West and the abduction scene on the South. But he considered only the formal, compositional advantages of such iconography: the practical value of chariotry and horsemen as dynamic and lively motifs that could effectively fill the lengthy space of a continuous frieze (fig. 31).[107]

Horsemanship was in fact a special prerogative or attribute of the hero in Greek culture. Despite the negative association of Amazons and Centaurs with the wild horse as a symbol of *hybris* and untamed bestiality, the mastery of horses by men was a noble effort, inspired by Poseidon and manifesting the *arete* of the heroic *ethos*. Shapiro's work on the east frieze of the Siphnian Treasury has shown how it utilized the myth of Antilochos to embody these values, much as Pindar did somewhat later in his Sixth Pythian Ode, cited above in the Introduction.[108] The poem and the frieze both illustrate the elevated status and aristocratic cachet of horsemanship, and how readily it evoked the heroic equestrian feats and virtue of the epic past.

Xenophon too (*On Horsemanship,* II, 8) extols the heroic associations that a graceful equestrian technique may impress upon spectators. Osborne has also noted the emphasis placed on horsemanship in the epitaph celebrating the Athenian dead at Tanagra, and the mounted format so prevalent in the sculptured grave stelai of Athenian soldiers.[109]

Moreover, the invention of the four-horsed chariot was attributed to the mythic Attic king Erichthonios, along with the institution of the Panathenaia itself and its chariot events.[110] The riding and chariot contests of the festival may actually have taken their inspiration from equestrian hero cults associated with the Bronze age tombs located along the route of the festival in the Agora, as Thompson and others have suggested. Excavations in the Agora uncovered a votive deposit, in use between the seventh and early fifth centuries, which included miniature terracotta sculptures of horsemen and chariot groups, and a prize tripod of bronze. On the evidence of this material, Thompson has proposed that the Panathenaic chariot events originated in the funeral games celebrated as part of these cults. In addition to these traditional heroic associations of the cavalry and chariotry displayed so emphatically in the Parthenon frieze, various riders and standing participants on the North, South, and West are depicted heroically nude (fig. 23, bottom right and left).[111]

It is possible that here too the planners followed the precedent of earlier temple decoration, which had already perfected the use of equestrian detail along with heroic nudity as stock attributes of mythic characters. It can hardly be accidental that so much of the Siphnian Treasury frieze emphasizes cavalry and chariotry, even in the Judgment of Paris on the West, where we might not expect it at all (fig. 31).[112] The horse or chariot imagery in the related Etruscan friezes may have served a similar purpose. To some extent the races or games at Murlo and Velletri, and those of their Ionian forerunners, reflect the popularity of aristocratic equestrian events among the Greeks and peoples of Central Italy. But there may also be some deeper connection between these scenes and the Olympian, heroic processions in the accompanying plaques, a connection perhaps analogous to the inclusion of such equestrian games in the actual Panathenaia. One need only recall the depiction of the chariot races at the funeral games for Patroklos on the François Vase to appreciate the heroic resonance of such contests in Archaic and Classical times, or the tendency of Greek artists to juxtapose them with slower processional depictions (the wedding file of Peleus and Thetis appears just below the racing scene on the François Vase).[113]

Nor are the seated Olympians inappropriate as spectators of such racing scenes. The funeral games for Pelias depicted on the reverse of the well-known Amphiaraos krater of about 575 B.C. show horse races in the pres-

ence of enthroned judges. While the latter are mortals rather than gods, it is clear that Archaic Greek art could also combine equestrian events and seated assemblies as a larger composition.[114] The chariot races and the rampant cavalry in the friezes from Murlo and Velletri may therefore have been customary pendants to the scenes of apotheosis or heroization depicted in the remaining plaques (figs. 33 and 35). This in turn helps us to appreciate the similar combination of imagery on the Parthenon frieze, particularly if Thompson is correct in deriving the equestrian events of the Great Panathenaia from an earlier tradition of heroic funeral games.

Thus the heroized aspect of the Panathenaic procession in the frieze depended upon a calculated adaptation of the themes and conventions used in the mythic narratives of earlier Greek temple decoration. But it was not only the formal motifs and compositional principles of such forerunners that appealed to the planners; it was also the capacity of these pictorial formulae to evoke the themes of heroic character or achievement and divine approbation that made them so attractive as prototypes or models. The designers of the frieze strove to portray the festival in idealized terms, for its depiction on the Parthenon would only seem justified if the celebrants displayed the *ethos* and attributes of the mythic heroes who were normally represented in the applied sculpture of a temple. By adapting the familiar and established conventions of mythic imagery from the sort of East Greek temple sculpture reflected in the Etruscan friezes or the Siphnian Treasury, the designers of the Parthenon transformed the immediate actuality of the Panathenaia into an image that made its participants appear particularly worthy in the eyes of the Olympians upon whom the entire composition converged.

As a result, this glorified aspect of the participants and their *ostensible* proximity or access to divinity also made the Panathenaic subject of the frieze an acceptable counterpart to the remaining sculptures of the Parthenon. The heroized Athenians who served and honored Athena and the other Olympians in the frieze became more analogous to the mythic Athenians in the west pediment who were involved in the contest between Athena and Poseidon. And if, as Harrison has cogently argued, the reclining male deity witnessing Athena's birth on the left half of the east pediment is indeed Herakles, who had attained immortality by virtue of his great achievements and Athena's protection, then one begins to sense how specific and pointed the formal or compositional allusions to apotheosis in the frieze really were.[115] The aura of divine acceptance or approval also paralleled the approximation between man and god that the metopes had asserted by juxtaposing or comparing the Gigantomachy itself with the various heroic struggles to uphold divine law. The heroized image of the present in the frieze complemented or inverted the contemporary relevance of the epic themes in

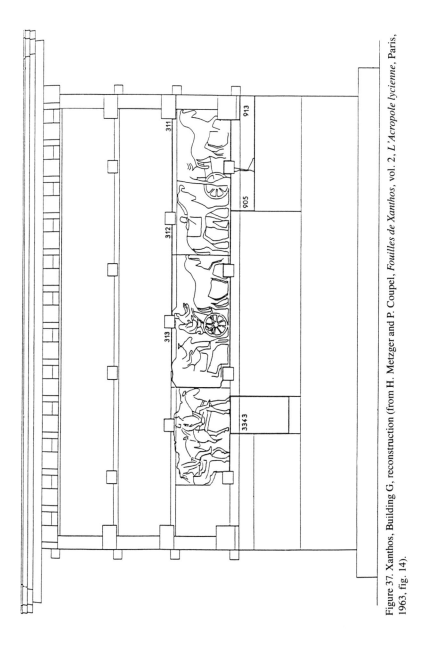

Figure 37. Xanthos, Building G, reconstruction (from H. Metzger and P. Coupel, *Fouilles de Xanthos*, vol. 2, *L'Acropole lycienne*, Paris, 1963, fig. 14).

the metopes; together they expressed a unified image of piety and excellence that effectively dissolved the boundaries between myth and actuality.

Still, despite the strong heroic or mythic resonance of the Parthenon frieze, the actuality inherent in its depiction of a real event or ceremonial is undeniable. But another monument can help clarify how this quality too followed the precedent of earlier architectural sculpture in the larger Greek sphere—the so-called Building G from the akropolis at Xanthos in Lycia, datable to about 470–460.[116] Thanks to the studies of Metzger and Coupel, the building and the placement of its sculptures have been provisionally restored. These included two continuous friezes running along both sides of the cella exterior, about halfway up the walls (fig. 37). The south frieze, almost entirely preserved, consisted of a procession with a chariot, cart, horsemen, and a groom on foot leading an unmounted horse (fig. 38). Only one section of the corresponding north frieze survives; it shows a procession on foot of seven figures, two of which are only partially preserved (fig. 39, top right).

On a purely formal level, these sculptures are strikingly similar to certain portions of the Parthenon frieze. The horsemen on the south side of the Lycian monument follow immediately upon the slow procession of vehicles, recalling the south side of the Panathenaic frieze from slabs XXII to XXVI (fig. 39, left). The Lycian horsemen do not gallop; they canter. Yet the first rider reigns in his horse as he nears the chariot in front of him. The horses immediately behind the chariot on slabs XXII to XXIV of the Parthenon are similarly restrained or arrested as the rapid motion of the cavalry adjusts to the more dignified pace of the procession that lies ahead. In the procession on the north frieze of Building G, the Lycian men turn and gesture to one another as they walk, recalling the processions of elders in the north and south friezes on the Parthenon (fig. 39, right). The pacing of the processions is also similar on both monuments; the distances and the degree of overlapping between the figures vary on the Lycian frieze, anticipating in a simpler form the momentary interactions and changing rhythms of the Athenians on foot in the Panathenaic frieze.

Unlike the other forerunners of the Parthenon frieze, there is no evidence to suggest that the sculptures of Building G depicted any mythic event. The building was probably a tomb, like the adjacent monuments at Xanthos, although it may also have served as a dynastic *heroön* or a temple with a cultic function.[117] Its friezes record some kind of peripatetic ceremonial associated with a local ruler, who is presumably the figure seated in the chariot (fig. 38, left). On the evidence of other related monuments from this period in Anatolia, the procession may well be a funeral cortege in which the ruler participates symbolically on his way to the hereafter.[118] The use of

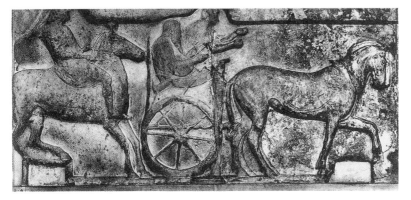

Figure 38. Xanthos, Building G, frieze, London, British Museum (after H. Metzger and P. Coupel, *Fouilles de Xanthos*, vol. 2, *L'Acropole lycienne*, Paris, 1963, pl. 39.

a throne chariot or cart is especially reminiscent of the processions from Murlo and Metapontum (figs. 33–34 and 37–38). Like the earlier Archaic Greek and Etruscan friezes, the Building G reliefs emphasize equestrian display to designate excellence or status, and the funerary theme here is also suggestive of apotheosis. But the Lycian reliefs do so in a setting more analogous to the Parthenon frieze, for they evidently portray a real event or ritual procession, and one that could have been performed at or around the building itself. Here, then, we may finally have a work that parallels not only the equestrian and processional content or structure of the Parthenon frieze, but also the actuality of its theme as a depiction of contemporary ceremonial.

In the latter respect the Building G reliefs may adhere more faithfully to oriental tradition than any of the other parallels discussed above. The style and possibly the workmanship are East Greek—basically Severe with a lingering archaism in the treatment of detail (fig. 38).[119] But iconographically they belong to the body of "Greco-Persian" funerary art produced across western Anatolia in the fifth century. Scholarship has tended to stress the Persian background of the equestrian trapping, the coiffure, and the breed of the horses in the Building G friezes, which, like the posture of the groom, can be closely paralleled in the Persepolis reliefs.[120] Yet the content and organization of the Lycian procession, with its throne chariot or cart and mounted horsemen, are very different from anything depicted on the Apadana and the nearby buildings (cf. figs. 26 and 39). They are best paralleled by reliefs and monumental tomb paintings found elsewhere in Lycia and the westernmost satrapies. And despite the Persian influence on dress and other details of material culture in all such works, more recent scholarship has begun to recognize the local oriental or Anatolian background of these

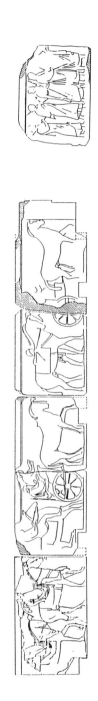

Figure 39. The friezes of Xanthos, Building G, compared with the south frieze of the Parthenon, as drawn by Carrey in 1674 (after H. Metzger and P. Coupel, *Fouilles de Xanthos*, vol. 2, *L'Acropole lycienne*, Paris, 1963, fig. 10, and F. Brommer, *Der Parthenonfries: Katalog und Untersuchung*, Mainz, 1977. pl. 110).

"Greco-Persian" monuments and the beliefs that they illustrated.[121] The specific practice of parading the ruler or dynast enthroned in his car was not originally a Persian custom; it already existed in Neo-Assyrian ceremonial and art, and it must have been known to the native Anatolians and their East Greek neighbors before the coming of the Achaemenids. Only then can one explain the westward diffusion of similar throne cart processions in works like the Murlo and Metapontum friezes by the second quarter of the sixth century B.C. (cf. figs. 33–34, and 38).[122]

Building G and its friezes demonstrate the extent to which Greek or Greek-trained sculptors working in western Asia for a native, non-Greek clientele had become familiar with Near Eastern forms of ceremonial and with the long-established oriental principle of utilizing contemporary ritual or protocol as a theme of architectural decoration. Unfortunately, only traces remain of the broader oriental legacy that may have permeated East Greek art at this time. One late Archaic Ionian vase painting depicts an equestrian procession with Persian horse trappings and mane coiffure identical to those in the Apadana and Building G reliefs; another shows an incense burner like those at the center of the Apadana reliefs (cf. fig. 26, top right).[123] Ridgway has similarly noted the Persian details of some of the fragments from the parapet frieze of the Artemision at Ephesos.[124] This all suggests that the sort of ceremonial depiction encountered at Xanthos may also have become current in the architectural sculpture of the East Greek cities as part of a more extensive reinfusion of Near Eastern artistic themes and conventions under Persian rule during the later sixth and early fifth centuries. In this case, it would be considerably easier to understand the factors that informed the ceremonial actuality of the Parthenon frieze, and even the inclusion of an incense burner of Persian type among the offerings carried by the female participants on the eastern portion of the procession (fig. 24, far right).

It would be wrong, however, to minimize the direct role of Lycia in this process. Xanthos and the neighboring cities came under Athenian domination around the time of Kimon's Eurymedon campaign of 469/68. Building G seems to date to this general period; perhaps, as the excavators maintain, it belongs to the rebuilding of the Xanthian akropolis between 470 and 460, sometime after the initial Athenian sack.[125] In either case the Lycian monuments of this kind would have been visible to the *episkopoi* and other Athenian officials who for a time watched over the affairs of these easternmost members of the Athenian "alliance." Nor is it unlikely that craftsmen from the school or atelier that produced the Lycian buildings might eventually have found their way to Athens along with the other resources extracted from the cities under Athenian rule.

Whether one chooses to see the Building G friezes as a local artistic

phenomenon or as the remnant of a more widespread development in the architectural sculpture of the western Asiatic coastland, it is clear that they too formed part of the rich and extensive tradition of processional iconography that went into the Parthenon frieze. They also help to document that the official monumental art patronized by the Athenian leadership was indeed open to themes and pictorial formulae of oriental derivation. But the Lycian reliefs indicate that these formulae did not reach Athens directly from the contemporary centers of Near Eastern or Persian culture, but rather from the oriental periphery, where they had already been adapted to local Anatolian and Greek artistic standards, in a form that was more readily accessible stylistically and geographically to the planners of the Parthenon.

The Frieze, the Allies, and East Greek Traditions of Architectural Sculpture

The use of a secondary Ionic frieze on the Parthenon was not unique or original. It had already appeared on the Athena temple at Assos, and the lost monument of Amyklai designed by Bathykles the Magnesian at the end of the sixth century seems to have included several continuous friezes. Perhaps the secondary frieze on the exterior cella walls of the early fourth-century Nereid Monument in Xanthos also reflected earlier East Greek tradition.[126] But this was only one of a number of architectural features on the Parthenon that can be traced to practices established in the western Asiatic coastland and the Aegean Islands. Others were the use of marble ceilings and the thinner proportions of the entablature and columns, as Coulton has shown.[127] To some extent this similarity may simply reflect the background and training of the architects and craftsmen who designed and executed the building, many of whom would have flocked to Athens from the various cities under its control. But one should not assume that the craftsmen were merely resorting to their native traditions in order to explain these "Ionicisms."[128]

Such precedents also possessed a distinct cultural and geographic aspect that correlated closely with the regions over which Athens held sway; in a real sense, the frieze presented the spectator not only with a depiction of the Panathenaia, but also with a compendium or resynthesis of the temple decoration current through most of the Athenian empire (Map 2). In its incorporation of East and Island Greek forms within a mainland Doric setting, the Parthenon was effectively an architectural counterpart to the collective Attic-Ionian propaganda of Athens and her allies at this time, and this cannot be entirely circumstantial or accidental. Pollitt has already suggested that this

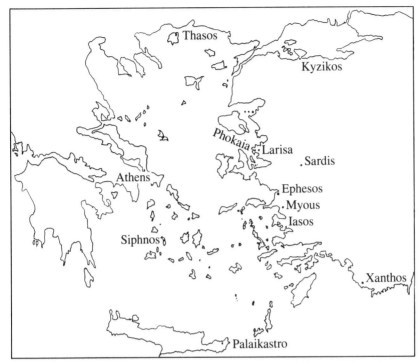

Map 2. The Aegean region: cities that commissioned continuous architectural friezes of Archaic and Early Classical date related to the Parthenon frieze.

combination of Doric and Ionic elements on the building was intended to evoke the kinship between the Athenians and the cities throughout the Asiatic coast and the Cyclades that they now dominated, and this is a possibility worth considering more closely in the frieze.[129] Fundamentally, the adaptation of Olympian, equestrian, and processional themes and conventions from earlier East Greek temple sculpture served to heroize and glorify Athens and her Panathenaic celebrants in established artistic terms, as emphasized above. But it is important to recognize that ultimately the designers of the frieze accomplished this goal by appropriating and reintegrating the sculptural and architectural traditions of the allies themselves to produce this image of the greatest of Athenian religious festivals.

At the time of its creation, this must have provided a powerful and unequivocal visual statement of the unity between Athens and her "ancient colonies" every bit as meaningful as the ritual or ceremonial that incorporated the allies within the Great Panathenaia. These allies were ostensibly present in the north and south processions, perhaps leading some of the

cows, but as we have already seen, nothing stated this absolutely. The frieze asserted the ethnic, religious, and political unity among Athens and the members of the alliance largely on a deeper, more subliminal level, by incorporating the traditions of temple decoration that constituted a significant aspect of the material cultural identity of the allies themselves.

To the designers of the frieze and the Athenian leaders for whom they worked, this more subtle and abstract approach was preferable to an explicit and potentially offensive image of subject delegations, and in the end it would have appeared far more meaningful and effective to the allied delegates who viewed the frieze when they ascended the Akropolis as part of the festival. The men from Thasos had such cavalry and female processants on the friezes of their religious buildings (fig. 27). Those from Myous, Kyzikos, Iasos, Larisa, and Phokaia would have recognized the sort of racing chariots that also decorated the friezes of their temples (fig. 28). The Siphnians would undoubtedly have been reminded of the chariots, galloping horsemen, and seated Olympians on the Treasury that they had long ago commissioned at Delphi (fig. 31). The representatives from Ephesos would have found the frieze similar to the parapet of their Artemision. Those from some unknown city or cities in East Greece whose architectural sculpture had inspired the friezes at Murlo and Velletri could hardly have missed the analogies offered by the Parthenon (figs. 33 and 35). And the Lycians too might well have encountered a remarkably familiar depiction of official ceremonial, had they not broken loose from Athenian authority before the frieze was completed (fig. 39).[130]

Today, the incorporation on the Parthenon of East Greek modes of architectural sculpture in conjunction with an ideology and public ceremonial professing ethnic kinship and unity with Athens may seem a small compensation for the loss of political independence, but initially at least the allies may have seen it in different terms. These artistic quotations were in a sense a mark of dignity and recognition; like allied participation in the Great Panathenaia itself, they signified visually that each member state of Athens' pan-Aegean symmachy was an essential part of a greater, prestigious entity. Perhaps for a while these ritual, sculptural, and architectural expressions were sufficient to placate the subject cities, before the reality of Athenian imperialism smashed the earlier Periklean propaganda of Attic-Ionian alliance and amphictyony beyond repair.

For most modern observers, and maybe even for those of antiquity after the fifth century B.C., this subtle, culturally referential statement of Athens' relation to her allies has evaporated. It resided not so much in the building itself as in the culturally determined interpretative strategies of those who originally beheld the temple. But even so, its frieze still impresses the spec-

tator as a timeless image of piety, civic virtue, and heroic excellence, without any outward reference to the imperialism that made the construction of the Parthenon possible. This response is not purely the result of our own inability to grasp fully the meaning and conventions of a work made by another culture in another age. The Parthenon was never intended as a monument to empire; it was instead a monument to military strength and alliance, and to religious solidarity, all predicated in turn upon the guiding cultural and ethical superiority of the Athenian people and the protection of the goddess who inspired them.[131]

If the image that the Parthenon projected falls short of the truth, it should not disturb or surprise us too much, despite the cherished status that the temple and it is sculptures have attained as a symbol of Western values and achievement. The idealized and self-serving view of Athenian power asserted by the frieze and the Panathenaic festival itself was fundamentally akin to the willful adjustments of narrative content applied in the metopes of the Parthenon, or in the paintings of Kimonian times, as officially sanctioned mythic analogues for contemporary events. The denial of Athenian imperialism in the frieze was effectively no different from the efforts of Polygnotos or Pheidias to reshape the tragic story of the Iliupersis into a paradigm of Greek excellence and well-deserved triumph over Asia. The Parthenon was not the first artistic monument whose designers had to twist and bend tradition and reality to meet the needs and self-perceptions of the society that produced it; nor would it be the last.

Appendix
Abbreviations
Notes
Selected Bibliography
Index

Appendix

Bakchylides' First Dithyramb, Ode XV(14): "The Sons of Antenor—The Demand for the Return of Helen"

The Greek text of Bakchylides' First Dithyramb is taken from the edition of B. Snell and H. Mähler, *Bacchylidis carmina cum fragmentis*, Leipzig, 1970, 52–54.

A′ Ἀντή]γορος ἀντιθέου
 ]ρακοιτις Ἀθάνας
 πρόσπολος
 ₃ ᴗ‗ᴗ‗‗] Παλλάδος ὀρσιμάχου
 ‗‗ᴗ‗‗χ]ρυσέας
 5 ‗ᴗ‗‗‗ᴗ]ν Ἀργείων Ὀδυσσεῖ
 Λαρτιάδαι Μενελ]άωι τ᾽
 Ἀτ|ρείδᾱι βασιλεῖ
 ₇‗ᴗ‗‗‗βαθύ]ζωνος Θεανώ
 ‗‗ᴗᴗ‗ᴗᴗ]ον
 ‗‗ᴗᴗ‗ᴗᴗ‗]ν προσήνεπεν·
 10 ₃‗‗ᴗ‗‗‗ᴗ ἐ]ϋκτιμέναν
 12 ‗ᴗ‗‗‗ᴗ‗‗]δων τυχόντες
 ‗ᴗᴗ‗ᴗᴗ‗‗‗ᴗᴗ‗]ς σὺν θεοῖς
 ₇‗ᴗ‗‗‗ᴗ‗‗‗ᴗ‗]δους

] the wife of godlike Antenor,

 priestess of Athena,
] of battle-rousing Pallas
] of gold,
] of the Argives, Odysseus,
 son of Laertes and Menel]aos,
 a king sprung of Atreus.
Deep]-girdled Theano.

] addressed

] well-built
] obtaining
] with the gods

B′ ‗‗ᴗᴗ‗ᴗᴗ‗]
 23 ‗‗ᴗᴗ‗ μεσονύ]κτιος κέαρ
 ἆγον, πατὴρ δ᾽ εὔβουλος ἥρως

 πάντα σάμαινεν Πριάμωι
 βασιλεῖ
 ₄ παίδεσσί τε μῦθον Ἀχαιῶν.
 40 ἔνθα κάρυκες δι᾽ εὐ-
 ρεῖαν πόλιν ὀρνύμενοι

midn]ight doom
] led, while their father, the hero
 wise in council,

made known to Priam the king and
 his sons
all the word of the Achaians.
Then the heralds, hastening through
 the city wide,

233

Τρώων ἀόλλιζον φάλαγγας

Γ΄ δεξίστρατον εἰς ἀγοράν.
πάντᾱι δὲ διέδ ͐ ραμεν αὐδάεις
λόγος·
45 ₃ θεοῖσ < ιν > δ᾽ ἀνίσχοντες
χέρας ἀθανάτοις
εὔχοντο παύσασθαι δυᾶν.
Μοῦσα, τίς πρῶτος λόγων
ἆρχεν δικαίων;
Πλεισθενίδας Μενέλαος γάρυϊ
θελξιεπεῖ
₇ φθέγξατ᾽, εὐπέπ ͐ λοισι κοινώσας
Χάρισσιν·

50 ,,ὦ Τρῶες ἀρηΐφιλοι,

Ζεὺς ὑψιμέδων δ ͐ ς ἅπαντα
δέρκεται
52 ₃ οὐκ αἴτιος θνατοῖς μεγάλων
ἀχέων,
53 ἀλλ᾽ ἐν ⌞μέσ⌟ωι κεῖται κιχεῖν
πᾶσιν ἀνθρώποις Δίκαν ἰθεῖαν,
ἀγ ͐ νᾶς
55 Εὐνομίας ἀκόλουθον καὶ
πινυτᾶς Θέμιτος
₇ ὀλβίων π ⌞αῖδές⌟ νιν αἱρεῦνται
σύνοικον.
ἁ δ᾽ αἰόλοις κέρδεσσι καὶ ἀφ
⌞ροσύναις
.ἐξαισίοις θάλλουσ᾽ ἀθαμβής
῎Υβ ⌞ρις, ἃ πλοῦτ[ο]ν δύναμίν τε
θοῶς
60 ₄ ἀλλότ ⌞ριον ὤπασεν, αὖτις

δὲς βαθὺν πέμπει φθόρον,

κε]ίνα καὶ ὑπερφιάλους
Γᾶς] παῖδας ὤλεσσεν
Γίγαντας."

assembled the ranks of the Trojans
in the meeting place of the troops.
The word of men ran all about

as, raising their hands to the
immortal gods,
they prayed for woe to cease.
Muse, who first began the righteous
pleadings?
Menelaos, son of Pleisthenes,
spoke;
counseled by the fair-robed
Graces,
he enchanted them with speech.
"O men of Troy, favored by the god
of war,
Zeus, who rules on high and sees all
things,
is not the cause of the great wailings
of mortals.
The way lies open for all men to
attain straightforward Dike,

The attendant of holy Eunomia and
prudent Themis.
Children of blessed men have her
as dweller among their homes.
Whereas she who is burgeoning
forth
with shifty wiles and lawless follies,
yes, irreverent Hybris,
she quickly gives (you) the wealth
and power belonging to another,

But then she leads into the depths of
ruin.
And that one (Hybris), she destroyed
those arrogant sons of Gaia, the
Giants."

Abbreviations

AA	*Archäologischer Anzeiger*
ABSA	*Annual of the British School at Athens*
ABV	J. D. Beazley, *Attic Black-Figure Vase-Painters*, Oxford, 1956
AJA	*American Journal of Archaeology*
AM	*Athenische Mitteilungen*
AMIran	*Archäologische Mitteilungen aus Iran*
ARV²	J. D. Beazley, *Attic Red-Figure Vase-Painters*, 2nd ed., Oxford, 1963
BCH	*Bulletin de correspondence hellénique*
BABesch	*Bulletin van de Vereeniging tot Bevordering der Kennis van de Antieke Beschaving*
BICS	*Bulletin of the Institute of Classical Studies of London University*
IM	*Istanbuler Mitteilungen*
JDAI	*Jahrbuch des Deutschen Archäologischen Instituts*
JHS	*Journal of Hellenic Studies*
JWCI	*Journal of the Warburg and Courtauld Institutes*
LIMC	*Lexicon Iconographicum Mythologiae Classicae*, Munich, 1981–.
RA	Revue archéologique
REG	Revue des études grecques
RM	Römische Mitteilungen
RVA	A. D. Trendall and A. Cambitoglou, *Red-Figured Vases of Apulia*, Oxford, 1978

Notes

Introduction

1. Here see especially P. Veyne, *Did the Greeks Believe in Their Myths? An Essay on Constitutive Imagination* (trans. P. Wissing), Chicago and London, 1988, who defines myths basically as narratives whose content was accepted without question.

2. For Xenokrates of Akragas, father to Thrasyboulos, c. 490 B.C., see R. Lattimore (trans.), *The Odes of Pindar,* Chicago, 1947, 74–75. Cf. Pindar's Olympian Ode X, for Agesidamos of Lokroi Epizephyrioi, and Bakchylides XIII, Nemean Ode for Pythias of Aigina. For a discussion of Pindar's technique of mythic comparison in the ode composed for Hieron of Syracuse, see D. E. Gerber, *Pindar's Olympian Ode One: A Commentary,* Toronto, 1982, xiv–xv.

3. J. J. Pollitt, *Art and Experience in Classical Greece,* Cambridge, 1972, 6–9.

4. J. Boardman is the foremost proponent of this view: see "Herakles, Peisistratos, and Sons," *RA,* 1972, 57–72, and "Image and Politics in Sixth Century Athens," in H. A. G. Brijder (ed.), *Ancient Greek and Related Pottery,* Proceedings of the International Vase Symposium, Amsterdam, 1985, 239–247. But see the reservations of W. G. Moon, "The Priam Painter: Some Iconographic and Stylistic Considerations," in W. G. Moon (ed.), *Ancient Greek Art and Iconography,* Madison, Wis., 1983, 101–106; M. B. Moore, "Athena and Herakles on Exekias' Calyx-Krater," *AJA,* 40, 1986, 38, n. 25; R. M. Cook, "Pots and Pisistratan Propaganda," *JHS,* 107, 1987, 167–169; W. R. Connor, "Tribes, Festivals, and Processions: Civic Ceremonial and Political Manipulation in Archaic Greece," *JHS,* 107, 1987, 42–47; and Boardman's insistent response, "Herakles, Peisistratos, and the Unconvinced," *JHS,* 109, 1989, 158–159. Connor, "Theseus in Classical Athens," in A. Ward (ed.), *The Quest for Theseus,* New York, 1970, 157–167, has suggested that Peisistratos fostered the myths of Theseus for political purposes; cf. W. B. Tyrrell and F. S. Brown, *Athenian Myths: Words in Action,* New York and Oxford, 1991, 163–165. J. Neils, *The Youthful Deeds of Theseus,* Archaeologia, 76, Rome, 1987, 149–150, attributes interest in Theseus primarily to the Alkmaionid family, especially in the later sixth century under Kleisthenes; cf. K. Schefold, "Kleisthenes," *Museum Helveticum,* 3, 1946, 59–93, and K. Schefold and F. Jung, *Die Urkönige, Perseus, Bellerophon, Herakles und Theseus in der klassischen und hellenistischen Kunst,* Munich, 1988, 230–231. H. A. Shapiro, *Art and Cult Under the Tyrants in Athens,* Mainz, 1989, 143–163, takes a broader view on the political circumstances affecting the imagery of Herakles, Theseus, and other heroes in Archaic Athens. Also see H. A. Shapiro, "Painting, Politics, and Geneology: Peisistratos and the Neileids," in Moon, *Greek Iconography,* 87–96; L. V. Watrous, "The Sculptural Program of the Siphnian Treasury at Delphi," *AJA,* 86, 1982, 159–172. Examining the private sphere, a context more analogous to Pindar's Odes, A. Stewart, "Stesichoros and the François Vase," in Moon, *Greek Iconography,* 69–70, has connected the choice and implication of the myths on the Kleitias krater

to a special commission celebrating an aristocratic marriage; cf. Neils, *Youthful Deeds of Theseus*, 150.

5. Many authors have addressed this phenomenon in Greek literature and art of the fifth century. For an extended, in-depth treatment, see F. Fischer, *Heldensage und Politik in der klassischen Zeit der Griechen*, Tübingen, 1957 (Diss. 1937), with extensive earlier bibliography; W. Kierdorf, *Erlebnis und Darstellungen der Perserkriege*, Hypomnemata, 16, Göttingen, 1966; E. Thomas, *Mythos und Geschichte: Untersuchungen zum historischen Gehalt griechischer Mythendarstellungen*, Cologne, 1976; P. duBois, *Centaurs and Amazons: Women and the Pre-History of the Great Chain of Being*, Ann Arbor, Mich., 1982, 54–71; W. B. Tyrrell, *Amazons: A Study in Athenian Mythmaking*, Baltimore and London, 1984, 9–19; and E. D. Francis, *Image and Idea in Fifth-Century Greece: Art and Literature after the Persian Wars*, London and New York, 1990, esp. 21 ff. W. Schindler, *Mythos und Wirklichkeit in der Antike*, Berlin, 1988, examines more broadly the contemporary political or cultural factors that conditioned the use of myth in art throughout classical antiquity.

6. The events enumerated by Herodotos' Athenians at Plataia appear as an extended catalogue in Lysias' *Funeral Oration* (II); 4–16 and 21–26; and in Demosthenes' *Funeral Oration* (II), 8–11. Isokrates utilizes the catalogue at even greater length in his *Panegyric* (IV), 55–56, 58–60, 64–65, 68–72, 83, 86, 88, and 97–98, and in his *Panathenaikos* (XII), 193–195. In the *Panegyric* (IV), 88, he too extols the Persian Wars as a greater achievement than the expedition against Troy. In *Archidamos* (VI), 42–43, he refers to the catalogue more briefly, as Herodotos did. It appears as well in the funeral speeches recited by Sokrates in Plato's *Menexenos*, 239–240, and in Xenophon's *Memorabilia*, III, 5, 10. For Herodotos' dependence on Athenian official rhetoric in the speech at Plataia and up-to-date bibliography on the subject more generally, see n. 26 to Chapter 2.

7. Aischines, *Ktesiphon*, III, 183–185; Plutarch, *Kimon*, VII, 4–6. The translation of Plutarch here is taken from I. Scott-Kilvert, *The Rise and Fall of Athens: Nine Greek Lives by Plutarch*, Harmondsworth, 1960, 148, but I have followed earlier scholarship in restoring the probable order of the verses. See H. L. Jeffery, "The Battle of Oinoe in the Stoa Poikile," *ABSA*, 60, 1965, 45, n. 19; F. Jacoby, "Some Athenian Epigrams from the Persian Wars," *Hesperia*, 14, 1945, 198–202; and H. T. Wade-Gery, "Classical Epigrams and Epitaphs: A Study of the Kimonian Age," *JHS*, 53, 1933, 87–95. On the location of the herms see H. A. Thompson and R. E. Wycherley, *The Athenian Agora: The Agora of Athens*, vol. 14, Princeton, N.J., 1972, 94–96, and J. M. Camp, *The Athenian Agora: Excavations in the Heart of Classical Athens*, London, 1986, 74–77.

8. See above all H. Herter, "Theseus der Athener," *Rheinisches Museum für Philologie*, N.F., 88, 1939, 291–299; idem, "Griechische Geschichte im Spiegel der Theseussage," *Die Antike*, 17, 1941, 223–226; C. Dugas, "L'Évolution de la légende de Thésée," *REG*, 56, 1943, 1ff. = *Recueil Charles Dugas*, Paris, 1960, 93–107; T. L. Shear, Jr., *Studies in the Early Projects of the Periklean Building Program*, Ph.D. Diss., Princeton, 1966, 64; G. Donnay, "Allusions politiques dans l'art attique du Ve siècle," *Revue de l'Université de Bruxelles*, N.S., 19, 1966–1967,

249–253; A. Molle, *Étude de l'iconographie de Thesée en relation avec la politique de Cimon*, Paris, 1968; W. den Boer, "Theseus: The Growth of a Myth in History," *Greece and Rome*, 16, 1969, 3, 7, and 9; Connor, "Theseus in Classical Athens," 157–167; A. Podlecki, "Cimon, Skyros, and Theseus' Bones," *JHS*, 91, 1971, 141–143; C. Delvoye, "Art et politique à Athènes à l'époque de Cimon," in *Le monde grec: Hommages à Claire Préaux*, Brussells, 1975, 803–807; H. W. Parke, *Festivals of the Athenians*, Ithaca, N.Y., 1977, 81–82; J. N. Davie, "Theseus the King in Fifth-Century Athens," *Greece and Rome*, 29, 1982, 25–34; J. Boardman, "Herakles, Theseus, and Amazons," in D. Kurtz and B. Sparkes (eds.), *The Eye of Greece: Studies in the Art of Athens*, Cambridge, 1982, 1–28; and Tyrrell and Brown, *Athenian Myths*, 167–170.

9. On the genealogy and the Kimonian overtones of the Fourth Dithyramb (Ode XVIII), see J. P. Barron, "Bakchylides, Theseus and a Woolly Cloak," *BICS*, 27, 1980, 1–4.

10. On the discovery and return of Theseus' remains, see Plutarch, *Kimon*, VIII, 3–6, and *Theseus*, XXXVI; Podlecki, *JHS*, 91, 1971; and Parke, *Festivals of the Athenians*, pp. 81–82. Plutarch, *Kimon*, X, also describes how the leader allowed the poor of Attika to help themselves to his fruit orchards, even providing free meals for those in need at his residence daily. He also took about with him well-dressed young men who were prepared to exchange their fine clothes with those of the poor of Athens, or to dispense small quantities of money to needy citizens. Plutarch does not expressly compare Kimon's actions to those of Theseus, but the parallel is unmistakable. One need only recall Plutarch's *Theseus*, XXXVI, to take the moralist's point. Also see Shear, *Periklean Building Program*, 62, on public works completed at Kimon's own expense.

11. C. Robert, *Die Nekyia des Polygnot*, Hallisches Winckelmannsprogram, 16, Halle, 1892; idem, *Die Iliupersis des Polygnot*, Hallisches Winckelmannsprogram, 17, Halle, 1893; idem, *Die Marathonschlacht in der Poikile und weiteres über Polygnot*, Hallisches Winckelmannsprogram, 18, Halle, 1895; T. Schreiber, *Die Wandbilder des Polygnot in der Halle der Knidier zu Delphi*, Leipzig, 1897; T. Löwy, *Polygnot: Ein Buch von Griechischen Malerei*, Vienna, 1929; C. Picard, "De 'l'Ilioupersis' de la lesché delphique aux métopes nord du Parthénon," *REG*, 50, 1937, 175–205; B. B. Shefton, "Herakles and Theseus on a Red-Figured Louterion," *Hesperia*, 31, 1962, 330–368; E. Simon, "Polygnotan Painting and the Niobid Painter," *AJA*, 67, 1963, 43–62; M. Robertson, "Conjectures in Polygnotos' Troy," *ABSA*, 62, 1967, 5–12; idem, *A History of Greek Art*, Cambridge, 1975, 240–259; K. Jeppesen, *Eteokleous Symbasis: Nochmals zur Deutung des Niobiden-kraters, Louvre G 341*, Acta Jutlandica, 40:3, Copenhagen, 1968; E. B. Harrison, "The South Frieze of the Nike Temple and the Marathon Painting in the Stoa," *AJA*, 76, 1972, 353–378; idem, "Preparations for Marathon, the Niobid Painter and Herodotus," *Art Bulletin*, 54, 1972, 390–402; J. P. Barron, "New Light on Old Walls," *JHS*, 92, 1972, 20–45; T. Hölscher, *Griechische Historienbilder des 5. und 4. Jahrhunderts vor Chr.*, Würzburg, 1973, 50–84; S. Woodford, "More Light on Old Walls," *JHS*, 94, 1974, 158–165; B. Cohen, "Paragone: Sculpture Versus Painting—Kaineus and the Kleophrades Painter," in Moon, *Greek Iconography*,

171–192, esp. 180ff.; M. D. Stansbury-O'Donnell, "Polygnotos's *Iliupersis:* A New Reconstruction," *AJA*, 93, 1989, 203–215; and idem, "Polygnotos's *Nekyia:* A Reconstruction and Analysis," *AJA*, 94, 1990, 213–235. For the issue of expressive emotional and moral content in such painting, see J. J. Pollitt, "The *Ethos* of Polygnotos and Aristeides," in L. Bonfante and H. von Heintze (eds.), *In Memoriam Otto J. Brendel: Essays in Archaeology and the Humanities*, Mainz, 1976, 49–54; idem, "Early Classical Greek Art in a Platonic Universe," in C. G. Boulter (ed.), *Greek Art: Archaic Into Classical*, Leiden, 1985, 96–111.

12. Pausanias, I, 28, 2, and X, 15, 4; W. Gauer, *Weihgeschenke aus den Perserkriegen*, Istanbuler Mitteilungen, Beiheft, 2, Tübingen, 1968, 103–107; also see Shear, *Periklean Building Program*, 60–61.

13. In his early work on these paintings, Robert, *Marathonschlacht*, 45, had already begun to address such issues. The interpretation of the paintings along these lines began to gather momentum with the work of Fischer, *Heldensage*, 17–19; Herter, *Rheinisches Museum für Philologie*, N.F., 88, 1939, 295–297, and *Die Antike*, 17, 1941, 226; and Dugas, "A la lesché des cnidiens," *REG*, 51, 1938, 53–59; idem, "La légende de Thésée," 21. The more recent studies of this kind include P. Amandry, "Athènes au lendemain des guerres médiques, "*Revue de l'Université de Bruxelles*, 13, 1960–1961, 222; Jeffery, *Battle of Oinoe,"* 42–46; A. Podlecki, *The Political Background of Aeschylean Tragedy*, Ann Arbor, Mich., 1966, 13–14; Gauer, *Weihgeschenke*, 18–19; J. S. Boersma, *Athenian Building Policy from 561/0–405/4 B.C.*, Scripta Archaeologica Groningana, Groningen, 1970 51–52, 55–57; Harrison, "Preparations for Marathon," 401; Hölscher, *Griechische Historienbilder*, 70–78; Delvoye, in *Hommages à Préaux*, 806; Thomas, *Mythos und Geschichte*, 39–40, 50–51, 61–63; R. B. Kebric, *The Paintings in the Cnidian Lesche at Delphi and Their Historical Context*, Mnemosyne Supplementum, Leiden, 1983; E. D. Francis, "Greeks and Persians: The Art of Hazard and Triumph," in D. Schmandt-Besserat (ed.), *Ancient Persia: The Art of an Empire*, Malibu, Calif., 1980, 62–63; Boardman, "Herakles, Theseus, and Amazons," 1–28, especially 16ff.; E. D. Francis and M. Vickers, "The Oenoe Painting in the Stoa Poikile and Herodotus' Account of Marathon," *ABSA*, 80, 1985, 99–113; and Tyrrell and Brown, *Athenian Myths*, 169–170.

14. E. Pfuhl, *Masterpieces of Greek Drawing and Painting*, New York, 1955, 47; P. Arias and M. Hirmer, *A History of 1000 Years of Greek Vase Painting*, New York, 1962, 354; T. B. L. Webster, "Polygnotos," *Oxford Classical Dictionary*, 2nd ed., Oxford, 1970, 855; J. J. Pollitt, *The Ancient View of Greek Art: Criticism, History, and Terminology*, New Haven and London, 1974, 184–189; idem, *Art and Experience*, 44–45; idem, "The *Ethos* of Polygnotos and Aristeides," 49–54; and idem, "Early Classical Greek Art," 104–106.

15. *Poetics*, 1450a 25–29. Also see the studies by Pollitt cited in the preceding note.

16. Pollitt, *Ancient View*, 31, 49, and 189.

17. See especially T. B. L. Webster, *Greek Art and Literature 700–530 B.C.*, New York, 1960; idem, *Greek Art and Literature 530–400 B.C.*, Oxford, 1939; idem, *Art and Literature in Fourth-Century Athens*, London, 1956; idem, *Hellen-*

istic Poetry and Art, London, 1964; Pollitt, *Art and Experience;* idem, *Art in the Hellenistic Age,* Cambridge, 1986. Also see the recent studies of individual monuments along such lines by J. M. Hurwit, "Narrative and Resonance in the East Pediment of the Temple of Zeus at Olympia," *Art Bulletin,* 69, 1, 1987, 6–15, and Stewart, "Stesichoros and the François Vase," 52–74.

18. See Pollitt, *Ancient View,* 58–63.

19. In the *Rhetoric,* 1371b, 23, and *Poetics,* 1450a, 25–29, 1450a, 39–1450b, 3, and 1460b, 8–9, Aristotle directly compares visual and literary arts; for the specific analogy of plot and character development to drawing and painting, see *Poetics,* 1450a, 39–1450b, 3. For Aristotle's conception of *mimesis,* see *Poetics,* 1447a, 18–1447b, 29; Pollitt, *Ancient View,* 39–40; G. F. Else, *Aristotle's Poetics: The Argument,* Cambridge, Mass., 1957, 68–73 and 251–263; idem, *Plato and Aristotle on Poetry* (rev. and ed. P. Burian), Chapel Hill, N.C., and London, 1986, 74–88; and S. Halliwell, *The Poetics of Aristotle: Translation and Commentary,* Chapel Hill, N.C., 1987, 70–72. On Plato's conception of *mimesis* in the arts, see the *Republic,* 398B–401C; Else, *Plato and Aristotle,* 17–46; and Pollitt, *Ancient View,* 38–39 and 42–43.

20. *Poetics,* 1450a, 25–29, and *Politics,* 1340a, 33–35; cf. Else, *Aristotle's Poetics,* 251–254. On the potential instructive and moral benefits that Aristotle ascribed to the arts, see Pollitt, *Ancient View,* 31, 49–50, and 189. On Aristotle's opinion concerning the capacity of tragedy to persuade or instruct, also see S. G. Salkever, "Tragedy and the Education of the Demos," in J. P. Euben (ed.), *Greek Tragedy and Political Theory,* Berkeley, Los Angeles, and London, 1986, 291.

21. *Rhetoric,* 1356a, 4, and 1417a, 8–9.

22. Pollitt, "The *Ethos* of Polygnotos and Aristeides," 52; idem, "Classical Greek Art," 104–105.

23. *Poetics,* 1450a, 1–2 and 5–6; 1450b 8–9; and 1454a, 17–19. On the relation between character and action in Aristotle's theory of poetry and drama, see Else, *Aristotle's Poetics,* 237–241 and 266–270; and idem, *Plato and Aristotle,* 103–124.

24. *Republic,* 602C–D; *Menexenos,* 235A–C. On Plato's objection to *skiagraphia,* see Pollitt, *Ancient View,* 44–45. On the deceptive aspects of such oratory, see K. R. Walters, "Rhetoric as Ritual: The Semiotics of the Attic Funeral Oration," *Florilegium,* 2, 1980, 16–17; for a broader overview of the negative qualities attributed to rhetoric, also see S. Fish, *Doing What Comes Naturally: Change, Rhetoric, and the Practice of Theory in Literary and Legal Studies,* Durham and London, 1989, 471–485.

25. Plato's disdain for the deceptive potential of artistic representation may also be attributable to his own epistemological orientations, and it was not necessarily shared by others like his older contemporary, the Sicilian rhetorician Gorgias of Leontini; see Pollitt, *Ancient View,* 45 and 50–52.

26. See above all U. Eco, *Opera aperta,* Milan, 1962 (partial Eng. trans. *The Open Work,* Cambridge, Mass., 1989); idem, *The Limits of Interpretation,* Bloomington and Indianapolis, 1990, esp. 44–63. On the text as invitation, see idem, *The Role of the Reader: Explorations in the Semiotics of Texts,* Bloomington, Ind., 1979, 9–10 and 63–65; and S. Fish, *Is There a Text in This Class? The Authority of*

Interpretive Communities, Cambridge, Mass., and London, 1980, 147–173, esp. 172–173. On shared interpretive strategies, see Fish, *Is there a Text,* 167ff., and *Doing What Comes Naturally,* 83, 141, 150–160; for a critical response, see W. A. Davis, "The Fisher King: *Wille zur Macht* in Baltimore," *Critical Inquiry,* 10, 1984, 668–694, and S. Mailloux, *Rhetorical Power,* Ithaca, N.Y., and London, 1989, 9, 15, and 151–154. On the ideal or model reader, Fish, *Is There a Text,* 158–161; Eco, *Role of the Reader,* 7–11 and 41, n. 6 (with references to earlier work along these lines); and Mailloux, *Rhetorical Power,* 34–35; on literary competence more generally, J. Culler, *Structuralist Poetics,* Ithaca, N.Y., 1975, 113–130. In "The Creative Act," a lecture presented in 1957, M. Duchamp had already posited the viewer's active involvement in the visual arts along these lines; see G. Battcock (ed.), *The New Art,* New York, 1966, 23–26. I am indebted to my colleague Kristine Stiles for this reference.

Chapter 1

1. The most extensive treatment of this subject is C. Del Grande, *Hybris: colpa e castigo nell'espressione poetica e letteraria degli scrittori della Grecia antica,* Naples, 1947. Also see R. Lattimore, *Story Patterns in Greek Tragedy,* London, 1964, 22–28. More recent studies have attempted to discern the full range of connotations attaching to this highly complex term; see D. M. MacDowell, "*Hybris* in Athens," *Greece and Rome,* ser. 2, 23, 1976, 14–31; idem, *The Law in Classical Athens,* Ithaca, N.Y., 1978, 129–132, from which this translation of Aristotle's *Rhetoric* is taken; and R. E. Fisher, "*Hybris* and Dishonor: I," *Greece and Rome,* ser. 2, 23, 1976, 177–193.

2. Isokrates, *To Nikokles* (II), 16: καλῶς δὲ δημαγωγήσεις, ἐὰν μὴθ᾽ ὑβρίζειν τὸν ὄχλον ἐᾷς μήθ᾽ ὑβριζόμενον περιορᾷς. For the legal aspects of *hybris,* see MacDowell, "*Hybris* in Athens," 24–29; and idem, *The Law in Classical Athens,* 129–132, from which the translation of these lines of Demosthenes is taken.

3. H. North, *Sophrosyne: Self-Knowledge and Self-Restraint in Greek Literature,* Ithaca, N.Y., 1966, 12–13, and 23–25. For tomb inscriptions see P. Friedlander, *Epigrammata,* Berkeley, 1948, nos. 6, 31, 71, and 85; and C. Kaibel, *Epigrammata graeca ex lapidibus conlecta,* Berlin, 1878, nos. 51 and 53. For *sophrosyne* as a civic virtue and funerary theme, also see S. C. Humphreys, "Family Tombs and Tomb Cult in Ancient Athens: Tradition or Traditionalism?" *JHS,* 100, 1980, 104, n. 16, and 114. On *sophrosyne* as a civic or political virtue in sophistic philosophical teaching, see I. S. Mark, "The Gods on the East Frieze of the Parthenon," *Hesperia,* 53, 1984, 322–324.

4. F. Heinimann, *Nomos und Physis: Herkunft und Bedeutung einer Antithese im griechischen Denken des 5. Jahrhunderts,* Basel, 1945, 9–41, esp. 29ff. On the Greek view of the distinctions between their society and that of the Persians, also see J. Jüthner, *Hellenen und Barbaren aus der Geschichte des Nationalbewusstseins,* Das Erbe des Alten, N.F., 8, Leipzig, 1923; H. Diller, "Die Hellenen-Barbaren-

Antithese im Zeitalter der Perserkriege," and Baldry's response, both in *Grecs et barbares: Fondation Hardt: Entretiens sur l'antiquité classique*, 8, Geneva, 1962, 39-70; G. C. Starr, "Greeks and Persians in the Fourth Century B.C., Part II," *Iranica Antiqua*, 12, 1977, 48-58; A. Momigliano, "The Persian Empire and the Idea of Freedom," in A. Ryan (ed.), *The Idea of Freedom: Essays in Honor of Isaiah Berlin*, Oxford, 1979, 139-151; T. Cuyler-Young, "480/79 B.C.—A Persian Perspective," *Iranica Antiqua*, 15, 1980, 213-239; E. D. Francis, "Greeks and Persians: The Art of Hazard and Triumph," in D. Schmandt-Besserat (ed.), *Ancient Persia: The Art of an Empire*, Malibu, Calif., 1980, 58-60 and 72-73; and T. Long, *Barbarians in Greek Comedy*, Carbondale and Edwardsville, Ill., 1986, 129-156.

5. Del Grande, *Hybris*, 118-120; H. Lloyd-Jones, *The Justice of Zeus*, 2nd ed., Berkeley, Los Angeles, and London, 1983, 63 and 88-89; North, *Sophrosyne*, 27-28 and 33-35; J. J. Pollitt, *Art and Experience in Classical Greece*, Cambridge, 1972, 14 and 22-24; Francis, "Greeks and Persians," 59-60 and 72-73; C. J. Herington, Introduction to *Aeschylus' Persians* (trans. J. Lembke and C. J. Herington), New York and Oxford, 1981, 9-10; and A. Podlecki, *"Polis* and Monarch in Early Attic Tragedy," in P. J. Euben (ed.), *Greek Tragedy and Political Theory*, Berkeley, Los Angeles, and London, 1986, 80.

6. *Persians*, 344-347:

> μή σοι δοκοῦμεν τῇδε λειφθῆναι μάχῃ;
> ἀλλ᾽ ὧδε δαίμων τις κατέφθειρε στρατόν,
> τάλαντα βρίσας οὐκ ἰσορρόπῳ τύχῃ.
> θεοὶ πόλιν σῴζουσι Παλλάδος θεᾶς.

Cf. lines 454-455 and 532-533.

7. *The Persians by Aeschylus* (trans. A. Podlecki), Englewood Cliffs, N.J., 1970, 95-97.

8. MacDowell, *"Hybris* in Athens," 15-17. On *hybris* and youth: Sophokles, frag. 786; Xenophon, *Lacedaemonian Constitution*, III, 2; Plato, *Euthydemos*, 237a. *Hybris* and wealth: Solon, 6; Euripides, frag. 438; Xenophon, *Kyropaideia*, VIII, 4, 14. On the Solonian background of the connection between wealth or prosperity and *hybris*, also see Herington, Introduction to *Aeschylus' Persians*, 10.

9. Fisher, *"Hybris* and Dishonor: I," esp. 181-185; Aristotle, *Rhetoric*, 1378b, 2; 1389b, 15-16; and 1391a, 1; *Politics*, 1295b, 9-11; 1307a, 18-20.

10. *Persians*, 73-75:

> πολυάνδρου δ᾽ Ἀσίας θούριος ἄρχων
> ἐπὶ πᾶσαν χθόνα ποιμα-
> νόριον θεῖον ἐλαύνει.

11. Del Grande, *Hybris*, 219-220; Lloyd-Jones, *Justice of Zeus*, 88-89; Francis, "Greeks and Persians," 59-60; and Podlecki, *"Polis* and Monarch in Early Attic Tragedy," in Euben, *Greek Tragedy and Political Theory*, 80. On the fundamental contradictions between the traditional Greek political structure and imperialism as they appeared in the fifth century, also see Chapter 5, below, "The Frieze and the

Ethics of Imperialism." H. C. Baldry, in *Fondation Hardt: Entretiens sur l'antiquité classique,* 8, Geneva, 1962, 69–70, offers a useful insight in this connection. Responding to H. Diller's opinions on the Hellene/Barbarian antithesis, he argues that the initially linguistic sense of the word *barbaros* gradually acquired an intellectual connotation, as the inability to speak Greek came to signify an inability to conceptualize in Greek terms, and hence an unwillingness or inability to grasp the Greek moral and political principles of rational order and self-limitation.

12. Lembke and Herington, trans., *Aeschylus' Persians,* 51.

13. Podlecki, trans., *The Persians,* 61–63, lines 388–423.

14. Aristotle, *Politics,* 1327b, 20–33, also posits a fundamental relation between forceful human spirit or courage, *thymos,* and a free society with good governmental institutions, such as one encounters among Greeks. The peoples of Asia, in contrast, lack *thymos,* and thus remain subjects and slaves. S. Goldhill, "Battle Narrative and Politics in Aeschylus' Persae," *JHS,* 108, 1988, 189–193, has noted generally that the opposition of cultural values central to the *Persians* anticipates the strategies of Athenian rhetoric.

15. P. duBois, *Centaurs and Amazons: Women and the Pre-History of the Great Chain of Being,* Ann Arbor, Mich., 1982, 81, exaggerates the extent to which Aischylos plays down the corresponding image of the Greeks as opposed to the Persians, but she recognizes the intentional contrast between peoples as the ultimate and central function of the play.

16. E. R. Dodds, *The Greeks and the Irrational,* Sather Classical Lectures, 25, Berkeley and Los Angeles, 1951, 50, with earlier bibliography; Lloyd-Jones, *Justice of Zeus,* 58–59 and 63–64; North, *Sophrosyne,* 27–28. For an extended discussion of the moral and religious outlook that may have informed Herodotos' interpretation of historical events, also see G. E. M. de Ste. Croix, "Herodotos," *Greece and Rome,* ser. 2, 23, 1976, 131–147, esp. 139ff.

17. Herodotos, VIII, 77:

> δῖα δίκη σβέσσει κρατερὸν κόρον, ὕβριος υιον,
> δεινὸν μαιμώοντα, δοκεῦντ' ἀνὰ πάντα πίεσθαι.
> χαλκὸς γὰρ χαλκῷ συμμίξεται, αἵματι δ' Ἄρης
> πόντον φοινίξει. τότ' ἐλεύθερον Ἑλλάδος ἦμαρ
> εὐρύοπα Κρονίδης ἐπάγει καὶ πότνια Νίκη.

18. Herodotos, VII, 10:

> ὁρᾷς τὰ ὑπερέχοντα ζῷα ὡς κεραυνοῖ ὁ θεὸς οὐδὲ ἐᾷ φαντάζεσθαι, τὰ δὲ σμικρὰ
> οὐδέν μιν κνίζει ὁρᾷς δὲ ὡς ἐς οἰκήματα τὰ μέγιστα αἰεὶ καὶ δένδρεα τὰ τοιαῦτα
> ἀποσκήπτει τὰ βέλεα· φιλέει γὰρ ὁ θεὸς τὰ ὑπερέχοντα πάντα κολούειν. οὕτω δὲ
> καὶ στρατὸς πολλὸς ὑπὸ ὀλίγου διαφθείρεται κατὰ τοιόνδε·
> οὐ γὰρ ἐᾷ φρονέειν μέγα ὁ θεὸς ἄλλον ἢ ἑωυτόν.

For this passage and the attribution of the Persian defeat to *hybris,* see Del Grande, *Hybris,* 219; and Herington, Introduction to *Aeschylus' Persians,* 9–11.

19. Herodotos VII, 10:

σὺ δὲ ὦ βασιλεῦ μέλλεις ἐπ᾽ ἄνδρας στρατεύεσθαι πολλὸν ἀμείνονας ἢ Σκύθας, οἳ κατὰ θάλασσάν τε ἄριστοι καὶ κατὰ γῆν λέγονται εἶναι.

. .

οἱ γὰρ ἄνδρες λέγονται εἶναι ἄλκιμοι, πάρεστι δὲ καὶ σταθμώσασθαι, εἰ στρατιήν γε τοσαύτην σὺν Δάτι καὶ Ἀρταφρένεϊ ἐλθοῦσαν ἐς τὴν Ἀττικὴν χώρην μοῦνοι Ἀθηναῖοι διέφθειραν.

20. On freedom as an incentive to martial prowess, see F. Hartog, *The Mirror of Herodotos: The Representation of the Other in the Writing of History,* Berkeley, Los Angeles, and London, 1988, 328.

21. Herodotos VII, 102: τῇ Ἑλλάδι πενίη μὲν αἰεί κοτε σύντροφος ἐστί, ἀρετὴ δὲ ἔπακτος ἐστί, ἀπό τε σοφίης κατεργασμένη καὶ νόμου ἰσχυροῦ· τῇ διαχρεωμένη ἡ Ἑλλὰς τήν τε πενίην ἀπαμύνεται καὶ τὴν δεσποσύνην.

22. Herodotos, VII, 104: ἐλεύθεροι γὰρ ἐόντες οὐ πάντα ἐλεύθεροι εἰσί· ἔπεστι γάρ σφι δεσπότης νόμος, τὸν ὑποδειμαίνουσι πολλῷ ἔτι μᾶλλον ἢ οἱ σοί σέ. ποιεῦσι γῶν τὰ ἂν ἐκεῖνος ἀνώγῃ· ἀνώγει δὲ τὠυτὸ αἰεί, οὐκ ἐῶν φεύγειν οὐδέν πλῆθος ἀνθρώπων ἐκ μάχης, ἀλλὰ μένοντας ἐν τῇ τάξι ἐπικρατέειν ἢ ἀπόλλυσθαι. Cf. VII, 208–209.

23. Hesiod: *Works and Days,* 276–283; Herakleitos: H. Diels and W. Kranz, *Die Fragmente der Vorsokratiker,* 6th ed., Berlin, 1952, vol. 2, 176, no. 114. In a rather Hesiodic vein, Bakchylides' Dithyramb I (XVII), 51–55, also speaks of Zeus and his helpmates Dike, Themis, and Eunomia (see Appendix). Pindar's Eighth Olympian Ode, 21–22, makes Themis the consort or co-adjutor of Zeus. Also see Lloyd-Jones, *Justice of Zeus,* 87.

24. Del Grande, *Hybris,* 237, has stressed the opposition between barbarian *hybris* and the Greek commitment to justice, freedom, and valor, and the concomitant protection of the gods, as a basic and pervasive theme in Herodotos. In this particular episode, however, the adherence to law subsumes all these principles and operates as a manifestation of the *sophrosyne* of the Greek people, in one central and overriding antithesis to the *hybris* of the Persians and their monarchy. Hartog, *The Mirror of Herodotos,* 330–334, also sees the King's *hybris* in his exchange with Demaratos as the ultimate antitype to *nomos;* in his view Herodotos' narrative portrays *hybris* as the mainspring of monarchy or despotism, along with the propensity of the despot to transgress *nomoi* of all kinds. For a more general discussion of the basic opposition between law and outrage in the Greek view, see J.-P. Vernant, *Myth and Thought Among the Greeks,* London, 1983, 190–212.

25. Those familiar with more recent European confrontations with the Near East will undoubtedly recognize in such discourse the basis for the modern Western attitudes of cultural superiority toward the Islamic world thoroughly traced by E. W. Said, *Orientalism,* New York, 1978, esp. 1–4, 32–33, 41–42, 56–57, and 70; idem, *Covering Islam: How the Media and the Experts Determine How We See the Rest of the World,* New York, 1981. For further analysis of Said's method, also see S. Mailloux, *Rhetorical Power,* Ithaca, N.Y., and London, 1989, 155–157.

26. καὶ ὀρθῶς μοι δοκέει Πίνδαρος ποιῆσαι νόμον πάντων βασιλέα φήσας εἶναι. On the rule of law or "nomocracy" as a Greek value central to

Herodotos' interpretation of the Persian Wars, see K. von Fritz, "Die griechische ELEUTHERIA bei Herodot," *Wiener Studien*, 78, 1965, 6–12. S. Flory, *The Archaic Smile of Herodotos*, Detroit, Mich., 1987, reassesses the "anecdotal" character of the Demaratos episode and the other apparent digressions of this sort in the *History.* He examines antithesis as a conscious literary technique that Herodotos applies to demonstrate the superiority of the Greeks over the Persians, arguing that the opposition in Herodotos between Greek and Persian is essentially that between nature and culture, between the "noble savage" in touch with the quality and limits of the natural world and the "prosperous aggressor," with his cultured refinement and wealth, who seeks to dominate the earthly environment. In Flory's view, Herodotos' lengthy narrative of the Scythian resistance to Persian invaders functioned as a deliberate analogue to the struggle of the Greeks, intended to reinforce the thematic nature/culture opposition in a wider setting.

Hartog, *The Mirror of Herodotos*, esp. 3–60, 202–204, 259, and 367–368, however, offers a more compelling reading of the Scythian *logos* and its relation to Herodotos' main theme of the Persian Wars. In Hartog's view, the Scythians and their nomadic tactics of retreat and abandonment serve to prefigure and rationalize the Athenian military strategy of 480 B.C. and the Periklean period. Moreover, the adherence to law that Herodotos stresses so forcefully as a distinctive Greek attribute is a decidedly cultural phenomenon; the Greeks represent not so much a unity with nature, but rather a modesty and respect toward the divine powers who control the natural, earthly sphere. Nor does it seem that fifth-century Greeks would have conceived of such modesty or their relative penury as a form of savagery, as Flory argues; it appears instead that they measured the wealth or worth of their society in more than material terms. The difference between Greeks and Persians in Herodotos is an opposition not of nature and culture, but of one kind of culture (and the character it engenders) and another.

27. C. Robert, *Die Marathonschlacht in der Poikile und weiteres über Polygnot*, Hallisches Winckelmannsprogram, 18, Halle, 1895, 1–4 and 16ff.; E. B. Harrison, "The South Frieze of the Nike Temple and the Marathon Painting in the Stoa," *AJA*, 76, 1972, 353–378; T. Hölscher, *Griechische Historienbilder des 5. und 4. Jahrhunderts vor Chr.*, Würzburg, 1973, 50–68; and E. D. Francis and M. Vickers, "The Oenoe Painting in the Stoa Poikile and Herodotus' Account of Marathon," *ABSA*, 80, 1985, 99–113.

28. For the most recent opinion and earlier bibliography, see Francis and Vickers, "Oenoe Painting," 109–113.

29. For the various primary sources on these figures in accounts of the Marathon painting and the battle itself, see Harrison, "Marathon Painting," 356–370, and the assembled testimonia, 371ff.

30. In his reconstruction, Hölscher, *Griechische Historienbilder*, 60–65, restricts himself to the hard evidence of Pausanias, I, 15, 3. Robert, *Marathonschlacht*, 30–41, however, had expanded the roster of gods well beyond Pausanias' tally. Harrison, "Marathon Painting," 366–367, maintains a middle ground, arguing that certain literary sources on the Battle of Marathon itself are based upon the painting even though they do not mention it specifically. On their evidence she would include

Hera, Demeter, Kore, and Pan as well as Athena, Herakles, Theseus, Marathon, and Echetlos.

31. The Orientalizing Attic amphora from Eleusis and the ivory from Samos, which show Athena protecting and inspiring the struggle of Perseus against the Gorgon, are early examples of this kind; see K. Schefold, *Myth and Legend in Early Greek Art,* New York, 1966, figs. 16 and 17. On the middle Archaic oinochoe by Lydos, Athena appears aiding Herakles against Kyknos; see J. Boardman, *Athenian Black Figure Vases,* New York, 1974, fig. 68. On a cup by Euphronios she intercedes on Herakles' behalf against Geryon; see J. Boardman, *Athenian Red Figure Vases: The Archaic Period,* New York and Toronto, 1975, fig. 26. Athena aids Herakles and Aias in the battle against the Trojans on the pediments from Aigina, and she lovingly confronts Theseus amidst his labors in the metopes of the Athenian Treasury at Delphi; see J. Boardman, *Greek Sculpture: The Archaic Period,* New York and Toronto, 1978, figs. 206 and 213; and H. Knell, *Mythos und Polis. Bildprogramme griechischer Bauskulptur,* Darmstadt, 1990, 55–60, fig. 80, and 69–70, fig. 100–102. On the role of Athena as protectress of heroes in Archaic Greek art, also see D. Le Lasseur, *Les déesses armées dans l'art classique grec et leurs origines orientales,* Paris, 1919, 73–84 and 326–334; and H. A. Shapiro, *Art and Cult Under the Tyrants in Athens,* Mainz, 1989, 37–38.

Athena appears as the divine protectress of Herakles in the metopes on the Temple of Zeus at Olympia (about contemporary with the Marathon painting), while on the west pediment Apollo literally directs the struggle of Theseus, Peirithoös, and the Lapiths against the Centaurs; see J. Boardman, *Greek Sculpture: The Classical Period,* London, 1985, fig. 21.3; and Knell, *Mythos und Polis,* 80–87, fig. 115–125. On Apollo's inclusion in the pediment as an expression of Dike, see A. F. Stewart, "Pindaric *Dike* and the Temple of Zeus at Olympia," *Classical Antiquity,* 2, 1, 1983, 133–144; and N. D. Tersini, "Unifying Themes in the Sculpture of the Temple of Zeus at Olympia," *Classical Antiquity,* 6, 1, 1987, 146–152.

Chapter 2

1. Pausanias, I, 17, 2–6; Plutarch, *Theseus,* XXXVI. For a summary of the extant literary evidence, see H. A. Thompson and R. E. Wycherley, *The Athenian Agora: The Agora of Athens,* vol. 14, Princeton, N.J., 124–126, and S. Koumanoudes, "Theseos Sekos," *Archaiologike Ephemeris,* 1976, 194–216. The shrine and its decorations should date to the period following the Skyros campaign; see Robertson, *A History of Greek Art,* Cambridge, 1975, 242. But it is not inconceivable that the paintings were added somewhat later, perhaps in the early 460s.

2. Pausanias was primarily concerned with the subject of the paintings rather than their authorship; he mentions Mikon only parenthetically in describing the scene of Theseus and Minos' ring. J. P. Barron, "New Light on Old Walls," *JHS,* 92, 1972, 23, 33, and 44, suggests that Mikon may have executed the other paintings as well, especially the Amazonomachy, since he is known to have depicted this theme in the

Stoa Poikile. But on the evidence of an emendation to Harpokration, he proposes that Mikon and Polygnotos may have collaborated, as they did in the Anakeion and the Stoa Poikile. J. Boardman, "Herakles, Theseus, and Amazons," in D. Kurtz and B. Sparkes (eds.), *The Eye of Greece: Studies in the Art of Athens,* Cambridge, 1982, 17, also thinks that the other Theseion paintings might be Mikon's work, especially the Amazonomachy.

3. J. Six, "Mikon's Fourth Picture in the Theseion," *JHS,* 29, 1919, 130–143; Barron, "New Light," 42–44; and Robertson, *History of Greek Art,* 243 and 255–256. Here, Six actually elaborated on the earlier suggestions of H. Brunn, *Geschichte der griechischen Künstler,* Stuttgart, 1857–1859, vol. 2, 24, and J. Overbeck, *Die antiken Schriftquellen zur Geschichte der bildenden Künste bei den Griechen,* Leipzig, 1868, 208, no. 1086. According to this view, the lost original is reflected in the well-known krater from Orvieto by the Niobid Painter, Louvre G 341, which shows Herakles and other heroes above a pair of warriors in a pit, presumably Theseus and his comrade Peirithoös. E. Simon, *Die griechischen Vasen,* Munich, 1976, 134, and "Polygnotan Painting and the Niobid Painter," *AJA,* 67, 1963, 44–45, has adduced further evidence for identifying the subject of this krater as the raising of Theseus, although she does not attribute the large-scale prototype to the Theseion; cf. E. D. Francis, *Image and Idea in Fifth-Century Greece: Art and Literature after the Persian Wars,* London and New York, 1990, 50–51. Also see E. B. Harrison, "Preparations for Marathon, the Niobid Painter, and Herodotus," *Art Bulletin,* 54, 1972, 390–402, who defends the attribution of the original to the Theseion. More recently, however, B. Cohen has questioned this connection on stylistic grounds in "Paragone: Sculpture Versus Painting: Kaineus and the Kleophrades Painter," in W. G. Moon (ed.), *Ancient Greek Art and Iconography,* Madison, Wis., 1983, 180 and 185. She argues that the developed use of multi-level spatial landscape on the Orvieto krater had not yet been achieved by the late 470s, when the Theseion paintings were presumably executed.

4. E. Thomas, *Mythos und Geschichte, Untersuchungen zum historischen Gehalt griechischer Mythendarstellungen,* Cologne, 1976, 49–50; S. Woodford, "More Light on Old Walls," *JHS,* 94, 1974, 161; P. duBois, *Centaurs and Amazons: Women and the Pre-History of the Great Chain of Being,* Ann Arbor, Mich., 1982, 27–32.

5. G. S. Kirk, *Myth: Its Meaning and Functions in Ancient and Other Cultures,* Cambridge, Berkeley, and Los Angeles, 1970, 152–162.

6. R. Lattimore, *Hesiod: The Works and Days, Theogony, The Shield of Herakles,* Ann Arbor, Mich., 1959, 202, lines 184–190. For the Centauromachy on the François vase, see K. Schefold, *Myth and Legend in Early Greek Art,* New York, 1966, pl. 51, and P. E. Arias and M. Hirmer, *A History of 1000 Years of Greek Vase Painting,* New York, 1962, 288 and pls. 41 and 43.

7. On the changes in the setting and narrative of the Centauromachy from Archaic into Classical times, see B. B. Shefton, "Herakles and Theseus on a Red-Figured Louterion," *Hesperia,* 31, 1962, 355; Barron, "New Light," 25 and 30–33; Woodford, "More Light," 161; Cohen, "Paragone," 175; and F. Brommer, *Theseus: Die Taten des griechischen Helden in der antiken Kunst und Literatur,* Darmstadt, 1982, 104–110.

8. For the fragment of Theognis, see J. M. Edmonds, *Elegy and Iambus* (Loeb Classical Library), London and New York, 1931, vol. 1, 292. I am indebted to Michael Behen for this reference. On drunkenness and *hybris* more generally, see D. M. MacDowell, *"Hybris* in Athens," *Greece and Rome,* ser. 2, 23, 1976, 16 and n. 5; cf. Anakreon, 356a; Xenophanes, 1, 17; and Plato, *Phaidros,* 238A–B.

9. For drunkenness and sexual incontinence, see R. Just, *Women in Athenian Law and Life,* London and New York, 1989, 186–187. On the *hybris* of untrammeled lust, MacDowell, *"Hybris* in Athens," 17 and nn. 9–11; cf. Aischylos, *Suppliants,* 29–30, 81, 104, 426, 487, 528, 817–818, 845, 880, and 881, where the term is used repeatedly to characterize the unlawful desire of Aigyptos' sons for the Danaids. Some scholars have argued that the very creation of the Centaurs in the Ixion myth symbolized the opposition between promiscuous lust and lawful marriage; see M. Detienne, *Les jardins d'Adonis,* Paris, 1972, 165–170; and duBois, *Centaurs and Amazons,* 27–28. On the Centaurs' crimes against *xenia,* see Woodford, "More Light," 161–162; Thomas, *Mythos und Geschichte,* 49; and duBois, *Centaurs and Amazons,* 28–29. *Trachinian Women,* 1095–1096: ὑβριστὴν ἄνομον, ὑπέροχον βίαν. Cf. Euripides, *Madness of Herakles,* 181: τετρασκελές θ᾽ ὕβρισμα Κενταύρων γένος, "the race of Centaurs, *hybris* on four feet."

10. E. Buschor, "Kentauren," *AJA,* 28, 1934, 128–132, first drew attention to the horselike conception of such monstrous opponents of Zeus as Typhon and Medusa in early Greek art. Cf. Kirk, *Myth,* 155, and Schefold, *Myth and Legend,* 21 and 34, and pls. 4 and 15b.

11. DuBois, *Centaurs and Amazons,* 31.

12. For the ethical connotations of the Centauromachy at the wedding feast, also see N. Tersini, "Unifying Themes in the Sculpture of the Temple of Zeus at Olympia," *Classical Antiquity,* 6, 1, 1987, 145–151. In her discussion of the Centauromachy of the west pediment at Olympia, she stresses the inclusion of Apollo, god of moderation, as a deliberate means of underscoring the moral implications of the battle, in accordance with divine judgment.

13. Florence, Museo Archeologico, 3997; *ARV²* 541, 1; C. Dugas and R. Flacelière, *Thésée: images et récits,* Paris, 1958, 64 and pl. 11. On the likelihood of this vase painting as a reflection of the one in the Theseion, see Woodford, "More Light," 162–164. Also see E. Pfuhl, *Malerei und Zeichnung der Griechen,* Munich, 1923, vol. 2, 524 (*Masterpieces of Greek Drawing and Painting* [trans. J. D. Beazley], London, 1926, 61), and K. Schefold and F. Jung, *Die Urkönige, Perseus, Bellerophon, Herakles und Theseus in der klassischen und hellenistischen Kunst,* Munich, 1988, 264, 266, and fig. 314, who emphasize the ethical qualities of the representation as well as its relation to monumental precedent.

14. New York Metropolitan Museum of Art, 07.286.84; *ARV²,* 613, 1. See Shefton, "Louterion," 360–363; Barron, "New Light," 25–27, pl. IIa–b; Woodford, "More Light," 163–164; and Schefold and Jung, *Die Urkönige,* 268 and 307, for the relation of this vase painting to the Centauromachy in the Theseion. These authors suggest that the closely related ax-swinger in the Centauromachy of the west pediment of the Temple of Zeus at Olympia, like the ceramic example, derives from the Theseion painting.

15. Xenophon, *Memorabilia*, III, 10, 4–5; H. G. Dakyns, trans., *The Works of Xenophon*, vol. III, 1, London, 1897, 114; bracketed terms added by the writer.

16. Woodford, "More Light," 161.

17. Ibid., 162.

18. On the reflection of the Theseion paintings in Attic red figure, see especially D. von Bothmer, *Amazons in Greek Art*, Oxford, 1957, 167–207; Shefton, "Louterion," passim; Barron, "New Light," passim; Woodford, "More Light," passim; Robertson, *History of Greek Art*, 258–259; and Cohen, "Paragone," passim. For the Amazonomachy on the krater by the Painter of the Woolly Satyrs, see Barron, "New Light," 34, pl. IVa, and P. Devambez, "Amazones," *LIMC*, I, 1, Munich, 1981, 606, no. 295. For a continuous reproduction of the scene on the front, see Pfuhl, *Malerei und Zeichnung der Griechen*, vol. 3, fig. 506, and A. Furtwängler and K. Reichhold, *Griechische Vasenmalerei*, Munich, 1924, pl. 12.

19. Ferrara, Museo Nazionale di Spina, T 411; *ARV*² 1029, 21; von Bothmer, *Amazons in Greek Art*, 198, no. 132, 200, and pl. LXXXIII, 7; H. L. Jeffery, "The Battle of Oinoe in the Stoa Poikile," *ABSA*, 60, 1965, 46; T. B. L. Webster, *Potter and Patron in Classical Athens*, London, 1972, 86; T. Hölscher, *Griechische Historienbilder des 5. und 4. Jahrhunderts vor Chr.*, Würzburg, 1973, 71; Thomas, *Mythos and Geschichte*, 97, n. 117; J. P. Barron, "Bakchylides, Theseus and a Woolly Cloak," *BICS*, 27, 1980, 4; and Brommer, *Theseus*, 121.

20. Philostratos, *Life of Apollonios*, IV, 21, quoting the first-century philosopher Apollonios of Tyana. Also see R. Weil, "Artémise ou le monde à l'envers," in *Receuil Plassart*, Paris, 1976, 221–224.

21. Votive clay shield from Tiryns; Von Bothmer, *Amazons in Greek Art*, 1–2 and pl. I, 1; Schefold, *Myth and Legend*, 25–26 and pl. 7b.

22. For arguments asserting the historical basis of the dominant female in the Amazon myth, see O. Schrader, *Die Indogermanen*, Leipzig, 1911, 74ff.; J. J. Bachofen, *Myth, Religion, and Mother Right*, (trans. R. Manheim), Princeton, N.J., 1967, 104–106; R. Graves, *The Greek Myths*, Harmondsworth, 1960, vol. 2, 130, n. 2; B. Schultz Engle, "The Amazons in Ancient Greece," *Psychoanalytic Quarterly*, 11, 1942, 512–554; M. Zografou, *Amazons in Homer and Hesiod: A Historical Reconstruction*, Athens, 1972; D. J. Sobol, *The Amazons of Greek Mythology*, South Brunswick and New York, 1972, 113–147; and Thomas, *Mythos und Geschichte*, 35–36. On matriarchy as a fiction created specifically to validate patriarchy, see J. Bamberger, "The Myth of Matriarchy: Why Men Rule in Primitive Society," in M. Z. Rosaldo and L. Lamphere (eds.), *Woman, Culture, and Society*, Stanford, Calif., 1974, 263–280; M. Merck, "The City's Achievements, the Patriotic Amazonomachy and Ancient Athens," in S. Lipschitz (ed.), *Tearing the Veil*, London, 1978, 96; F. Zeitlin, "The Dynamics of Misogyny in the Oresteia," in J. Peradotto and J. P. Sullivan (eds.), *Women in the Ancient World: The Arethusa Papers*, Albany, N.Y., 1984, 160–162; M. R. Lefkowitz, *Women in Greek Myth*, London, 1986, 17–29; W. B. Tyrrell, *Amazons: A Study in Athenian Mythmaking*, Baltimore and London, 1984, xiii–xvi and 23–33.

On a religious level, the myth certainly expressed a rivalry between the supporters of the cults of male and female divinities, or perhaps the supremacy of Zeus over

the mother goddess. On an Archaic Etruscan bronze chariot relief from Perugia, whose iconography presumably depends upon Greek sources, Zeus aids and protects his son Herakles against the Amazon opponents, while a female divinity, possibly Hera, intercedes on behalf of the warrior women; see R. Hampe and E. Simon, *Griechische Sagen in der frühen etruskischen Kunst,* Mainz, 1964, 11–17, 16, fig. 3, pl. 21, and Beilage; and E. Mavleev, "Amazones Etruscae," *LIMC,* I, 1, Munich, 1981, 661, no. 51. On the Amazonomachy as a struggle against warrior priestesses of the mother goddess, see A. H. Sayce, *The Hittites: The Story of a Forgotten People,* 4th ed., London, 1925, 101–103; Graves, *Greek Myths,* vol. 2, 355, n. 1; Sobol, *The Amazons of Greek Mythology,* 136–139; Zografou, *Amazons in Homer and Hesiod;* and M. Stone, *When God Was a Woman,* New York, 1976, 46.

23. Thomas, *Mythos und Geschichte,* 35–39; Merck, "The Patriotic Amazonomachy," 99–102; Boardman, "Herakles, Theseus, and Amazons," 2–16; Tyrrell, *Amazons,* 2–9; Brommer, *Theseus,* 110–119; and Schefold and Jung, *Die Urkönige,* 231–232 and 272. For a survey of the relevant artistic depictions featuring Herakles, see von Bothmer, *Amazons in Greek Art,* 3–69, 131–143, and pls. II–XLIX; and Devambez, "Amazones," *LIMC,* I, 1, 587–592, nos. 1–89. For those with Theseus: von Bothmer, 125–130, and pls. LXVII–LXVIII; Devambez, 602, no. 45; and A. Kaufmann-Samaras, "Antiope," *LIMC,* I, 1, Munich, 1981, 858–859, nos. 4–13.

24. Scholarly opinion concurs overwhelmingly that the paintings showed the Attic Amazonomachy; see especially Barron, "New Light," 33 and n. 102, and Boardman, "Herakles, Theseus, and Amazons," 16–17. On the identification of the version on the Parthenos shield, see n. 27 to Chapter 4, below.

25. Merck, "The Patriotic Amazonomachy," 102–103; W. Gauer, "Die Gruppe der ephesischen Amazonen, ein Denkmal des Perserfriedens," in H. A. Cahn and E. Simon (eds.), *Tainia: Roland Hampe zum 70. Geburtstag,* Mainz, 1980, 218; Boardman, "Herakles, Theseus, and Amazons," 14–15, and 27; and K. R. Walters, "Rhetoric as Ritual: The Semiotics of the Attic Funeral Oration," *Florilegium,* 2, 1980, 25–26, n. 42. Also see Brommer, *Theseus,* 119–123.

26. For the Attic Amazonomachy in Athenian funerary rhetoric, see N. Loraux, *The Invention of Athens: The Funeral Oration in the Classical City* (trans. A. Sheridan), Cambridge, Mass., and London, 1986, 146–148; Walters, "Rhetoric as Ritual," 15 and n. 41; Tyrrell, *Amazons,* 13–19; W. B. Tyrrell and F. S. Brown, *Athenian Myths: Words in Action,* New York and Oxford, 1991, 198–200. For the inception of such speeches by the 470s, see O. Schroeder, *De Laudibus Athenarum a Poeticis Tragicis et ab Oratoribus Epidicticis Excultis,* Göttingen, 1914, 68–76, and W. Kierdorf, *Erlebnis und Darstellungen der Perserkriege,* Hypomnemata, 16, Göttingen, 1966, 94, 105, and 109. F. Jacoby, "PATRIOS NOMOS: State Burial in Athens and the Public Cemetery in the Kerameikos," *JHS,* 64, 1944, 37–66, saw these speeches as a development of the 460s; cf. Loraux, *Invention of Athens,* 56–72, and C. W. Clairmont, *Patrios Nomos: Public Burial in Athens During the Fifth and Fourth Centuries B.C.,* British Archaeological Reports, 161 (i), Oxford, 1983, 25. H. Strasburger, "Thukydides und die politische Selbstdarstellung der

Athener," *Hermes,* 86, 1958, 20–22, places their origin more broadly between 480 and 460. On the debt of Herodotos, IX, 27, to such rhetoric, see Kierdorf, *Perserkriege,* 97–100; Walters, "Rhetoric as Ritual," 12 and n. 26; Tyrrell, *Amazons,* 13–14; and Loraux, *Invention of Athens,* 65 and n. 290. Also see Kierdorf, *Perserkriege,* 97–100, 105, and 109, on the opinion that the catalogue of deeds originally developed in various forms of public oratory, and not just in eulogies for the war dead.

27. On the deliberate distortion of myth and history in oratory to propagandize the Athenian military and political ascendency during this period, see R. Stupperich, *Staatsbegräbnis und Privatgrabmal im klassischen Athen,* Diss. Westfälischen Wilhelms-Universität zu Münster, 1977, 45–53 and 226–238; Loraux *Invention of Athens,* passim, esp. 56–76 and 141–165; Walters, "Rhetoric as Ritual," passim; Strasburger, "Thukydides," 17–40, esp. 22–28; and P. Wendland, "Die Tendenz des platonischen Menexenus," *Hermes,* 25, 1890, 171–195.

28. More than any other orator, Lysias repeatedly asserts the Athenian role as guarantors of justice from time immemorial; see esp. II, 6, 10, 14, 17, 46, and 61; cf. Loraux, *Invention of Athens,* 67–68 and 145–165; Walters, "Rhetoric as Ritual," 3–9; and Strasburger, "Thukydides." Tyrrell, *Amazons,* 114–116; Tyrrell and Brown, *Athenian Myths,* 195–200; and Loraux, *Invention of Athens,* 148–152, have especially stressed the Athenian preoccupation with autochthony as an added rationale for their noble and altruistic dedication to justice. On the theme of autochthony more generally, also see Chapter 4 below, "The West Metopes: The Amazonomachy," with n. 28.

29. Lysias, II, 6: ἐκεῖναι μὲν οὖν τῆς ἀλλοτρίας ἀδίκως ἐπιθυμήσασαι τὴν ἑαυτῶν δικαίως ἀπώλεσαν.

30. On this parallel see Walters, "Rhetoric as Ritual," 25–26, n. 42; P. E. Arias, "Nuovo contributo alla tradizione figurata dell'Amazzonomachia del V sec. a.C.," in F. Krinzinger, B. Otto, and E. Walde-Psenner (eds.), *Forschungen und Funde: Festschrift Bernard Neutsch,* Innsbruck, 1980, 53; E. B. Harrison, "Motifs of the City-Siege on the Shield of Athena Parthenos," *AJA,* 85, 1981, 295–296; Boardman, "Herakles, Theseus, and Amazons," 6, 11–15, 18–20, and 23–24; Gauer, "Ephesischen Amazonen," 218; Brommer, *Theseus,* 119 and 122; and E. D. Francis and M. Vickers, "The Oenoe Painting in the Stoa Poikile and Herodotus' Account of Marathon," *ABSA,* 80, 1985, 112.

31. Quoted by Stobaeus, IV, 23, 39: ὑπὸ γυναικὸς ἄρχεσθαι ὕβρις εἴη ἂν ἀνδρὶ ἐσχάτη. Cf. H. Diels and W. Kranz, *Die Fragmente der Vorsokratiker,* 6th ed., Berlin, 1952, vol. 2, 164, no. 111. Plato, *Laws,* 774C, also describes as *hybris* the improper influence that a wife may have over her husband because of her dowry. On women and *hybris,* also see N. R. E. Fisher, "*Hybris* and Dishonor: I," *Greece and Rome,* ser. 2, 23, 1976, 184.

32. *Lysistrata,* 658–659 and 672–680:

 ΧΟ. ΓΕ. ταῦτ' οὖν οὐχ ὕβρις τὰ πράγματ'
 ἐστὶ πολλή;

εἰ γὰρ ἐνδώσει τις ἡμῶν ταῖσδε κἂν σμικρὰν λαβήν,
οὐδὲν ἐλλείψουσιν αὗται λιπαροὺς χειρουργίας.
ἀλλὰ καὶ ναῦς τεκτανοῦνται, κἀπιχειρήσουσ’ ἔτι
ναυμαχεῖν καὶ πλεῖν ἐφ’ ἡμᾶς, ὥσπερ Ἀρτεμισία·
ἢν δ’ ἐφ’ ἱππικὴν τράπωνται, διαγράφω τοὺς ἱππέας,
ἱππικώτατον γάρ ἐστι χρῆμα κἄποχον γυνή,
κοὐκ ἂν ἀπολίσθοι τρέχοντος· τὰς δ’ Ἀμαζόνας σκόπει,
ἃς Μίκων ἔγραψ’ ἐφ’ ἵππων μαχομένας τοῖς ἀνδράσιν.
ἀλλὰ τούτων χρῆν ἁπασῶν ἐς τετρημένον ξύλον
ἐγκαθαρμόσαι λαβόντας τουτονὶ τὸν αὐχένα.

33. Aristotle, *Politics*, 1269b, 12–13: "Permissiveness towards women is harmful to the purposes of the community and to the happiness of the state . . . for they live without restraint in every kind of indulgence and luxury"; trans. E. C. Keuls, *The Reign of the Phallus*, New York, 1985, 321. On this passage from Aristotle also see Just, *Women in Athenian Law and Life*, 207–209. Although female incontinence as a justification for the repression of women is a central theme of Just's study, esp. 153ff., and of Tyrrell's *Amazons*, neither, surprisingly, discusses or refers to the passage in *Lysistrata*.

34. On the control of women as an essential prerequisite of the well-ordered *polis*, see Just, *Women in Athenian Law and Life*, 194–216, esp. 215.

35. J. Gould, "Law, Custom and Myth: Aspects of the Social Position of Women in Classical Athens," *JHS*, 100, 1980, 38–59. On the various terms for maidens and maidenhood, see ibid., 53. Gould does not, however, cite any specific texts that use these terms. For examples of *polos* see Anacreon, 75, 1; and Euripides, *Hekabe*, 142; *Hippolytos*, 546; and *Andromache*, 621. For *admes* (cf. *admetos* or *adametos*), *Odyssey*, VI, 109 and 228; Aischylos, *Suppliant Maidens*, 143 and 149. And for *polos adzugos*, Euripides, *Hippolytos*, 546. For additional examples and treatment of this issue, see Just, *Women in Athenian Law and Life*, 231 and n. 6. On the *nomos/physis* antithesis, see Gould, "Law Custom and Myth," 46, 52–53, and 57–58; S. Ortner, "Is Female to Male as Nature Is to Culture?" *Feminist Studies*, Fall 1972, 5–31 (reissued in Rosaldo and Lamphere [eds.], *Woman, Culture, and Society*, 67–87); and the more extensive study by S. W. Tiffany and K. J. Adams, *The Wild Woman: An Inquiry Into the Anthropology of an Idea*, Cambridge, Mass., 1985.

36. Earlier scholarship has noted the recurrent image of the Amazons in Greek art as mounted warriors, although without exploring the ethical implications of such usage; see von Bothmer, *Amazons in Greek Art*, 100–106 and 175–184; and Schultz Engle, *Psychoanalytic Quarterly*, 11, 1942, 516.

37. On the names of the Amazons, see Sobol, *The Amazons of Greek Mythology*, 162; and Merck, "The Patriotic Amazonomachy," 110. For such names on the vases, von Bothmer, *Amazons in Greek Art*, 160, no. 4; 162, nos. 12 and 15; 177, no. 30; 197, no. 120; and, for the Spina krater, 198, no. 132.

38. Palermo, Museo Nazionale, G 1283; *ARV*² 599, 2; Barron, "New Light," 36 and pl. Vb; von Bothmer, *Amazons in Greek Art*, 161, no. 5, 166–167, and pl. 74,3; Arias and Hirmer, *1000 Years*, 356–357 and pls. 177–179; Devambez, *LIMC*, I, 1, 606, no. 297; and Schefold and Jung, *Die Urkönige*, 274, 277–278, and fig. 325.

39. DuBois, *Centaurs and Amazons,* 4–6, 27–42, 56–57, and 61–62; Tyrrell, *Amazons,* xiii–xix, 26–31, 40–63, and 83–85. Also see Tyrrell and Brown, *Athenian Myths,* 177–179 and 183–185; Just, *Women in Athenian Law and Life,* 246; Merck, "The Patriotic Amazonomachy," 96 and 107–110; and Keuls, *Reign of the Phallus,* 3–4.

40. Trans. D. Fagles, *Bacchylides: Complete Poems,* New Haven and London, 1961, no. 17, 51–56. Bracketed terms added by the writer.

41. Lines 41–45:

> . . . ἢ θεὸς αὐτὸν ὁρμᾶι,
> δίκας ἀδίκοισιν ὄφ⌐ρα μήσεται·
> οὐ γὰρ ῥάιδιον αἰὲν ἔρ-
> δοντα μή 'ντχκεῖν κακῶι.
> πάντ' ἐν τῶι δολιχῶι χρόνωι τελεῖται.

42. Barron, "Theseus and a Woolly Cloak," 1–4.

43. On the ethical dimension of Bakchylides' handling of this myth, see above all C. Del Grande, *Hybris: colpa e castigo nell'espressione poetica e letteraria degli scrittori della Grecia antica,* Naples, 1947, 58–59. But even more generally, the scholarship on Bakchylides' Ode XVII has tended to see this clash of Theseus and Minos in terms of the opposing roles of hero and villain. The Athenian background of this negative view of Minos has been stressed especially by A. Maniet, "Le caractère de Minos dans l'ode XVII de Bacchylide," *Les études classiques,* 10, 1941, 38–54, esp. 47ff. More recently, G. J. Giesekam, "The Portrayal of Minos in Bacchylides 17," *Arca Classical and Medieval Texts, Papers, and Monographs,* 2, 1976, 237–252, esp. 240–242, has argued that here Bakchylides was actually attempting to mitigate the image created and promulgated by the Athenians. Also see the latter two works for thorough references to the earlier bibliography on this poem and these issues.

44. Bologna, Museo Civico 303; ARV² 1184, 6. On the supposed dependence of the Kadmos Painter's krater on the earlier monumental work, see C. Robert, *Die Marathonschlacht in der Poikile und weiteres über Polygnot,* Hallisches Winckelmannsprogram, 18, Halle, 1895, 50–51; Six, *JHS,* 29, 1919, 130–143, esp. 139ff.; S. Kaempf-Dimitriadou, "Amphitrite," *LIMC,* I, 1, Munich, 1981, 731 and 734, nos. 79–80; and Schefold and Jung, *Die Urkönige,* 240. P. Jacobsthal, *Theseus auf dem Meeresgrunde,* Leipzig, 1911, 14ff., had already rejected any connection between this vase and Mikon's painting in the Theseion; he argued that the reclining figure of Poseidon was unknown in Mikon's time. Barron, "New Light," 40–41, has also emphasized the lack of any positive evidence that the vase painter drew upon the earlier monumental work here. Robertson, *History of Greek Art,* 420, and Brommer, *Theseus,* 81–82, are less skeptical; they suggest that the main lines of the composition and the chief characters on the krater could derive from the version in the Theseion. J. Neils, *The Youthful Deeds of Theseus,* Archaeologia, 76, Rome, 1987, 139 and 150, ignores the issue entirely in her discussion of the vase. For a good reproduction of the Kadmos Painter's vase, also see Dugas and Flacelière,

Thésée, 69–70 and pls. 18–19, and Pfuhl, *Malerei und Zeichnung der Griechen*, vol. 3, fig. 590.

45. Brommer, *Theseus*, 82.

46. Lines 31–32, Φοίνικος ... κόρα, and 53–54, νύμ[φα] Φοίνισσα λευκώλενος.

47. Barron, "Theseus and a Woolly Cloak," 4.

48. E. B. Harrison, "Athena and Athens in the East Pediment of the Parthenon," *AJA*, 71, 1967, 41, and "Preparations for Marathon," 401, has suggested that this painting alluded to the growing status of Athens as a naval power.

49. On Apollo as League patron, see R. Meiggs, *The Athenian Empire*, Oxford, 1972, 43, 47, and 67; on his role as castigator of *hybris*, see H. North, *Sophrosyne: Self-Knowledge and Self-Restraint in Greek Literature*, Ithaca, N.Y., 1966, 30–31 and 60–65; E. Simon, *Die Götter der Griechen*, Munich, 1969, 142–146; and Tersini, "Temple of Zeus," 147–148. As Tersini points out, the motto "hate *hybris*" was inscribed on Apollo's temple at Delphi; cf. W. Guthrie, *The Greeks and Their Gods*, London, 1950, 184.

50. See Maniet, *Les études classiques*, 10, 1941, 50, and Giesekam, "The Portrayal of Minos," 237–238 and n. 5.

51. The theme was depicted by Oltos, Onesimos, Euxitheos, and the Harrow, Syriskos, Sosias, Copenhagen, Briseis, and Triptolemos Painters. For Late Archaic works of this kind, see Jacobsthal, *Theseus auf dem Meeresgrunde*, passim; Barron, "New Light," 40 and n. 150; Dugas and Flacelière, *Thésée*, 63 and pl. 9; F. Brommer, *Vasenlisten zur griechische Heldensage*, Marburg/Lahn, 1960, 165 and 185; idem, *Theseus*, 78–82; Kaempf-Dimitriadou, *LIMC*, I, 1, 730–731 and 733, nos. 75–78; Schefold and Jung, *Die Urkönige*, 238–243, fig. 290–292; and Neils, *Youthful Deeds of Theseus*, 155, 159, and 160–161, cat. nos. 15, 44, and 59. On the appearance of the theme in late Archaic Athens, also see C. Dugas, "L'Évolution de la légende de Thésée," *REG*, 56, 1943, 14–15; and W. Schindler, *Mythos und Wirklichkeit in der Antike*, Berlin, 1988, 73–74.

52. Apart from Bakchylides, the shipboard quarrel occurs only in Pausanias, I, 17, 3, and Hyginus, *Astronomica Poetica*, II, 5, while Plutarch, *Theseus*, XVII, quoting the fifth-century historian Hellanikos, at least documents the version in which Minos himself supervised the collection of the Athenian hostages; cf. Diodorus Siculus, IV, 61. Also see Giesekam, "The Portrayal of Minos," 238–239, and E. Wüst, "Der Ring des Minos: Zur Mythenbehandlung bei Bakchylides," *Hermes*, 96, 1968, 532. Wüst, 532–536, argues that Bakchylides may have invented the quarrel episode, or that he was the first to link it to the undersea visit, as part of the larger narrative of the voyage to Crete. If so, one should be cautious about the relation between Bakchylides' treatment of the story and Late Archaic Attic red figure examples posited by Neils, *Youthful Deeds of Theseus*, 60–61. Also see H. A. Shapiro, "Theseus, Athens, and Troizen, *AA*, 1982, 291–297.

53. On the statue and its connection to Pheidias' chryselephantine Parthenos in Athens, see Robert, *Marathonschlacht*, 64, and Robertson, *History of Greek Art*, 294.

54. Robertson, *History of Greek Art*, 245–246. W. Gauer, *Weihgeschenke aus den*

Perserkriegen, Istanbuler Mitteilungen, Beiheft, 2, Tübingen, 1968, 98–99, doubts the authenticity of the oath of Plataia, but he too argues, *ex silentio,* for a date after 479 B.C., emphasizing that Herodotos does not mention Athena or her shrine in his account of the battle or the religious ceremonies offered by the Greeks before the engagement to secure the aid of the gods. On the oath's authenticity, also see n. 1 to Chapter 4 below.

55. Robert, *Marathonschlacht,* 65. Gauer, *Weihgeschenke,* 99, dates the cult statue more generally to the second quarter of the fifth century B.C., and he tentatively attributes the paintings to the Severe Style.

56. Gauer, *Weihgeschenke,* is disinclined to accept the testimony that the shrine at Plataia or the Promachos in Athens had any real connection with Marathon or its spoils. He argues instead that Pausanias has transmitted a popular tradition that erroneously tended to ascribe Athenian votives for later victories against Persians to their greatest triumph, the battle of Marathon; cf. idem, "Das Athener-Schatzhaus und die marathonische Akrothinia in Delphi," in Krinzinger, Otto, and Walde-Psenner (eds.), *Festschrift Neutsch,* 129. Yet Pheidias' statue group at Delphi, which included Miltiades among the most illustrious mythic Athenians, was clearly a Marathonian monument of this sort, produced long after the battle from a tithe of the spoils. If we can believe that this work was actually financed in this way, as Gauer himself allows (*Weihgeschenke,* 25–26 and 65, and "Athener-Schatzhaus," 129–130), then it seems somewhat arbitrary to dismiss entirely Pausanias' evidence about the funding and Marathonian connection of the Promachos or the shrine of Athena Areia and its decorations. In contrast, K. Jeppesen, *Eteokleous Symbasis: Nochmals zur Deutung des Niobidenkraters, Louvre G 341,* Acta Jutlandica, 40, 3, Copenhagen, 1968, 46, and M. Tiverios, "Sieben gegen Theben," *AM,* 96, 1981, 152, both accept Pausanias' report of Athenian funding for the shrine. Jeppesen, moreover, tends to see the Plataia paintings in connection with the other Marathonian monuments commissioned by Athens shortly before the middle of the fifth century.

57. Cf. Pausanias IX, 5, 11. Jeppesen, *Eteokleous Symbasis,* 53–54, attempted to explain the name Onasias as a textual corruption, suggesting that this mysterious painter is identifiable with Onatas, the well-known sculptor from Aigina, who worked in the Severe Style.

58. R. B. Kebric, *The Paintings in the Cnidian Lesche at Delphi and Their Historical Context,* Mnemosyne Supplementum, Leiden, 1983, 3–13 and 33–36.

59. Gauer, *Weihgeschenke,* 32 and 98–99; cf. Thomas, *Mythos und Geschichte,* 69–70. Herodotos' account of the battle (IX, 61, 3) stresses the intercession of Hera; at no point does he mention Athena.

60. Herodotos, VI, 111; J. Boardman, "The Parthenon Frieze—Another View," in U. Höckmann and A. Krug (eds.), *Festschrift für Frank Brommer,* Mainz, 1977, 47.

61. F. G. Welcker, review in *Allgemeine Literatur Zeitung,* 1836, 205; Robert, *Marathonschlacht,* 65, wholeheartedly agreed. Cf. T. Löwy, *Polygnot: Ein Buch von griechischen Malerei,* Vienna, 1929, 12, and Gauer, *Weihgeschenke,* 98–100.

62. In the context of Plataia, Thomas, *Mythos und Geschichte,* 74, and Tiverios,

"Sieben gegen Theben," 152–154, have attributed a specifically anti-Theban intent to Onasias' painting.

63. Thomas, *Mythos und Geschichte*, 74.

64. Cf. Isokrates, *Panegyric* (IV), 55 and 58; also see Del Grande, *Hybris*, 168, and Tyrrell and Brown, *Athenian Myths*, 213–214.

65. Euripides, *Suppliants*, 743–744:

ὕβρις; ὑβρίζων τ'αὖθις ἀνταπώλετο
Κάδμου κακόφρων λαός.

The Athenian commitment to uphold this panhellenic law comes up repeatedly during the play; cf. lines 306–313, 526–529, and 561–563. For discussions of the two versions of the Athenian intervention at Thebes, with earlier bibliography, see Walters, "Rhetoric as Ritual," 10–14; Loraux, *Invention of Athens*, 69 and n. 312; and Stupperich, *Staatsbegräbnis*, 47–48.

66. Ferrara, Museo Nazionale di Spina T. 579; *ARV²* 612, 1; A. Rumpf, *Handbuch der Archäologie*, vol. 4, 1, Berlin 1953, 95; cf. E. Simon, "Der Goldschatz von Panagjuriste—eine Schöpfung der Alexanderzeit," *Antike Kunst*, 3, 1960, 15; idem, "Polygnotan Painting," 56; Gauer, *Weihgeschenke*, 99; Thomas, *Mythos und Geschichte*, 73; Tiverios, "Sieben gegen Theben," 153; J. P. Small, *Studies Related to the Theban Cycle on Late Etruscan Urns*, Archaeologica, 20, 1981, 143–144; and I. Krauskopf, "Amphiaraos," *LIMC*, I, 1, Munich, 1981, 699 and 709, no. 38. Others are convinced that the vase reflects a monumental prototype, although they remain uncertain about its location; see Jeffery, "*Battle of Oinoe,*" 50 n. 38; Barron, "New Light," 42 n. 165; and E. B. Harrison, "Two Pheidian Heads," in Kurtz and Sparkes, *Eye of Greece*, 67–68. For the most recent discussion, see B. von Freytag Gen. Löringhoff, *Das Giebelrelief von Telamon und seine Stellung innerhalb der Ikonographie der Sieben gegen Theben*, Römische Mitteilungen, Erganzungsheft, 27, 1986, 101–102.

67. Pausanias, IX, 5, 12, makes this subsequent reference as part of a digression on the Theban myth to prove that Oidipodes' mother Iokasta/Epikaste was not also the mother of his sons. But see Tiverios, "Sieben gegen Theben," 153, who suggests that the male observer at the right of the battle on the Spina krater may be Oidipodes, following Onasias' monumental version, even though Pausanias makes no mention of this character in his discussion of the painting.

68. Simon, "Polygnotan Painting," 54–56; U. Finster-Holz, "Epigonoi," *LIMC*, III, 1, Munich, 1986, 805, no. 3.

69. Jeppesen, *Eteokleous Symbasis*, 54–55; with subsequent modifications, idem, "Dilemma der Sieben vor Theben: neue Bemerkungen zur Quellenwert und zur Deutung des Niobidenkraters Louvre G 341," *Acta Archaeologica*, 41, 1970, 155–179.

70. Jeppesen, *Eteokleous Symbasis*, 32–53.

71. Schauenburg, K., review of Jeppesen, *Gymnasium*, 77, 1970, 150–152; Barron, "New Light," 42 and n. 165; Thomas, *Mythos und Geschichte*, 110 n. 247; and Small, *Studies Related to the Theban Cycle*, 141–143, reject Jeppesen's interpretation of the Orvieto krater as unsubstantiated. Schindler, *Mythos und Wirklichkeit*,

76, is attracted by the attempt to provide an inclusive explanation for its complex cast of characters, but he still considers Jeppesen's identification essentially hypothetical. On the interpretation of the scene as Herakles' rescue of Theseus from Hades, see n. 3 above.

72. Simon, "Polygnotan Painting," 56–57.

73. Later, Pausanias, IX, 5, 11, provides additional detail about the Theban painting at Plataia, but purely as a digression in another context. He wishes to prove that Euryganeia rather than Iokaste was the mother of Oidipodes' sons, and so he notes that Onasias showed her grief-stricken over the duel between Eteokles and Polyneikes. This suggests that his approach to the monuments was often anecdotal rather than an attempt to be thoroughly informative. J. M. Hurwit, "Narrative Resonance in the East Pediment of the Temple of Zeus at Olympia," *Art Bulletin,* 69, 1, 1987, 11–12, has pointed to the omissions that Pausanias sometimes makes in the course of his descriptions. In other cases he is simply arbitrary about the information that he chooses to supply. His reference to the Theseion, for example, identifies the artist (Mikon) and the specific subject matter for only one of the paintings (I, 17, 2–4).

74. *Iliad,* XIV, 114; Pindar, Nemean Ode, IX, 22–24, and Olympian Ode, VI, 12ff.; cf. Walters, "Rhetoric as Ritual," 11–13.

75. Walters, "Rhetoric as Ritual," 10–14; cf. Tyrrell, *Amazons,* 15. G. Zuntz, *The Political Plays of Euripides,* Manchester, 1955, 16–20, had already emphasized the general analogy between Euripides' treatment of the Theban myth and the existing tradition of Attic funerary orations; in *The Political Plays of Aeschylus,* Manchester, 1955, Zuntz also suggested that the *Eleusinians* was similarly intended to promote the alliance with Argos. Cf. Jeffery, *"Battle of Oinoe,"* 51; Simon, "Polygnotan Painting," 55; and Tiverios, "Sieben gegen Theben," 152. Jeppesen, *Eteokleous Symbasis,* 34, suggested instead that Euripides' version of the story drew upon earlier sources such as lyric poetry or tragedy, and he did not stress the specifically Attic background of the development.

76. On late sixth-century relations between Athens and Thebes as a background or stimulus for the adaptation of the mythic Theban cycle in Attic rhetoric, also see Stupperich, *Staatsbegräbnis,* 231–233.

77. Jeffery, *"Battle of Oinoe,"* 49–52, has already argued that the Athenians commissioned such a large-scale painting showing the appeal of Adrastos, or Theseus' campaign against Thebes, to celebrate Athenian solidarity with the Argives during the early 450s. However, she identifies this painting not with Onasias' work at Plataia, but rather with the problematic "Oinoe" painting mentioned by Pausanias in the Stoa Poikile, which, in her view, utilized the Theban epic as a mythic guise for the otherwise undocumented historical battle between Athenians and Spartans at Argive Oinoe; cf. Thomas, *Mythos und Geschichte,* 75. Nevertheless, the evidence for a painting made under the official patronage of Athens, showing the assault of the Seven or its aftermath, is far more pressing for the shrine at Plataia. At the same time, Francis and Vickers, "Oenoe Painting," have argued convincingly, as we shall see, that the Oinoe scene in the Stoa depicted the events leading up to Marathon rather than the Athenian campaigns of the 450s.

Concerning the continued ill will between the Plataians and Thebans, and the ongoing resentment against the Medism of the Thebans through the Peloponnesian War, see Thucydides, III, 52–68.

78. Thomas, *Mythos und Geschichte,* 69; cf. Robert, *Marathonschlacht,* 65; Gauer, *Weihgeschenke,* 100; and O. Touchefeu-Meynier, *Thèmes odysséens dans l'art antique,* Paris, 1968, 287.

79. Odessey I, 368; IV, 321 and 625–627; XV, 325–329; XVI, 78–86, 410, and 418; XVII, 167–168 and 564–565; XXIII, 63–64; and XXIV, 351–352; cf. Del Grande, *Hybris,* 12–19.

80. Trans. R. Lattimore, *The Odyssey of Homer,* New York, Evanston, and London, 1967, 322.

81. Ibid., 332. Cf. the words of Laertes (XXIV, 351–352): "Father Zeus, there are gods indeed upon tall Olympos, if truly the suitors have had to pay for their reckless violence [*hybris*]; trans. Lattimore, *Odyssey,* 354, brackets inserted by writer.

82. On the *arete* of Odysseus as the reason for divine protection and aid throughout his quest to regain his home and kingdom, see Lloyd-Jones, *The Justice of Zeus,* 2nd ed., Berkeley, Los Angeles, and London, 1983, 29.

83. C. Robert, "Freiermord des Odysseus," *Hermes,* 25, 1890, 422–431, tended to accept these and other works as helpful indices of the Polygnotan original; cf. Robert, *Marathonschlacht,* 64–65. Shefton, "Louterion," 364, emphasizing that Polygnotos showed not the actual slaying, but its aftermath, has questioned any substantive relation between the monumental painting and the subsequent depictions of this theme in fifth- and fourth-century Greek vase painting and relief. Touchefeu-Meynier, *Thèmes odysséens,* 263 and 268, has also noted that Polygnotos was averse to violent scenes of this kind; cf. E. Pfuhl, *Masterpieces of Greek Drawing and Painting* (trans. J. D. Beazley), London, 1926, 74; Gauer, *Weihgeschenke,* 100. Polygnotos' version was surely more calm and reflective.

84. Plutarch, *Kimon,* IV, 5; scholiast on Demosthenes, XX, 112; Diogenes Laertius, VII, 1, 5; and Suidas, under *Zenon;* Overbeck, *Die antiken Schriftquellen,* nos. 1055–1056. On the patronage of Peisianax for the Stoa, see Jeffery, *"Battle of Oinoe,"* 41–42; J. S. Boersma, *Athenian Building Policy from 561/0–405/4 B.C.,* Scripta Archaeologica Groningana, 4, Groningen, 1970, 55–56; Thompson and Wycherley, *The Agora of Athens,* 90; Meiggs, *The Athenian Empire,* 471; and Robertson, *History of Greek Art,* 243. On the possible dating of the monument to the time of Kimon's ostracism, see Thomas, *Mythos und Geschichte,* 39. For the recent discovery and date of the Stoa, see T. L. Shear, Jr., "The Athenian Agora: Excavations of 1980–1982," *Hesperia,* 53, 1984, esp. 13–15 and 18, and J. M. Camp, *The Athenian Agora: Excavations in the Heart of Classical Athens,* London, 1986, 64–72 and figs. 40–44. This work disclosed a red earth fill with pottery fragments dated exclusively to the period of 470–460 B.C., corresponding precisely to the literary evidence for the Stoa's date.

85. Thompson and Wycherley, *The Agora of Athens,* 92; R. E. Wycherley, *The Stones of Athens,* Princeton, N.J., 1978, 40–41. On the possible use of spoils to finance the Stoa, see Boersma, *Athenian Building Policy,* 56.

86. Pausanias, I, 15, 2–3, describes the paintings but reports nothing concerning

their authorship. Arrian, *Anabasis,* VII, 13, 5, says that Mikon (mistakenly spelled "Kimon") painted Amazons and Greeks in combat with Persians, but not where. The scholiast on *Lysistrata,* 678ff., also attributes the Amazonomachy of the Stoa Poikile to Mikon, whereas Aristophanes himself, like Arrian, refers to him only as a painter of Amazons. See Boardman, "Herakles, Theseus, and Amazons," 17. Pliny, *Natural History,* XXXV, 59, simply states that Mikon painted in the Stoa. Plutarch, *Kimon,* IV, 5, identifies the Troy painting in the Stoa as the work of Polygnotos. Pausanias, V, 11, 6, and Pliny, *Natural History,* XXXV, 57, attribute the Marathon painting to Panainos, the brother of Pheidias, while Aelian, *On Animals,* VII, 38, vacillates between Mikon and Polygnotos. Thompson and Wycherley, *The Agora of Athens,* 92, suggest a collaboration among all three artists for the Marathon painting.

87. Von Bothmer, *Amazons in Greek Art,* 198, no. 132, and 200. Von Bothmer, ibid.; Hölscher, *Griechische Historienbilder,* 72 and n. 331; and Brommer, *Theseus,* 121, have all plausibly suggested that the Amazons Dolope and Peisianassa on the Spina krater could have been adapted from the paintings of both monuments; cf. Thomas, *Mythos und Geschichte,* 97, n. 117.

88. On this use of portraiture, see W. R. Connor, "Theseus in Classical Athens," in A. Ward (ed.), *The Quest for Theseus,* New York, 1970, 163; Hölscher, *Griechische Historienbilder,* 70; and Barron, "Theseus and a Woolly Cloak," 4.

89. Robert, *Marathonschlacht,* 44–45; F. Fischer, *Heldensage und Politik in der klassischen Zeit der Griechen,* Tübingen, 1957 (Diss. 1937), 17; H. Herter, "Theseus der Athener," *Rheinisches Museum für Philologie,* N.F., 88, 1939, 295–297; P. Amandry, "Athènes au lendemain des guerres médiques," *Revue de l'Université de Bruxelles,* 13, 1960–1961, 222; Hölscher, *Griechische Historienbilder,* 70–73 and 77–78; Thomas, *Mythos und Geschichte,* 39–40 and 62; E. D. Francis, "Greeks and Persians: The Art of Hazard and Triumph," in D. Schmandt-Besserat (ed.), *Ancient Persia: The Art of an Empire,* Malibu, Calif., 1980, 62–63; and Gauer, "Athener-Schatzhaus," 132–133.

90. Plutarch, *Kimon,* XIV, 1; Jeffery, *"Battle of Oinoe,"* 45 and n. 21; and Francis and Vickers, "Oenoe Painting," 112.

91. Pausanias, X, 10, 3–4, also identifies the statue group of the Seven against Thebes at Delphi as a votive for the battle of Oinoe. However, the very existence of this obscure engagement is highly problematic; see A. Andrewes, "Could There Have Been a Battle at Oenoe?" in B. Levick (ed.), *The Ancient Historian and His Materials: Essays in Honor of C. E. Stevens on His Seventieth Birthday,* Farnborough, 1975, 9–16, and E. D. Francis and M. Vickers, "Argive Oenoe," *L'Antiquité classique,* 54, 1985, 105–115. Meiggs, *The Athenian Empire,* 471–472, following earlier scholarship, placed the battle in the first Peloponnesian War in the 450s. He proposed that the Oinoe painting would have been inserted into the Stoa's existing program shortly after the battle itself. Jeffery, *"Battle of Oinoe,"* 42, 47–57, made a similar argument, but she suggested that Oinoe was shown in a mythic guise—as the story of the Seven against Thebes. Others have also interpreted the Oinoe painting as an afterthought placed on one of the short or lateral walls: K. Wachsmuth, *Die Stadt Athen im Alterthum,* Vol. 2, Leipzig, 1890, 517; Gauer, *Weihgeschenke,* 19; Boersma, *Athenian Building Policy,* 56; and Wycherley, *Stones*

of Athens, 40. However, Robert, *Marathonschlacht,* 44–45, and J. G. Frazer, *Pausanias' Description of Greece,* London, 1898, vol. 2, 136–137, envisioned Oinoe and Marathon opposite one another on both side walls as an original part of the overall program. Hölscher, *Griechische Historienbilder,* 75–76, leaves the question open.

92. Francis and Vickers, "Oenoe Painting," 99–113, esp. 99–109. Cf. Francis, *Image and Idea in Fifth-Century Greece,* 87–89, fig. 32.

93. R. E. Wycherley, "Pausanias and Praxiteles," *Hesperia,* Supplement 20, 1982, 188, and C. Habicht, *Pausanias' Guide to Ancient Greece,* Berkeley, Los Angeles, and London, 1985, 77, strongly defend the general accuracy of Pausanias. For Demosthenes and the Akropolis, see Chapter 4, below, "The Parthenon as a Victory Monument," with n. 6.

94. On Kimon's "philolakonian" orientation, see Plutarch, *Kimon,* XVI, 1, and *Perikles,* XXIX, 2; on the problems that this raises for the traditional interpretation of the Oinoe painting, see Meiggs, *Athenian Empire,* 471, n. 5, and Francis and Vickers, "Oenoe Painting," 100. Accordingly, Jeffery, *"Battle of Oinoe,"* 42, dated the painting to the period of Kimon's ostracism, seeing it as a later addition to the original Kimonian program of the Stoa.

95. Stupperich, *Staatsbegräbnis,* 51–52; Tyrrell and Brown, *Athenian Myths,* 204; and Walters, "Rhetoric as Ritual," 3–6, who has discussed at length the Athenian claims to have accomplished great deeds such as Marathon unaided. See the Athenian speech in Herodotos, IX, 27 (cf. VII, 10); Lysias, *Funeral Oration* (II), 20 and 23; and Demosthenes, *Funeral Oration* (LX), 10–11; Plato, *Menexenos,* 240C, and *Laws,* 698B–699D; Isokrates, *Panegyric* (IV), 97, and VII, 75; and the famous Marathon epigram in Lykourgos, *Leokrates,* 104, attributed to Simonides (see n. 34 to Chapter 3 below). Walters tends to take these claims at face value as distortions asserting Athens' exclusive role in these events, although he also stresses their ultimate purpose as evidence of altruism and devotion to the greater good of Greece. But here also see Loraux, *Invention of Athens,* 145–165, esp. 161 and n. 210, who cites Aristotle's observation in the *Rhetoric* (1368a, 10–11) that actions can be made to appear more impressive if they are claimed as the first of their kind or as unparalleled.

96. On the relevance of the speech in Herodotos, IX, 27, to the Stoa paintings, see Jeffery, *"Battle of Oinoe,"* 51–52; Hölscher, *Griechische Historienbilder,* 73; Boardman, "Herakles, Theseus, and Amazons," 6; and Francis and Vickers, "Oenoe Painting," 112–113. Boardman suggests that the Athenian speech at Plataia reflects what had become standard Athenian lore by Herodotos' time. Jeffery had already recognized the analogy between this speech and the program of the Stoa's paintings. However, she proposed that Herodotos' account actually depended upon the depictions of the Stoa—that he based the content of his Athenian speech at Plataia on the mythic comparisons of the Stoa paintings. More recently, Francis and Vickers, "Oenoe Painting," 109–113, have reiterated this view. This seems implausible. The more detailed and extensive version of this catalogue of exploits in the funeral orations of Lysias and Demosthenes is clearly derived from the same tradition of funerary rhetoric or official speeches that influenced Herodotos, a tradition that

scholarship has attributed to the early 450s if not earlier (see n. 26 above). It seems far more likely that the Stoa's paintings were intended to exploit an existing popular association between the Persian Wars and the great battles of myth.

97. E. B. Harrison, "The South Frieze of the Nike Temple and the Marathon Painting in the Stoa," *AJA*, 76, 1972, 356; Aischines, *Ktesiphon*, 186; Aelius Aristedes, *On the Four*, 174; scholiast on Aristedes, *On the Four*, 174; and Cornelius Nepos, *Miltiades*, VI, 3.

98. Harrison, "Marathon Painting," 356–357.

99. Cf. Francis and Vickers, "Oenoe Painting," 112–113.

100. See especially D. Kluwe, "Das Marathonweihgeschenk in Delphi," *Wissenschaftliche Zeitschrift der Friedrich-Schiller Universität Jena*, 14, 1965, 21–27; Gauer, *Weihgeschenke*, 25, 45, and 65–71; Connor, "Theseus in Classical Athens," 164; and U. Kron, *Die zehn attischen Phylenheroen. Geschichte, Mythos, Kult und Darstellungen*, Athenische Mitteilungen, Beiheft, 5, 1976, 215–226, who stress the Kimonian date and background of this monument. On the inclusion of Philaios, see Connor, "Theseus in Classical Athens," 164, and Kebric, *Cnidian Lesche*, 26 and n. 89.

101. A. Gauer, "Athener-Schatzhaus," 129–130; Kron, *Phylenheroen*, 217–218. Also see A. Podlecki, *The Political Background of Aeschylean Tragedy*, Ann Arbor, Mich., 1966, 13–14, and Francis and Vickers, "Oenoe Painting," 105 and 112, on Kimon's desire to glorify his father's memory similarly in the Stoa paintings. The concern with lineage among the Athenian elite of Archaic and Classical times also manifested itself in family tomb groups and in the practice of ritual offerings to great ancestors; see S. C. Humphreys, "Family Tombs and Tomb Cult in Ancient Athens: Tradition or Traditionalism?" *JHS*, 100, 1980, 96–126. The planning of the Stoa certainly reflects this background.

102. Wachsmuth, *Die Stadt Athen*, vol. 2, 515–516; C. Robert, *Die Iliupersis des Polygnot*, Hallisches Winckelmannsprogram, 17, Halle, 1893, 74; Jeffery, *"Battle of Oinoe,"* 45 n. 18; Boersma, *Athenian Building Policy*, 56–57; Hölscher, *Griechische Historienbilder*, 70; U. Kron, "Akamas und Demophon," *LIMC*, I, 1, Munich, 1981, 438 and 443, no. 10; and idem, *Phylenheroen*, 157–158, have all suggested the inclusion of Theseus' sons and Menestheus in the Troy painting at the Stoa, based on their presence in the similar scene by Polygnotos at Delphi, as recorded by Pausanias.

103. Jeffery, *"Battle of Oinoe,"* 45; Boersma, *Athenian Building Policy*, 56–57. For the location of the Stoa of the Herms, see Thompson and Wycherley, *The Agora of Athens*, 94–95, who argue on the basis of literary and archaeological evidence that this monument once stood in the northwest corner of the Agora, between the Stoa Poikile and the Stoa Basileios.

104. A. Rumpf, *Malerei und Zeichnungen der klassischen Antike*, Munich, 1953, 94ff., had argued that the Attic red figure Amazonomachies with more complex arrangements of the figures reflected the pictorial advances achieved by the time the Stoa version was painted, while those with a simpler composition reflected the one in the Theseion. Cohen, "Paragone," 184, has also suggested that the spatial qualities of the Theseion paintings must have been less advanced than those of the

later monuments; Schefold and Jung, *Die Urkönige,* 274–278, make finer stylistic distinctions. Barron, "New Light," 39, proposes differences in narrative detail. On the evidence of vase painting, he has suggested that the Theseion version included Antiope fighting on the side of Theseus; Tyrrell, *Amazons,* 12–13, has elaborated somewhat on this argument. However, Brommer, *Theseus,* 121; Boardman, "Herakles, Theseus and Amazons," 24–25; and Schefold and Jung, *Die Urkönige,* 274, are less certain about the existence of this "friendly Amazon" motif.

105. On women as timid and prone to panic, see K. J. Dover, *Greek Popular Morality in the Time of Plato and Aristotle,* Oxford, 1974, 99–102, and Just, *Women in Athenian Law and Life,* 154–157. On woman's slavish nature, see Just, 166–170 and 184–191.

106. Here it is useful to compare Xenophon's *Oikonomikos,* VI, 23, 2–5, where Ischomachos instructs his new young wife on the difference between the mental and physical capacities of men and women, and the differing character and behavior that result. The passage is discussed in Just, *Women in Athenian Law and Life,* 154, although not in connection with the Amazons; cf. 250–251.

107. DuBois, *Centaurs and Amazons,* 86; Tyrrell, *Amazons,* 63; Just, *Women in Athenian Law and Life,* 187–188 and 251.

108. Bologna, Museo Civico, 289; *ARV*² 891; von Bothmer, *Amazons in Greek Art,* 164–165 and pl. LXXIV, 1; Dugas and Flacelière, *Thésée,* 85 and pls. 12–13; G. Bermond Montanari, *Corpus Vasorum Antiquorum,* Bologna, Museo Civico, fasc. IV (Italia, fasc. XXVII), Rome, 1957, 13 and tav. 73–74; Barron, "New Light"; 35–36 and pl. VIa; and Devambez, *LIMC,* I, 1, 606, no. 299. For a continuous depiction of the scene, see Pfuhl, *Malerei und Zeichnung der Griechen,* fig. 504; Barron, "New Light," pl. VIa; and Schefold and Jung, *Die Urkönige,* 277, fig. 327.

109. Dinos, London, British Museum, 99.7–21.5 from Agrigento, and krater from Numana, New York, Metropolitan Museum of Art, 07.286.86, *ARV*² 616, 3; see Pfuhl, *Malerei und Zeichnung der Griechen,* fig. 507; von Bothmer, *Amazons in Greek Art,* 162, pl. LXXIV, 2; Barron, "New Light," pl. IVb, bottom right, and pl. Vc, bottom center; Connor, "Theseus in Classical Athens," 156, ill. 162; Devambez, *LIMC,* I, 1, 602, no. 233a, and 606, no. 296; and Schefold and Jung, *Die Urkönige,* 283, fig. 332.

110. For further examples see the dinos of the Group of Polygnotos: Barron, "New Light," pl. Vc, top center, and von Bothmer, *Amazons in Greek Art,* pl. LXXVII, 2; and another krater by the Niobid Painter in Naples, Museo Nazionale 2421: Boardman, "Herakles, Theseus and Amazons," pl. 5b; Barron, "New Light," pl. VIb, center, and pl. VIc, left; von Bothmer, *Amazons in Greek Art,* pl. LXXIV, 4; and Pfuhl, *Malerei und Zeichnung der Griechen,* fig. 505. Cf. a lekythos by the Eretria Painter, New York, Metropolitan Museum of Art, 31.11.13; a bell krater by the Guglielmi Painter, Naples, Museo Nazionale 1768; and an amphora by Polygnotos, London, British Museum E 272: *ARV*² 1031, 38; von Bothmer, *Amazons in Greek Art,* pl. LXXVII, 1 and 4, pl. LXXXI, 2; and Devambez, *LIMC,* I, 1, 602, no. 242, 606, no. 305, and 607, no. 315a.

111. For additional examples, see Hölscher, *Griechische Historienbilder,* pl. 4,

and A. Bovon, "Les représentations des guerriers perses et la notion de barbare dans la Ire moitié du Ve siècle," *BCH,* 87, 1963, 580, fig. 2, and 589, fig. 13. On the possible relation of such vases to the Marathon painting, see Hölscher, *Griechische Historienbilder,* 51, and W. Raeck, *Zum Barbarenbild in der Kunst Athens im 6. und 5. Jahrhundert v. Chr.,* Bonn, 1981, 160. For fig. 5, see chapter 3, n. 19, below.

112. Jerusalem, Israel Museum, 124/1; Boardman, "Herakles, Theseus and Amazons," 24–25, pl. 5a.

113. Basel, Antikensammlung and Sammlung Ludwig BS 486; *ARV²* 612, 2; Barron, "New Light," 38–39; E. Berger, "Hauptwerke des Basler Antikenmuseums zwischen 460 und 430 v. Chr.," *Antike Kunst,* 11, 1968, 62 and pl. 17, 1–2; Devambez, *LIMC,* I, 1, 606, no. 302; Boardman, "Herakles, Theseus and Amazons," 22 and pl. 4; Schefold and Jung, *Die Urkönige,* 275–276, fig. 326.

114. Pausanias, I, 15, 2: μόναις δὲ ἄρα ταῖς γυναιξὶν οὐκ ἀφῆρει τὰ πταίσματα τὸ ἐς τοὺς κινδύνους ἀφειδές.

115. Lysias, II, 5–6: μᾶλλον ἐκ τῶν κινδύνων ἢ ἐκ τῶν σωμάτων ἔδοξαν εἶναι γυναῖκες. μόναις δ᾽ αὐταῖς οὐκ ἐξεγένετο ἐκ τῶν ἡμαρτημένων μαθούσαις

116. H. Sancisi-Weerdenburg, "Exit Atossa: Images of Women in Greek Historiography on Persia," in A. Cameron and A. Kuhrt (eds.), *Images of Women in Antiquity,* Detroit, 1983, 24–27.

117. Loraux, *Invention of Athens,* 69–72, has especially stressed the rejection of the Trojan cycle in the catalogue of deeds preserved in fourth-century Attic funerary speeches. She would attribute this omission to the very inception of such rhetoric because panhellenism, in her view, did not accord with Athenian foreign policy in the 460s. She therefore suggests that Herodotos, for his own reasons, simply interpolated the Trojan campaign into the catalogue of exploits in his account of the Athenian speech at Plataia. In deference to the unambiguous emphasis on the Trojan War in the verses of the Eion herms, Stupperich, *Staatsbegräbnis,* 49, inclines to the more likely possibility that the Trojan theme was an original and important component of the *epitaphios logos* that later dropped out when its inclusion no longer seemed useful. Yet even the use of the Trojan expedition in Demosthenes and Isokrates as a foil for the greater achievements of the Persian Wars or contemporary initiatives still documents the function of this theme as a measure or standard of mythic comparison rooted in earlier usage (see Introduction and Chapter 4, "Epilogue: The Iliupersis After Polygnotos and Pheidias," with n. 129).

118. Lloyd-Jones, *Justice of Zeus,* 74–75, has stressed the collective guilt that Paris' crime brought upon the heads of the entire Trojan people.

119. On this poem also see Del Grande, *Hybris,* 59–60. On the conception of Themis and her daughters Dike and Eunomia in Greek art of the Archaic and Classical periods, also see H. A. Shapiro, *Personification of Abstract Concepts in Greek Art and Literature to the End of the Fifth Century B.C.,* Ph.D. Diss., Princeton University (University Microfilms, Ann Arbor, Mich.), 1977, 42–48, 175–180, 222–232, and 266–268.

120. Bakchylides, Ode 11(10), 120-126:

> . . . Πριάμοι᾽ ἐπεὶ χρόνωι
> βουλαῖσι θεῶν μακάρων
> πέρσαν πόλιν εὐκτιμέναν
> χαλκοθωράκων μετ᾽ Ἀτ¹ρειδᾶν. δικαίας
> ὅστις ἔχει φρένας, εὑ-
> ρήσει σὺν ἅπαντι χρόνωι
> μυρίας ἀλκὰς Ἀχαιῶν.

121. Line 372: οὐκ εὐσεβής; and lines 382-384: ἀνδρί λακτίσαντι μέγαν Δίκας βωμὸν εἰς ἀφάνειαν.

122. Agamemnon, 367: Διὸς πλαγὰν ἔχουσιν εἰπεῖν; and lines 374-378:

> πέφανται δ᾽ ἐκτίνουσ᾽
> ἀτολμήτων ἀρὴ
> πνεόντων μεῖζον ἢ δικαίως,
> φλεόντων δωμάτων ὑπέρφευ
> ὑπὲρ τὸ βέλτιστον.

Cf. lines 699-715. On the crimes of the Trojans, also see Del Grande, *Hybris,* 105.

123. Lysias, II, 6. For the Greek text, see n. 29 above. On female lust and sexual excess, see Dover, *Greek Popular Morality,* 99-100, and Just, *Women in Athenian Law and Life,* 157-163.

124. On the fundamental propensity to incontinence, luxury, and sensuality attributed to women and barbarians alike, see Just, *Women in Athenian Law and Life,* 187-188.

125. For archaeological evidence or discussions of the building itself, see W. B. Dinsmoor, *The Architecture of Ancient Greece,* 3rd ed., New York, 1975, 206; D. S. Robertson, *Greek and Roman Architecture,* 2nd ed., Cambridge, 1969, 164; J. Pouilloux, *Fouilles de Delphes,* vol. 2, *Topographie et l'architecture, la région nord du sanctuaire,* Paris, 1960, 120-139; and R. A. Tomlinson, "Two Notes on Possible Hestiatoria," *ABSA,* 75, 1980, 225-227.

126. Troy taken: Robert, *Iliupersis;* M. Robertson, "Conjectures in Polygnotos' Troy," *ABSA,* 62, 1967, 5-12; idem, *History of Greek Art,* 248-251; M. D. Stansbury-O'Donnell, "Polygnotos's *Iliupersis:* A New Reconstruction," *AJA,* 93, 1989, 203-215. Underworld: C. Robert, *Die Nekyia des Polygnot,* Hallisches Winckelmannsprogram, 16, Halle, 1892; Touchefeu-Meynier, *Thèmes odysséens,* 133-134 and 143-144; Robertson, *History of Greek Art,* 266-270; M. D. Stansbury-O'Donnell, "Polygnotos's *Nekyia:* A Reconstruction and Analysis," *AJA,* 94, 1990, 213-235.

127. C. Dugas, "A la lesché des cnidiens," *REG,* 51, 1938, 56-57.

128. Kebric, *Cnidian Lesche,* 3-13. Robertson, *History of Greek Art,* 242, had already suggested a symbolic connection with Eurymedon. Kebric's dating for the battle of Eurymedon and accordingly for the Lesche and its paintings may be several years too early; see E. Badian, "The Peace of Callias," *JHS,* 107, 1987, 5-6.

129. Kebric, *Cnidian Lesche*, 33–36.

130. Robert, *Iliupersis*, 77; Jeffery, *"Battle of Oinoe,"* 45, n. 18; and Robertson, *History of Greek Art*, 249.

131. *Iliad*, X, 435; Euripides, *Rhesos*, 279–280; Robert, *Iliupersis*, 14.

132. Robert, *Iliupersis*, 66; Jeffery, *"Battle of Oinoe,"* 45; Thomas, *Mythos und Geschichte*, 65; Hölscher, *Griechische Historienbilder*, 71; Barron, "Theseus and a Woolly Cloak," 4; Francis, *Image and Idea in Fifth-Century Greece*, 95. The likelihood of this eponymic interpretation is confirmed by an Attic red figure oinochoe of the 460s depicting a naked Greek who gestures rudely with his penis at the buttocks of a terrified bowing Persian. The vessel is inscribed, "I am Eurymedon and I stand bent over." Here the eponymous Asiatic undoubtedly refers to this greatest of Kimon's victories; see K. Schauenburg, "Eurymedon Eimi," *AM*, 90, 1975, 103–104, 116–121, and pl. 25.

133. Herodotos, VI, 41, 3; Barron, "Theseus and a Woolly Cloak," 4; Francis, ibid.

134. Robert, *Nekyia*, 78–84.

135. Kebric, *Cnidian Lesche*, 20–22.

136. Ibid., 26–29. On this Philaid genealogy more generally, see Barron, "Theseus and a Woolly Cloak," 1–3; K. Kinzel, *Miltiades-Forschungen*, Vienna, 1968, 1–25; and H. A. Shapiro, *Art and Cult Under the Tyrants in Athens*, Mainz, 1989, 155.

137. On Tyro, Chloris, and Pero, see the *Odyssey*, XI, 235–259 and 281–291; cf. Apollodoros, *Library*, I, 9, 8–9, I, 9, 12, and III, 5, 6, and Hyginus, *Fabulae*, X. On Kodros and Neleus/Neileus, see Herodotos, V, 65, and IX, 97; Kallimachos, *Hymn to Artemis* (III), 225–227; Strabo, *Geography*, 633; J. P. Barron, "Milesian Politics and Athenian Propaganda," *JHS*, 82, 1962, 3; and idem, "Religious Propaganda of the Delian League," *JHS*, 84, 1964, 46.

138. Robert, *Nekyia*, 81–82; cf. Hölscher, *Griechische Historienbilder*, 71. On Triopas and Iaseus or Iasos, see Hellanikos, frag. 37; Pausanias, II, 16, 1, and X, 11, 1; and Diodorus Siculus, IV, 58, 7–8. On Iasos and Chloris, *Odyssey*, XI, 281–283.

139. On Iphimedeia's descent also see Apollodoros, *Library*, I, 7, 4. At least ten women in Greek myth bore the name of "Klymene." Pausanias, X, 29, 6, identifies the one in the painting as Minyas' daughter and the wife of the Athenian Kephalos, but she is also recorded as the wife of Iasos and mother to Atalanta in Apollodoros, *Library*, III, 9, 2; cf. W. H. Roscher, *Ausführliches Lexikon der griechischen und römischen Mythologie*, Hildesheim and New York, 1978, II, 1, 1227. The site of Pergamon is first mentioned in Xenophon, *Hellenica*, III, 6, in connection with the campaigns of Kyros and Tissaphernes about 400 B.C. Excavations have produced remains of the Archaic period, but little is known of the town's earlier history. The myth of Telephos as a colonizer of the western Asiatic coast is at least as old as the fifth century, when (in 438 B.C.) it provided the subject of Euripides' *Telephos*. Only the fragmentary prologue survives, but here Telephos recounts his lineage as the son of Auge, from Arkadia, and his subsequent exploits as ruler of Mysia. On Tellis see Hölscher, *Griechische Historienbilder*, 71, and Kebric, *Cnidian Lesche*, 46.

140. Kebric, *Cnidian Lesche*, 28–29, has emphasized this genealogical connec-

tion to Kimon; Phokos was the son of Aiakos and Psamathe, and therefore the half-brother of Telamon and Peleus and great-uncle to Philaios, grandson of Telamon. Kebric nevertheless overlooks the implications of the friendship between Phokos and Iaseus as a prefiguration of League solidarity. The story of Iaseus and Phokos is attested only in this painting, or in Pausanias' account of it. But Robert, *Nekyia,* 81–82, concluded plausibly that Iaseus is a variant of the name Iasos (also Iasios), elsewhere attested as the husband of Klymene, grandfather of Chloris, son of Triopas (who founded Knidos), and founder of Iasos in Karia.

141. Kebric, *Cnidian Lesche,* 26, stresses the propagandistic aspects of the Marathon monument with regard to the Delian League and Ionian foundation myths, and he points out the analogous inclusion of Kimon's mythic relatives in the Lesche paintings. But here again he apparently misses the functional similarity of Neleus and Kodros in the Marathon monument to the extensive Neleid and Ionian genealogy portrayed in the Nekyia painting.

142. See V. J. Matthews, *Panyassis of Halikarnassos: Text and Commentary,* Mnemosyne Supplementum, 33, Leiden, 1974, 26–30. F. Brommer, "Attische Kö-nige," in K. Schauenburg (ed.), *Charites: Festschrift Langlotz,* Bonn, 1957, 161, has argued that the figure of Kodros was first created in the second half of the fifth century B.C., and that literary and artistic testimonia for this Attic king cannot be traced before Herodotos or the vase painting of the 430s. But Kodros is already attested in Panyassis, whose floruit was between 480 and 450; see Matthews, *Panyassis,* 12–19. The inclusion of Kodros in the Marathon statue group at Delphi also belongs to the 450s: Kron, *Phylenheroen,* 218. Even the Athenian tyrants of the sixth century B.C. had already begun to claim descent from Neleus for the purposes of propaganda; see H. A. Shapiro, "Painting, Politics, and Genealogy: Peisistratos and the Neleids," in W. G. Moon (ed.), *Ancient Greek Art and Iconography,* Madison, Wis., 1983, 87–96, and Shapiro, *Art and Cult Under the Tyrants,* 49 and 103–104.

Chapter 3

1. O. Touchefeu-Meynier, *Thèmes odysséens dans l'art antique,* Paris, 1968, 143.

2. *Odyssey,* VIII, 521–530, trans. R. Lattimore, *The Odyssey of Homer,* New York, Evanston, and London, 1967, 134–135.

3. K. Schefold, *Myth and Legend in Early Greek Art,* New York, 1966, 46–47; J. Boardman, *Athenian Red Figure Vases: The Archaic Period,* New York and Toronto, 1975, 94. For more extensive discussions or surveys of the Iliupersis in Greek art, see Schefold, *Myth and Legend,* passim; C. Dugas, "Tradition littéraire et tradition graphique dans l'antiquité grecque," *L'Antiquité classique,* 6, 1937, 5–26; J. Davreux, *La légende de la prophétesse Cassandre d'après les textes et les monuments,* Bibliotheque de la Faculté de Philosophie et Lettres de l'Université de Liège, fasc. 94, Liège and Paris, 1942, 138–211; M. Wiencke, "An Epic Theme in

Greek Art," *AJA*, 58, 1954, 285–306; P. E. Arias, "Dalle Necropoli di Spina: la tomba 136 di Valle Pega," *Rivista dell'Istituto Nazionale di Archeologia e Storia dell'Arte*, N.S., 4, 1955, 110–116; F. Brommer, *Vasenlisten zur griechischen Heldensage*, Marburg/Lahn, 1960, 273–274, 282–286, 298–299, and 331–333; J. Moret, *L'Ilioupersis dans la céramique italiote: les mythes et leur expression figurée au IVe siècle*, Rome, 1975, esp. 51–60; M. Robertson, *A History of Greek Art*, Cambridge, 1975, 232–235; U. Kron, *Die zehn attischen Phylenheroen: Geschichte, Mythos, Kult, und Darstellungen*, Athensiche Mitteilungen, Beiheft, 5, Berlin, 1975, 152–156; H. A. Cahn, "Aithra I," *LIMC*, I, 1, Munich, 1981, 426–427 and 430, nos. 59–72; F. Canciani, "Aineias," *LIMC*, I, 1, Munich, 1981, 386–388 and 395, nos. 59–141; O. Touchefeu-Meynier, "Aias II," *LIMC*, I, 1, Munich, 1981, 339–344, nos. 16–70; idem, "Andromache I," *LIMC*, I, 1, Munich, 1981, 771–772, nos. 43–47; idem, "Astyanax," *LIMC*, II, 1, Munich, 1984, 931–933, nos. 7–24; A. Delivorrias, "Aphrodite," *LIMC*, II, 1, Munich, 1984, 140–141, nos. 1470–1480; L. Ghali-Kahil, *Les enlèvements et le retour d'Hélène dans les textes et les documents figurés*, École Française d'Athènes, travaux et mémoires, 10, Paris, 1955; idem, "Helen," *LIMC*, IV, 1, Munich, 1988, 537–550, nos. 210–227 and 235–357.

The most lurid textual account of the sack that has come down to us is Tryphiodoros' *Taking of Ilion*. Though late antique in date, it provides an excellent parallel for the sacrilege and the murder of young and old consistently emphasized in the visual representations of the Iliupersis. Another late work, Quintus of Smyrna's *Posthomerica*, XIII, often stresses the retributive motivation or basis of the Greek sack, but it too presents a graphic literary counterpart for the horror of Troy's fall as it appeared in Archaic and Early Classical Greek art.

4. Schefold, *Myth and Legend*, 46–47 and pls. 34–35, and R. Hampe and E. Simon, *The Birth of Greek Art from the Mycenaean to the Archaic Period*, New York, 1981, 82 and pls. 116–120 and 122.

5. Berlin, Staatliche Museen, 1685, from Vulci; *ABV* 109, 24; Wiencke, "An Epic Theme," 296–297, fig. 14, and cf. figs. 8–18.

6. For this detail on the Mykonos amphora, see Schefold, *Myth and Legend*, pl. 34b, and Hampe and Simon, *Birth of Greek Art*, pl. 122. For numerous other examples in Attic vase painting, see Ghali-Kahil, *Le retour d'Hélène* and *LIMC* IV, 1, 537–550.

7. Berlin, Staatliche Museen, 2280–2281 and Vatican frr.; *ARV*² 19, 1–2; Wiencke, "An Epic Theme," 302, fig. 27; H. Speier, "Die Iliupersisschale des Euphronios," *Neue Beiträge zur klassischen Altertumswissenschaft: Festschrift B. Schweitzer*, Stuttgart, 1954, 113–124, pl. 23, a; D. Williams, "The Iliupersis Cup in Berlin and the Vatican," *Jahrbuch des Berliner Museums*, 18, 1976, 9–25; and Touchefeu-Meynier, *LIMC*, II, 1, 932, no. 16; B. Sparkes, "Aspects of Onesimos," in C. G. Boulter, *Greek Art: Archaic Into Classical*, Leiden, 1985, 24 and fig. 2.

8. Naples, Museo Nazionale, 2422; *ARV*² 189, 74; Wiencke, "An Epic Theme," 303 and fig. 31; J. Boardman, "The Kleophrades Painter at Troy," *Antike Kunst*, 19, 1976, 7–11; Touchefeu-Meynier, *LIMC*, I, 1, 341, no. 44; idem, *LIMC*, II, 1, 933, no. 19.

9. Trans. G. Nagy, *The Best of the Achaeans: Concepts of the Hero in Archaic Greek Poetry*, Baltimore and London, 1979, 156. In *Works and Days* this third generation precedes the bronze warriors of the Trojan epic. But Nagy, ibid., 155–159, has shown that this kind of atavistic violence was still very much a part of the darker side of the Greeks at Troy, especially Achilleus. Also see F. Vian, "La fonction guerrière dans la mythologie grecque," in J. P. Vernant (ed.), *Problèmes de la guerre en Grèce ancienne*, Paris and The Hague, 1968, 53–68; and A. Stewart, "Stesichoros and the François Vase," in W. G. Moon (ed.), *Ancient Greek Art and Iconography*, Madison, Wis., 1983, 65.

10. J. J. Pollitt, "Early Classical Greek Art in a Platonic Universe," in Boulter, *Greek Art*, 103; Boardman, "Kleophrades Painter," 14–15; idem, *Athenian Red Figure Vases*, 94.

11. Trans. R. Lattimore, in D. Grene and R. Lattimore (eds.), *Greek Tragedies*, vol. 1, Chicago, 1959, 45. W. Kierdorf, *Erlebnis und Darstellungen der Perserkriege*, Hypomnemata, 16, Göttingen, 1966, 14–15, has noted the similarity between the portrayal of the Greeks at Troy's fall in the *Agamemnon* and that of Xerxes in the *Persians*.

12. *Agamemnon*, 461–466 and 468–470:

> τῶν πολυκτόνων γὰρ οὐκ
> ἄσκοποι θεοί. κελαι-
> ναὶ δ᾽ Ἐρινύες χρόνῳ
> τυχηρὸν ὄντ᾽ ἄνευ δίκας
> παλιντυχεῖ τριβᾷ βίου
> τιθεῖσ᾽ ἀμαυρόν,
>
>
>
> τὸ δ᾽ ὑπερκόπως κλύειν
> εὖ βαρύ· βάλλεται γὰρ ὅσ-
> σοις Διόθεν κάρανα.

13. *Odyssey*, III, 130–135, and V, 103–109; Euripides, *Trojan Women*, 57–97; cf. Quintus of Smyrna, *Posthomerica*, XIV, 419–658. On the self-destructive insolence of the Greeks at Troy in Euripides' *Trojan Women*, also see C. Del Grande, *Hybris: colpa e castigo nell'espressione poetica e letteraria degli scrittori della Grecia antica*, Naples, 1947, 174–177.

14. Del Grande, *Hybris*, 105–106, has especially stressed the moral ambivalence or paradox of Troy's fall as portrayed in the *Agamemnon*, where the main character ultimately surpasses the outrage and impiety of Paris and pays dearly for doing so.

15. D. M. Leahy, "The Representation of the Trojan War in Aeschylus' *Agamemnon*," *American Journal of Philology*, 95, 1974, 8–9; cf. N. Loraux, *The Invention of Athens: The Funeral Oration in the Classical City* (trans. A. Sheridan), Cambridge, Mass., and London, 1986, 70–71 and n. 276.

16. In the past, scholars have been inclined to see Polygnotos' use of the Trojan theme as analogous to Aischylos' *Agamemnon; G.* Méautis, "Eschyle et Polygnote," *RA*, ser. 6, 10, 1937, 169–173. The recent study by M. D. Stansbury-O'Donnell, "Polygnotos's *Iliupersis:* A New Reconstruction," *AJA*, 93, 1989, 212–

214, also posits a connection between the Lesche painting and Aischylos' treatment of the Iliupersis as a condemnation of Greeks and Trojans alike, without considering of how this might accord with the prefigurative function that scholars from Robert to Kebric have repeatedly adduced for the painting. Only B. S. Ridgway, *Fifth Century Styles in Greek Sculpture,* Princeton, N.J., 1981, 18–19, seems to have noted briefly the problems posed by the traditional interpretation of the Iliupersis in these monuments.

17. See P. Veyne, *Did the Greeks Believe in Their Myths? An Essay on Constitutive Imagination* (trans. P. Wissing), Chicago and London, 1988, 27–28, on the perceived reliability of the speaker as a factor in how readily a myth might find acceptance.

18. See D. von Bothmer, *Amazons in Greek Art,* Oxford, 1957, pls. LXI–LXVI and LXVIII–LXXXVI; and K. Schauenburg, "Achilleus als Barbar: ein antikes Missverständnis," *Antike und Abendland,* 20, 1974, 89.

19. G. M. A. Richter and L. F. Hall, *Red Figured Vases in the Metropolitan Museum of Art,* New Haven, 1936, 57; A. Bovon, "Les représentations des guerriers perses et la notion de barbare dans la Ire moitié du Ve siècle," *BCH,* 87, 1963, 597 and 600; T. Hölscher, *Griechische Historienbilder des 5. und 4. Jahrhunderts vor Chr.,* Würzburg, 1973, 40 and 44–45; K. Schauenburg, "Eurymedon Eimi," *AM,* 90, 1975, 107–108; A. Lezzi-Hafter, *Der Schuwalow-Maler: Eine Kannenwerkstatt der Parthenonzeit,* Mainz, 1976, 80; and W. Raeck, *Zum Barbarenbild in der Kunst Athens im 6. und 5. Jahrhundert V. Chr.,* Bonn, 1981, 101–103 and 111. For the example illustrated in fig. 5 in this volume, New York, Metropolitan Museum of Art, 06.1021.117, see *ARV²* 1656, Richter and Hall, *Red Figured Vases,* 56, pl. 34; and Bovon, *BCH,* 87, 1963, 581, fig. 3.

20. For additional ceramic reflections of Mikon's Amazonomachies, see von Bothmer, *Amazons in Greek Art,* 161–174 and pls. LXXIV–LXXXI; J. P. Barron, "New Light on Old Walls," *JHS,* 92, 1972, 33–40 and pls. IV–VI; P. Devambez, "Amazones," *LIMC,* I, 1, Munich, 1981, 606–607, nos. 295–315a; and Robertson, *History of Greek Art,* 255–259. Devambez, 642, has pointed to the deliberate use of oriental costume and equipment here.

21. Moret, *Ilioupersis,* 152, and Schauenburg, "Achilleus als Barbar," 89.

22. Raeck, *Barbarenbild,* 263–264, n. 359. For other possible images of Paris as a Scythian archer, see G. Ferrari Pinney, "Achilles Lord of Scythia," in Moon, *Greek Iconography,* 127–146. D. Ohly, *Glyptothek München: griechische und römische Skulpturen,* Munich, 1977, 63, has recently identified the oriental archer of the west pediment of the Aphaia temple at Aigina as Paris. See Schauenburg, "Achilleus als Barbar," 89, for an example of Memnon in oriental dress. The trousered legs on a fragmentary red figure Iliupersis in Athens (see Wiencke, "An Epic Theme," fig. 28) probably belong to one of the Scythian archers who appear on both sides in the Trojan War scenes of Late Archaic Attic vase painting. For these in general see M. Vos, *Scythian Archers in Archaic Vase Painting,* Groningen, 1963, especially 34–38, and Raeck, *Barbarenbild,* 62–63.

23. C. Robert, *Die Iliupersis des Polygnot,* Hallisches Winckelmannsprogram, 17, Halle, 1893, 37.

24. See Hölscher, *Griechische Historienbilder,* 40–41, and Schauenburg, "Eurymedon Eimi," 107–108 and pl. 26, 2, Attic red figure oinoche. For additional cuirassed Persians, see Vos, *Scythian Archers,* pl. XIVb; Bovon, *BCH,* 87, 1963, 586, fig. 10, and 589, fig. 13; and Raeck, *Barbarenbild,* fig. 53 and 55. For trousered and cuirassed Amazons, see von Bothmer, *Amazons in Greek Art,* pl. LXXIV, 3. Cuirassed Scythians also appear on the famous gold comb from Solocha; see M. I. Artamonov, *The Splendor of Scythian Art,* New York and Washington, 1969, pl. 150, and B. Piotrovsky, L. Galanina, and N. Grach, *Scythian Art,* Oxford and Leningrad, 1987, pls. 128–129.

25. See especially the reconstructions of Lloyd, Riepenhausen, Welcker, Gebhardt, and Michalek, published by O. Benndorf in *Wiener Vorlegeblätter für archäologische Übungen,* 1888, pl. X–XII.

26. See Moret, *Ilioupersis,* 152–159.

27. I. Raab, *Zu den Darstellung des Paris in den griechischen Kunst,* Frankfurt am Main, 1972, 61 and 63; Raeck, *Barbarenbild,* 86–87; Ghali-Kahil, *Le retour d'Hélène,* pls. XXIII, 1–2, and XXX–XXXIII.

28. Ferrara, Museo Nazionale di Spina, T 136 VP; Arias, "Necropoli di Spina," 96 and 101, figs. 2, 7, and 8; idem, *Corpus Vasorum Antiquorum,* Italia, fasc. XXXVII (Museo Nazionale di Ferrara), Rome, 1963, 7, and pl. 13, 1 and 4; Touchefeu-Meynier, *LIMC,* I, 1, 347, no. 91. An Attic red figure sherd from Athens may be from a nearly identical vase; R. S. Young, "An Industrial District of Ancient Athens," *Hesperia,* 20, 1951, 256 and pl. 80, 4.

29. H. Bacon, *Barbarians in Greek Tragedy,* New Haven, 1961, 18–19, 27–28, 32, 34–36, and 39–41. Also see E. D. Francis, *Image and Idea in Fifth-Century Greece: Art and Literature after the Persian Wars,* London and New York, 1990, 34–35.

30. Ibid., 17 and 19–20.

31. Ibid., 101–104.

32. Ibid., 124. For the early date of the *Cyclops,* see D. J. Conacher, *Euripides' Drama: Myth, Theme, and Structure,* Toronto, 1967, 320, and *Euripides* (Loeb Classical Library), trans. A. S. Way, vol. 2, London, 1912, Introduction, xi. For a later date see R. Seaford, "The Date of Euripides' *Cyclops,*" *JHS,* 102, 1982, 161–172, and idem, *Euripides' Cyclops,* Oxford, 1984, 48.

33. A. Alföldi, "Gewaltherrscher und Theaterkönig: Die Auseinandersetzung einer attischen Ideenprägung mit persischen Repräsentationsformen im politischen Denken und in der Kunst bis zur Schwelle des Mittelalters," in K. Weitzmann et al., *Late Classical and Mediaeval Studies in Honor of Albert Mathias Friend, Jr.,* Princeton, N.J., 1955, 15–55, esp. 38–44; Schauenburg, "Achilleus als Barbar," 89; and idem, "Eurymedon Eimi," 114–115.

34. E. D. Francis and M. Vickers, "The Marathon Epigram in the Stoa Poikile," *Mnemosyne,* ser. 4, 38, 1985, 390–393. The epigram runs as follows:

Ἑλλήνων προμαχοῦντες Ἀθηναῖοι Μαραθῶνι
χρυσοφόρων Μήδων ἐστόρεσαν δύναμιν.

35. For these reconstructions see n. 25 above, and Robert, *Iliupersis*. L. Faedo, "Breve racconto di una caccia infruttosa: Polignoto a Delfi," *Ricerche di storia dell'arte*, 30, 1986, 5–15, sees the variation among such attempts as an indication of how poorly they reflect the appearance of the original painting.

36. M. Robertson, "Conjectures in Polygnotos' Troy," *ABSA*, 62, 1967, 5–12; idem, *History of Greek Art*, 247–252.

37. C. Robert, *Die Nekyia des Polygnot*, Hallisches Winckelmannsprogram, 16, Halle, 1892, 39–45; E. Simon, "Polygnotan Painting and the Niobid Painter," *AJA*, 67, 1963, passim; Robertson, *History of Greek Art*, 252–259; and B. Cohen, "Paragone: Sculpture Versus Painting: Kaineus and the Kleophrades Painter," in Moon, *Greek Iconography*, 184–185.

38. Stansbury-O'Donnell, "Polygnotos's *Iliupersis*," 203–215, figs. 3–5; idem, "Polygnotos's *Nekyia:* A Reconstruction and Analysis," *AJA*, 94, 1990, 213–235, figs. 2–5. For other attempts of this kind, see F. S. Kleiner, "The Kalydonian Hunt: A Reconstruction of a Painting from the Circle of Polygnotos," *Antike Kunst*, 15, 1972, 7–19, and S. Woodford, "More Light on Old Walls," *JHS*, 94, 1974, 158–165, which offers a reconstruction of the Centauromachy in the Theseion.

39. Robertson, *History of Greek Art*, 248, maintains that since the Troy painting occupied the right half of the Lesche, Pausanias started in the middle of the long wall opposite the doorway as he entered and described the work from left to right, thus reversing the order assumed by Robert, *Iliupersis*. Stansbury-O'Donnell, "Polygnotos's *Iliupersis*," 206, compares this to the mode of description used by Pausanias for the pedimental sculptures of the Temple of Zeus at Olympia, and he therefore similarly reconstructs the Troy painting in the Lesche from left to right.

40. Robert, *Iliupersis*, 71–72; C. Praschniker, *Parthenonstudien*, Augsburg and Vienna, 1928, 115–116; C. Dugas, "A la lesché des cnidiens," *REG*, 51, 1938, 51; S. Ras, "Dans quel sens faut-il regarder les métopes nord du Parthénon?" *REG*, 57, 1944, 101; Wiencke, "An Epic Theme," 289; Moret, *Ilioupersis*, 59; Robertson, *History of Greek Art*, 251; Kron, *Phylenheroen*, 155; and Ridgway, *Fifth Century Styles*, 19, n. 11.

41. Following prevailing opinion, Robertson, "Conjectures," 8–9, had earlier argued that the wall essentially bisected the painting. Nevertheless, Stansbury-O'Donnell, "Polygnotos's *Iliupersis*," 207 and 210–211, has made a better case for distributing the scene of Aias and the other Greek kings along most of the short or east wall of the Lesche, with the wall of Troy serving as a transitional device to the left in the corner between this central panel and the section to the left depicting Helen and the Trojan captives (fig. 11d in this volume).

42. Robertson, "Conjectures," 11.

43. F. Seeliger, "Die Überlieferung der griechischer Heldensage bei Stesichoros," *Jahresbericht der Fürsten- und Landesschule S. Afra in Meissen*, 1886, 30; P. Corssen, "Die Sendung der Lokrerinnen," *Revue Socrates*, May 1913, 237; J. G. Frazer, *Pausanias' Description of Greece*, London, 1898, vol. 5, 367; Davreux, *Cassandre*, 210; J. J. Pollitt, *The Ancient View of Greek Art: Criticism, History, and Terminology*, New Haven and London, 1974, 188; and idem, "The *Ethos* of Polygnotos and Aristeides," in L. Bonfante and H. von Heintze (eds.), *In*

Memoriam Otto J. Brendel: Essays in Archaeology and the Humanities, Mainz, 1976, 52.

44. Robert, *Iliupersis*, 63, and Robertson, "Conjectures," 11–12; cf. Stansbury-O'Donnell, "Polygnotos's *Iliupersis*," 212.

45. E. D. Francis and M. Vickers, "The Oenoe Painting in the Stoa Poikile and Herodotus' Account of Marathon," *ABSA*, 80, 1985, 112, n. 100, have suggested that the scene of Aias in the Lesche and the related depiction in the Troy painting of the Stoa alluded to the judgment of the Hellenic League concerning the fitness of the Spartan general Pausanias as commander. However, the anti-Spartan sentiment implicit in this interpretation does not at all accord with the pro-Spartan leanings of Kimon and his supporters (cf. Plutarch, *Kimon*, XVI–XVII, and *Perikles*, XXIX, 2). It is also likelier that the Troy paintings referred to Kimon's more recent victories than to the events of 480/79.

46. Dares the Phrygian, 40–42; Dictys Cretensis, IV, 22ff. For a more recent assertion of Antenor's turpitude, see Robertson, *History of Greek Art*, 250 and n. 164.

47. The *Iliad*, III, 205–219, already refers to this embassy and to the hospitality offered by Antenor (cf. Pausanias, X, 26, 7–8). It is mentioned again in Quintus of Smyrna, *Posthomerica*, XIII, 291–299, and Tryphiodoros, *Taking of Ilion*, 656–659, where Antenor is similarly referred to as "godlike" and "hospitable" (cf. Quintus, XIV, 321).

48. Quintus, *Posthomerica*, XIII, 291–299:

Ἄλλοι δ' αὖτ' ἄλλοις ἐν δώμασι θυμὸν ἔλειπον ἀνέρες· ἐν δ' ἄρα τοῖσι βοὴ
πολύδακρυς ὀρώρει· ἀλλ' οὐκ ἐν μεγάροις Ἀντήνορος, οὕνεκ' ἄρ' αὐτοῦ
Ἀργεῖοι μνήσαντο φιλοξενίης ἐρατεινῆς, ὡς ξείνισσε πάροιθε κατὰ πτόλιν ἠδ'
ἐσάωσεν ἰσόθεον Μενέλαον ὁμῶς Ὀδυσῆι μολόντα· τῷ δ' ἐπίηρα φέροντες
Ἀχαιῶν φέρτατοι υἷες αὐτὸν μὲν ζώοντα λίπον καὶ κτῆσιν ἔασαν καὶ Θέμιν
ἀζόμενοι πανδερκέα καὶ φίλον ἄνδρα.

49. Lykophron, *Alexandra*, 494–503, refers obliquely to this story, but it is recounted more fully in Parthenios, *Narrationes Amatoriae*, XVI, 1–4. See *Lycòphron's Alexandra* (trans. C. von Holzinger), Leipzig, 1895, 246–247 (commentary). Cf. Tzetzes, *On Lykophron*, 495. Plutarch, *Theseus*, XXXIV, gives a variant version in which Laodike bore the child of Demophon rather than Akamas. Also see Robert, *Iliupersis*, 66 and 73–74; and H. L. Jeffery, "*The Battle of Oinoe* in the Stoa Poikile," *ABSA*, 60, 1965, 45, n. 18.

50. In Tryphiodoros, *Taking of Ilion*, 660–663; Apollodoros, *Epitome*, V, 23; and Quintus of Smyrna, *Posthomerica*, XIII, 544–547, Laodike is literally swallowed by the earth so that she can avoid captivity.

51. Robertson, *History of Greek Art*, 251–252, and Pollitt, "The *Ethos* of Polygnotos and Aristeides," 52.

52. Written sources tell us that after the hostilities were over, the assembled Greeks decided to have Astyanax thrown from the ramparts of Troy, and Polyxena sacrificed over Achilleus' tomb: Euripides, *Trojan Women*, 709–789 and 1123–

1155; Apollodoros, *Epitome*, V, 23; Dictys Cretensis, V, 13; Dares the Phrygian, 43; Tryphiodoros, *Taking of Ilion*, 644–646 and 686–687; Quintus of Smyrna, *Posthomerica*, XIII, 251–257, and XIV, 235–328; and Arktinos of Miletos, *Iliupersis*, quoted in Proklos, *Chrestomathy*, B, V. On the disparity between the literary accounts and the death of Astyanax in Attic vase painting, see Dugas, "Tradition littéraire," 53–59.

53. For example, Pausanias recognizes only Deinome as one of the captive women in the literary tradition; he assumes that Polygnotos made up the others, for whom he cannot account (X, 26, 1–2). He knows of Priam's daughter Laodike, but not in the established catalogue of the captive Trojan women (X, 26, 7). Nor has he heard of the Trojan Elasos, slain by Neoptolemos (X, 26, 4). And he is completely perplexed by the corpses of Eresos and Laomedon (X, 27, 3).

54. On the punishment of Sisyphos, Tantalos, and Tityos, also see the Homeric account of the Underworld in the *Odyssey*, XI, 576–600.

55. On Marsyas and Thamyris, see Apollodoros, *Library*, I, 4, 2, and III, 3, 3; Diodorus Siculus, III, 59, 2; and Hyginus, *Fabulae*, CLXV. Pausanias himself recounts Meleager's punishment by Apollo as he describes him in the painting (X, 31, 3), thus supporting the interpretation of his presence offered here. For Aktaion, see Apollodoros, *Library*, III, 3, 4, and Hyginus, *Fabulae*, CLXXX–CLXXXI. On Kallisto, see Apollodoros, *Library*, III, 8, 2, and Ovid, *Metamorphoses*, II, 401–531. On Maira, see Pherekydes, quoted by a scholiast on *Odyssey*, 325; Eustathios on Homer, 1688, 62; and Hesychios, S. V. Maira. W. H. Roscher, *Ausfürliches Lexikon der griechischen und römischen Mythologie*, Hildesheim and New York, 1978, II, 2, 2285, emphasizes Maira's position in the painting as a deliberate counterpart to Aktaion and his fate.

56. On Chloris and Niobe, see Hyginus, *Fabulae*, IX–X; Apollodoros, *Library*, III, 5, 6; and Pausanias, II, 21, 9–10, and V, 16, 4. On Iphimedeia and her sons, see *Odyssey*, XI, 305–320, and Hyginus, *Fabulae*, XXVIII.

57. Robert, *Nekyia*, 71–72.

58. Simon, "Polygnotan Painting," 48 and n. 25; Robertson, *History of Greek Art*, 270. On the opposition of Marsyas and Apollo more generally in Classical art, see W. Schindler, *Mythos und Wirklichkeit in der Antike*, Berlin, 1988, 118–127, who unfortunately does not discuss the Lesche painting. For Orpheus' close connection to Apollo, see "Orpheus," in W. Kroll (ed.), *Paulys Real-Encyclopädie der classischen Altertumswissenschaft*, vol. 18, 1, Stuttgart, 1939, 1300–1302.

59. *RVA*, 430–431, nos. 81–82, 523, no. 225; 533, no. 284; 733, no. 46; 763, no. 293; and 863, no. 17. Also see H. R. W. Smith, *Funerary Symbolism in Apulian Vase-Painting*, Berkeley, Los Angeles, and London, 1976, figs. 11, 17, 18, and pl. 1a; M. Pensa, *Rappresentazioni dell' oltretomba nella ceramica apula*, Studia archaeologica, 18, Rome, 1977, 23–28, figs. 1, 5, 7–8, pl. I, IVb, V, and XII; W. K. Guthrie, *Orpheus and Greek Religion: A Study of the Orphic Movement*, London, 1935, 187–191 and figs. 16–17; and J. E. Harrison, *Prolegomena to the Study of Greek Religion*, Cambridge, 1922, 599–613 with figs. 161–162.

60. On Orphic eschatology and mystic catharsis, see Harrison, *Prolegomena*, 470 and 478–623; Guthrie, *Orpheus*, 148–191 and 197; F. Graf, *Eleusis und die*

orphische Dichtung Athens in vorhellenistischer Zeit, Religionsgeschichtliche Versuche und Vorarbeiten, 32, Berlin and New York, 1974, 79–126; M. L. West, *The Orphic Poems,* Oxford, 1983, 21–26, 98–101, 107, and 110 with n. 82; and W. Burkert, *Ancient Mystery Cults,* Cambridge, Mass., and London, 1987, 23, 87–88, and 96–98.

61. On Apollo's intimate association with the maxim "know thyself," see Plato, *Charmides,* 164C–165A, and Plutarch, *The E at Delphi,* 17 (392A).

62. B. Schweitzer, "Der Paris des Polygnot," *Hermes,* 71, 1936, 288–294. Schweitzer suggested further that the figure in Phrygian costume dancing for a flute-playing satyr on a bell-krater by the Painter of the Berlin Dinos was a reflection of the Paris in the Nekyia painting: ibid., Beilage I. Stansbury-O'Donnell, "Polyg-notos's *Nekyia,*" 228, has questioned Schweitzer's argument on the grounds that dancing would have been inappropriate to the somber mood of the painting.

63. But see Stansbury-O'Donnell, "Polygnotos's *Nekyia,*" 223 and 227, n. 54, who interprets the presence of Antilochos as an intentional contrast to the character of Agamemnon and discounts the possibility of any larger contrast between Greeks and Trojans.

64. M. Robertson, "The Hero with Two Swords," *JWCI,* 15, 1952, 99–100, and Stansbury-O'Donnell, "Polygnotos's *Nekyia,*" 222–223.

65. For Theseus' expedition to the Underworld, see Diodorus Siculus, IV, 63; Apollodoros, *Epitome,* I, 24; and Hyginus, *Fabulae,* LXXIX.

66. Simon, "Polygnotan Painting," 45. The fact that Odysseus also tells of seeing the phantom of Herakles' mortal body indicates further that he was past the time of Herakles' exploits, at a point when Theseus should already have died.

67. Here one may also compare the evidence of a fourth-century Apulian Under-world scene with Orpheus, Munich 3297, *RVA,* 533, no. 282, pl. 194, which also includes Theseus and Peirithoös seated by Dike, who is wielding a sword. Only one of the figures is seated; the other stands. Consequently, Harrison, *Prolegomena,* 611, argues that Dike is content to punish only Peirithoös, while Theseus will be allowed to leave, and Harrison in this case too sees the positive depiction of Theseus as the result of Attic influence. Although the figures have no inscriptions, the identification of Dike and Peirithoös is verified by a related fragment at Karlsruhe, B 1549, which is inscribed: G. Hafner, *Corpus Vasorum Antiquorum,* Karlsruhe, Badisches Landesmuseum, bd. 2 (Deutschland, bd. 8), Munich, 1952, 30–31, pl. 64, no. 7. Also see H. A. Shapiro, "Dike," in *LIMC,* III, 1, 1986, 389–390, nos. 5–8; Pensa, Rappresentazioni dell'oltretomba nella ceramica apula, 23, 25, fig. 5, and pl. XIVa; and K. Schefold, *Die Göttersage in der klassischen und hellenistischen Kunst,* Munich, 1981, 149–150, fig. 200.

68. On the positive aspect of Theseus and Peirithoös here, also see R. B. Kebric, *The Paintings in the Cnidian Lesche at Delphi and Their Historical Context,* Mnemosyne Supplementum, Leiden, 1983, 21, who stresses their adventure in the Underworld as a testament to Theseus' unflinching loyalty to his friend.

69. On the death of Aias Oileus, see the *Odyssey,* IV, 499; Apollodoros, *Epitome,* VI, 6; and Proklos, *Chrestomathy,* on the *Nostoi.* Euripides, *Trojan Women,* 77–97, portrays the stormy vengeance of Athena and Poseidon as directed more generally at the Greeks who participated in the sack of Troy.

70. On the degeneration of Aias' character after his loss to Odysseus, see Sophokles' *Aias;* Apollodoros, *Epitome,* V, 6–7; and, for an extended discussion, W. B. Tyrrell and F. S. Brown, *Athenian Myths: Words in Action,* New York and Oxford, 1991, 65–72 and 89–98.

71. The sources for this plot are Apollodoros, *Epitome,* III, 7–8; Hyginus, *Fabulae,* CV; scholiast on Euripides' *Orestes,* 432; Philostratos, *Heroica,* X, 2ff.; and Tzetzes, *On Lykophron,* 384ff. and 1097.

72. In Dictys Cretensis, II, 15, Odysseus and Diomedes throw him down a well and stone him.

73. On the potential of Greek artists to manipulate this and other myths freely, see M. Simpson, *Gods and Heroes of the Greeks: The Library of Apollodorus,* Amherst, 1976, 251–252 (commentary). In Quintus of Smyrna, *Posthomerica,* V, 197–199, it is Telamonian Aias who recounts the charge of connivance against Palamedes in order to discredit Odysseus during the contest for Achilleus' armor. The tale of Odysseus' treachery may well have originated as invective of this sort.

74. However, see Stansbury-O'Donnell, "Polygnotos's *Nekyia,* " 226–227, who does not see the contrast between the Greeks and Odysseus as extending to Palamedes.

75. For Pelias' crimes, see Apollodoros, *Library,* I, 9, 27, and Diodorus Siculus, IV, 51, 1–53, 1. On Laomedon and his broken promises, see Apollodoros, *Library,* II, 5, 9, and II, 6, 4, and Stansbury-O'Donnell, "Polygnotos's *Nekyia,* " 213.

76. On the mystic connections of Orpheus, see Harrison, *Prolegomena,* 469–470 and 478–571; Guthrie, *Orpheus,* 194–215, esp. 201ff.; Graf, *Eleusis,* 22–39; West, *The Orphic Poems,* 15–18 and 24–27; and Burkert, *Ancient Mystery Cults,* 5, 18, 46, 71, and 89.

77. In addition to Pausanias, Plato, *Gorgias,* 493B, also identifies water-carrying with the uninitiated. For these characters in the Nekyia and their background in Greek art and belief, see A. Kossatz-Deissmann, "Amyetoi," in *LIMC,* I, 1, Munich, 1981, 736–738, esp. 737, nos. 1–4; Graf, *Eleusis,* 107–110; Harrison, *Prolegomena,* 613–623, esp. 618; and E. C. Keuls, *The Water Carriers in Hades: A Study in Catharsis Through Toil in Classical Antiquity,* Amsterdam, 1974, 39–41. Keuls disputes Robert's early attempt to reconstruct all these figures as a single group to whom the inscription would apply equally. Harrison explains the eventual conflation of such generic figures with the Danaides in Apulian red figure Underworld scenes, although there is no evidence of this in the Polygnotan painting; cf. Kossatz-Deissmann, *LIMC,* I, 1, 738, and E. Keuls, "Danaides," in *LIMC,* III, 1, Munich, 1986, 337–341, esp. 338–339, nos. 7–19.

78. On Oknos see Keuls, *Water Carriers,* 35–38; Shapiro, *Personifications of Abstract Concepts in Greek Art,* 155–158; O. Rossback, "Dämonen der Unterwelt," *Rheinisches Museum für Philologie,* N.S., 48, 1893, 596–601; and Graf, *Eleusis,* 110–112, 118–120, and 188–194. On the vase with Oknos, his donkey, and the water carriers (Palermo 996), see Harrison, *Prolegomena,* 617, fig. 165; Keuls, *Water Carriers,* 35–38; Graf, *Eleusis,* 188–190; and Kossatz-Deissmann, *LIMC,* I, 1, 737, no. 3.

79. For the vase, Naples, Private Collection 369, see *RVA,* 922–923, no. 87, and M. Robertson, "Eurynomos," *LIMC,* IV, 1, Munich, 1988, 109, no. 2.

80. R. Merkelbach, *Roman und Mysterium in der Antike,* Munich, 1962, 44, suggested that Oknos was condemned to pointless labor in the Underworld because he had been "tardy" in seeking initiation to the mysteries; cf. Graf, *Eleusis,* 192 and n. 31. There is no direct evidence for this in surviving literary sources, although these authors may well be correct in stressing Oknos' connection to traditions associated with the mysteries. Graf (ibid. and 118–119) also sees Oknos more generally as a figure of punishment, a pendant to the water carriers, Sisyphos, and Tantalos. But in this case one must explain why Polygnotos put Oknos and these others at the opposite extremes of the painting.

81. Robertson, *History of Greek Art,* 269–270. The belief that the initiate could achieve eternal bliss in the afterlife was a tenet of mystery religions, and it has recently been confirmed by the discovery of an inscribed gold tablet from Hipponion; see Burkert, *Ancient Mystery Cults,* 5 and 21–24, and for the ills suffered in death by the uninitiated, 21 and 24. On the role of Orphic teaching here, see Graf, *Eleusis,* 94–126.

82. Robert, *Iliupersis,* 73–74; Jeffery, *"Battle of Oinoe,"* 45, n. 17, with the supporting comments of Robertson; and Hölscher, *Griechische Historienbilder,* 70. Robert considered the painting in the Stoa as the earlier work, which Polygnotos would then have elaborated at Delphi (cf. Robertson, *History of Greek Art,* 242–244). The evidence for the Lesche as a building made about 469–465, and the Stoa as a building of the late 460s or early 450s, indicates that the reverse was probably the case. For historical arguments in favor of dating the Delphic monument to the early 460s, see Kebric, *Cnidian Lesche,* 9–13, and n. 128 to Chapter 2, above; for the date of the Stoa, see Jeffery, *"Battle of Oinoe,"* 41; L. Shoe, "The Stoa Poikile in the Athenian Agora," *AJA,* 68, 1964, 200; and n. 84 to Chapter 2, above.

83. Robert, *Iliupersis,* 73.

84. The *Iliupersis* of Arktinos of Miletos quoted in Proklos, *Chrestomathy,* B, V, describes how Aias first took refuge at the altar of Athena to avoid being stoned for his act; cf. Apollodorus, *Epitome,* V, 23.

85. See n. 102 to Chapter 2, above.

86. Robert, *Iliupersis,* 73–74.

87. Hölscher, *Griechische Historienbilder,* 70–71, has doubted the reliability of Plutarch's testimony here and its implications for the interpretation of the painting. But in contrast see W. R. Connor, "Theseus in Classical Athens," in A. Ward (ed.), *The Quest for Theseus,* New York, 1970, 163, and Kebric, *Cnidian Lesche,* 18.

88. For the most thorough and recent discussion of these qualities in Early Classical art and especially in the work of Polygnotos, see J. J. Pollitt, *Art and Experience in Classical Greece,* Cambridge, 1972, 43–54; idem, *Ancient View,* 184–189; and idem, "The *Ethos* of Polygnotos and Aristeides," passim.

Chapter 4

1. T. L. Shear, Jr., *Studies in the Early Projects of the Periklean Building Program,* Ph.D. Diss., Princeton, 1966, chap. 1: "Monuments to Impiety," 14–65, has discussed the nature of these changes in detail, particularly the attitude of the Greeks toward rebuilding the shrines destroyed by the Persian invaders, and the related problem of the oath sworn after the Battle of Plataia banning any such restoration. On the oath itself and its authenticity, see R. Meiggs, *The Athenian Empire,* Oxford, 1972, 504–507; on its relevance to the building program, idem, "The Political Implications of the Parthenon," in *Parthenos and Parthenon,* Greece and Rome, Suppl. to vol. 10, 1963, 39; and D. Kagan, *Pericles of Athens and the Birth of Democracy,* New York, Oxford, Singapore, and Sidney, 1991, 153.

2. On these temples and their date, see W. B. Dinsmoor, "The Temple of Ares at Athens," *Hesperia,* 9, 1940, 44–47; idem, "Observations on the Hephaisteion," *Hesperia,* Suppl. 5, 1941, 153–155; idem, *The Architecture of Ancient Greece,* London, 1950, 179–183; and most recently, M. M. Miles, "A Reconstruction of the Temple of Nemesis at Rhamnous," *Hesperia,* 58, 2, 1989, 131–249, esp. 227, where the building is redated to the period just before or the decade following the death of Perikles. On these temples as rebuildings of shrines destroyed by the Persians, see J. S. Boersma, *Athenian Building Policy from 561/0–405/4 B.C.,* Scripta Archaeologica Groningana, 4, Groningen, 1970, 36–37, 77–78, and 80–81. On the difficulty of connecting them with Perikles, see ibid., 80–81.

The Hephaisteion near the Athenian Agora may also have been part of this program. Boersma, ibid., 58–60, and in an earlier study, "On the Political Background of the Hephaisteion," *BABesch,* 39, 1964, 101–106, preferred to see this temple as Kimon's brainchild, but it can only have been begun shortly before his death or, more likely, just after it, c. 449; cf. J. Neils, *The Youthful Deeds of Theseus,* Archaeologia, 76, Rome, 1987, 127 and 151. Others, like C. H. Morgan, "The Sculptures of the Hephaisteion III," *Hesperia,* 32, 1963; 104, and Shear, *Periklean Building Program,* 138, considered the Hephaisteion an integral part of the Periklean campaign of public works, although, as in the case of the Sounion and Rhamnous temples, this cannot be documented. Nor is it certain that the Hephaisteion replaced an earlier shrine destroyed in the Persian sack, but this is very possible. For the archaeological evidence, see Dinsmoor, *Hesperia,* Suppl. 5, 1941, 126–127; Morgan, *Hesperia,* 32, 1963, 104, and Boersma, *Athenian Building Policy,* 59.

More recently, T. L. Shear, "The Demolished Temple at Eleusis," in *Studies in Ancient Athenian Architecture, Sculpture, and Topography,* Hesperia, Suppl. 20, 1982, 126–140, has reiterated his earlier view that the immediately pre-Periklean phase of the sanctuary at Eleusis was destroyed by the Persians in 480. If so, then the rebuilding of the site under Perikles would have been yet another monument to the defeat of the Asiatic invader; cf. Shear, *Periklean Building Program,* 147a–150.

3. B. S. Ridgway, *Fifth Century Styles in Greek Sculpture*, Princeton, N.J., 1981, 18–19, and E. Berger, *Der Parthenon in Basel. Dokumentation zu den Metopen*, Mainz, 1986, 13 and 78–79.

4. C. J. Herington, *Athena Parthenos and Athena Polias. A Study in the Religion of Periclean Athens*, Manchester, 1955, 49; Shear, *Periklean Building Program*, 89 and 313–314; W. Gauer, *Weihgeschenke aus den Perserkriegen*, Istanbuler Mitteilungen, Beiheft, 2, Tübingen, 1968, 19 and 128; idem, "Das Athener-Schatzhaus und die marathonischen Akrothinia in Delphi," in F. Krinzinger, B. Otto, and E. Walde-Psenner (eds.), *Forschungen und Funde: Festschrift Bernard Neutsch*, Innsbruck, 1980, 133; idem, "Die Gruppe der ephesischen Amazonen, ein Denkmal des Perserfriedens," in H. A. Cahn and E. Simon (eds.), *Tainia: Roland Hampe zum 70. Geburtstag*, Mainz, 1980, 221–222; J. J. Pollitt, *Art and Experience in Classical Greece*, Cambridge, 1972, 65–66; E. Thomas, *Mythos und Geschichte: Untersuchungen zum historischen Gehalt griechischer Mythendarstellungen*, Cologne, 1976, 27 and 40; and B. Fehr, "Zu religionspolitischen Funktion der Athena Parthenos im Rahmen des delisch-attischen Seebundes—Teil III," *Hephaistos*, 3, 1981, 63, have all laid special emphasis on the Parthenon and the Periklean rebuilding of the entire Akropolis as a monument to the victorious struggle with Persia. For the dating of the pre-Periklean buildings to the 480s, immediately preceding the Persian sack, see O. Dörpfeld, "Die Zeit des älteren Parthenon," *AM*, 27, 1902, 379–416; W. B. Dinsmoor, "The Date of the Older Parthenon," *AJA*, 38, 1934, 448; idem, "The Correlation of Greek Archaeology with History," in *Studies in the History of Culture: The Disciplines of the Humanities*, Menasha, Wis., 1942, 205–207; idem, *Architecture of Ancient Greece*, 198, n. 2; W. H. Plommer, "The Archaic Acropolis: Some Problems," *JHS*, 80, 1960, 134–140; Shear, *Periklean Building Program*, 33–36; Gauer, *Weihgeschenke*, 128 and n. 607; Boersma, *Athenian Building Policy*, 38–39 and 176; W. B. Dinsmoor, Jr., *The Propylaia to the Athenian Akropolis*, vol. 1: *The Predecessors*, Princeton, N.J., 1980, with a critical evaluation of earlier scholarship; H. Drerup, "Parthenon und Vorparthenon: Zum Stand der Kontroverse," *Antike Kunst*, 24, 1981, 21–38; T. Seki, "The Relationship Between the 'Older' and the 'Periclean' Parthenon," in E. Berger (ed.), *Parthenon-Kongress Basel: Referate und Berichte 4. bis 8. April 1982*, Mainz, 1984, 77; and J. M. Hurwit, *The Art and Culture of Early Greece 1100–480 B.C.*, Ithaca and London, 1985, 327–332. See especially Dinsmoor, Jr., *Propylaia*, 52–54 and 63–64, and Drerup, *Antike Kunst*, 24, 26–36, on the implausibility of the post-Persian or Kimonian date sometimes adduced for the Older Parthenon and Propylaia.

5. Pausanias, I, 27, 1; Demosthenes, XXIV, 129; cf. Gauer, *Weihgeschenke*, 42–44. On this theme in general, see D. Burr Thompson, "Persian Spoils in Athens," in S. Weinberg (ed.), *The Aegean and the Near East: Studies Presented to Hetty Goldman*, Locust Valley, N.Y., 1956, 281–291.

6. Demosthenes, XXII, 13:

οἱ τὰ προπύλαια καὶ τὸν παρθενῶν· οἰκοδομήσαντες ἐκεῖνοι καὶ τἄλλ᾽ ἀπὸ τῶν βαρβάρων ἱερὰ κοσμήσαντες, ἐφ᾽ οἷς φιλοτιμούμεθα πάντες εἰκότως.

Herington, *Athena Parthenos*, 2–3 and 49, first drew attention to this passage as evidence of the votive nature of the Parthenon; cf. Shear, *Periklean Building Program*, 89; Gauer, *Weihgeschenke*, 128; and idem, "Ephesischen Amazonen," 221–222. On Demosthenes' misconceptions about the buildings' date and patronage, see B. D. Meritt and H. T. Wade-Gery, "Athenian Resources in 449 and 431 B.C.," *Hesperia*, 26, 1957, 167 and 182, and Shear, *Periklean Building Program*, 101. The ancient commentator on this passage of Demosthenes (preserved in the *Anonymous Argentinensis*, a papyrus of the late first or early second century A.D.) recognized the orator's mistake and corrected it by quoting a lost Periklean decree, the so-called Reserve or Papyrus Decree of 450/49. The document and its implications are carefully analyzed by Meritt and Wade-Gery in *Hesperia*, 26, 1957, and in their subsequent study, "The Dating of Documents to the Mid-Fifth Century—II," *JHS*, 83, 1963, 105–109. Also see Meiggs, *Athenian Empire*, 515–518, who with some hesitation generally accepts their edition and restoration of the *Argentinensis*.

Dinsmoor, *AJA*, 38, 1934, 448, tried instead to justify Demosthenes' statement by arguing that the orator was referring to the precursors of the Periklean Parthenon and Propylaia—that is, those which were begun in the 480s, and which he considered a thank-offering for Marathon. But Demosthenes' statement connects the buildings with the victors of Salamis, not Marathon; and the association with Salamis would accord better with the dating of the Older Parthenon and Propylaia in the 470s and 460s, which, however, the studies of Dinsmoor and others have refuted. And in any case, Demosthenes' later reference to the Propylaia and the Parthenon in XXII, 76, shows that he was speaking of the existing buildings, whose real date and subsidization from the funds of the Delian League he either did not know or chose to ignore. It is possible that by Demosthenes' time the traditions connecting the Older Parthenon with Persian spoils had gradually become associated with the Periklean rebuilding as well, or that the accumulated funds of the Delian League included spoils from Kimon's campaigns against the Persians, as Meiggs, *Athenian Empire*, 66–67, has suggested. But none of this would explain the orator's attribution of the existing monuments specifically to the victors of Salamis.

7. H. T. Wade-Gery, "Thucydides the Son of Melesias, a Study of Periklean Policy," *JHS*, 52, 1932, 205–215, presents an excellent analysis of the oligarchic opposition to the party and policies of Perikles. Also see F. J. Frost, "Pericles, Thucydides, son of Melesias, and Athenian Politics before the War," *Historia*, 13, 1964, 385–399; H. D. Meyer, "Thukydides Melesiou und die oligarchische Opposition gegen Perikles," *Historia*, 16, 1967, 141–154; S. Perlman, "Panhellenism, the Polis, and Imperialism," *Historia*, 25, 1976, 16–17; and Meiggs, *Athenian Empire*, 156–157.

8. See Meiggs, *Athenian Empire*, 132–140, for his own views and a summary of the earlier scholarship arguing against the passage. However, the existence of the Peace of Kallias itself has also been hotly contested. For a critical discussion of this controversy, see ibid., 129–151 and 487–495, and, more recently, A. P. Bosworth, "Plutarch, Callisthenes and the Peace of Callias," *JHS*, 110, 1990, 1–13, and E. Badian, "The Peace of Callias," *JHS*, 107, 1987, 1–39, who upholds the authenticity of the Peace and a date of about 449/8.

9. Badian, "Peace of Callias," 19. For a more positive assessment of Plutarch, *Perikles*, XII, 1–4, along these lines, also see H. T. Wade-Gery, "The Question of the Tribute in 449/448 B.C.," *Hesperia*, 14, 1945, 212–229.

10. H. Nesselhauf, *Untersuchungen zur Geschichte der delisch-attischen Symmachie*, Klio, Beiheft, N.S., 17, Leipzig, 1933, 29, has emphasized the ongoing threat of Persia to the Greek cities of Asia Minor as a factor in preserving the League even after the treaty. Also see D. M. Lewis, *Sparta and Persia: Lectures Delivered at the University of Cincinnati Autumn 1976 in Memory of Donald W. Bradeen*, Leiden, 1977, 59–60, and Kagan, *Pericles of Athens*, 132–133.

11. Plutarch's phraseology προπολεμοῦντες αὐτῶν "protecting them (the allies)," and τοὺς βαρβάρους ἀνείργοντες, "keeping off the barbarians (Persians)," denotes preventive measures or guardianship rather than hostile or aggressive operations. There may even be some rhetorical exaggeration here in Perikles' description of Athens' responsibilities toward the allies, as an added justification for the collection of tribute. Wade-Gery, "The Question of the Tribute," 224, n. 30, also indicated that πρὸς τὸν πόλεμον could easily mean "for general war purposes," in the sense of a standing defense fund, rather than a reference to an actual war against Persia. Badian, "Peace of Callias," 19, has further emphasized that the participial phrase προπολεμοῦντες often signified the past tense in common usage, and thus it could refer to earlier hostilities before the Peace was in force.

12. The cessation of open hostilities must have prompted demands from the allies to stop the war levy. The contributions would then have lapsed, but only temporarily, since Athens would have insisted on maintaining its military strength as a precaution against the Persians. See Nesselhauf, *Delisch-attischen Symmachie*, 31–32. On the Kleinias Decree see Wade-Gery, "The Question of the Tribute," 226–228; on the tribute enforcement see Meritt and Wade-Gery, "Athenian Resources," 197, and Meiggs, *Athenian Empire*, 157–159 and 165–166.

13. On the debate in Plutarch and the Reserve or Papyrus Decree, see Wade-Gery, "The Question of the Tribute," 224–225; Meritt and Wade-Gery, "Athenian Resources," 164–188 and 197. Despite his doubts about Plutarch, *Perikles*, XII, Meiggs, *Athenian Empire*, 518, concedes that the Papyrus Decree adds substance to this account of the debate over the Akropolis project. The authenticity of the Congress Decree has also been questioned: R. Seager, "The Congress Decree: Some Doubts and a Hypothesis," *Historia*, 18, 1969, 129–141, and A. B. Bosworth, "The Congress Decree: Another Hypothesis," *Historia*, 20, 1971, 600–616. But see Perlman, "Panhellenism," 8–12 and Meiggs, *Athenian Empire*, 512–515, for counterarguments in support of the decree. Nesselhauf, *Delisch-attischen Symmachie*, 31–33, has stressed the relevance of the Congress Decree to the symbolic meaning of the building program. Also see Kagan, *Pericles of Athens*, 104–106.

14. Shear, *Periklean Building Program*, 2–4, emphasizes the compromises involved in the Peace. But Athens gave up only what she did not have—the dream of conquering Cyprus, Egypt, or Asia. Seventy years later the orator Isokrates, *Panegyric* (IV), 120, still portrayed the Peace as a great achievement, as the terms imposed on Persia by Athens; cf. Lykourgos, *Leokrates*, 72–73. The Periklean regime will have made the most of the positive aspects; see Wade-Gery, *JHS*, 52,

1932, 212–213, and Kagan, *Pericles of Athens*, 102. According to one account of the terms of the Peace, Persian land and sea forces were not to go beyond the line from Sardis to the Chelidonian Rocks; in another, they were restricted to the limits of Phaselis and the River Halys; see R. Sealey, "The Peace of Callias Once More," *Historia*, 3, 1954–1955, 329–331, and idem, "Theopompos and Athenian Lies," *JHS*, 80, 1960, 194–195. In the latter case especially, the treaty would have appeared as a major triumph for Athens and her allies in the Anatolian and Aegean sphere.

15. An impressive catalogue of scholars has suggested this as an important aspect of the metopes: R. Demangel, *La frise ionique*, Paris, 1932, 505–510; F. Fischer, *Heldensage und Politik in der klassischen Zeit der Griechen*, Tübingen, 1957 (Diss. 1937), 17–18; C. Dugas, "L'Évolution de légende de Thésée," *REG*, 56, 1943, 22; H. Schrader, "Das Zeusbild des Pheidias in Olympia," *JDAI*, 56, 1941, 3; Herington, *Athena Parthenos*, 59–62; Shear, *Periklean Building Program*, 314–316; E. B. Harrison, "Athena and Athens in the East Pediment of the Parthenon," *AJA*, 71, 1967, 27; Gauer, *Weihgeschenke*, 19; idem, "Athener-Schatzhaus," 133; Boersma, *Athenian Building Policy*, 68; Pollitt, *Art and Experience*, 80–82; T. Hölscher, *Griechische Historienbilder des 5. und 4. Jahrhunderts vor Chr.*, Würzburg, 1973, 72–73; R. Ross Holloway, *A View of Greek Art*, Providence, R.I., 1973, 123–124 and 132; E. Simon, "Versuch einer Deutung der Südmetopen des Parthenon," *JDAI*, 90, 1975, 118; idem, "Der Goldschatz von Panagjuriste—eine Schopfung der Alexanderzeit," *Antike Kunst*, 3, 1960, 20; Thomas, *Mythos und Geschichte*, 27, 40–42, 53, and 65–66; J. Boardman, "The Parthenon Frieze—Another View," in U. Höckmann and A. Krug (eds.), *Festschrift für Frank Brommer*, Mainz, 1977, 39; H. Knell, *Perikleische Baukunst*, Darmstadt, 1979, 29–33; E. D. Francis, "Greeks and Persians: The Art of Hazard and Triumph," in D. Schmandt-Besserat (ed.), *Ancient Persia, The Art of an Empire*, Malibu, Calif., 1980, 83–84; B. Wesenberg, "Perser oder Amazonen? Zu den Westmetopen des Parthenon," *AA*, 1983, 206–208; and, most recently, J. Boardman, *Greek Sculpture: The Classical Period*, London, 1985, 171–172; S. Woodford, *An Introduction to Greek Art*, Ithaca, N.Y., 1986, 112; and H. Knell, *Mythos und Polis. Bildprogramme griechischer Bauskulptur*, Darmstadt, 1990, 124.

16. Plutarch, *Perikles*, XIII, 1–4, specifically identifies the sculptor Pheidias as manager and supervisor of the Periklean building projects, but Pheidias' precise role in the production of the Parthenon sculptures has stimulated controversy in the modern scholarship. F. Brommer, *Die Metopen des Parthenon, Katalog und Untersuchung*, Mainz, 1967, 178–181, would at least ascribe the basic decisions concerning the metopes' design and programmatic content to Pheidias' supervisory capacity, although he emphasizes that the sculptors probably had considerable freedom in executing his instructions. The references in the present study to Pheidias' role in the creation of the sculpture program are intended only in this sense.

17. The Olympeion at Akragas, erected about 480 B.C. after the victory over the Carthaginians, had already paired the Gigantomachy with the Iliupersis in the pedimental sculptures of the temple, possibly as a prefiguration of the recent victory over the Phoenicians of Carthage: Thomas, *Mythos und Geschichte*, 26 and 63–64; Ridgway, *Fifth Century Styles*, 33, n. 38. But the use of the Gigantomachy within a

larger program of this type is unprecedented in the Athenian sphere before the Periklean period. In addition to the Parthenon, this subject has traditionally been identified in the badly damaged remains of the frieze from the roughly contemporary Temple of Poseidon at Cape Sounion, along with the Centauromachy and the Labors of Theseus; see R. Herbig, "Untersuchungen am dorischen Peripteraltempel auf Kap Sounion," *AM*, 66, 1941, 96–103 and 111–114; A. Delivorrias, "Poseidon-tempel auf Kap Sunion: Neue Fragmente der Friesdekoration," *AM*, 84, 1969, 137–140; and Ridgway, *Fifth Century Styles*, 83–85. However, a new consideration of the Sounion frieze indicates that the Centauromachy was paired with the Kalydonian Boar Hunt rather than a Gigantomachy or Theseus' Labors; F. Felten and K. Hoffelner, "Die Relieffriese des Poseidontempels in Sunion," *AM*, 102, 1987, 169–184. Although they too are badly preserved, the identification of the east Parthenon metopes as a Gigantomachy has been assured since Praschniker's studies; see Brommer, *Metopen*, 198–209.

18. On the *peplos* see Euripides, *Hekabe*, 466–473; Plato, *Euthyphro*, 6B–C; E. Pfuhl, *De Atheniensium sacris*, Berlin, 1900, 11ff.; L. Deubner, *Attische Feste*, Berlin, 1932, 18–19; and Herington, *Athena Parthenos*, 60. For the pediments of the Old Athena temple, see H. Schrader et al., *Die archaischen Marmorbildwerke der Akropolis*, Frankfurt am Main, 1939, no. 631; H. Payne and G. Mackworth Young, *Archaic Marble Sculpture from the Acropolis*, 2nd ed., London, 1950, 52ff.; J. Boardman, *Greek Sculpture: The Archaic Period*, New York and Toronto, 1978, 155 and fig. 199; H. A. Shapiro, *Art and Cult Under the Tyrants in Athens*, Mainz, 1989, 12, 15, 38, and pl. 4d–e; and Knell, *Mythos und Polis*, 39–42, fig. 56–60.

19. Herington, *Athena Parthenos*, 60–62.

20. Preserved in Athenaeus, *Deipnosophists*, 462C; cf. H. Diels and W. Kranz, *Die Fragmente der Vorsokratiker*, vol. 1, Berlin, 1951, 127–128, no. 1, 13–24:

> οὐχ ὕβρις πίνειν δ' ὁπόσον κεν ἔχων ἀφίκοιο
> οἴκαδ' ἄνευ προπόλου, μὴ πάνυ γηραλέος.
> ἀνδρῶν δ' αἰνεῖν τοῦτον ὃς ἐσθλὰ πιὼν ἀναφαίνῃ
> ὡς οἱ μνημοσύνη, καί τόνος ἀμφ' ἀρετῆς.
> οὔτι μάχας διέπειν Τιτήνων οὐδέ Γιγάντων
> οὐδέ τι Κενταύρων, πλάσματα τῶν προτέρων,
> ἢ στάσιας σφεδανάς, τοῖς οὐδὲν χρηστὸν ἔνεστι,
> θεῶν δὲ προμηθείην αἰὲν ἔχειν ἀγαθόν.

On this poem and its significance, especially concerning the social and ethical value or propriety of depicting the Gigantomachy, see C. M. Bowra, "Xenophanes, Fragment 1," *Classical Philology*, 33, 1938, 353–367, and E. M. Sanford, "The Battle of the Gods and Giants," *Classical Philology*, 36, 1941, 52–57.

21. For the Megarian Treasury, see P. C. Bol, "Die Giebelskulpturen des Schatzhauses von Megara," *AM*, 89, 1974, 67, pl. 31, 2, and Beilage 1 on the probable identification of the mostly destroyed central figures *E* and *F* as Athena and Zeus. Cf. Boardman, *Greek Sculpture: The Archaic Period*, fig. 215. On the pediment of the Old Athena Temple on the Akropolis, see n. 18 above.

22. Boardman, "Herakles, Peisistratos and Sons," *RA*, 1972, 61–62.

23. Pollitt, *Art and Experience*, 12, has suggested that the Persians may well have appeared to the Greeks as a foreign "giant" symbolizing a primordial chaos that threatened their orderly and established existence. But in spite of such evidence, some scholars have tended to see the Gigantomachy on the Parthenon as a separate paradigm without any immediate relevance to the Persians. F. Vian, *La guerre des géants: le mythe avant l'époque hellénistique*, Paris, 1952, 288–289, has categorically denied that this theme acquired a new political significance following the Persian Wars, allowing no analogy between the Giants and Xerxes' troops. In following Vian, Gauer, *Weihgeschenke*, 19, n. 51, saw the Gigantomachy and even the Centauromachy as distinct from the mythic allusions to the Persian Wars in the north and west metopes. He argued for a less unified program, with only the north and west metopes prefiguring the Persians, while those on the East and South represent Olympian supremacy and the victory of civilized culture over barbarism in more general terms.

24. Aischylos, *Persians*, 347.

25. Athena also appears in the mythic scenes in the pediments of the Aphaia Temple at Aigina, in the Theseus metopes on the Athenian Treasury at Delphi, and the Herakles metopes on the Temple of Zeus at Olympia. For these examples and the Olympia west pediment, see n. 31 to Chapter 1, above.

26. Brommer, *Metopen*, 191–195, has suggested that the badly mutilated west metopes might actually have represented the Persians themselves rather than the Amazons, and thus they would have functioned as a sculptural equivalent or pendant to the Marathon painting. Only Knell, *Perikleische Baukunst*, 17 and 29–32, briefly accepted Brommer's thesis, but see his more recent work, *Mythos und Polis*, 101. Most scholars hold to the identification as an Amazonomachy; see Simon, "Südmetopen," 100–101, and 118; J. Boardman, "Herakles, Theseus, and Amazons," in D. Kurtz and B. Sparkes (eds.), *The Eye of Greece: Studies in the Art of Athens*, Cambridge, 1982, 18–21; Berger, *Metopen*, 99; and Wesenberg, *AA*, 1983, 203–208. The Amazonomachy also appeared as the subordinate decoration of the colossal Parthenos inside the temple, along with the Centauromachy and the Gigantomachy, which certainly repeated the themes of the south and east metopes. In and of itself, this parallelism strongly suggests that the Amazonomachy of the Parthenos also echoed the theme of the west metopes, although Brommer makes little of it. Moreover, the falling chitons with bare shoulders and crisscrossed breast cords still visible on west 14 (cf. Brommer, *Metopen*, pl. 33) are customary for Amazons rather than Persians. These features, as Wesenberg, *AA*, 1983, 204–207, has observed, constitute decisive evidence that the metopes only represented the Persians indirectly, in the mythic guise of the warrior women.

27. Simon, "Südmetopen," 100–101, and Berger, *Metopen*, 99, are among the more recent proponents of the west metopes as scenes of the Amazon invasion of Attika specifically, but C. Praschniker, *Parthenonstudien*, Augsburg and Vienna, 1928, passim, had already made this identification. E. B. Harrison's studies on the Parthenos shield, "The Composition of the Amazonomachy on the Shield of Athena Parthenos," *Hesperia*, 35, 1966, 131–133, and "The Motifs of the City-Siege on the

Shield of Athena Parthenos," *AJA,* 85, 1981, esp. 295 and 310, emphasize the Athenian defense of the Akropolis as a central theme of the representation; in the latter study she has revised her reconstruction to include the walls of the Akropolis itself. T. Hölscher and E. Simon, "Die Amazonenschlacht auf dem Schild der Athena Parthenos," *AM,* 91, 1976, 133–135, suggest the Pnyx or Mouseion hills as an alternative setting. Boardman, "Herakles, Theseus, and Amazons," 27, considers the shield an indisputable artistic testimony for the Attic Amazonomachy, while in the case of the metopes it is likely, but not proven.

28. W. B. Tyrrell, *Amazons: A Study in Athenian Mythmaking,* Baltimore and London, 1984, 14–19 and 114–116; W. B. Tyrrell and F. S. Brown, *Athenian Myths: Words in Action,* New York and Oxford, 1991, 195–197; K. R. Walters, "Rhetoric as Ritual: The Semiotics of the Attic Funeral Oration," *Floregium,* 2, 1980, 3. On this theme more generally, also see N. Loraux, "L'Autochthonie: une topique athénienne, le mythe dans l'espace civique," *Annales economies, sociétés, civilisations,* 34, 2, 1979, 3–26; idem, *Les enfants d'Athéna: idées athéniennes sur la citoyenneté et la division des sexes,* Paris, 1981, 7–73; idem, *The Invention of Athens: The Funeral Oration in the Classical City* (trans. A. Sheridan), Cambridge, Mass., and London, 1986, 148–152; R. Parker, "Myths of Early Athens," in J. Bremmer (ed.), *Interpretations of Greek Mythology,* Totowa, N.J., 1986, 194–195; and A. W. Saxonhouse, "Myths and the Origin of Cities: Reflections on the Autochthony Theme in Euripides' *Ion,*" in J. P. Euben (ed.), *Greek Tragedy and Political Theory,* Berkeley, Los Angeles, and London, 1986, 252–273.

29. Also see Xenophon's *Memorabilia,* III, 5, 9–12, where the advice of Sokrates to rekindle the Athenian longing for achievement by remembering past exploits essentially reiterates the *topoi* of the *epitaphios logos,* with the catalogue of exploits culminating in the theme of Athenian autochthony and the concomitant responsibility of Athenians to help others.

30. P. Stavropoullos, *He Aspis tes Athenas Parthenou tou Phediou,* Athens, 1950, 72; Harrison, "Amazonomachy," 129–132; idem, "City-Siege," 300–303; Tyrrell, *Amazons,* 126.

31. Herington, *Athena Parthenos,* 63–64; Harrison, "Amazonomachy," 132; cf. Shear, *Periklean Building Program,* 311.

32. The identifications here follow the monograph of F. Brommer, *Die Skulpturen der Parthenon-Giebel: Katalog und Untersuchung,* Mainz, 1963, 30–61 and 165–170. E. B. Harrison, "U and Her Neighbors in the West Pediment of the Parthenon," in D. Fraser, H. Hibbard, and M. J. Lewine (eds.), *Essays in the History of Art Presented to Rudolf Wittkower,* London, 1967, 1–9, tentatively identifies some of the figures more specifically, especially those on the right half of the composition. Her identifictitons depart at times from the possibilities that Brommer considers likely, but this does not affect the interpretation of the pediment attempted here. Also see E. Simon, "Die Mittelgruppe im Westgiebel des Parthenon," in Cahn and Simon (eds.), *Tainia,* 239–255, and Ridgway, *Fifth Century Styles,* 43–46. For the identification of the child next to Kekrops' daughters as Erichthonios, see B. S. Spaeth, "Athenians and Eleusinians in the West Pediment of the Parthenon," *Hesperia,* 60, 1991, 350 and 360.

33. On this account see S. Pembroke, "Women in Charge: The Function of Alternatives in Early Greek Tradition and the Ancient Idea of Matriarchy," *JWCI*, 30, 1967, 26–27; P. Vidal-Naquet, "Esclavage et gynécocratie dans la tradition, le mythe, l'utopie," in *Recherches sur les structures sociales dans l'antiquité classique*, Paris, 1970, 77–78 (cf. the English version, "Slavery and the Rule of Women in Tradition, Myth, and Utopia," reissued in R. L. Gordon [ed.], *Myth, Religion, and Society*, Paris, 1981, 198–199); Loraux, *Les enfants d'Athéna*, 121; Tyrrell, *Amazons*, 28–30. Only Tyrrell and Brown, however, in *Athenian Myths*, 180–182, consider the possible relevance of Varro's version to the west pediment, and they do so only in passing.

34. Vidal-Naquet, ibid. The sources that he has collected for Kekrops' institution of marriage are Kleanthos of Soloi, preserved in Athenaeus, *Deipnosophists*, 555D; Charax of Pergamon, frag. 38, in F. Jacoby, *Die Fragmente der griechischen Historiker*, Berlin and Leiden, 1923–1958, 103; Joannis Antiochenus, frag. XIII, 5, in K. and T. Müller, *Fragmenta Historicorum Graecorum*, Paris, 1878–1885, vol. 4 547; Nonnos, *Dionysiaca*, XLI, 383; Justin, II, 6; and the scholia on Aristophanes' *Ploutos*, 773. Also see Tyrrell, *Amazons*, 30 and n. 20, who adds the scholia on the *Iliad*, XVIII, 483. On the exaggerated sexual appetites routinely attributed to women, see K. J. Dover, *Greek Popular Morality in the Time of Plato and Aristotle*, Oxford, 1974, 101, and R. Just, *Women in Athenian Law and Life*, London and New York, 1989, 158–163.

35. On the exclusion of women from the very classification of "Athenian," see Loraux, *Les enfants d'Athéna*, 14 and 119ff.

36. The remark is part of a dialogue that Xenophon attributes to Sokrates and Perikles, the son of the great Athenian leader of the same name. On the evidence of the references to conflict with the Boiotians, this conversation probably dates to the next to last decade of the fifth century; see H. G. Dakyns, *The Works of Xenophon*, London and New York, 1890–1897, vol. III, 1, xxix. In the third century B.C., the poet Kallimachos, *Iambs*, frag. 194, 67–69, also attributed the judgment in the contest between Athena and Poseidon over Attika to Kekrops, although he did not mention any other Athenians; see C. A. Trypanis, *Callimachus, Fragments* (Loeb Classical Library), London and Cambridge, 1958, 124–125.

37. Brommer, *Parthenon-Giebel*, 158; Simon, "Westgiebel des Parthenon," 239ff.

38. Ridgway, *Fifth Century Styles*, 45–46, and Brommer, *Parthenon-Giebel*, 96–97.

39. Simon, "Westgiebel des Parthenon," 243–244; also see Spaeth, "Athenians and Eleusinians," 333, n. 3.

40. M. Robertson, *A History of Greek Art*, Cambridge, 1975, 300. The wording of Apollodoros, *Library*, III, 14, 1, makes plain that after parting them, Zeus appointed more than one judge: διαλύσας Ζεὺς κριτὰς ἔδωκεν.

41. Simon, "Westgiebel des Parthenon," 245–248.

42. J. Binder, "The West Pediment of the Parthenon: Poseidon," in K. J. Rigsby (ed.), *Studies Presented to Sterling Dow on His Eightieth Birthday*, Duke University, Greek, Roman, and Byzantine Monograph, 10, Durham, N.C., 1984, 15–22, cf.

C. Robert, "Der Streit der Götter um Athen," *Hermes,* 16, 1881, 60–87; and Parker, "Myths of Early Athens," 198 and nn. 48–49.

43. The fragment (Akropolis 888) currently referred to as U^* may be yet another female holding a child that once occupied the space between U and V; see Brommer, *Parthenon-Giebel,* 169 and pl. 126; and Harrison, "U and Her Neighbors," in Fraser, Hibbard, and Lewine, *Essays Presented to Rudolf Wittkower,* 8–9. Robertson, *History of Greek Art,* 300, is one of the more ardent proponents of the river-god identification in recent times; for the opposing view, see R. M. Gais, "Some Problems of River-God Iconography," *AJA,* 82, 1978, 355–370, esp. 361–362; Ridgway, *Fifth Century Styles,* 43–44; and Spaeth, "Athenians and Eleusinians," 336.

44. The idea that the spectators in the pediment were opposing partisans (divine or mortal) of Athena and Poseidon is not new; see L. Weidauer, "Eumolpus und Athen: eine ikonographische Studie," *AA,* 1985, 195–210. Most recently Spaeth, "Athenians and Eleusinians," 338–362, has expanded on this idea in geographic terms. Following Simon, she interprets the scene as the aftermath of the judgment, when Poseidon attacked Athens. In Spaeth's view the lefthand figures are Athenians, supporters of Athena, while those on the right are Eleusinians, including Eumolpos, partisans of Poseidon, and thus the confrontation between the gods would be subsumed under the larger mythic enmity between Athens and Eleusis. The difficulties of Simon's thesis have already been discussed. But, in addition, Spaeth's interpretation does not consider the gender issues inherent in the myth or the particular emphasis on women in the right half of the pediment. Nor is there any clear evidence that the righthand figures are Eleusinians rather than Athenians, as most scholars believe.

45. On Athenian autochthony as the "denial of birth from the womb," see Loraux, *Les enfants d'Athéna,* 11–16, and Tyrrell, *Amazons,* 115–116; and cf. Saxonhouse, "Reflections on Autochthony," in Euben, *Greek Tragedy and Political Theory,* 258–259 and 272.

46. On the development of Athena Parthenos from the more primitive mother goddess, see E. Fehrle, *Die kultische Keuschheit im Altertum,* Giessen, 1910, 194–201; M. P. Nilsson, *Minoan-Mycenaean Religion and Its Survival in Greek Religion,* 2nd rev. ed., Lund, 1950, 485–501, esp. 498–500; and Herington, *Athena Parthenos,* 11–12 and 44–47. J. E. Harrison, *Themis: A Study of the Social Origins of Greek Religion,* 2nd ed., Cambridge, 1927, 500–504, and B. C. Dietrich, *The Origins of Greek Religion,* Berlin, 1974, 154–158 and 181–183, have also emphasized the origin of Athena and Artemis from the Bronze Age *Potnia* or "Mistress."

47. On the myth of Erichthonios, see Loraux, *Les enfants d'Athéna,* 27–30 and 57–64; Parker, "Myths of Early Athens," 193–194; Tyrrell and Brown, *Athenian Myths,* 139–141. For the sources on the myth, see Apollodoros, *Library,* III, 14, 6; Hyginus, *Astronomica Poetica,* II, 13; and idem, *Fabulae,* CLXVI. On the identification of Erichthonios in the pediment, see Spaeth, "Athenians and Eleusinians," 350 and 360.

48. Aischylos, *Eumenides,* 736–738, trans. R. Lattimore in D. Grene and R. Lattimore (eds.), *The Complete Greek Tragedies,* vol. 1: *Aeschylus,* Chicago, 1959,

161. The play generally negates the woman's role in the process of procreation; cf. Apollo's comments in lines 657–666. On the birth of Athena from Zeus as a symbol of male Olympian usurpation of the power and procreative capacity of female divinity, see Harrison, *Themis*, 500–501; M. Merck, "The City's Achievements, the Patriotic Amazonomachy and Ancient Athens," in S. Lipschitz (ed.), *Tearing the Veil*, London, 1978, 106; Loraux, *Les enfants d'Athéna*, 132–157; C. Segal, *Pindar's Mythmaking: The Fourth Olympian Ode*, Princeton, N.J., 1986, 176–177; Parker, "Myths of Early Athens," 191; and N. F. Rubin, "Pindar's Creation of Epinician Symbols," *Classical World*, 74, 1980/81, 70–75 and 70, n. 13, with additional bibliography on this myth. Also see J. P. Vernant, "The Union with Metis and the Sovereignty of Heaven," in R. L. Gordon (ed.), *Myth, Religion and Society*, Paris, 1981, 1–15. On the fundamental distinction between Athena's warlike aspect and that of the Amazons, see J.-P. Vernant and M. Detienne, *Cunning and Intelligence in Greek Culture and Society*, Sussex, 1978, 187–215, and F. Hartog, *The Mirror of Herodotos: The Representation of the Other in the Writing of History* (trans. J. Lloyd), Berkeley, Los Angeles, and London, 1988, 224 and n. 29.

49. On the sexual immoderation of the Amazons and their opposition to the chaste and lawful Greek wife, see Tyrrell, *Amazons*, 54–55, 66, and 78–82, and Just, *Women in Athenian Law and Life*, 244–245 and 249.

50. See Gauer, *Weihgeschenke*, 19, n. 51; E. B. Harrison, "Apollo's Cloak," in G. Kopcke and M. B. More (eds.), *Studies in Classical Archaeology: A Tribute to Peter Heinrich von Blanckenhagen*, Locust Valley, N.Y., 1979, 94; and Berger, *Metopen*, 79.

51. Simon, "Südmetopen," 118; Knell, *Perikleische Baukunst*, 28; Thomas, *Mythos und Geschichte*, 53; and Berger, *Metopen*, 78–79.

52. Brommer, *Metopen*, 232–233 and 238–240.

53. Simon, "Südmetopen," 103.

54. This identification is supported by Simon, ibid., 102–105; Harrison, "Apollo's Cloak," 93 and 96–98; and Knell, *Mythos und Polis*, 100.

55. Simon, "Südmetopen," 102 and 106. For the possibility that the Lapith in metope 32 once wore a helmet, see Berger, *Metopen*, 98.

56. J. P. Barron, "New Light on Old Walls," *JHS*, 92, 1972, 32–33.

57. South metopes, 1, 2, 7, 26, and 32 also depict the Centaur's face as bestial and masklike, comparable to the monumental sculpture and painting of the immediately preceding decades. On the relation of the Olympia pediment to monumental painting, see Barron, "New Light," 26–29. For Pheidias as a painter see Pliny, *Natural History*, XXXV, 54.

58. M. Robertson, "Two Question Marks on the Parthenon," in G. Kopcke and M. B. Moore (eds.), *Studies in Classical Archaeology: A Tribute to Peter Heinrich von Blanckenhagen*, Locust Valley, N.Y., 1979, 75–87; idem, "The South Metopes: Theseus and Daidalos," in Berger, *Parthenon-Kongress Basel*, 206–208. Berger, *Metopen*, 92–93, gives the most up-to-date survey of these opinions, but also see Brommer, *Metopen*, 230–231. For a more recent identification as scenes of ancient Attic kings, see K. Schefold and F. Jung, *Die Urkönige, Perseus, Bellerophon, Herakles und Theseus in der klassischen und hellenistischen Kunst*, Munich, 1988, 70–71.

59. E. Langlotz, *Phidiasprobleme*, Frankfurt, 1947, 19; P. Corbett, *The Sculpture of the Parthenon*, London, 1959, 12; cf. Knell, *Mythos und Polis*, 101. For those who maintain the connection with the Centauromachy, see H. Kähler, *Das griechische Metopenbild*, Munich, 1949, 107; Herington, *Athena Parthenos*, 60, n. 1; P. Fehl, "The Rocks on the Parthenon Frieze," *JWCI*, 24, 1961, 26–27, n. 73; Simon, "Südmetopen," 110–120; and Harrison, "Apollo's Cloak," 93 and 96–98. A. Mantis, "Neue Fragmente von Parthenon-metopen," *JDAI*, 102, 1987, 163–181, and idem, "Beiträge zur Wiederherstellung der mittleren Südmetopen des Parthenon," in H. U. Cain, H. Gabelmann, and D. Salzmann (eds.), *Festschrift für Nikolaus Himmelmann*, Mainz, 1989, 109–114, has recently published a series of fragments securely attributed to the lost south metopes. These verify and refine the evidence of Carrey's drawings, and perhaps they may eventually help in the identification of the subjects.

60. Harrison, "Apollo's Cloak," 93 and 96–98.

61. Simon, "Südmetopen," 106–116.

62. For criticism of Simon's thesis, see Harrison, "Apollo's Cloak," passim; Ridgway, *Fifth Century Styles*, 20 and n. 12; and J. Dörig, "Traces des Thraces sur le Parthénon," *Museum Helveticum*, 35, 1978, 221–232; and K. Schefold, *Die Göttersage in der klassischen und hellenistischen Kunst, Munich*, 1981, 155.

63. Harrison, "Apollo's Cloak," 92. Simon, "Südmetopen," 112, had already considered this possibility. Harrison, 93, uses a similar argument to modify Simon's identification of Boutes on metope 14; because of the figure's youthful appearance, she does not place him at his daughter's wedding, but rather in an earlier exploit where he abducts Koronis.

64. See A. H. Smith, *The Sculptures of the Parthenon*, London, 1910, 32, 46, and pl. 26, no. 241; Brommer, *Metopen*, 100–102, pl. 202–204; and the more recent study of Mantis, "Beiträge," in Cain, Gabelmann, and Salzmann, *Festschrift für Nikolaus Himmelmann*, 110 and fig. 1 (incorrectly labeled "fig. 2").

65. Praschniker, *Parthenonstudien*, 239. Since Simon, "Südmetopen," 113–114, identifies these figures as Aidos and Nemesis, she interprets the archaism of the metope as a deliberate visual device suggesting the ancient time in which these goddesses departed the earth. Roberston, "The South Metopes: Theseus and Daidalos," in Berger, *Parthenon-Kongress Basel*, 207, has noted the use of archaism in fifth-century art to distinguish statues from living people. Because he considers the central metopes to be a depiction of the Daidalos story, the archaism on south 18 suggests to him the famed moving statues made by the mythic sculptor. Yet as a visual device simultaneously denoting artifice and antiquity, the archaism here would also make sense for Nephele, especially in view of the cloudlike forms at her feet.

66. The fragments that Mantis, *JDAI*, 102, 1987, 171–177, fig. 6 and 9, has convincingly attributed to south metope 20 show a cloth or garment of some kind in the hand of the female figure to the left. This would fit the interpretation of wedding preparations.

67. Simon, "Südmetopen," 117–118.

68. On this see especially M. Detienne, *Les jardins d'Adonis*, Paris, 1972,

165–170; cf. P. duBois, *Centaurs and Amazons: Women and the Pre-History of the Great Chain of Being,* Ann Arbor, Mich., 1982, 27–28.

69. Pindar, Pythian Ode II, 20–49, stresses fully the ethical dimension of Ixion's insatiable *hybris;* also see C. M. Bowra, *Pindar,* Oxford, 1964, 81–82, and N. Tersini, "Unifying Themes in the Sculpture of the Temple of Zeus at Olympia," *Classical Antiquity,* 6, 1, 1987, 149.

70. As evidence of Pheidias' familiarity with the theme, Simon, "Südmetopen," 117, notes that the Ixion myth was the subject of public dramatic performances like Aischylos' lost or fragmentary plays *Perrhaibides* and *Ixion.* However, this indicates as well the familiarity of the subject to Athenians more generally, and in a form that would undoubtedly have stressed the moral issues of the story. Ixion's crime and punishment were also depicted in Attic vase painting throughout the fifth century; see Schefold, *Die Göttersage in der klassischen und hellenistischen Kunst,* 153–155, fig. 203–206.

71. For the Amazons see Lysias, *Funeral Oration* (II), 5; for the aggressive appetite of the Persian king, cf. (II), 21. On Xerxes' misguided obsession with increasing the Persian empire in Europe, see Aischylos, *Persians,* 753–792, and Herodotos, VII, 10.

72. For Xerxes as motivated by madness or by spirits that created insane delusions, see Aischylos, *Persians,* 725 and 750; on his competition with the gods, 749. Herodotos too attributes Xerxes' obsessions to deluding spirits in the episode concerning the king's dreams after the Persian war council; see VII, 13–14.

73. Cf. Artabanos' unheeded warnings in Herodotos, VII, 10.

74. Simon, "Südmetopen," 118; cf. Knell, *Perikleische Baukunst,* 28, and Berger, *Metopen,* 78–79. Gauer, *Weihgeschenke,* 19, n. 51, interpreted the south metopes as a symbol of culture versus savagery rather than Greeks versus Greeks, but he too denied any connection between the Centaurs and the Persians.

75. *Mythos und Geschichte,* 53.

76. See "The East Metopes: The Gigantomachy" and n. 20, above.

77. G. Rodenwaldt, "Köpfe von den Südmetopen des Parthenon," *Abhandlungen der Deutschen Akademie der Wissenschaft zu Berlin,* Philosopisch-historische Klasse, 7, 1945/1946 (1948); W. Schindler, *Mythos und Wirklichkeit in der Antike,* Berlin, 1988, 106–107. Schindler, 111–112, further compares this tendency toward a more empathetic depiction of the enemy to the contemporary image of the wounded and defeated Amazons in the statue group set up at the Artemision in Ephesos (cf. Gauer, "Ephesischen Amazonen," esp. 219–221).

78. Plutarch, *Perikles,* XXVIII, 7, quoting the account of Ion of Chios on the *epitaphios logos* delivered by Perikles after the Samian campaign of 440/439; cf. R. Stupperich, *Staatsbegräbnis und Privatgrabmal im klassischen Athen,* Diss., Westfälischen Wilhelms-Universität zu Münster, 1977, 33–34, and Loraux, *Invention of Athens,* 70.

79. On the Trojans and Giants here, see C. Del Grande, *Hybris: colpa e castigo nell'espressione poetica e letteraria degli scrittori della Grecia antica,* Naples, 1947, 59–60.

80. For the literary and archaeological evidence, see G. P. Stevens, "The Per-

iklean Entrance Court of the Acropolis of Athens," *Hesperia*, 5, 1936, 460–461; A. E. Raubitschek, *Dedications from the Athenian Acropolis*, Cambridge, Mass., 1949, 208–209 and 524–525; and U. Kron, *Die zehn attischen Phylenheroen, Geschichte, Mythos, Kult und Darstellungen*, Athenische Mitteilungen, Beiheft, 5, Berlin, 1975, 151–152 and 270, Ak6. Pausanias' wording ὑπερκύπτουσιν, makes it uncertain whether the Greeks are peeping out of the horse or emerging from it.

81. Brommer, *Metopen*, 215–216; Hölscher, *Griechische Historienbilder*, 57 and n. 231; Thomas, *Mythos und Geschichte*, 67.

82. A. Michaelis, *Der Parthenon*, Leipzig, 1871, 137–138. For the oinochoe, Vatican H525, see Praschniker, *Parthenonstudien*, 98–99, fig. 74; Ghali-Kahil, *Les enlèvements et le retour d'Hélène dans les textes et les documents figurés*, Paris, 1955, pl. LXVI, 1–3; and E. Simon, "Die Wiedergewinnung der Helena," *Antike Kunst*, 7, 1964, 91–95, pl. 30. On the identification of these metopes, see Brommer, *Metopen*, 48–50, 213–215, and 220, and Berger, *Metopen*, 16–17 and 37–39.

83. Brommer, *Metopen*, 54, 214, and 220; Berger, *Metopen*, 16–17 and 44–45. Only the identity of the accompanying female figure as Kreusa or Aphrodite is disputed.

84. In addition to Aithra, scholars have also identified these metopes as depicting Polyxena or Theano, wife of Antenor. Aithra is especially plausible on an Attic monument, but there is no clear or certain evidence for such precise identifications. See Brommer, *Metopen*, 48, 52, 66, and 214; Berger, *Metopen*, 16–17, 32–33, and 41–43; and Kron, *Phylenheroen*, 155–156.

85. Brommer, *Metopen*, 41–43 and 219; Berger, *Metopen*, 14 and 20–23.

86. Brommer, *Metopen*, 63–65; Berger, *Metopen*, 14. Other fragments ascribed to indeterminate north metopes *F, H, I, M, P, T, U*, and *V* are comparable to the extant north metopes: naked males, shields, portions of draped female figures. See Brommer, *Metopen*, 67–70, and the references there to Praschniker's discussion of these fragments.

87. C. Dugas, "A la lesché des cnidiens," *REG*, 56, 1943, 53–54 and 58–59; S. Ras, "Dans quel sens faut-il regarder les métopes nord du Parthénon?" *REG*, 57, 1944, 101–105; Brommer, *Metopen*, 217–218; and Kron, *Phylenheroen*, 156.

88. J. Boardman, "The Kleophrades Painter at Troy," *Antike Kunst*, 19, 1976, 7, and pl. 2, nos. 3 and 4; Berger, *Metopen*, 16–17 and 41–43.

89. Praschniker, *Parthenonstudien*, 118; C. Picard, "De 'l'Ilioupersis' de la lesché delphique aux métopes nord du Parthénon," *REG*, 50, 1937, 195–196; K. Jeppesen, "Bild und Mythus an dem Parthenon," *Acta Archaeologica*, 34, 1963, 44, fig. 10c, and 47–48; Brommer, *Metopen*, 215–216; J. Moret, *L'Ilioupersis dans la céramique italiote: les mythes et leur expression figurée au IVe siècle*, Rome 1975, 275–277; and Berger, *Metopen*, 30–33.

90. J. Dörig, "Les métopes nord du Parthénon," in Berger, *Parthenon-Kongress Basel*, 204 and ill. on 202. For illustrations of the Iliupersis by the Brygos Painter, see P. E. Arias and M. Hirmer, *A History of 1000 Years of Greek Vase Painting*, New York, 1962, pl. 139; J. Boardman, *Athenian Red Figure Vases: The Archaic Period*, New York and Toronto, 1975, fig. 245.2; and M. Wiencke, "An Epic Theme in Greek Art," *AJA*, 58, 1954, 285–306, fig. 22, a–b.

91. Ridgway, *Fifth Century Styles*, 18–19.

92. On north 25 Helen is taking refuge in a temple, since she grasps a *xoanon* or cult image. Whether this is the temple of Aphrodite, as Ibykos recounts it (scholiast on Euripides, *Andromache*, 627–631; see P. Clement, "The Recovery of Helen," *Hesperia*, 27, 1958, 48–49), or the temple of Athena, as the Palladion on the red figure oinochoe Vatican H525 indicates, one cannot say for certain; the statue on the metope is nearly all gone. See Moret, *Ilioupersis*, 275, and Berger, *Metopen*, 38–39, for opposing views. In any case Menelaos' submission specifically to the will of Aphrodite is paralleled in Quintus of Smyrna, *Posthomerica*, XIII, 385–402. And even if Aphrodite does not appear again on north 28, the Greek awe at the goddess's protection of her son Aineias is implicit or understood here. Ridgway, *Fifth Century Styles*, 19, has nevertheless speculated that the north metopes may still connote those aspects of the Iliupersis that did not show the Greeks in too good a light. In keeping with his view of the Kleophrades Painter's hydria, J. Boardman, *The Parthenon and Its Sculptures*, Austin, 1985, 249, also considers the possibility that the destruction of Troy in the north metopes may have prefigured the Persian sack of Athens, but he hesitates to conclude that the Athenians would have tampered with so well-established a myth.

93. Kron, *Phylenheroen*, 155.

94. F. Studniczka, "Neues über die Parthenonmetopen," *Neue Jahrbücher für Wissenschaft und Jugendbildung*, 5, 1929, 646; C. Picard, "Sur les métopes nord du Parthénon," *Revue des études anciennes*, 47, 1945, 185–186.

95. On the unity of theme, see Brommer, *Metopen*, 213–216.

96. See Brommer, ibid., 216–217, for the various sequential and directional versus synchronous or nondirectional interpretations of the narrative.

97. Dörig, "Les métopes nord," in Berger, *Parthenon-Kongress Basel*, 204–205; Jeppesen, "Bild und Mythus," 42–43, fig. 10a–b, and 44–49.

98. See n. 86 above for Brommer's discussion of the north fragments and Praschniker's earlier attributions. For the newly attributed north fragments published by Mantis, see *JDAI*, 102, 1987, 181–184.

99. H. Schrader, *Phidias*, Frankfurt am Main, 1924, 300; Praschniker, *Parthenonstudien*, 114–131, passim; T. Löwy, *Polygnot: Ein Buch von griechischen Malerei*, Vienna, 1929, 29 and 59; Picard, " 'L'Ilioupersis,' " 175–205. For counterarguments see n. 87 just above.

100. Brommer, *Metopen*, 55 and 213–214; Berger, *Metopen*, 14 and 46.

101. Brommer, *Metopen*, 39–40 and 215; Berger, *Metopen*, 12–14, 19, 22–23, and 50–53.

102. Brommer, *Metopen*, 58; Berger, *Metopen*, 48.

103. Brommer, *Metopen*, 57, 59–60, and 215; Berger, *Metopen*, 47 and 49–53. Praschniker, *Parthenonstudien*, 141, first identified the series as a *dios boule*, a divine conference concerning the war and its outcome. On the general use of divine assemblies in Archaic and Classical art, see n. 88 to Chapter 5, below.

104. Praschniker, *Parthenonstudien*, 132–141. Other scholars have accepted the general outline of his interpretation; Picard, " 'L'Ilioupersis'," 183–184; Ras, "Les métopes nord," 96; Brommer, *Metopen*, 48 and 221; and Berger, *Metopen*, 50–53.

105. νὺξ μὲν ἔην μέσση, λαμπρὴ δ᾽ ἐπέτελλε σελήνη, scholiast on
Lycophron's *Alexandra,* 344; see H. G. Evelyn-White, *Hesiod, the Homeric
Hymns, and Homerica* (Loeb Classical Library), London and Cambridge, Mass.,
1943, 516–517, no. 11. Cf. Simon, "Südmetopen," 109–110.

106. Quintus, *Posthomerica,* XIII, 369–373:

σὲ δ᾽ οὐκ ἄρα μέλλεν ὀνήσειν ἡμετέρη παράκοιτις, ἐπεὶ Θέμιν οὔποτ᾽
ἀλιτροὶ ἀνέρες ἐξαλέονται ἀκήρατον, οὕνεκ᾽ ἄρ᾽ αὐτοὺς εἰσοράᾳ νυκτός τε καὶ
ἤματος, ἀμφὶ δὲ πάντη ἀνθρώπων ἐπὶ φῦλα διηερίη πεπότηται τινυμένη σὺν Ζηνὶ
κακῶν ἐπιίστορας ἔργων.

107. Simon, "Südmetopen," 110–111.
108. Ibid., 109–110.
109. Berger, *Metopen,* 12–13 and 50.
110. For the seated goddess as Hera, see Praschniker, *Parthenonstudien,*
136–139, and Brommer, *Metopen,* 59–60. K. Schwab, in a paper delivered at the
1985 meeting of the Archaeological Institute of America, "The Gods of Parthenon
North Metopes N31 and N32" (abstract, *AJA,* 90, 1986, 207), has put forward a new
argument identifying the seated goddess of north 32 as Hera, complementing Zeus
on 31, based on analogies in Attic vase painting showing the *hieros gamos* of the
divine couple.
111. On the meaning of the raised garment, see E. G. Pemberton, "The Gods of
the East Frieze of the Parthenon," *AJA,* 80, 1976, 116 and n. 21. The gesture is often
interpreted as bridal, and Themis was also a bride of Zeus (Hesiod, *Theogony,*
901–906). But Pemberton points out that in Greek art the raised garment also
indicates fear or supplication on the part of female figures; cf. J. Henle, *Greek
Myths: A Vase Painter's Notebook,* Bloomington and London, 1973, 35–37 and figs.
22 and 24. The use of this gesture for Helen on Lydos' amphora (fig. 8 in this
volume) may simultaneously connote fear or supplication along with her role as
Menelaos' wife. However, Daphne raises her veil as she is pursued by Apollo on an
Attic red figure kylix by the Ashby Painter (London E 64), and since she never
became Apollo's bride, the gesture here would seem to imply only panic or an
appeal, either toward her pursuer or toward her divine father; see *ARV*² 455, no. 9,
and K. Schefold, "Die ältesten Bilder von Apollo und Daphne," in *Mélanges
Mansel,* Ankara, 1974, vol. I, 53–57 and pl. 27; idem, *Göttersage in der klassischen
und hellenistischen Kunst,* 205–206, fig. 278. On an amphora by Phintias in the
Louvre, G 42, Leto raises her garment imploringly toward Apollo as she is carried
off by Tityos; see *ARV*² 23, no. 1, and J. Charbonneaux, R. Martin, and F. Villard,
Archaic Greek Art, London, 1971, fig. 378. Here again, the gesture can only
indicate panic or supplication. Cf. the Penthesileia Painter's version, Munich 2689,
where the woman who raises her veil has been identified as Leto, or as Gaia
imploring Apollo to spare her son; *ARV*² 879–880, no. 2; Arias and Hirmer, *1000
Years,* 352 and pls. 170–171; and Schefold, *Göttersage,* 148–149, Abb. 197.
112. Praschniker, *Parthenonstudien,* 138 and 141, rather arbitrarily dismissed any
connection between north 30–32 and Quintus of Smyrna, XII, 157–218. He pre-

ferred to see the meaning of the assembled gods as a "kraftiges Amen" occurring after the sack was over. Berger, *Metopen,* 52, has emphasized, however, that there is little enough literary evidence for the divine reaction to Troy's fall, let alone for a *dios boule* of this sort. Such an expression of divine will would be more effective during or just before the sack. Although he too ignores the analogies to the episode in Quintus, Picard, " 'L'Ilioupersis,' " 182–183, had already suggested that the setting of the scene with the gods was Mount Ida.

113. Whatever these metopes depicted, the issue of divine justice and retribution would have been a significant component. J. M. Hurwit, "Narrative Resonance in the East Pediment of the Temple of Zeus at Olympia," *Art Bulletin,* 69, 1, 1987, 6–15, and Tersini, "Temple of Zeus at Olympia," 145–157, have recently stressed the theme of *dike* as a central aspect of the slightly earlier Olympia sculptures. The Parthenon metopes probably reflect the wider preoccupation with this theme in the poetry and religious architectural decoration of the fifth century.

114. The bibliography on the Parthenos is immense. For a concise synthesis of the historical and archaeological evidence for the statue and earlier scholarship, see N. Leipen, *Athena Parthenos, a Reconstruction,* Toronto, 1971; idem, "Athena Parthenos: Problems of Reconstruction," in Berger, *Parthenon-Kongress Basel,* 177–181; and V. M. Strocka, "Das Schildrelief: Zum Stand der Forschung," ibid., 188–196. On the political implications of the statue, see esp. B. Fehr, "Zur religion-spolitischen Funktion der Athena Parthenos in Rahmen des delisch-attischen See-bundes: Teil 1," *Hephaistos,* 1, 1979, 71–91.

115. *Trojan Women,* 95–97:

> μῶρος δὲ θνητῶν ὅστις ἐκπορθῶν πόλεις,
> ναούς τε τύμβους θ᾽, ἱερὰ τῶν κεκμηκότων,
> ἐρημίᾳ δοὺς αὐτὸς ὤλεθ᾽ ὕστερον.

116. *Trojan Women,* 764–765 and 771–772:

> ὦ βάρβαρ᾽ ἐξευρόντες Ἕλληνες κακά,
> τί τόνδε παῖδα κτείνετ᾽ οὐδὲν αἴτιον;
> .
> πολλοῖσι κῆρα βαρβάροις Ἕλλησί τε.
> ὄλοιο·

117. Ridgway, *Fifth Century Styles,* 19, n. 11. Cf. Thucydides, V, 84, 1–116, 4, and Meiggs, *Athenian Empire,* 344.

118. For Helen, Vatican H525 and a few others; Ghali-Kahil, *Le retour d'Hélène,* 90, nos. 70–72, and 95, no. 77, pls. LXII, 3; LXIV, 1–2; LXVI, 1–3; and LXVII, 1–2; and idem, "Helen," *LIMC,* IV, 1, Munich, 1988, 543–544, nos. 267, 269, 272, and 276. For the rape of Kassandra, see the Marlay painter: P. E. Arias, "Dalle necropoli di Spina: la tomba 136 di Valle Pega," *Rivista dell'Istituto Nazionale di Archeologia e Storia dell'Arte,* N.S., 4, 1955, 111, no. 14, and 112, fig. 19; J. Davreux, *La légende de la prophétesse Cassandre d'après les textes et les monuments,* Bibliotheque de la Faculté de Philosophie et Lettres de l'Université de Liège, fasc.

94, Liège and Paris, 1942, 160, no. 94; O. Touchefeu-Meynier, "Aias II," *LIMC*, I, 1, Munich, 1981, 344, no. 67, by the Kodros Painter. Three other examples appear only at the end of the century, after a hiatus of several decades, and the theme disappears entirely from the Attic repertory in the fourth century. See C. Dugas, "Tradition littéraire et tradition graphique dans l'antiquité grecque," *L'Antiquité classique*, 6, 1937, 18–19; Moret, *Ilioupersis, 54; and* Ridgway, *Fifth Century Styles*, 19, n. 11. The late fifth-century examples are the krater from Valle Pega (fig. 20 in this volume); the fragments of a similar work, *Hesperia*, 20, 1951, 256 and pl. 80, 4; as well as a fragmentary vessel in Würzburg with the rape of Kassandra and the wooden horse: Hölscher and Simon, "Amazonenschlacht," 133–134, and pl. 47, 1–3.

119. Moret, *Ilioupersis*, 59. M. D. Stansbury-O'Donnell's careful survey, "Polygnotos's *Nekyia*. A Reconstruction and Analysis," *AJA*, 94, 1990, 232–234, also indicates that the accompanying painting in the Lesche had no impact on fifth-century vase painting.

120. For these examples see Arias, "Necropoli di Spina," 107, no. 19, and 108, fig. 15; and Moret, *Ilioupersis*, 45–47 and pls. 20 and 26–27, British Museum F278, and Louvre K88.

121. Moret, *Ilioupersis*, 165 and pl. 1, Lecce 681; Touchefeu-Meynier, *LIMC*, I, 1, 1981, 347, no. 95.

122. Pausanias, X, 25, 9, and X, 26, 5; Arias, "Necropoli di Spina," 109. Robert's reconstruction of the Fall of Troy in the Lesche showed Andromache seated; Stansbury-O'Donnell's shows her standing with Astyanax (fig. 10a in this volume, lower right). Pausanias' account gives no specific indication as to which is correct, although his observation that the standing child was tugging at his mother's breast tends to suggest that she was lower down or seated.

123. Moret, *Ilioupersis*, 165–166.

124. Sparta had already attempted to bring Persia into the war in 430, but Athens intercepted the embassy on its way to Susa: Thucydides, II, 67, 1–4. In the same year the Persians intervened in support of an uprising against Athens by the Kolophonians at Notion: Thucydides, III, 34, 1–4. In 425 the Athenians managed to intercept a Persian embassy bound for Sparta: Thucydides, IV, 50, 1–2. In 412–411, however, the Spartans negotiated a series of treaties that would, in return for financial aid, give the Persians back the territories lost to Athens: Thucydides, VIII, 18, 1–2; VIII, 37, 1–5; VIII, 39, 2, and VIII, 58, 1–7. See Lewis, *Sparta and Persia*, 61–70 and 83–134 passim; C. D. Hamilton, *Sparta's Bitter Victories: Politics and Diplomacy in the Corinthian War*, Ithaca and London, 1979, 25–27 and 32–40; and Meiggs, *Athenian Empire*, 314–315, 330, and 352–354.

125. Earlier scholarship maintains that the battle against the Persians here actually represented Plataia or Marathon, and Harrison has even suggested that the south frieze depended on the Marathon painting in the Stoa Poikile. At Marathon as well as Plataia, some Greeks fought on the Persian side (Herodotos, VI, 98–99, and IX, 31). If the Nike temple did show either of these battles specifically, these subjects would have functioned rather well as a more recent guise for Persian involvement in the Peloponnesian War. For a discussion of such earlier opinion, see E. B. Harrison,

"The South Frieze of the Nike Temple and the Marathon Painting in the Stoa," *AJA*, 76, 1972, 353–378, and Hölscher, *Griechische Historienbilder*, 92–93 and nn. 451–452. Hölscher, 92–94, has especially criticized the notion that the north, west, and south friezes of the Nike temple collectively represented the battle of Plataia with the Boiotian auxiliaries aiding the Persians. But whether one accepts the battle with the Persians as a specific event or a generic depiction, as Hölscher argues, its juxtaposition to the battles against other Greeks still strongly suggests Persian involvement with the Spartan enemy during the period in which the monument was erected; cf. Knell, *Mythos und Polis*, 148–149.

126. F. Felten, *Griechische tektonische Friese archaischer und klassischer Zeit*, Schriften aus dem Athenaion der klassischer Archäologie Salzburg, 4, Waldsassen-Bayern, 1984, 123–131, esp. 127–129, and pl. 47, 1–4; cf. Knell, *Mythos und Polis*, 141–143; fig. 222–225.

127. Francis, "Greeks and Persians," 53–55 and 77–81.

128. Robertson, *History of Greek Art*, 420, has also focused on this late fifth-century nostalgia for Kimonian and Periklean times to explain why the Kadmos Painter may have adapted Mikon's painting of Theseus retrieving Minos' ring.

129. *Panegyric* (IV), 180–182 and 186; Fischer, *Heldensage*, 20 and 29; and Thomas, *Mythos und Geschichte*, 63. The Peace of Antalkidas, c. 387 B.C., was also known as the King's Peace, since Persia effectively dictated the terms: the Greeks were not only to cease the war, but to give up their attempt to liberate the kindred cities of Asia Minor that had fallen back under Persian control. See Lewis, *Sparta and Persia*, 146–147; Hamilton, *Sparta's Bitter Victories*, 301–325; and P. Cartledge, *Agesilaos and the Crisis of Sparta*, Baltimore, 1987, 369–370. Isokrates' point here is also that the Greeks of the fourth century did not measure up to their immediate ancestors as Persian-bashers. Earlier, in IV, 82–83 and 120, he had praised the triumphs of the Greeks over Xerxes as greater in extent and consequence than the expedition against Troy, for this was a period in which the Greeks rather than the Persian king had imposed the terms of peace. As we saw earlier, Demosthenes, in his *Funeral Oration* (LX), 10, had made the same claim.

130. Xenophon, *Hellenica*, III, 4, 3–4; Pausanias, III, 9, 3–4; Fischer, *Heldensage*, 19; H. U. Instinsky, *Alexander der Grosse am Hellespont*, Godesberg, 1949, 24–27; Thomas, *Mythos und Geschichte*, 63; and Hamilton, *Sparta's Bitter Victories*, 133.

131. Thomas, *Mythos und Geschichte*, 66–67.

132. Hamilton, *Sparta's Bitter Victories*, 218–219 and 292–298.

133. Xenophon, *Hellenica*, IV, 2, 16, and VI, 3, 2; A. Burford, *The Greek Temple Builders at Epidauros*, Liverpool, 1969, 27–28.

134. *Iliad*, II, 731–732; J. F. Crome, *Die Skulpturen des Asklepiostempels von Epidauros*, Berlin, 1951, 53. Surprisingly, Crome and B. Schlörb, *Timotheos*, Jahrbuch des Deutschen Archäologischen Instituts, Erganzungsheft, 22, Berlin, 1965, 9, do not see these circumstances as a significant indication of symbolic intent.

135. N. Yalouris, " 'Die Epione' vom Asklepiostempel in Epidauros," in Höckmann and Krug, *Festschrift für Frank Brommer*, 307–309.

136. Crome, *Asklepiostempels,* 11; Schlörb, *Timotheos,* 28–35; G. Roux, *L'Architecture de l'Argolide aux IVe et IIIe siècles avant J-C.,* Paris, 1961, 129–130; Burford, *Temple Builders,* 28 and 54; and Ridgway, *Fifth Century Styles,* 33.

137. See especially Schlörb, *Timotheos,* 1–24 and Beilage. Her reconstruction has been somewhat modified by I. Beyer, in J. Boardman, J. Dörig, W. Fuchs, and M. Hirmer, *Greek Art and Architecture,* New York, 1967, fig. 168 (fig. 22 in this volume). N. Yalouris has been preparing a new reconstruction of the east pediment based on more fragments that have come to light.

138. Pollitt, *Art and Experience,* 144–145, has characterized the expressive head of Priam on this pediment as the lineal ancestor of the Giants on the Pergamene Altar.

139. In fourth-century Greek vase painting, Helen is shown clutching the idol, sometimes kneeling and with one exposed breast, just as on the Epidauros pediment: Moret, *Ilioupersis,* 31 and pls. 22–24, Apulian krater, Berlin 1968.11 and Campanian lekythos, Frankfurt X 14.356.

140. On Alexander's descent from Achilleus, see Plutarch, *Alexander,* II, 1, and Arrian, *Anabasis of Alexander,* I, 11, 8; on his rivalry with Achilleus and the copy of the *Iliad,* Arrian, VII, 14, 4–5, and Plutarch, VIII, 2. On Alexander at Troy, see Plutarch, XV, 4; Arrian, I, 11, 7–8 to I, 12, 1; Diodorus Siculus, XVII, 17, 1–3; Fischer, *Heldensage,* 20; Instinsky, *Alexander der Grosse,* 12–14, 17–28, and 59–60; and Thomas, *Mythos und Geschichte,* 63.

141. Instinsky, *Alexander der Grosse,* 58–59, has also discussed the analogies between the rituals performed by Alexander at Troy and those of Xerxes a century and a half earlier, as reported by Herodotus, VII, 43.

142. Plutarch, *Alexander,* XIV, 4; on the benefits of Polygnotos for the young, Aristotle, *Politics,* 1340a, 37–40.

Chapter 5

1. B. Ashmole, *Architect and Sculptor in Classical Greece,* London, 1972, 99, 109, and 116.

2. C. Kardara, "Glaukopis: Ho Archaios Naos kai to thema tas zophorou tou Parthenonos," *Archaiologike Ephemeris,* 1961, 61–158, advanced the theory that the frieze depicted a Panathenaia from the remote past, including mythic Athenians as participants rather than those of more recent or contemporary times. R. R. Holloway, "The Archaic Acropolis and the Parthenon Frieze," *Art Bulletin,* 48, 1966, 223–227, rejected the Panathenaic interpretation entirely, preferring instead to see the frieze as a symbolic restoration of the votives on the Akropolis destroyed by the Persians in 480. For a good overview of the problems surrounding the frieze, see J. Boardman, "The Parthenon Frieze," in E. Berger (ed.), *Parthenon-Kongress Basel: Referate und Berichte 4. bis 8 April 1982,* Mainz, 1984, 210–215; L. Beschi, "Il fregio del Partenone: una proposta di lettura," *Rendiconti dell' Accademia dei Lincei,* classe di scienze morali, storiche e filologiche, 39, 1984, 173–195; and

R. Osborne, "The Viewing and Obscuring of the Parthenon Frieze," *JHS*, 107, 1987, 98–105.

3. A. W. Lawrence, "The Acropolis and Persepolis," *JHS*, 71, 1951, 111–119.

4. M. Cool Root, "The Parthenon Frieze and the Apadana Reliefs at Persepolis: Reassessing a Programmatic Relationship," *AJA*, 89, 1985, 103–120.

5. E. G. Pemberton, "The Gods of the East Frieze of the Parthenon," *AJA*, 80, 1976, 123–124; G. M. A. Hanfmann, "Narration in Greek Art," *AJA*, 61, 1957, 76–77; H. Luschey, "Iran und der Westen," *AMIran*, 1, 1968, 22–24; Ashmole, *Architect and Sculptor*, 117; S. Moscati, *Il volto del potere: arte imperialistica nell'antichità*, Rome, 1978, 122; W. Gauer, "Was geschieht mit dem Peplos?" in Berger, *Parthenon-Kongress Basel*, 227–228; and idem, "Die Gruppe der ephesischen Amazonen, ein Denkmal des Perserfriedens," in H. A. Cahn and E. Simon (eds.), *Tainia: Roland Hampe zum 70. Geburtstag*, Mainz, 1980, 222.

6. The identification of the allies in the frieze will be discussed in further detail below.

7. F. Thureau-Dangin, *Til Barsib*, Bibliotheque archéologique et historique, 23, Paris, 1936, pls. XLIX and LII; A. Parrot, *The Arts of Assyria*, New York, 1961, figs. 112–113; and A. Moortgat, *Die Kunst des Alten Mesopotamiens: die klassische Kunst Vorderasiens*, Cologne, 1967, 144–145, fig. 98–99. Here too the Assyrian monarch is shown receiving the homage of his nobles and the submission of foreigners. On the more general use of processional imagery in Assyrian and Phoenician art, see H. Frankfort, *Art and Architecture of the Ancient Orient*, 2nd ed., Harmondsworth, 1985, figs. 189, 193, 198–199, and 317; G. Loud, *Khorsabad*, vol. 1, Chicago, 1936, ills. 35 and 45; and M. Cool Root, *The King and Kingship in Achaemenid Art: Essays on the Creation of an Iconography of Empire*, Acta Iranica, textes et mémoires, 9, Leiden, 1979, figs. 60–61. For Egyptian examples see W. S. Smith, *Art and Architecture of Ancient Egypt*, 2nd ed., Harmondsworth, 1981, ills. 168, 236, 239, 240, and 337.

8. F. Brommer, *Der Parthenonfries: Katalog und Untersuchung*, Mainz, 1977, 173, saw the general compositional analogies between the frieze and the Persepolis reliefs as largely superficial or unconvincing, especially in comparison to such Greek precedents; cf. even the brief remarks of S. Woodford in her elementary introduction, *The Parthenon*, Cambridge, 1981 (2nd ed. 1983), 36.

9. This theory was elaborately propounded by R. Ghirshman, "Notes irannienes VII, à propos de Persépolis," *Artibus Asiae*, 20, 1957, 265–278, but the idea was already well established; see E. Schmidt, *Persepolis*, vol. 1, Chicago, 1953, 82, and K. Erdmann's review in *Bibliotheca Orientalis*, 13, 1/2, 1956, 65. A. T. Olmstead entitled a chapter in his *History of the Persian Empire*, Chicago, 1948, "New Year's Day at Persepolis"; see esp. 274–277. In the decades that followed, scholars rarely took the trouble to emphasize the hypothetical nature of this identification (but see E. Porada, *The Art of Ancient Iran: Pre-Islamic Cultures*, New York, 1965, 148 and 151). G. Walser, for example, treats the identification as beyond dispute: *Die Völkerschaften auf den Reliefs von Persepolis: historische Studien über den sogennanten Tributzug an der Apadanatreppe*, Berlin, 1966, 20 and 22–23; idem, *Persepolis: die Königspfalz des Darius*, Tübingen, 1980, 8. F. Krefter, *Persepolis*

Rekonstruktionen, Tehraner Forschungen, 3, Berlin, 1971, 96–102, has greatly elaborated on Ghirshman's thesis by proposing a week-long *Nawruz,* involving the specialized functions of different buildings as indicated by the subject matter of their relief decorations. For a more extensive bibliography on the ritual interpretations of the site, see Root, *Kingship,* 157, n. 79.

10. C. Nylander, "Al-Beruni and Persepolis," in *Commémoration Cyrus: actes du Congrès de Shiraz 1971 et autres études rédigées à l'occasion du 2500e anniversaire de la fondation de l'empire perse,* Leiden, 1974, vol. 1, 137–150; P. Calmeyer, "Textual Sources for the Interpretation of Achaemenian Palace Decorations," *Iran,* 18, 1980, 55–63.

11. A later and fragmentary Arabic source of the eleventh century mentions gifts presented to the Persian king by foreigners in the *Nawruz* ceremony of Sassanian times, but these are not necessarily conquered subjects as in the Achaemenid period. See R. Ehrlich, "The Celebration and Gifts of the Persian New Year (*Nawruz*) According to an Arabic Source," in *Dr. Modi Memorial Volume,* Bombay, 1930, 100–101, and Root, *Kingship,* 278.

12. See especially Walser, *Völkerschaften,* 20–26.

13. Calmeyer, *Iran,* 18, 1980, 56–57. L. Trümpelmann, "Tore von Persepolis: Zur Bauplanung des Dareios," *AMIran,* 7, 1974, 163, had already argued for a symbolic interpretation of the work as an abstract statement of the Great King's power and the extent of his empire, much like the reliefs of the throne bearers of all the lands on the Achaemenid royal tombs at Naqsh–i–Rustam. It is significant that even Root, in *Kingship,* 278–279 and 282, and in "The Persepolis Perplex: Some Prospects Born of Retrospect," in D. Schmandt-Besserat, *Ancient Persia: The Art of an Empire,* Malibu, Calif., 1980, 11, originally followed these scholars in dismissing the *Nawruz* interpretation of the Apadana reliefs; she too interpreted them as an abstract embodiment or evocation of imperial harmony rather than the illustration of an actual ceremonial event. Only later, in "Parthenon Frieze," 112 and 118, did she accept the theory of a pan-imperial New Year's festival.

14. N. Cahill, "The Treasury of Persepolis: Gift-Giving at the City of the Persians," *AJA,* 89, 1985, 387–388, following Calmeyer, Nylander, and Root's earlier work, would agree that the Apadana reliefs depict a more idealized or abstract conception of the Great King and the totality of his empire, which corresponded only indirectly to the gift-giving ceremonies that may really have taken place at Persepolis.

15. On the explicitly antityrannical or antimonarchic stance of fifth-century Athenian propaganda, see A. J. Podlecki, "The Political Significance of the Athenian 'Tyrannicide'-Cult," *Historia,* 15, 1966, 129–141; H. A. Thompson and R. E. Wycherley, *The Athenian Agora: The Agora of Athens,* vol. 14, Princeton, N.J., 1972, 155–160; E. D. Francis, "Greeks and Persians: The Art of Hazard and Triumph," in Schmandt-Besserat, *Ancient Persia,* 60–61; and F. Hartog, *The Mirror of Herodotos: The Representation of the Other in the Writing of History* (trans. J. Lloyd), Berkeley, Los Angeles, and London, 1988, 322–339.

16. Cf. Osborne, "Parthenon Frieze," 104, who stresses that the meaning of the frieze cannot be understood outside the context of the temple as a whole.

17. Herodotos, VI, 42, 1–2; J. M. Balcer, "The Athenian Episkopos and the Achaemenid 'King's Eye,'" *American Journal of Philology,* 98, 1977, 252–263; idem, *Sparda by the Bitter Sea: Imperial Interaction in Western Anatolia,* Chico, Calif., 1984, 379–380; Root, "Parthenon Frieze," 116, n. 55.

18. The clearest statement of this concept of kingship is the inscription of Dareios at Naqsh-i-Rustam: "I am Dareios, the Great King, King of Kings, king of lands of every tongue, king of this great distant territory, son of Hystaspes, an Achaemenid, a Persian. . . . When Ahuramazda saw that these lands were hostile, and against one another they fought, afterward he gave it to me. And I, over it for kingship he appointed me. I am king. In the protection of Ahuramazda I established them in their place. And what I said to them they did according to my will." Trans. Olmstead, *History of the Persian Empire,* 123–124. Olmstead, 119–134, has thoroughly examined the Old Babylonian sources for Dareios' theology of kingship, but see also the strong analogies to Middle Assyrian precedents glorifying royal imperial authority: E. Weidner, *Die Inschriften Tukulti-Ninurtas I. und seiner Nachfolger,* Archiv für Orientforschung, Beiheft, 12, Graz, 1959, 8–14, nos. 2–6.

19. V. Ehrenberg, *The Greek State,* New York, 1960, 17–18 and 45.

20. Ehrenberg, ibid., 121–131, discusses the exception to this: local tribal or regional leagues consisting of several *poleis* with a common ethnic or geographic proximity. Yet even here such unity was often weak or ill-defined.

21. S. Perlman, "Panhellenism, the Polis, and Imperialism," *Historia,* 25, 1976, 1–30.

22. Herodotos, VI, 29–30; Thucydides, I, 98, 4, and III, 9–10; Cicero, *Letters to Atticus,* VI, 2, 4; Ehrenberg, *Greek State,* 93–95; K. von Fritz, "Die griechische ELEUTHERIA bei Herodot," *Wiener Studien,* 78, 1965, 5–31; W. Schuller, *Die Herrschaft der Athener im Ersten Attischen Seebund,* Berlin, 1974, 104–106; J. M. Balcer, *The Athenian Regulations for Chalkis: Studies in Athenian Imperial Law,* Historia, Einzelschriften, 33, Wiesbaden, 1978, 5–7; idem, *Sparda,* 359–360; G. C. Starr, "Greeks and Persians in the Fourth Century B.C.: Part II," *Iranica Antiqua,* 12, 1977, 57–58; and T. Cuyler-Young, "480/79 B.C.—A Persian Perspective," *Iranica Antiqua,* 15, 1980, 213–239.

23. Thucydides, esp. I, 97–98, describes this subversion baldly, and recent studies have documented the process in all its stages, using not only the evidence of Greek historians but also the direct corroboration of the Athenian decrees from the middle of the century and the decades following. See especially H. Nesselhauf, *Untersuchungen zur Geschichte der delisch-attischen Symmachie,* Klio, Beiheft, N.S., 17, Leipzig, 1933, 1ff.; W. Kolbe, "Die Anfänge der attischen Arché," *Hermes,* 73, 1938, 249–268; D. W. Bradeen, "The Popularity of the Athenian Empire," *Historia,* 9, 1960, 257–269; T. J. Quinn, "Thucydides and the Unpopularity of the Athenian Empire," *Historia,* 13, 1964, 257–266; and H. Popp, "Zum Verhältnis Athens zu seinen Bündern im attisch-delischen Seebund," *Historia,* 17, 1968, 425–443. For an in-depth treatment of the transition from league to empire, see R. Meiggs, *The Athenian Empire,* Oxford, 1972; Schuller, *Herrschaft;* Balcer, *Regulations for Chalkis;* and idem, *Sparda.* In contrast to most of this work, M. F. McGregor, *The Athenians and Their Empire,* Vancouver, 1987, esp. 166–177, pre-

sents a more generous assessment of the empire and its aims; Kagan's evaluation, *Pericles of Athens,* 91-116, is mixed.

24. On the right to supress secession by virtue of the charter oath of the League, see Balcer, *Sparda,* 351-354. Meiggs, *Athenian Empire,* 579-582, has collected the relevant texts of the loyalty oaths imposed on rebellious states. However, Balcer, *Regulations for Chalkis,* 26ff., offers a close analysis of such documents. Also see Schuller, *Herrschaft,* 100-106.

25. Thucydides, I, 96, 1-2, and Plutarch, *Aristeides,* XXV, 3. On the implications of the change, see Balcer, *Sparda,* 348, 350, and 407, and Meiggs, *Athenian Empire,* 234-235. Eventually the Athenians transferred the League treasury from Delos to Athens itself, ostensibly because of the threat of a Persian invasion of the Aegean in 454. The issue of security was, of course, only a pretext to justify what was in effect the total arrogation of the League funds, and these were henceforth sent directly to Athens.

26. On the jurisdiction of amphictyonic councils, see Ehrenberg, *Greek State,* 111-112. On the transfer of central authority from the League Synod to the Athenian *Boule,* see Balcer, *Sparda,* 349-351.

27. See Balcer, *Sparda,* 401-402 and n. 35. To some extent the common federal coinage of the Peloponnesian cities belonging to the Arcadian League in the second quarter of the fifth century also provides a native, nonimperial precedent for the Coinage Decree of 448 B.C., rather than the Persian source or impetus advanced by Root, "Parthenon Frieze," 115, n. 47. For these Arcadian issues see C. M. Kraay, *Archaic and Classical Greek Coins,* Berkeley and Los Angeles, 1976, 97-98.

28. This occurred at Erythrai in 453/2, at Miletos in 446-442, and at Samos in 439/8: Meiggs, *Athenian Empire,* 113, 188, and 193. For the texts of the Athenian regulations, see ibid., 579 and 581-582, and R. Meiggs and D. Lewis, *A Selection of Greek Historical Inscriptions to the End of the Fifth Century B.C.,* Oxford, 1969, 89-90 and 151-152. On the implementation of democracies as a means of establishing control in the allied cities, also see Schuller, *Herrschaft,* 82-100. Balcer, *Sparda,* 380-382 and 420-422, sees this process as an Athenian attempt to exploit the internal factionalism between the urban *demos* and the oligarchic landed gentry of the member states.

29. Meiggs, *Athenian Empire,* 205-207 and 214-215; Schuller, *Herrschaft,* 14-25.

30. As, for example, the Kleinias Decree, the Coinage Decree, and the various regulations imposed on rebellious allies individually. Balcer, *Sparda,* 381-410, and esp. 386, has stressed that the Athenians may have been the first to institutionalize imperialism by "discrete judicial procedures." Also see Meiggs, *Athenian Empire,* 152-174 and 207, and Schuller, *Herrschaft,* 100-112, for a full analysis of these measures and their effectiveness.

31. Thucydides, III, 10, 5-6, and III, 11, 2:

ἀδύνατοι δὲ ὄντες καθ᾽ ἓν γενόμενοι διὰ πολυψηφίαν ἀμύνασθαι οἱ ξύμμαχοι
ἐδουλώθησαν πλὴν ἡμῶν καὶ Χίων· ἡμεῖς δὲ αὐτόνομοι δὴ ὄντες καὶ ἐλεύθεροι
τῷ ὀνόματι ξυνεστρατεύσαμεν.

... αὐτόνομοί τε ἐλείφθημεν οὐ δι᾽ ἄλλο τι ἢ ὅσον αὐτοῖς ἐς τὴν ἀρχὴν εὐπρεπείᾳ τε λόγου καὶ γνώμης μᾶλλον ἐφόδῳ ἢ ἰσχύος τὰ πράγματα ἐφαίνετο καταληπτά.

32. πόλεις ὅσων Ἀθηναῖοι κρατοῦσι : F. Hiller de Gaertringen (ed.), *Inscriptiones Graecae*, vol. 1, 2, Berlin, 1924, nos. 27 and 27A, dated before 445 B.C. One of the three remaining examples (ibid., no. 56) could be as early as 430, but the others are considerably later; see Meiggs, *Athenian Empire*, 171 and 425–427. These are punitive decrees against the murder of resident Athenians or *proxenoi*, local collaborators who facilitated Athenian rule in the allied cities, and this may explain the exceptional language here. H. B. Mattingly, "Athenian Finance in the Peloponnesian War," *BCH*, 92, 1968, 478–485, and "The Growth of Athenian Imperialism," *Historia*, 12, 1963, 263–265 and 271, finds this unusual terminology too imperial for the 440s. He has attempted to downdate these inscriptions to the 420s along with the other Athenian decrees that instituted the empire, whose real development he would place after 440 B.C. Mattingly is certainly right to stress the Athenians' reluctance to declare their imperialism boldly before 430, but it is hard to deny that Athens had been pursuing frankly imperialist policies by the 450s if not earlier, and his lower dating of the decrees has not found acceptance. For the use of the terms *archomenoi* and *hypekooi*, see Thucydides, I, 77, 2 and 6; II, 41, 3; III, 37, 2; V, 91, 1; V, 95; and V, 100.

33. Meiggs and Lewis, *Greek Historical Inscriptions*, 111–113 and 117–119.

34. See for example the regulations imposed on Erythrai in 453/2, Chalkis in 446/5, and Samos in 439/8, the decrees on the Temple of Athena in 430–420, Methone in 426/5, and Aphytaeis in 426, the Sicilian expedition in 415, and the accounts of the treasurers of Athena in 410/409: Meiggs, *Athenian Empire*, 579–581; Meiggs and Lewis, *Greek Historical Inscriptions*, 90, 139, 152, 178, 237, and 257; *Inscriptiones Graecae*, vol. 1, 2, nos. 50 and 57, and vol. 1, 3, no. 63. If the restorations of lines 31 and 35 on the Kleinias Decree are correct, even this major instrument of Athenian imperial policy used the term *symmachoi* for the allies, in addition to describing them neutrally as the "cities"; see Meiggs and Lewis, *Greek Historical Inscriptions*, 118. On the use of the term *symmachoi* in these decrees, also see Schuller, *Herrschaft*, 149 and 203–204, and idem, "Der attische Seebund und der Parthenon," in Berger, *Parthenon-Kongress Basel*, 24.

35. On this document see especially Balcer, *Regulations for Chalkis*, 26–82. The regulations imposed on Samos in 439/8, which required the inhabitants to swear to be loyal to Athens and her allies, appear to place a similar emphasis on symmachy. Meiggs, *Athenian Empire*, 193–194, suggested that these decrees deliberately revived the hegemonial language of the League.

36. Cf. Thucydides' remark, I, 98, 4, that Athenian subjugation of the allies was contrary to established custom or practice; von Fritz, *Wiener Studien*, 78, 1965, 28; Popp, *Historia*, 17, 1968, 425–443; Schuller, *Herrschaft*, 140–141 and 203–204; and Balcer, *Sparda*, 386. Fourth-century evidence substantiates this as well. Despite the traditional or official apologist stance on Athenian power in the fifth century that Isokrates had retained in his *Panegyric*, he later came to admit the

fundamental injustice and the ruinous consequences of the empire in his *Peace* (VIII), 77–79, 94–95, and 105–107. Aristotle too, in the *Politics*, 1333b, 27–1334a 3, could only extol an altruistic hegemony dedicated to the common interests of the member states. Any Greek *polis* that sought to rule despotically over those around it was like a citizen within an individual city-state who attempted to dictate to his fellows; this only courted disaster. Thus, Aristotle fragment 81, advises Alexander to rule the barbarians despotically, but to govern the Greeks as a *hegemon*. On the illegal status of empire in Greek thinking of the fourth century, see Popp, *Historia*, 17, 1968, 436ff.; Perlman, "Panhellenism," 25–30; and H. Lloyd-Jones, *The Justice of Zeus*, 2nd ed., Berkeley, Los Angeles, and London, 1983, 138–140.

37. Trans. A. J. Podlecki, *The Persians by Aeschylus*, Englewood Cliffs, N.J., 1970, 75–76, lines 584–594. Also see A. Momigliano, "The Persian Empire and the Idea of Freedom," in A. Ryan (ed.), *The Idea of Freedom: Essays in Honor of Isaiah Berlin*, Oxford, 1979, 142–143 and 145–146; E. Petrounias, *Funktion und Thematik der Bilder bei Aischylos*, Göttingen, 1976, 21–22; and Francis, "Greeks and Persians," 60–61.

38. Lysias, *Funeral Oration*, (II), 55–57: ἑβδομήκοντα μὲν ἔτη τῆς θαλάττης ἄρξαντες ἀστασιάστους δὲ παρασχόντες τοὺς συμμάχους, οὐ τοῖς ὀλίγοις τοὺς πολλοὺς δουλεύειν ἀξιώσαντες, ἀλλὰ τὸ ἴσον ἔχειν ἅπαντας ἀναγκάσαντες, οὐδὲ τοὺς συμμάχους ἀσθενεῖς ποιοῦντες, ἀλλὰ κἀκείνους ἰσχυροὺς καθιστάντες, καὶ τὴν αὑτῶν δύναμιν τοσαύτην ἐπιδείξαντες, ὥσθ᾿ ὁ μέγας βασιλεὺς οὐκέτι τῶν ἀλλοτρίων ἐπεθύμει, ἀλλ᾿ ἐδίδου τῶν ἑαυτοῦ καὶ περὶ τῶν λοιπῶν ἐφοβεῖτο, καὶ οὔτε τριήρεις ἐν ἐκείνῳ τῷ χρόνῳ ἐκ τῆς Ἀσίας ἔπλευσαν, οὔτε τύραννος ἐν τοῖς Ἕλλησι κατέστη, οὔτε Ἑλληνὶς πόλις ὑπὸ τῶν βαρβάρων ἠνδραποδίσθη· τοσαύτην σωφροσύνην καὶ δέος ἡ τούτων ἀρετὴ πᾶσιν ἀνθρώποις παρεῖχεν. ὧν ἕνεκα δεῖ μόνους καὶ προστάτας τῶν Ἑλλήνων καὶ ἡγεμόνας τῶν πόλεων γίγνεσθαι.

39. Isokrates, *Panegyric* (IV), 80–81: τὸν αὐτὸν δὲ τρόπον καὶ τὰ τῶν ἄλλων διῴκουν, θεραπεύοντες ἀλλ᾿ οὐχ ὑβρίζοντες τοὺς Ἕλληνας, καὶ στρατηγεῖν οἰόμενοι δεῖν ἀλλὰ μὴ τυραννεῖν αὐτῶν, καὶ μᾶλλον ἐπιθυμοῦντες ἡγεμόνες ἢ δεσπόται προσαγορεύεσθαι καὶ σωτῆρες ἀλλὰ μὴ λυμεῶνες ἀποκαλεῖσθαι, τῷ ποιεῖν εὖ προσαγόμενοι τὰς πόλεις, ἀλλ᾿ οὐ βίᾳ καταστρεφόμενοι. . . . οὐχ οὕτως ἐπὶ ταῖς δυναστείαις μέγα φρονοῦντες, ὡς ἐπὶ τῷ σωφρόνως.

40. Meiggs, *Athenian Empire*, 397–403, tended to see these fourth-century passages as products of their own time, vehicles of a nostalgic picture of Athenian greatness that avoided the true nature of the empire to suit contemporary political purposes; in contrast, see H. Strasburger, "Thukydides und die politische Selbstdarstellung der Athener," *Hermes*, 86, 1958, 17–40.

41. Lysias, *Funeral Oration* (II), 17–19; cf. Demosthenes, *Funeral Oration* (LX), 6–7, where he completes the praises of his countrymen's autochthony by stating that the Athenians had never treated any man unjustly. It was their way to be "most just," and to distinguish themselves in defensive exploits. Also see W. B. Tyrrell, *Amazons: A Study in Athenian Mythmaking*, Baltimore and London, 1984, 114–115.

42. Cf. Thucydides, I, 98, 4–I, 101. Balcer, *Sparda*, 327–388, has extensively

analyzed the imperialist initiatives that already typified Athenian participation in the League by the 460s.

43. Strasburger, "Selbstdarstellung der Athener," 22–28, and K. R. Walters, "Rhetoric as Ritual: The Semiotics of the Attic Funeral Oration," *Florilegium, 2,* 1980, 2–5, 8–9, and 12.

44. Strasburger, "Selbstdarstellung der Athener," 24–25 and 27, considers this benign and altruistic image of Athenian leadership as the official line, created during the League and remaining in use throughout the period of the empire. He has also analyzed the glaring discrepancy between the official Athenian pretense of just leadership reflected in Attic rhetoric, and the unabashedly imperialist stance of the remaining Athenian speeches portrayed all through Thucydides' account. He concludes that Thucydides' speeches are therefore largely unhistorical; they were not meant to depict the actual arguments that Athenian leaders and envoys would have presented during the period of the empire. They are instead "unveiled" or "unmasked" statements of the real nature of Athenian policy, which served primarily as vehicles for Thucydides' own views on the unjust and illegal nature of Athens' subjugation of the allies: ibid., 28–35.

45. On the origin and function of amphictyonies, see Ehrenberg, *Greek State,* 108–112.

46. Meiggs, *Athenian Empire,* 43, 47, and 67, and Balcer, *Sparda,* 347–348.

47. See B. D. Meritt and H. T. Wade-Gery, "The Dating of Documents to the Mid-Fifth Century—I," *JHS,* 82, 1962, 71; and A. E. Raubitschek, "The Peace Policy of Pericles," *AJA,* 70, 1966, 37–38. B. Fehr, "Zur religionspolitischen Funktion der Athena Parthenos in Rahmen des delisch-attischen Seebundes: Teil 1," *Hephaistos,* 1, 1979, 71–91, has especially examined the religious and ideological aspects of this shift in cult or divine patronage.

48. Meritt and Wade-Gery, "Dating of Documents—I," 69–71; Meiggs and Lewis, *Greek Historical Inscriptions,* 118, lines 41ff. The participation of individual allied cities in the Great Panathenaia is already attested by 453/2 in the regulations for Erythrai: Meiggs and Lewis, 90, lines 2–4.

49. Ehrenberg, *Greek State,* 121–122, and Balcer, *Sparda,* 394.

50. Solon, frag. 4; Herodotos, I, 147, 2; V, 97, 2; IX, 106, 3; and Thucydides, I, 12, 4; I, 95, 1; VI, 82, 2–4; VII, 57, 2–4. On this tradition also see Meritt and Wade-Gery, "Dating of Documents—I," 70–71; Schuller, *Herrschaft,* 113; and J. P. Barron, "Religious Propaganda of the Delian League," *JHS,* 84, 1964, 46–48. For the fragmentary *Ionika* by Panyassis of Halikarnassos, which also celebrated the Athenian foundation of the Ionian *poleis,* see n. 142 to Chapter 2, above.

51. On the maintenance of the League and enforced allied revenues after the Peace, see n. 12 to Chapter 4, above.

52. The evidence of the Congress Decree (Plutarch, *Perikles,* XVII) of about 449 B.C. suggests that Perikles may originally have envisioned an Athens-centered amphictyony of panhellenic proportions; see Nesselhauf, *Delisch-attischen Symmachie,* 31ff., and Perlman, "Panhellenism," esp. 6–17. When his congress failed to materialize, he may have decided upon a more limited pan-Ionian conception analogous to that of the League and its forerunner.

53. See Meritt and Wade-Gery, "Dating of Documents—I," 69–71; Barron, "Religious Propaganda of the Delian League," 47; A. Graham, *Colony and Mother City in Ancient Greece,* New York, 1964, 62–63. Barron, 35–46, has also discussed the mid-fifth-century epigraphic evidence from the Aegean Islands documenting the promulgation of an Athena cult among the subject *poleis,* closely tied to the foundation myths of Ion and his sons. Barron explains this development in connection with the new amphictyonic emphasis accorded to Athena following the transfer of the League funds to Athens, and colonist propaganda that Athens fostered to justify these changes.

54. On the identification of the *metoikoi* in the earlier literature, see Brommer, *Parthenonfries,* 214 and 217, and also H. W. Parke, *Festivals of the Athenians,* Ithaca, N.Y., 1977, 44. E. Simon, "Die Mittelszene im Ostfries des Parthenon," *AM,* 97, 1982, 134–135, and *Festivals of Attica: An Archaeological Commentary,* Madison, Wis., 1983, 63–64, has advanced a plausible argument that the hydria-bearers are the victors of the Panathenaic torch race holding their trophies, since the prizes for this event were hydriae rather than amphorae. In this she follows the earlier indications of E. Diehl, *Die Hydria: Formgeschichte und Verwendung im Kult des Altertums,* Mainz, 1964, 195.

55. A. E. Raubitschek, "Die historisch-politisch Bedeutung der Parthenon und seines Skulpturenschmuckes," in Berger, *Parthenon-Kongress Basel,* 19, suggests that the frieze represented the participants of the entire Athenian Empire, but he does not expressly identify the figures with the cows on the north and south friezes as the allied delegates. On the identification of certain of the cattle as cows, and the practice of such offerings among native Athenians as well, see Brommer, *Parthenonfries,* 215 and 218; and L. Deubner, *Attische Feste,* Berlin, 1932, 26–27. J. Boardman, "The Parthenon Frieze—Another View," in U. Höckmann and A. Krug (eds.), *Festschrift für Frank Brommer,* Mainz, 1977, 43–44; idem, "The Parthenon Frieze," 211; and Schuller, "Attische Seebund," 25, do not feel that the allies can be positively identified in the frieze. Parke, *Festivals of the Athenians,* 45, is similarly uncertain whether the cows of the frieze are the offerings of local or overseas participants.

56. Parke, *Festivals of the Athenians,* 38–45, provides a good discussion of the gaps between the literary sources on the Panathenaia and its presentation in the frieze. Also see Holloway, *Art Bulletin,* 48, 1966, 223; Boardman, "Parthenon Frieze," 211; idem, "Another View," 42–45; Schuller, "Attische Seebund," 25; and S. I. Rotroff, "The Parthenon Frieze and the Sacrifice to Athena," *AJA,* 81, 1977, 379–382.

57. Boardman, "Another View," 46, and "Parthenon Frieze," 211, sees the apparent omission of the allies as indicating that the frieze did not depict a contemporary Panathenaic procession—that is, one that occurred after the early 440s, when allied participation became mandatory. But if the allies were included in this more ambiguous or less specific form, then the procession would be readily intelligible as a generalized but contemporary depiction.

58. In this regard see especially Rotroff, *AJA,* 81, 1977, 381–382; Simon, *Festivals of Attica,* 65–66; and Beschi, "Il fregio del Partenone," 191.

59. For surveys of this material, see the major study by P. Demangel, *La frise ionique,* Paris, 1932; A. Akerström, *Die architektonischen Terrakotten Kleinasiens,* Acta Instituti Atheniensis Regni Sueciae, ser. 4, 11, Lund, 1966; B. S. Ridgway, "Notes on the Development of the Greek Frieze," *Hesperia,* 35, 1966, 188–204; idem, *The Archaic Style in Greek Sculpture,* Princeton, N.J., 1977, 253–279; N. Bookidis, *A Study of the Use and Geographical Distribution of Architectural Sculpture in the Archaic Period,* Ph.D. Diss., Bryn Mawr College, 1967 (Catalogue, under "friezes"); and, most recently, F. Felten, *Griechische tektonische Friese archaischer und klassischer Zeit,* Schriften aus dem Athenaion der klassischer Archäologie, Salzburg, 4, Waldassen-Bayern, 1984, 15–44.

60. Thasos: Demangel, *Frise ionique,* 155, fig. 36; Ridgway, *Hesperia,* 35, 1966, pl. 59c. Düver: Akerström, *Architektonischen Terrakotten,* 256, fig. 75; E. Akurgal, *The Art of Greece,* New York, 1968, 220, pl. 68. Prinias: Demangel, *Frise ionique,* 162, fig. 39, and 165, fig. 42; Ridgway, *Hesperia,* 35, 1966, pl. 59d; J. Boardman, *Greek Sculpture: The Archaic Period,* New York and Toronto, 1978, fig. 32.3; and Felten, *Friese,* 19, 28–29, and 35. On the Prinias frieze as a precursor of the cavalry on the Parthenon, see Brommer, *Parthenonfries,* 151–153.

61. Kyzikos, Myous, and Iasos: Boardman, *Greek Sculpture: The Archaic Period,* figs. 221–222; Ridgway, *Hesperia,* 35, 1966, pl. 59b; and C. Laviosa, "Un rilievo arcaico di Iasos e il problema del fregio nei templi ionici," *Annuario della Scuola Italiana di Atene,* N.S., 34–35, 1972–1973, 397–418, figs. 2, 13, and 16–17; Larisa, Phokaia, and Sardis: Akerström, *Architektonischen Terrakotten,* 73, fig. 22, 200, fig. 65, 1–4, and pl. 21–25, 33–34, 39 and 41; Felten, *Friese,* 21–22 and 28–32, pl. 4, 1–3. On the analogies of these monuments with the Parthenon, see Brommer, *Parthenonfries,* 151–153.

62. Brommer, *Parthenonfries,* 151.

63. Rome, Villa Albani, inv. nr. 1014; W. Helbig, *Führer durch die öffentlichen Sammlungen klassischer Altertümer in Rom,* vol. 4, 4th ed., Tübingen, 1972, no. 3240; E. Simon, *Augustus: Kunst und Leben in Rom um Zeitenwende,* Munich, 1986, 120–121, fig. 158; and P. C. Bol (ed.), *Forschungen zur Villa Albani: Katalog der antiken Bildwerke,* vol. 1, Berlin, 1988, 380–388, cat. no. 124, pl. 218–220.

64. L. Savignoni, "Di una sima jonica con bassorilievi dell'isola di Creta," *RM,* 21, 1906, 66, fig. 1 and pl. II; Demangel, *Frise ionique,* 159, fig. 37. A similar terracotta frieze, but with a walking, winged horse, was found in Magna Graecia, at the site of San Biagio alla Venella near Metapontum: E. Fabbricotti, "Fregi fittili arcaici in Magna Grecia," *Atti e memorie della Società Magna Grecia,* N.S., 18–20, 1977–1979, pl. LXIa–b.

65. H. Schrader et al., *Die archaischen Marmorbildwerke der Akropolis,* Frankfurt am Main, 1939, 399; H. Payne and G. Mackworth Young, *Archaic Marble Sculpture from the Acropolis,* 2nd ed., London, 1950, 47; W. B. Dinsmoor, *The Architecture of Ancient Greece,* London, 1950, 90; H. Berve, G. Gruben, and M. Hirmer, *Greek Temples, Theatres, and Shrines,* New York, 1962, 168; and Felten, *Friese,* 24 and 35. Brommer, *Parthenonfries,* 152, and Ridgway, *Archaic Style,* 271, are still inclined to accept the hypothesis that these fragments already depicted the Panathenaic festival, but too little of the frieze remains to permit the identification of

its subject or its attribution to a specific monument. Boardman, *Greek Sculpture: The Archaic Period,* 155 and fig. 200, accepts the fragments as an architectural frieze, but he rejects the attribution to the Peisistratid temple because he regards the style as too late.

66. Felten, *Friese,* 23, 29, 38–40, and pl. 44; Boardman, *Greek Sculpture: The Archaic Period,* figs. 212.2–212.4; P. de la Coste-Messelière, *Au Museé de Delphes: recherches sur quelques monuments archaïques et leur décor sculpté,* Paris, 1936, 331–412 and pls. XXX–XXXIII, XXXV, XXXVIII–XXXIX, XLII–XLIII, XLV–XLVIII; P. de la Coste-Messelière and G. De Miré, *Delphes,* Paris, 1947, pls. 66–81. Though a mainland monument, the patronage and Ionic style of the architecture and the friezes is East Greek; Ridgway, *Archaic Style,* 269–270, would trace the origin and training of the two master sculptors who produced the friezes to the Cyclades and the centers of Asia Minor.

67. Brommer, *Parthenonfries,* 152.

68. Demangel, *Frise ionique,* 478; P. de la Coste-Messelière, "Nouvelles remarques sur les frises siphniennes," *BCH,* 68–69, 1944–1945, 31, n. 2; Brommer, *Parthenonfries,* 152; and, most recently, R. Vasic, "The Parthenon Frieze and the Siphnian Frieze," in Berger, *Parthenon-Kongress Basel,* 307–311.

69. Vasic, "Parthenon Frieze," 307–311. De la Coste-Messelière, *BCH,* 68–69, 1944–1945, 31, n. 2, had already emphasized the significance of Pheidias' stay at Delphi in comparing the two monuments.

70. D. G. Hogarth, *Excavations at Ephesus: The Archaic Artemisia,* London, 1908, 300–312, fig. 87, and atlas, pl. XV (reconstructions); F. N. Pryce, *Catalogue of Sculpture in the Department of Greek and Roman Antiquities in the British Museum,* vol. 1, part 1, London, 1928, 65–99, figs. 76–163; and Felten, *Friese,* 26 and 36. For a tentative reconstruction also see F. Krischen, *Die griechische Stadt: Wiederherstellungen,* Berlin, 1938, pl. 33.

71. For the seated figures see Pryce, *Catalogue of Sculpture in the British Museum,* 96–97, figs. 160–161. The combination of chariotry and seated figures recalls not only the Siphnian Treasury but also the Archaic marble frieze from the Akropolis cited in n. 65 above. Ridgway, *Archaic Style,* 264, points out that certain of the Artemision fragments could belong to a Centauromachy or battle scene of some sort as part of a larger ensemble including many themes, although these can no longer be identified.

72. G. M. A. Hanfmann and N. H. Ramage, *Sculpture from Sardis: The Finds Through 1975,* Cambridge, Mass., and London, 1978, 43–51, no. 7, and figs. 20–50; Felten, *Friese,* 35–36 and pl. 10, 3–6.

73. Hanfmann and Ramage, *Sculpture from Sardis,* 43, note the friable nature of the coarse-grained, half-crystalized marble from which the shrine was carved.

74. Ridgway, *Archaic Style,* 262 and n. 11.

75. On the shrine's relation to actual architecture and the Near Eastern background of the applied decoration across the full height of the walls, see Hanfmann and Ramage, *Sculpture from Sardis,* 44–45, and G. M. A. Hanfmann, *From Croesus to Constantine: The Cities of Western Asia Minor and Their Arts in Greek and Roman Times,* Ann Arbor, Mich., 1975, 12. Hanfmann seems ambivalent about

reading the figural decorations as separate metope-like panels or continuous friezes running behind the columns.

76. Hanfmann and Ramage, *Sculpture from Sardis*, 48–49, have already compared the lions atop the volutes and the Centaur on the rear of the shrine to the terracotta revetments from Sardis and Larisa, and the frieze of the Archaic temple at Assos; cf. Akerström, *Terrakotten*, pl. 26–27, and Boardman, *Greek Sculpture: The Archaic Period*, fig. 216. Centaurs and heraldic pairs of animals or monsters flanking a tree also occur at Assos and in the terracotta friezes from Gordion and Pazarli: Boardman, *Greek Sculpture: The Archaic Period*, fig. 216, nos. 1 and 5–8; and Akerström, *Terrakotten*, pl. 82, 84–88, and 94. The figure in the chariot has its counterpart in the friezes from Sardis: Akerström, *Terrakotten*, pl. 39 and 41. The shrine's use of reliefs with female offerants converging on a central doorway, sometimes containing the image of a goddess, is strikingly analogous to the early fifth-century architectural friezes from Thasos: C. Picard, *Études thasiennes*, vol. 8, *Les portes sculptées à images divines*, Paris, 1962, 50, fig. 16 and pl. III; E. Berger, *Das Basler Arztrelief: Studien zum griechischen Grab- und Votivrelief um 500 v. Chr. und zur vorhippokratischen Medizin*, Basel, 1970, 52–53, fig. 51–53. The processions of revelers and silenes or komasts with wineskins on the left of the shrine is also closely paralleled by the terracotta frieze from Acquarossa, an Etruscan work reflecting the same sort of East Greek prototypes behind the model (cf. figs. 32 and 36 in this volume).

77. Hanfmann, *Croesus to Constantine*, 12–13. Also see J. Kroll, "The Parthenon Frieze as a Votive Relief," *AJA*, 83, 1979, 348–352, who accepts Hanfmann's suggestion concerning the Ionian background of processional friezes in temple architecture. However, the additional comparison that Hanfmann draws between the processions on the Archaic column drums of the Artemision and the Parthenon frieze is less compelling; the tectonic context is so different and only generally analogous to the longer and unbroken processions of friezes applied to the entablature or the cella wall of a temple. The processions in the Thasos reliefs cited in the preceding note have in one case been identified from inscriptions as the Charites. In other cases they may be Horai or nymphs; see Berger, *Basler Arztrelief*, 52–53. The female figures on the Kybele shrine could be lesser divinites of this kind attending the goddess in the niche at the center of the model, as they do at Thasos, or they could be maenads corresponding to the Dionysiac revelers below. See G. M. A. Hanfmann, "On the Gods of Lydian Sardis," *Beiträge zur Altertumskunde Kleinasiens: Festschrift Kurt Bittel*, Mainz, 1983, 224 and fig. 2–3.

78. Brommer, *Parthenonfries*, 151 and n. 7.

79. K. M. Phillips, Jr., "Poggio Civitate," *Archaeology*, 21, 4, 1968, 252–261, with illustrations; T. N. Gantz, "Divine Triads on an Archaic Etruscan Frieze Plaque," *Studi etruschi*, 39, 1971, 3–24, tav. I–IV; idem, "The Procession Frieze from the Etruscan Sanctuary at Poggio Civitate," *RM*, 81, 1974, pl. 1–7 and 9; A. Andrén, "Osservazioni sulle terrecotte architettoniche etrusco-italiche," *Opuscula Romana*, 8, 1974, tav. XVIII–XXII.

80. Gantz, "Processional Frieze," 11–12, U. Höckmann, "Zur Darstellung auf

einer 'tyrrhenischen' Amphora in Leipzig," in U. Höckmann and A. Krug (eds.), *Festschrift für Frank Brommer*, Mainz, 1977, 184–185.

81. A. Andrén, *Architectural Terracottas from Etrusco-Italic Temples*, Lund, 1940, 407–413, pls. 126–128; idem, "Osservazioni ," 8, 1974, pl. II–VI; Demangel, *Friese ionique*, 175, 179, 438, 445, and 451, figs. 45, 49, 92, 95, and 97; A. Akerström, "Untersuchungen über der figürlichen Terrakottafriese aus Etrurien und Latium," *Opuscula Romana*, 1, 1954, 191–231, fig. 1–5, 29, and 32. In his publication of 1940, *Architectural Terracottas*, 408–409, Andrén had already presented these terracottas as a homogeneous group decorating a temple, and he reasserted this view in his later study, "Osservazioni," 4.

82. Andrén, "Osservazioni," 10–11; cf. Gantz, "Processional Frieze," 11–12. Also see the recent attempt of F. Romana Fortunati, "Ipotesi ricostruttive della decorazione del tempio de Velletri," *Prospettiva*, 47, 1986, 3–9, esp. fig. 9, areas *d* and *e*, where the plaques with the slow chariot procession run around the corner of the temple into the frieze of seated gods.

83. Friezes with chariot processions and cavalry occur at Poggio Buco, Palestrina, Rome, Tuscania, and Caere, while the ones from Tuscania, Veii, and Caere show the warrior entering the chariot: Andrén, *Architectural Terracottas*, pls.5, 24–25, 104, and 115; idem, "Osservazioni," pl. I, VIII–XVII, and XXV–XXVI. For the Acquarossa frieze see idem, "Osservazioni," pl. XXIII–XXIV; M. Strandberg Olofsson, *Acquarossa*, vol. 5, *The Head Antefixes and Relief Plaques*, Acta Instituti Romani Regni Sueciae, Ser. 4, vol. 38, Stockhom, 1984, p. 22, pl. IV, 1–2; and idem, in S. Stopponi (ed.), *Case e palazzi d'Etruria*, Milan, 1985, 54–58.

84. Andrén, *Architectural Terracottas*, cxxix–cxli; idem, "Osservazioni," 1–2, Akerström, *Terrakotten*, 269.

85. Racing chariots appear at Larisa, Kyzikos, Myous, and Iasos; the warrior entering the chariot at Palaikastro; horsemen at Prinias, Thasos, and Düver; processions on foot and in chariot on the Sardis shrine, Ephesos parapet, and Thasos reliefs; banquets at Larisa and Thasos; a divine assembly on the Siphnian Treasury. Demangel, *Frise ionique*, 451, and Akerström, "Untersuchungen," have emphasized the direct dependence of the Velletri gods upon Greek prototypes like the Treasury. See nn. 60–61, 64, and 70 above for the references to monuments not illustrated here. The procession on the Murlo plaques is best paralleled by Archaic and Early Classical terracottas from Magna Graecia; see Fabbricotti, "Fregi fittili," 161–168, fig. 4, and tav. LXI c (fig. 34 in this volume). On the evidence of the Building G reliefs from Xanthos, which will be discussed later (fig. 38 in this volume), friezes showing such processions with throne cars are probably of western Asiatic origin as well. The East Greek background of the Etruscan friezes emerges most clearly in the monuments that display a larger range of connections—like the Acquarossa friezes, whose Dionysiac revelers, chariot procession, and Herakles can all be found on the Kybele shrine, or the Velletri friezes, which compare so closely to the similar array of cavalry, chariotry, and seated gods on the Siphnian Treasury (cf. figs. 31–32 and 35–36 in this volume).

86. M. Cool Root, "An Etruscan Horse Race from Poggio Civitate," *AJA*, 77, 1973, 122–137, esp. 126ff., has stressed the impact of Corinthian art in the stylistic

detail of the plaques; cf. Phillips, *Archaeology,* 21, 4, 1968, 255; A. Small, "The Banquet Frieze from Poggio Civitate (Murlo)," *Studi etruschi,* 39, 1971, 59; Andrén, "Osservazioni," 2; and Fabbricotti, "Fregi fittili," 168–169, who stress Corinthian influence on the architectural terracottas of the Greek South as well as those of central Italy. It is also clear that the thrones and certain other objects shown in the Murlo frieze derive from the local Etruscan culture: Phillips, *Archaeology,* 21, 4, 1968, 256; and J. Macintosh, "Representations of Furniture on the Frieze Plaques from Poggio Civitate," *RM,* 81, 1974, 15–40. Yet Akerström's views on this subject, *Terrakotten,* 269–270, and "Untersuchungen," 191–232, esp. 223–225, are too extreme. He has argued that only the tectonic and ornamental format of the Italic friezes reflects East Greek prototypes, and that their iconography was borrowed from Greek minor arts, especially Corinthian and Attic vase painting. In contrast, Andrén, *Architectural Terracottas,* cxxxix–cxxli, and "Osservazioni," 2, has consistently stressed the East Greek derivation of the iconography as well as the tectonics of the Italic friezes. Cf. O. J. Brendel, *Etruscan Art,* Harmondsworth, 1978, 134, and E. Richardson, *The Etruscans: Their Art and Civilization,* 2nd ed., Chicago, 1976, 99. Such an origin is also clear from the direct analogies between the repertories of Asiatic and Italic friezes cited in the preceding note.

87. I. S. Mark, "The Gods on the East Frieze of the Parthenon," *Hesperia,* 53, 1984, 289–342, with a good review of the earlier bibliography on this problem. Other studies also include Pemberton, *AJA,* 80, 1976, 113–124; A. Linfert, "Die Götterversammlung im Parthenon-Ostfries und das attische Kultsystem unter Perikles," *AM,* 94, 1979, 41–47; H. Kenner, "Die Göttergruppe des Parthenonostfrieses," *Anzeiger der Österreichischen Akademie der Wissenschaften,* Philosophisch-historische Klasse, 118, 8, 1981, 273–309; Simon, "Mittelszene," 127–144; and T. Schäfer, "Diphroi und Peplos aus dem Ostfries des Parthenon: zur Kultpraxis bei den Panathenäen in klassischer Zeit," *AM,* 102, 1987, 185–212.

88. N. Himmelmann-Wildschütz, "Die Götterversammlung der Sosias-Schale," *Marburger Winckelmann-Program,* 1960, 41–48; H. Knell, *Die Darstellung der Götterversammlung in der attischen Kunst des VI. u. V. Jahrhunderts v. Chr.—Ein Untersuchung zur Entwicklungsgeschichte des "Daseinsbildes,"* Freiburg, 1965; idem, "Zur Götterversammlung am Parthenon-Ostfries," *Antaios,* 10, 1968, 38–54. Knell's studies reveal that the image of the assembled Olympians is especially associated in vase painting with depictions of the birth of Athena and the entry of Herakles to Olympos. Also see H. A. Shapiro, *Art and Cult Under the Tyrants,* Mainz, 1989, 135–139.

89. Höckmann, in Höckmann and Krug (eds.), *Festschrift Brommer,* 184–185; cf. Phillips, *Archaeology,* 21, 4, 1968, 256, who had already suggested a wedding scene.

90. As on the Archaic and Early Classical terracotta friezes from Metapontum and Lokroi: Fabbricotti, "Fregi fittili," 161–168, fig. 4, and pl. LXI c; P. Zancani Montuoro, "La Teogamia di Locri Epizefiri," *Archivio storico per Calabria e Lucania,* 24, 1955, 283–308, and pl. I–III; and H. Prückner, *Die lokrischen Tonreliefs: Beitrag zur Kultgeschichte von Lokroi Epizephyrioi,* Mainz, 1968, 19–22, fig. 2.

91. Andrén, "Osservazioni," 10–11.

92. Gantz, "Processional Frieze," 12–13. Although he doubts Andrén's suggestion, Gantz, 8–10, nevertheless admits the funerary connections of this processional iconography as it appears in later Etruscan art.

93. See for example the terracotta votive plaques from Lokroi in Prückner, *Die lokrischen Tonreliefs,* fig. 1, 7, and 14, and pl. 1, and 25, 5, where the deities always appear alone or in pairs, and the Archaic and Classical votive depictions discussed by Kroll, *AJA,* 83, 1979, 350–352.

94. Akerström, "Untersuchungen," 205–214; cf. Gantz, *Studi etruschi,* 39, 1971, 7–8.

95. On vases with the apotheosis of Herakles as a chariot procession to Olympos, see Boardman, "Herakles, Peisistratos, and Sons," *RA,* 1972, 60–64, fig. 1–3, and Shapiro, *Art and Cult Under the Tyrants,* 54, pl. 24c–d. For the version with Zeus enthroned, see Shapiro, 55, 135, and 158, pls. 25b–c, 47c–d, and 61a. For additional bibliography on vases with this theme, see n. 103 below.

96. Andrén, "Osservazioni," 10–11. For an interpretation of the Velletri plaques and the similar imagery at Acquarossa as scenes of heroic apotheosis, also see C. Chateigner, "Cortèges en armes en Étrurie. Une étude iconographique de plaques de revetment architectoniques étrusques du VIe siècle," *Revue belge de philosophie et d'histoire,* 67, 1989, 123–138, esp. 130ff.

97. A similar argument applies to the more recent interpretations of Etruscologists who see the enthroned figures of the Murlo plaques as a local Etruscan ruler and his family, or as an assembly of priests or magistrates; M. Cristofani, "Considerazioni su Poggio Civitate (Murlo, Siena)," *Prospettiva,* 1, 1975, 12; idem, *L'arte degli etruschi,* Turin, 1978, 133–134 and 136; A. J. Pfiffig, *Religio etrusca,* Graz, 1975, 36; J. P. Thuillier, "A propos des 'triades divines' de Poggio Civitate (Murlo)," in R. Bloch (ed.), *Recherches sur les religions de l'antiquité classique,* Hautes études du monde gréco-romain, 10, Geneva and Paris, 1980, 383–394; A. Rathje, in Stopponi, *Case e palazzi d'Etruria,* 123; S. Moscati, *Italy Before Rome,* Milan, 1987, 235–238. Whatever the sense or function of Etruscan scenes like the Murlo plaques, it is still likely that they were based on Greek depictions of apotheosis with seated groups of divinities. M. Torelli, moreover, has reasserted the identification of the Murlo plaque as a divine assembly: "*Polis* e 'palazzo': architettura, ideologia e artigianato greco in Etruria tra VII e VI sec. A.C.," in *Architecture et société de l'archaisme grec à la fin de la république romaine,* Collection de L'École Française de Rome, 66, Rome, 1983, 479–480.

98. For discussions of the east frieze and its iconography, see P. de la Coste-Messelière, *BCH,* 68–69, 1944–1945, 8–27; L. Vance Watrous, "The Sculptural Program of the Siphnian Treasury at Delphi," *AJA,* 86, 1982, 171–172; and Knell, *Mythos und Polis,* 28–32, fig. 40–43. The identification of the frieze as the battle of Achilleus and Memnon over the body of Antilochos has now been verified by the evidence of the painted inscriptions or legends; see V. Brinkmann, "Die aufgemalten Namenbeischriften an Nord- und Ostfries des Siphnierschatzhauses," *BCH,* 109, 1985, 85–87, and 110–121; cf. K. D. Shapiro, "Pindar's Sixth Ode and the Treasury of the Siphnians," *Museum Helveticum,* 45, 1, 1988, 1–5, who has argued for the

impact of the frieze on Pindar's version of the battle, quoted here in the Introduction. Demangel, *Frise ionique,* 450–453, had little problem in seeing the gods on the Treasury in much the same terms as those in the closely related Velletri plaques— that is, as symbols of divine intervention in or concern with the affairs of heroic protégés on earth, and he considered this usage as ancestral to the friezes of the Parthenon and the Hephaisteion (still misidentified as the Theseion) in the fifth century B.C.

99. For the inclusion of the gods on this monument, see H. A. Thompson, "The Sculptural Adornment of the Hephaisteion," *AJA,* 66, 1962, 342 and 344; Felten, *Friese,* 57–66 and pl. 45; B. S. Ridgway, *Fifth Century Styles in Greek Sculpture,* Princeton, N.J., 1981, 86; J. Dörig, *La frise est de L'Héphaisteion,* Mainz, 1985, 13–18, 49–56, figs. 17–22 and 52–59; and Knell, *Mythos und Polis,* 136–138, figs. 215–219. Thompson identifies the theme as Theseus fighting the sons of Pallas, and Felten and Knell now see it as a battle from the Trojan War; but the subject of the frieze has never been conclusively identified. For an overview of past opinion, see Dörig, *Frise est,* 67–73, who prefers to leave it open as the victory of some ancient Attic king.

100. Cf. Boardman, "Another View," 46, who notes the quality of apotheosis implicit in the frieze's juxtaposition of the seated gods with processional imagery, but only in relation to the Olympian *Daseinsbilder* in vase painting, without considering the specific precedents of this kind in earlier architectural sculpture. J. J. Pollitt, *Art and Experience in Classical Greece,* Cambridge, 1972, 87, has also pointed out the aura of apotheosis that the frieze accorded to the Athenians simply by placing them in a setting normally allotted to the depiction of gods or demigods.

101. Root, "Parthenon Frieze," 112–113.

102. Cf. Root's earlier discussion of this material, *Kingship,* 267–270.

103. See especially the lip cup by the Phrynos Painter, J. Boardman, *Athenian Black Figure Vases,* New York, 1974, fig. 123.2, which is so reminiscent of Near Eastern presentation scenes. For a more complete list and classification of such depictions, see P. Mingazzini, "Le rappresentazioni vascolari del mito dell'apoteosi di Herakles," *Atti della Reale Accademia Nazionale dei Lincei,* memorie della classe di scienze morali, storiche, e filologiche, ser. 6, 1, 1925–1926, 417–490; F. Brommer, *Vasenlisten Zur griechischen Heldensage,* Marburg/Lahn, 1960, 123ff.; K. Schauenburg, "Herakles unter Göttern," *Gymnasium,* 70, 2, 1963, 113–133; and idem, "Iliupersis auf einer Hydria des Priamosmalers," *RM,* 71, 1964, 66–68. For the pediment from the Archaic Akropolis, see Boardman, *Greek Sculpture: The Archaic Period,* fig. 194; Shapiro, *Art and Cult Under the Tyrants,* 21–23, pl. 6c; and Knell, *Mythos and Polis,* 7–9, fig. 14. On the continued use of this imagery in fifth-century Attic vase painting, also see B. Shefton, "The Krater from Baksy," in D. Kurtz and B. Sparkes (eds.), *The Eye of Greece: Studies in the Art of Athens,* Cambridge, 1982, 149–181, fig. 3 and pl. 45b.

104. Boardman, "Herakles, Peisistratos, and Sons," 61–62.

105. Boardman, "Another View," 46–47. For criticism of Boardman's thesis, see Brommer, *Parthenonfries,* 149, n. 15; E. B. Harrison, "Time in the Parthenon Frieze," in Berger, *Parthenon-Kongress Basel,* 230; Simon, *Festivals of Attica,*

58–60; and Beschi, "Il fregio del Partenone," 175. In particular, the great emphasis on cavalry in the frieze does not square with the specifics of the battle itself, since there is no evidence that the Athenians deployed any mounted troops against the Persians at Marathon, or even in the victories over Xerxes a decade later; see G. R. Bugh, *The Horsemen of Athens,* Princeton, N.J., 1988, 7–13.

106. For the identification of the Eponymous Heroes in the Parthenon frieze, see Boardman, "Parthenon Frieze," 213; E. B. Harrison, "The Iconography of the Eponymous Heroes on the Parthenon and in the Agora," in *Greek Numismtics and Archaeology: Essays in Honor of Margaret Thompson,* Wetteren, 1979, 71–85; idem, "Time in the Parthenon Frieze," in Berger, *Parthenon-Kongress Basel,* 230–234; U. Kron, "Die Phylenheroen am Parthenonfries," in Berger, *Parthenon-Kongress,* 235–244; idem, *Die zehn attischen Phylenheroen, Geschichte, Mythos, Kult und Darstellungen,* Athenische Mitteilungen, Beiheft, 5, Berlin, 1975, 202–214; Simon, *Festivals of Attica,* 59, 65, and 70; Beschi, "Il fregio del Partenone," 188–189; and Boardman, "Another View," 46, who sees these figures in a zone of transitional status between the Olympians and the rest of the celebrants, the heroized dead of Marathon. For the opposing view, see Ridgway, *Fifth Century Styles,* 78–79; P. Fehl, "The Rocks on the Parthenon Frieze," *JWCI,* 24, 1961, 16–17 and n. 38; I. Jenkins, "The Composition of the So-called Eponymous Heroes on the East Frieze of the Parthenon," *AJA,* 89, 1985, 121–127; Root, "Parthenon Frieze," 105; and most recently, B. Nagy, "Athenian Officials on the Parthenon Frieze," *AJA,* 96, 1992, 55–69.

107. Vasic, "The Parthenon Frieze," 308–311; cf. M. B. Moore, "The West Frieze of the Siphnian Treasury: A New Reconstruction," *BCH,* 109, 1985, 131–156, esp. 132–133. For the identification of the subject in the south frieze, also see Watrous, *AJA,* 86, 1982, 169–171.

108. Shapiro, *Museum Helveticum,* 45, 1, 1988, 1–5.

109. Osborne, "Parthenon Frieze," 104.

110. For the sources on Erichthonios here, see Eratosthenes, *Katasterismoi,* 13; the Parian Marble, 10, lines 18 and 21; Pliny, *Natural History,* VII (LVI), 202; Hyginus, *Poetica Astronomica,* II, 13; and Harpokration, Suidas, and Photios, s.v. "Panathenaia." Also see Brommer, *Parthenonfries,* 221, and Beschi, "Il fregio del Partenone," 184.

111. H. A. Thompson, "The Panathenaic Festival," *AA,* 1961, 224–231; cf. Thompson and Wycherley, *Agora,* 119–121; Boardman, "Another View," 45; idem, "Parthenon Frieze," 211–212; Simon, *Festivals of Attica,* 62. For the finds from the Agora, D. Burr, "A Geometric House and a Proto-Attic Votive Deposit," *Hesperia,* 2, 1933, 616–621, nos. 302–329, figs. 83–87; and H. A. Thompson, "Activities in the Athenian Agora: 1957," *Hesperia,* 27, 1958, 147–152, pls. 41–42.

112. The equestrian preoccupation of the west and south friezes on the Treasury is so striking that de la Coste-Messelière, *BCH,* 68–69, 1944–1945, 29–31, had questioned the identification as the Judgment of Paris here. But it has been reaffirmed by Moore, *BCH,* 109, 1985, 131–156, esp. 132–133.

113. Boardman, *Athenian Black Figure Vases,* fig. 46; P. E. Arias and M. Hirmer, *A History of 1000 Years of Greek Vase Painting,* New York, 1962, pl. 40.

The funerary and probably heroic connotation of chariot races is also documented by an Attic black figure pinax of the very late sixth century B.C.: Berger, *Basler Arztrelief*, 102, fig. 123.

114. See L. E. Roller, "Funeral Games in Greek Art," *AJA*, 85, 2, 1981, 106–119 and pl. 19, fig. 1; and E. Pfuhl, *Malerei und Zeichnung der Griechen*, vol. 3, Munich, 1923, fig. 179.

115. E. B. Harrison, "Athena and Athens in the East Pediment of the Parthenon," *AJA*, 71, 1967, 43–45; cf. H. Lloyd-Jones, "Heracles or Dionysos?" *AJA*, 74, 1970, 181.

116. H. Metzger and P. Coupel, *Fouilles de Xanthos*, vol. 2, *L'Acropole lycienne*, Paris, 1963, 49–61 and pls. XXX–XLI; H. Metzger, "Reliefs inédits de l'acropole de Xanthos," *RA*, 1969, part 2, 225–232; idem, "La frise des 'coqs et poules' de l'acropole de Xanthos: essai de restitution et d'interprétation," *RA*, 1976, part 2, 247–264. For the sculptures of Building G, see Pryce, *Catalogue of Sculpture in the British Museum*, vol. 1, 141–146, and pls. XXIX–XXXI.

117. Metzger and Coupel, *Fouilles de Xanthos*, vol. 2, 61.

118. R. Ghirshman, *The Arts of Ancient Iran from Its Origins to the Time of Alexander the Great*, New York, 1964, 350; P. Bernard, "Remarques sur le décor sculpté d'un edifice de Xanthos," *Syria*, 42, 1965, 261–288; H. Metzger, "Sur deux groupes de reliefs 'gréco-perses' d'Asie Mineure," *L'Antiquité classique*, 40, 1971, 509, 511–515; idem, "Ekphora, convoi funèbre cortège de dignitaires en Grèce et la péripherie du monde grec," *RA*, 1975, 209–220; J. Borchhardt, "Epichorische, gräko-persisch beeinflusste Reliefs in Kilikien," *IM*, 18, 1968, 180; idem, "Das Heroon von Lymyra—Grabmal des lykischen Königs Perikles," *AA*, 1970, 372–377 and fig. 29; M. J. Mellink, "Excavations at Karatas-Semayük and Elmali, Lycia, 1972," *AJA*, 77, 1973, 300–301; and A. Farkas, *Achaemenid Sculpture*, Istanbul, 1974, 113. For a more recent discussion of this type of funeral procession or ekphora in Lycian and Greco-Persian art, see R. Fleischer, *Der Klagenfrauensarkophag aus Sidon*, Istanbuler Forschungen, 34, Tübingen, 1983, 44–54.

119. B. S. Ridgway, *The Severe Style in Greek Sculpture*, Princeton, N.J., 1970, 25; Farkas, *Achaemenid Sculpture*, 114.

120. Ghirshman, *Arts of Ancient Iran*, 350; Bernard, *Syria*, 42, 1965, 261–288; and Farkas, *Achaemenid Sculpture*, 113. The impact of official Persian art on the Lycian monuments was first proposed by F. J. Tritsch, "The Harpy Tomb at Xanthos," *JHS*, 62, 1942, 39–50. E. Akurgal, *Die Kunst Anatoliens von Homer bis Alexander*, Berlin, 1961, 135 and 137, doubted a substantial Persian impact in Lycian sculpture much before the middle of the fifth century. But see the more recent arguments of J. Borchhardt, "Zur Deutung lykischer Audienzszenen," *Actes du Colloque sur la Lycie Antique*, Bibliotheque de l'Institut Français d'Études Anatoliennes d'Istanbul, 27, Paris, 1980, 7–12, and Akurgal's response, 13–14. A. Shapur Shabazi, *The Irano-Lycian Monuments: The Principal Antiquities of Xanthos and Its Region as Evidence for Iranian Aspects of Achaemenid Lycia*, Tehran, 1975, has also argued for the considerable impact of Iranian art and ceremonial in the Lycian monuments. He explains this development largely on political

grounds; he sees the Lycian dynasty in the fifth century as the descendants of Harpagos the Mede, who had originally subdued western Anatolia for Kyros.

121. The most thorough and extensive recent surveys of this material are the studies of Borchhardt and Metzger cited in n. 118 above, along with E. Akurgal, "Griechisch-persische Reliefs aus Daskyleion," *Iranica Antiqua,* 6, 1966, 147–156; J. M. Dentzer, "Reliefs au 'banquet' dans l'Asie Mineure du Ve siècle av. J.-C.," *RA,* 1969, part 2, 195–224; and P. Bernard, "Les bas-reliefs gréco-perses de Dascylion à la lumière de nouvelle découvertes," *RA,* 1969, part 1, 17–28. To the reliefs of this type one must now add the tomb painting from Karaburun near Elmali: M. Mellink, "Excavations at Karatas-Semayük and Elmali, Lycia, 1971–1973," *AJA,* 76, 1972, 263–279 and pls. 58–60; *AJA,* 77, 1973, 297–301 and pls. 44–46; *AJA,* 78, 1974, 355–359 and pls. 67–70; and Fleischer, *Klagenfrauensarkophag,* 44–54. On the native Anatolian connections of Greco-Persian reliefs, see Akurgal, *Iranica Antiqua,* 6, 1966, 152–154; and Dentzer, *RA,* 1969, part 2, 202–207, 213, 215–216, and 220. Borchhardt, *IM,* 18, 1968, 180–181 and 183–185, had also pointed to the Hittite background of the rituals and beliefs represented in the Greco-Persian reliefs of western Anatolia. In her studies of the Lycian tomb paintings discovered in the Elmali region, Mellink, too has argued for a native continuity with old oriental artistic traditions; also see her other articles, "Notes on Anatolian Wall Painting," in *Mélanges Mansel,* Ankara, 1974, 537–547; idem, "Local, Phrygian, and Greek Traits in Northen Lycia," *RA,* 1976, part 1, 21–34; idem, "A Sample Problem from the Painted Tomb at Kizilbel," *Actes du Colloque sur la Lycie Antique,* Bibliotheque de l'Institut Français d'Études Anatoliennes d'Istanbul, 27, 1980, 15–20; and idem, "The Anatolian Exchange: Phrygian and Lycian Wall Painting," *AJA,* 87, 1983, 245.

122. The only analogies for the horse-drawn throne cart in Persian art proper are the models of chariots with seated riders from the so-called Oxus Treasure and the Lytton Collection: O. M. Dalton, *The Treasure of the Oxus with Other Examples of Early Oriental Metal-Work,* 2nd ed., London, 1926, xli, fig. 22; Ghirshman, *Arts of Ancient Iran,* fig. 301. A Persian cylinder seal in Karlsruhe shows a throne cart pulled by camels; P. Calmeyer, "Zur Genese altiranischer Motive II: Der leere Wagen," *AMIran,* 7, 1974, 49–77 and pl. 10, 1. For Neo-Assyrian depictions of the ruler in the throne cart, see the wall painting from Til Barsip: Thureau-Dangin, *Til Barsib,* pl. LI; and the relief from Nineveh: Moortgat, *Alten Mesopotamien,* 157, fig. 110. Also see B. Hrouda, *Die Kulturgeschichte des assyrischen Flachbildes,* Bonn, 1965, 68 and pl. 17.

123. See the fragmentary late sixth-century B.C. bowl of East Greek manufacture excavated at Masat Höyük: T. Özgüc, *Masat Höyük II: A Hittite Center Northeast of Bogazköy,* Ankara, 1982, 123, pl. 64, 1a–1b, and pl. I; and P. Calmeyer, "Zur Genese altiranischer Motive IX: Die Verbreitung des westiranischen Zaumzeugs im Achaimenidenreich," *AMIran,* 18, 1985, 131 and pl. 46, 2. For the incense burner, see the Ionian hydria in Pfuhl, *Malerei und Zeichnung,* vol. 3, fig. 146, and J. Charbonneaux, R. Martin, and F. Villard, *Archaic Greek Art,* London, 1971, 93, fig. 102. A silver burner of this kind with a Lydian inscription now in the Metropolitan Museum of Art documents the currency of such objects in the westernmost

satrapies in the later sixth century; see D. von Bothmer, *A Greek and Roman Treasury,* New York, 1984, 44, no. 68, where it is mistakenly identified as a Greek work.

124. Ridgway, *Archaic Style,* 264.

125. Metzger and Coupel, *Fouilles de Xanthos,* vol. 2, 60–61 and 81–82.

126. Brommer, *Parthenonfries,* 153, has already pointed to the use of an additional Ionic frieze on the Doric temple at Assos; for this work see Boardman, *Greek Sculpture: The Archaic Period,* 160 and fig. 216; Felten, *Friese,* 22, 28, 35–36 and pl. 6, 1–5. On the monument at Amyklai and the most recent opinion on the reconstruction, see R. Martin, "Bathyclès de Magnésie et le 'trône' d'Apollon à Amyklae," *RA,* 1976, part 2, 205–218 and figs. 6–7; Felten, *Friese,* 25–26 and 37. An extensive account of the excavations and the surviving portions of the foundation and architectural decoration appears in E. Buschor and W. von Massow, "Vom Amyklaion," *AM,* 52, 1927, 1–84, esp. 65ff., with Beilage IV–V and X, and pl. XVI–XXIII; and G. Daux, "Chronique des fouilles 1967," *BCH,* 92, 1968, 812–817 and figs. 6–9. For the Nereid monument in Xanthos, about 390–380 B.C., see W. H. Schuchhardt, "Die Friese der Nereiden-Monumentes von Xanthos," *AM,* 52, 1927, 94–161, esp. 117–127, with Beilage XV–XVI, and now W. A. P. Childs and P. Demargne, *Fouilles de Xanthos,* vol. 8, *Le monument des Néréides: le décor sculpté,* Paris, 1989, 235–251, 279–291, pls. LXXXVII–LXXXIX.

127. J. J. Coulton, "The Parthenon and Periklean Doric," in Berger, *Parthenon-Kongress Basel,* 43–44.

128. Osborne, "Parthenon Frieze," 104–105, has observed more generally that one runs the risk of misinterpreting the frieze as a whole if one fails to recognize that stylistic features constituted a significant aspect of its meaning or subject matter.

129. Pollitt, *Art and Experience,* 79.

130. All these sites can be documented at about the middle of the fifth century in the epigraphic testimonia for the cities under Athenian imperial control, and they would presumably have been required to participate in the Great Panathenaia. See B. D. Meritt, H. T. Wade-Gery, and M. F. McGregor, *The Athenian Tribute Lists,* Princeton, N.J., 1953—Thasos: vol. 3, 23, 55, and 271; Myous: vol. 3, 25 and 54; Kyzikos: vol. 2, 24, 56, and 271; Larisa: vol. 3, 25 and 199; Iasos: vol. 3, 23, 53, and 239; Phokaia: vol. 3, 28, 54, and 273; Siphnos: vol. 3, 27, 57, and 239; and Ephesos: vol. 3, 22, 53, and 271. The Lycian cities were recorded as a group and not individually in the tribute lists, and they disappear around 440 B.C.: vol. 3, 7, 9, 25, and 209–212.

131. Here too the detail and arrangement of the architectural components on the Parthenon may have been consciously expressive, asserting a specifically martial conception of male excellence, discipline, and leadership; see J. Onians, "War, Mathematics, and Art in Ancient Greece," *History of the Human Sciences,* 2, 1, 1989, 39–62, esp. 57ff.

Selected Bibliography

This Bibliography lists works cited more than three times and abbreviated in the Notes.

Akerström, A.
1954 "Untersuchungen über der figürlichen Terrakottenfriese aus Etrurien und Latium," *Opuscula Romana,* 1, 191–231.
Akerström, A.
1966 *Die architektonishen Terrakotten Kleinasiens,* Acta Instituti Atheniensis Regni Sueciae, ser. 4, 11, Lund.
Andrén, A.
1940 *Architectural Terracottas from Etrusco-Italic Temples,* Lund.
Andrén, A.
1974 "Osservazioni sulle terrecotte architettoniche etrusco-italiche," *Opuscula Romana,* 8, 1–16.
Arias, P. E.
1955 "Dalle necropoli di Spina: la tomba 136 di Valle Pega," *Rivista dell'Istituto Nazionale di Archeologia e Storia dell'Arte,* n.s., 4, 95–178.
Arias, P. E., and Hirmer, M.
1962 *A History of 1000 Years of Greek Vase Painting,* New York.
Badian, E.
1987 "The Peace of Callias," *JHS,* 107, 1–39.
Balcer, J. M.
1978 *The Athenian Regulations for Chalkis: Studies in Athenian Imperial Law,* Historia, Einzelschriften, 33, Wiesbaden.
Balcer, J. M.
1984 *Sparda by the Bitter Sea: Imperial Interaction in Western Anatolia,* Chico, Calif.
Barron, J. P.
1964 "Religious Propaganda of the Delian League," *JHS,* 84, 35–48.
Barron, J. P.
1972 "New Light on Old Walls," *JHS,* 92, 20–45.
Barron, J. P.
1980 "Bakchylides, Theseus and a Woolly Cloak," *BICS,* 1–8.
Berger, E. (ed.)
1984 *Parthenon-Kongress Basel: Referate und Berichte 4. bis 8. April 1982,* vols. 1–2, Mainz.
Berger, E.
1986 *Der Parthenon in Basel: Dokumentation zu den Metopen,* Mainz.
Beschi, L.
1984 "Il fregio del Partenone: una proposta di lettura," *Rendiconti dell'*

Accademia dei Lincei, classe di scienze morali storiche e filologiche, 39, 173–195.

Boardman, J.
1972 "Herakles, Peisistratos, and Sons," *RA,* 57–72.

Boardman, J.
1974 *Athenian Black Figure Vases,* New York.

Boardman, J.
1975 *Athenian Red Figure Vases: the Archaic Period,* New York and Toronto.

Boardman, J.
1976 "The Kleophrades Painter at Troy," *Antike Kunst,* 19, 3–18.

Boardman, J.
1977 "The Parthenon Frieze—Another View," in U. Höckmann and A. Krug (eds.), *Festschrift für Frank Brommer,* Mainz, 39–49.

Boardman, J.
1978 *Greek Sculpture: The Archaic Period,* New York and Toronto.

Boardman, J.
1982 "Herakles, Theseus, and Amazons," in D. Kurtz and B. Sparkes (eds.), *The Eye of Greece: Studies in the Art of Athens,* Cambridge, 1–28.

Boardman, J.
1984 "The Parthenon Frieze," in E. Berger (ed.), *Parthenon-Kongress Basel: Referate und Berichte 4. bis 8. April 1982,* Mainz, 210–215.

Boersma, J. S.
1970 *Athenian Building Policy from 561/0–405/4 B.C.,* Scripta Archaeologica Groningana, 4, Groningen.

Bothmer, D. von
1957 *Amazons in Greek Art,* Oxford.

Brommer, F.
1960 *Vasenlisten zur griechischen Heldensage,* Marburg/Lahn.

Brommer, F.
1963 *Die Skulpturen der Parthenon-Giebel: Katalog und Untersuchung,* Mainz.

Brommer, F.
1967 *Die Metopen des Parthenon: Katalog und Untersuchung,* Mainz.

Brommer, F.
1977 *Der Parthenonfries: Katalog und Untersuchung,* Mainz.

Brommer, F.
1982 *Theseus: Die Taten des griechischen Helden in der antiken Kunst und Literatur,* Darmstadt.

Cohen, B.
1983 "Paragone: Sculpture Versus Painting—Kaineus and the Kleophrades Painter," in W. G. Moon (ed.), *Ancient Greek Art and Iconography,* Madison, Wis., 171–192.

Connor, W. R.
1970 "Theseus in Classical Athens," in A. Ward (ed.), *The Quest for Theseus,* New York, 143–174.

Davreux, J.
1942 *La légende de la prophétesse Cassandre d'après les textes et les monu-
 ments,* Bibliotheque de la Faculté de Philosophie et Lettres de l'Univer-
 sité de Liège, fasc. 94, Liège and Paris.
Del Grande, C.
1947 *Hybris: colpa e castigo nell'espressione poetica e letteraria degli scrit-
 tori della Grecia antica,* Naples.
Demangel, R.
1932 *La frise ionique,* Paris.
Devambez, P.
1981 "Amazones," *LIMC,* I, 1, Munich, 586–653.
duBois, P.
1982 *Centaurs and Amazons: Women and the Pre-History of the Great Chain
 of Being,* Ann Arbor, Mich.
Dugas, C.
1937 "Tradition littéraire et tradition graphique dans l'antiquité grecque,"
 L'Antiquité classique, 6, 5–26. = *Receuil Charles Dugas,* Paris, 1960,
 59–74.
Dugas, C.
1938 "A la lesché des cnidiens," *REG,* 51, 53–59. = *Receuil Dugas,* 75–79.
Dugas, C.
1943 "L'Évolution de la légende de Thésée," *REG,* 56, 1–23 = *Receuil
 Dugas,* 93–107.
Dugas, C., and Flacelière, R.
1958 *Thésée: images et récits,* Paris.
Ehrenberg, V.
1960 *The Greek State,* New York.
Euben, J. P. (ed.)
1986 *Greek Tragedy and Political Theory,* Berkeley, Los Angeles, and London.
Fabbricotti, E.,
1977– "Fregi fittili arcaici in magna grecia," *Atti e memorie della Società
1979 Magna Grecia,* N.S., 18–20, 149–170.
Felten, F.
1984 *Griechische tektonische Friese archaischer und klassischer Zeit,*
 Schriften aus dem Athenaion der klassischer Archäologie Salzburg, 4,
 Waldsassen-Bayern.
Fischer, F.
1957 *Heldensage und Politik in der klassischen Zeit der Griechen,* Tübingen,
 (Diss. 1937).
Fisher, N. R. E.
1976 "*Hybris* and Dishonor: I," *Greece and Rome,* ser. 2, 23, 177–193.
Francis, E. D.
1980 "Greeks and Persians: The Art of Hazard and Triumph," in D. Schmandt-
 Besserat (ed.), *Ancient Persia: The Art of an Empire,* Malibu, Calif.,
 53–86.

Francis, E. D., and Vickers, M.

1985 "The Oenoe Painting in the Stoa Poikile and Herodotus' Account of Marathon," *ABSA*, 80, 99–113.

Francis, E. D.

1990 *Image and Idea in Fifth-Century Greece: Art and Literature after the Persian Wars*, London and New York.

Gantz, T. N.

1974 "The Processional Frieze from an Etruscan Sanctuary at Poggio Civitate," *RM*, 81, 1–14.

Gauer, W.

1968 *Weihgeschenke aus den Perserkriegen*, Istanbuler Mitteilungen, Beiheft, 2, Tübingen.

Gauer, W.

1980 "Das Athener-Schatzhaus und die marathonischen Akrothinia in Delphi," in F. Krinzinger, B. Otto, and E. Walde-Psenner (eds.), *Forschungen und Funde: Festschrift Bernard Neutsch*, Innsbruck, 127–136.

Gauer, W.

1980 "Die Gruppe der ephesischen Amazonen, ein Denkmal des Perserfriedens," in H. A. Cahn and E. Simon (eds.), *Tainia: Roland Hampe zum 70. Geburtstag*, Mainz, 201–226.

Gauer, W.

1984 "Was geschieht mit dem Peplos?" in E. Berger (ed.), *Parthenon-Kongress Basel: Referate und Berichte 4. bis 8. April 1982*, Mainz, 220–229.

Ghali-Kahil, L.

1955 *Les enlèvements et le retour d'Hélène dans les textes et les documents figurés*, Ecole Française d'Athènes, travaux et mémoires, 10, Paris.

Giesekam, G. J.

1976 "The Portrayal of Minos in Bacchylides 17," *Arca Classical and Medieval Texts, Papers, and Monographs*, Papers of the Liverpool Latin Seminar, 2, 237–252.

Graf, F.

1974 *Eleusis und die orphische Dichtung Athens in vorhellenistischer Zeit*, Religionsgeschichtliche Versuche und Vorarbeiten, 32, Berlin and New York.

Hamilton, C. D.

1979 *Sparta's Bitter Victories: Politics and Diplomacy in the Corinthian War*, Ithaca and London.

Harrison, E. B.

1966 "The Composition of the Amazonomachy on the Shield of Athena Parthenos," *Hesperia*, 35, 107–133.

Harrison, E. B.

1967 "Athena and Athens in the East Pediment of the Parthenon," *AJA*, 71, 27–58.

Harrison, E. B.

1972 "Preparations for Marathon, the Niobid Painter and Herodotus," *Art Bulletin*, 54, 4, 390–402.

Harrison, E. B.
1972 "The South Frieze of the Nike Temple and the Marathon Painting in the Stoa," *AJA*, 76, 353–378.
Harrison, E. B.
1979 "Apollo's Cloak," in G. Kopcke and M. B. Moore (eds.), *Studies in Classical Art and Archaeology: A Tribute to Peter Heinrich von Blanckenhagen*, Locust Valley, N.Y., 91–98.
Harrison, E. B.
1981 "The Motifs of the City-Siege on the Shield of Athena Parthenos," *AJA*, 85, 281–317.
Harrison, E. B.
1984 "Time in the Parthenon Frieze," in E. Berger (ed.), *Parthenon-Kongress Basel: Referate und Berichte 4. bis 8. April 1982*, Mainz, 230–234.
Harrison, J. E.
1922 *Prolegomena to the Study of Greek Religion*, Cambridge.
Hartog, F.
1988 *The Mirror of Herodotos: The Representation of the Other in the Writing of History* (trans. J. Lloyd), Berkeley, Los Angeles, and London.
Herington, C. J.
1955 *Athena Parthenos and Athena Polias: A Study in the Religion of Periclean Athens*, Manchester.
Hölscher, T.
1973 *Griechische Historienbilder des 5. und 4. Jahrhunderts vor Chr.*, Würzburg.
Hölscher, T., and Simon, E.
1976 "Die Amazonenschlacht auf dem Schild der Athena Parthenos," *AM*, 91, 115–148.
Hurwit, J. M.
1987 "Narrative Resonance in the East Pediment of the Temple of Zeus at Olympia," *Art Bulletin*, 69, 1, 6–15.
Jeffery, H. L.
1965 "The *Battle of Oinoe* in the Stoa Poikile," *ABSA*, 60, 41–57.
Jeppesen, K.
1963 "Bild und Mythus an dem Parthenon," *Acta Archaeologica*, 34, 1–96.
Jeppesen, K.
1968 *Eteokleous Symbasis: Nochmals zur Deutung des Niobidenkraters, Louvre G. 341*, Acta Jutlandica, 40, 3, Copenhagen.
Just, R.
1989 *Women in Athenian Law and Life*, London and New York.
Kagan, D.
1991 *Pericles of Athens and the Birth of Democracy*, New York, Oxford, Singapore, and Sidney.
Kebric, R. B.
1983 *The Paintings in the Cnidian Lesche at Delphi and Their Historical Context*, Mnemosyne Supplementum, Leiden.

Kierdorf, W.
 1966 *Erlebnis und Darstellungen der Perserkriege,* Hypomnemata, 16, Göttingen.
Kirk, G. S.
 1970 *Myth: Its Meaning and Functions in Ancient and Other Cultures,* Cambridge, Berkeley, and Los Angeles.
Knell, H.
 1990 *Mythos und Polis. Bildprogramme griechischer Bauskulptur,* Darmstadt.
Kron, U.
 1975 *Die zehn attischen Phylenheroen: Geschichte, Mythos, Kult und Darstellungen,* Athenische Mitteilungen, Beiheft, 5, Berlin.
Kurtz, D., and Sparkes, B. (eds.),
 1982 *The Eye of Greece: Studies in the Art of Athens,* Cambridge.
Lloyd-Jones, H.
 1983 *The Justice of Zeus,* Sather Classical Lectures, 41, 2nd ed., Berkeley, Los Angeles, and London.
Loraux, N.
 1981 *Les enfants d'Athéna: idées athéniennes sur la citoyenneté et la division des sexes,* Paris.
Loraux, N.
 1986 *The Invention of Athens: The Funeral Oration in the Classical City* (trans. A. Sheridan), Cambridge, Mass., and London.
MacDowell, D. M.
 1976 "*Hybris* in Athens," *Greece and Rome,* ser. 2, 23, 14–31.
Meiggs, R.
 1972 *The Athenian Empire,* Oxford.
Merck, M.
 1978 "The City's Achievements, the Patriotic Amazonomachy and Ancient Athens," in S. Lipschitz (ed.), *Tearing the Veil,* London, 95–115.
Meritt, B. D., and Wade-Gery, H. T.
 1957 "Athenian Resources in 449 and 431 B.C.," *Hesperia,* 26, 163–197.
Meritt, B. D., and Wade-Gery, H. T.
 1962 "The Dating of Documents to the Mid-Fifth Century–I," *JHS,* 82, 67–74.
Merritt, B. D., and Wade-Gery, H. T.
 1963 The Dating of Documents to the Mid-Fifth Century–II," *JHS,* 83, 100–117.
Momigliano, A.
 1979 "The Persian Empire and the Idea of Freedom," in A. Ryan (ed.), *The Idea of Freedom: Essays in Honor of Isaiah Berlin,* Oxford, 139–151.
Moon, W. G. (ed.)
 1983 *Ancient Greek Art and Iconography,* Madison, Wis.
Moret, J.
 1975 *L'Ilioupersis dans la céramique italiote: les mythes et leur expression figurée au IVe siècle,* Rome.
Neils, J.
 1987 *The Youthful Deeds of Theseus,* Archaeologia, 76, Rome.

Nesselhauf, H.
1933 *Untersuchungen zur Geschichte der delisch-attischen Symmachie,* Klio, Beiheft, N.S., 17, Leipzig.

North, H.
1966 *Sophrosyne: Self-Knowledge and Self-Restraint in Greek Literature,* Ithaca, N.Y.

Osborne, R.
1987 "The Viewing and Obscuring of the Parthenon Frieze," *JHS,* 107, 98–105.

Parke, H. W.
1977 *gestivals of the Athenians,* Ithaca, N.Y.

Parker, R.
1986 "Myths of Early Athens," in J. Bremmer (ed.), *Interpretations of Greek Mythology,* Totowa, N.J., 187–214.

Perlman, S.
1976 "Panhellenism, the Polis, and Imperialism" *Historia,* 25, 1–30.

Pfuhl, E.
1923 *Malerei und Zeichnung der Griechen,* 3 vols., Munich.

Pfuhl, E.
1926 *Masterpieces of Greek Drawing and Painting* (trans. J. D. Beazley), London; New York, 1955.

Picard, C.
1937 "De 'l'Ilioupersis' de la lesché delphique aux métopes nord du Parthénon," *REG,* 50, 175–205.

Pollitt, J. J.
1972 *Art and Experience in Classical Greece,* Cambridge.

Pollitt, J. J.
1974 *The Ancient View of Greek Art: Criticism, History, and Terminology,* New Haven and London.

Pollitt, J. J.
1976 "The *Ethos* of Polygnotos and Aristeides," in L. Bonfante and H. von Heintze (eds.), *In Memoriam Otto J. Brendel: Essays in Archaeology and the Humanities,* Mainz, 49–54.

Pollitt, J. J.
1985 "Early Classical Greek Art in a Platonic Universe," in C. G. Boulter (ed.), *Greek Art: Archaic Into Classical,* Leiden, 96–111.

Praschniker, C.
1928 *Parthenonstudien,* Augsburg and Vienna.

Raeck, W.
1981 *Zum Barbarenbild in der Kunst Athens im 6. und 5. Jahrhundert v. Chr.,* Bonn.

Ras, S.
1944 "Dans quel sens faut-il regarder les métopes nord du Parthénon?" *REG,* 57, 87–105.

Ridgway, B. S.
1977 *The Archaic Style in Greek Sculpture,* Princeton, N.J.

Ridgway, B. S.
1981 *Fifth Century Styles in Greek Sculpture*, Princeton, N.J.

Robert, C.
1892 *Die Nekyia des Polygnot*, Hallisches Winckelmannsprogram, 16, Halle.

Robert, C.
1893 *Die Iliupersis des Polygnot*, Hallisches Winckelmannsprogram, 17, Halle.

Robert, C.
1895 *Die Marathonschlacht in der Poikile und weiteres über Polygnot*, Hallisches Winckelmannsprogram, 18, Halle.

Robertson, M.
1967 "Conjectures in Polygnotos' Troy," *ABSA*, 62, 5–12.

Robertson, M.
1975 *A History of Greek Art*, Cambridge.

Root, M. Cool,
1979 *The King and Kingship in Achaemenid Art: Essays on the Creation of an Iconography of Empire*, Acta Iranica, textes et memoires, 9, Leiden.

Root, M. Cool,
1985 "The Parthenon Frieze and the Apadana Reliefs at Persepolis: Reassessing a Programmatic Relationship," *AJA*, 89, 103–120.

Schauenburg, K.
1974 "Achilleus als Barbar: ein antikes Missverständnis," *Antike und Abendland*, 20, 88–96.

Schauenburg, K.
1975 "Eurymedon Eimi," *AM*, 90, 97–121.

Schefold, K.
1966 *Myth and Legend in Early Greek Art*, New York.

Schefold, K.
1981 *Die Gottersage in der klassischen und hellenistischen Kunst*, Munich.

Schefold, K., and Jung, F.
1988 *Die Urkönige, Perseus, Bellerophon, Herakles und Theseus in der klassischen und hellenistischen Kunst*, Munich.

Schindler, W.
1988 *Mythos und Wirklichkeit in der Antike*, Berlin.

Schmandt-Besserat, D.
1980 *Ancient Persia: The Art of an Empire*, Malibu, Calif.

Schuller, W.
1974 *Die Herrschaft der Athener im Ersten Attischen Seebund*, Berlin.

Schuller, W.
1984 "Der attische Seebund und der Parthenon," in E. Berger (ed.) *Parthenon-Kongress Basel: Referate und Berichte 4. bis 8. April 1982*, Mainz, 20–25.

Shapiro, H. A.
1989 *Art and Cult Under the Tyrants in Athens*, Mainz.

Shear, T. L., Jr.
1966 *Studies in the Early Projects of the Periklean Building Program,* Ph.D.
 Diss., Princeton.

Shefton, B.
1962 "Herakles and Theseus on a Red-Figured Louterion," *Hesperia,* 31,
 330–368.

Simon, E.
1963 "Polygnotan Painting and the Niobid Painter," *AJA,* 67, 43–62.

Simon, E.
1975 "Versuch einer Deutung der Südmetopen des Parthenon," *JDAI,* 90,
 100–120.

Simon, E.
1980 "Die Mittelgruppe im Westgiebel des Parthenon," in H. A. Cahn and
 E. Simon (eds.), *Tainia: Roland Hampe zum 70. Geburtstag,* Mainz,
 238–255.

Simon, E.
1982 Die Mittelszene im Ostfries des Parthenon," *AM,* 97, 127–144.

Simon, E.
1983 *Festivals of Attica: An Archaeological Commentary,* Madison, Wis.

Spaeth, B. S.
1991 "Athenians and Eleusinians in the West Pediment of the Parthenon,"
 Hesperia, 60, 331–362.

Stansbury-O'Donnell, M. D.
1989 "Polygnotos's *Iliupersis:* A New Reconstruction," *AJA,* 93, 203–215.

Stansbury-O'Donnell, M. D.
1990 "Polygnotos's *Nekyia:* A Reconstruction and Analysis," *AJA,* 94, 213–235.

Stewart, A.
1983 "Stesichoros and the François Vase," in W. G. Moon (ed.), *Ancient
 Greek Art and Iconography,* Madison, Wis., 53–74.

Strasburger, H.
1958 "Thukydides und die politische Selbstdarstellung der Athener,"
 Hermes, 86, 17–40.

Stupperich, R.
1977 *Staatsbegräbnis und Privatgrabmal im klassischen Athen,* Diss., West-
 fälischen Wilhelms-Universität zu Münster.

Tersini, N.
1987 "Unifying Themes in the Sculpture of the Temple of Zeus at Olympia,"
 Classical Antiquity, 6, 1, 139–159.

Tiverios, M.
1981 "Sieben gegen Theben," *AM,* 96, 145–161.

Thomas, E.
1976 *Mythos und Geschichte: Untersuchungen zum historischen Gehalt
 griechischer Mythendarstellungen,* Cologne.

Thompson, H. A., and Wycherley, R. E.
1972 *The Athenian Agora: The Agora of Athens,* vol. 14, Princeton, N.J.

Touchefeu-Meynier, O.
 1968 *Thèmes odysséens dans l'art antique,* Paris.
Tyrrell, W. B.
 1984 *Amazons: A Study in Athenian Mythmaking,* Baltimore and London.
Tyrrell, W. B., and Brown, F. S.
 1991 *Athenian Myths: Words in Action,* New York and Oxford.
Vasic, R.
 1984 "The Parthenon Frieze and the Siphnian Frieze," in E. Berger (ed.),
 Parthenon-Kongress Basel: Referate und Berichte 4. bis 8. April 1982,
 Mainz, 307–311.
Wade-Gery, H. T.
 1945 "The Question of the Tribute in 449/448 B.C.," *Hesperia,* 14, 212–229.
Walters, K. R.
 1980 "Rhetoric as Ritual: The Semiotics of the Attic Funeral Oration," *Flo-*
 rilegium, 2, 1–27.
Wiencke, M.
 1954 "An Epic Theme in Greek Art," *AJA,* 58, 285–306.
Woodford, S.
 1974 "More Light on Old Walls," *JHS,* 94, 158–165.

Index

327

Wisconsin Studies in Classics

General Editors
Barbara Hughes Fowler and Warren G. Moon

E. A. Thompson
Romans and Barbarians: The Decline of the Western Empire

Jennifer Tolbert Roberts
Accountability in Athenian Government

H. I. Marrou
A History of Education in Antiquity
Histoire de l'Education dans l'Antiquité, translated by George Lamb
(originally published in English by Sheed and Ward, 1956)

Erika Simon
Festivals of Attica: An Archaeological Commentary

G. Michael Woloch
Roman Cities: Les villes romaines by Pierre Grimal,
translated and edited by G. Michael Woloch,
together with A Descriptive Catalogue of Roman Cities
by G. Michael Woloch

Warren G. Moon, editor
Ancient Greek Art and Iconography

Katherine Dohan Morrow
Greek Footwear and the Dating of Sculpture

John Kevin Newman
The Classical Epic Tradition

Jeanny Vorys Canby, Edith Porada, Brunilde Sismondo Ridgway,
and Tamara Stech, editors
Ancient Anatolia: Aspects of Change and Cultural Development

Ann Norris Michelini
Euripides and the Tragic Tradition